# IMPRESSIONISM
## AND EUROPEAN MODERNISM

# IMPRESSIONISM
## AND EUROPEAN MODERNISM

THE SIRAK COLLECTION

with essays by Richard Brettell and Peter Selz

CATALOGUE ENTRIES BY

Richard Brettell
E. Jane Connell
Leslie Stewart Curtis
Esti Dunow
Rosalyn Frankel Jamison
Sharon Kokot
Kathryn Kramer
Diane Lesko
Nannette V. Maciejunes
Anne Mochon
Myroslava M. Mudrak
Joachim Pissarro
Todd Porterfield
Eliza Rathbone
Horst Uhr
Gary Wells

Research Curator, Leslie Stewart Curtis

Edited by Norma Roberts

COLUMBUS MUSEUM OF ART
COLUMBUS, OHIO

DISTRIBUTED BY
THE UNIVERSITY OF WASHINGTON PRESS
SEATTLE AND LONDON

This catalogue has been published in conjunction with *Masterpieces of Impressionism and European Modernism: The Sirak Collection,* an exhibition held at the Columbus Museum of Art, Columbus, Ohio, October 12, 1991– October 11, 1992.

Funding for the catalogue has been provided by Battelle Memorial Institute, the Huntington National Bank, Women's Board of the Columbus Museum of Art, the Frederick W. Schumacher Foundation, the Greater Columbus Arts Council, and the Estate of Ruth B. Lea.

Generous funds for the presentation of the Sirak Collection have been provided by the National Endowment for the Arts.

Library of Congress Cataloging-in-Publication Data
Columbus Museum of Art.
    Impressionism and European modernism : the Sirak collection / with essays by Richard Brettell and Peter Selz ; catalogue entries by Richard Brettell . . . [et al.] ; research and documentation by Leslie Stewart Curtis ; edited by Norma Roberts.
        p.   cm.
    Includes bibliographical references.
    ISBN 0-295-97133-9 : $40.00.—ISBN 0-295-97134-7 (pbk.) : $24.95
    1. Art, European—Exhibitions. 2. Modernism (Art)—Europe— Exhibitions. 3. Art, Modern—19th century—Europe—Exhibitions. 4. Art, Modern—20th century—Europe—Exhibitions. 5. Sirak, Howard D.—Art collections—Exhibitions. 6. Sirak, Babette L.—Art collections—Exhibitions. 7. Art—Private collections—Ohio—Columbus—Exhibitions. 8. Columbus Museum of Art -Exhibitions. I. Brettell, Richard R. II. Selz, Peter Howard, 1919–        . III. Roberts, Norma J. IV. Title.
N6447.C65   1991
709'.03'407477157—dc20                                        90-85293

The following photographs were taken by Sheldan Collins: cat. nos. 1, 4, 7, 11–14, 18–21, 24–25, 28–29, 31, 35–37, 39–40, 42–48, 50, 52–53, 55–56, 58–60, 62, 65, 69–73, 75–77. The following photographs were taken by Jeff Bates: cat. nos. 26, 66. All other photographs of artworks are from the museum's archives. The portrait of Sam Salz (page 11) is by Peter Fink, and the portrait of Howard and Babette Sirak (page 11) is by Jeff Rycus.

The Museum of Modern Art graciously granted permission to quote from Kirk Varnedoe, *Vienna 1900: Art, Architecture and Design.* Copyright © 1986.

Jacket/cover: Claude Monet, *Basket of Grapes* (detail).
Jacket/cover verso: Emil Nolde, *Sunflowers in the Windstorm* (detail).

Page 2: Ernst Ludwig Kirchner, *Girl Asleep* (detail).
Page 6: Kees van Dongen, *Lilacs with Cup of Milk* (detail).
Page 10: Alexej Jawlensky, *Schokko with Red Hat* (detail).
Page 22: Henri Matisse, *Maternity* (detail).
Page 180: André Derain, *Portrait of Maud Walter* (detail).

Printed and bound in Japan.

# CONTENTS

# PREFACE

We at the Columbus Museum of Art are pleased and very excited to present the inaugural exhibition of the Howard D. and Babette L. Sirak Collection of European modernist masterpieces. As these works take their place in the permanent collection, the museum's community feels a sense of profound gratitude mixed with pride. In coming to this museum, the collection, which *ARTnews* saluted in 1976 as one of the finest private collections in the world, forges another link in the grand tradition in which enlightened collectors entrust works of art to a public institution. Few museums have an opportunity such as this to acquire so many distinguished works at a single time. This museum is immeasurably grateful to the Siraks for the privilege of housing these great works of art and the opportunity to offer them now for public view and enjoyment.

Had we set out to organize a major exhibition of Impressionist and early modernist works with the intent of documenting some of the most revolutionary trends in the history of art, we could hardly have assembled a more sweeping, and at the same time more satisfying, survey. This group of seventy-eight works, publicly exhibited in its entirety for the first time, includes the gentle light-filled reveries of the Impressionists as well as some of those artists' more provocative social commentaries. Also included are the cerebral ruminations of the Cubists, and the bold emotional revelations of expressionists of many persuasions. For all its diversity, the Sirak Collection is a remarkably coherent entity that cuts a wide swath through the range of artistic possibilities. Here are paintings, works on paper, and sculptures. Here are small, exquisite works such as Morandi's sparkling little etchings, and much larger paintings by Delaunay, De Staël, and Vuillard, among others. Here are early works of major artists such as Matisse that foretell grand innovations, mature works by giants such as Monet that sum up much of the character and accomplishment of a long successful career, and, in the case

of Paul Klee, eleven works that illuminate an entire career. Here are characteristic as well as rare creations by thirty-seven of the most important artists of the late nineteenth and early twentieth centuries.

Howard and Babette Sirak formed the collection during the years 1964–1977, guided by personal taste, as well as arduous study and conversations with such art world luminaries as Sam Salz, a renowned dealer in Impressionist art, and Ulfert Wilke, a well-known collector. Through Sam Salz, the Siraks were able to obtain a number of paintings that came directly from members of the Durand-Ruel family, whose grandfather had been the original dealer for Monet, Pissarro, Renoir, Sisley, Degas, and others. Clearly, both Siraks are endowed with a talent for seeing that goes beyond those abilities that can be acquired by diligence and determination. Many of the countless viewers who were graciously permitted to see the works in the Siraks' home in Columbus will attest to the privilege of having one or both of the Siraks as tour guides—often unexpectedly. Their love of these treasures could be observed in their eyes as well as in their words, as they recounted story after story about the artists, about the works, about collecting. A visitor not familiar with the proposition that works of art have a life of their own soon would be convinced that this indeed is true.

Happily, the Sirak Collection adds entirely new dimensions to the museum's holdings in European modernist works, strengthening the collection in some areas and increasing its scope overall. With the addition of these works, the Columbus Museum of Art establishes a major public collection in the Midwest, with particular strengths in Impressionism, Fauvism, Cubism, and German Expressionism. As part of our inaugural celebration, we offer this catalogue of the collection, an assemblage of some of the latest scholarship by experts on the artists and the periods represented.

We are especially grateful to Richard Brettell,

director of the Dallas Museum of Art, and Peter Selz, professor emeritus, University of California (Berkeley), who contributed informative essays and served as readers of other contributions. Our thanks go also to the scholars who provided the catalogue entries. Particular commendation is due to Leslie Stewart Curtis, who made frequent trips to key archives to research the works and provide a solid foundation for future inquiries into provenances, exhibition histories, and references, and to Norma Roberts, who not only edited the catalogue but marshalled all forces necessary to put it together beautifully and on time.

The museum is forever grateful to those groups and institutions that provide financial support for its services to an expanding arts community, both at home and nationwide. We are indebted to the National Endowment for the Arts for generous funding of the inaugural presentation of the Sirak Collection. We gratefully acknowledge the many contributions to the Campaign for Enduring Excellence, which made the acquisition and future maintenance of the collection possible. And for providing funds for this publication we extend our heartfelt thanks to Battelle Memorial Institute, Huntington National Bank, the Frederick W. Schumacher Foundation, the Greater Columbus Arts Council, the Women's Board of the Columbus Museum of Art, and the Estate of Ruth G. Lea. Because of the generosity and enlightenment of such as these, the arts continue to thrive and the community is made richer.

Merribell Parsons
Director

# COLLECTORS' STATEMENT

*There is a tide in the affairs of men*
*Which taken at the flood leads on to fortune;*
*Omitted, all the voyage of their life*
*Is bound in shallows and in miseries.*
  William Shakespeare
  *Julius Caesar*, ACT 4, SCENE 3

One Saturday, in early 1964, we were in New York, walking on 57th Street near Fifth Avenue. We came to Knoedler's art gallery, where Babs's father had bought a painting about fourteen years earlier. On the spur of the moment, we decided to go in. Neither of us had ever been in an art gallery before. As we entered, we were greeted by a pleasant gentleman named Martin Jennings. We told him we would like to look at some pictures. He conducted us to a fourth-floor viewing room and, after we sat down, began placing one picture after the other on a viewing stand in front of us.

Of the many paintings we were shown, we especially liked an abstract landscape by Maria Elena Vieira da Silva, and a bold, vivid, explosive painting by German artist Emil Nolde entitled *Sunflowers in the Windstorm*. Martin Jennings could see that we were drawn to the Vieira da Silva, and so he told us that we could try living with it in our home. There would be no expense to us, he assured us: "We'll pay all the shipping and crating costs even if you decide to return it. It won't cost you a cent." We couldn't resist. "What have we got to lose?" we said to each other.

After the Vieira da Silva arrived home, we hung it in different rooms. Everywhere we placed it, we liked it, and so a month later we bought it. But we couldn't get the other painting out of our minds. One day, Babs came home with a book called *Emil Nolde and His Friends*. We would lie in bed at night with our two-year-old son John between us, poring over this book and the others that began to pile up on either side of our bed. We didn't realize it then, but we were studying art and falling in love with it.

Five months later, we were back in New York and heading straight for Knoedler's. Martin Jennings greeted us and immediately took us upstairs. He

brought out the Nolde *Sunflowers*. Astutely recognizing that we were hooked on the picture, Martin repeated his speech that we should try living with the painting in our home, and again he said, "It won't cost you a cent." Needless to say, *Sunflowers* was never sent back. This painting proved to be a catalyst, because the next year, 1965, we acquired thirty-six paintings: works by Vlaminck, Utrillo, Monet, Müller, Klimt (two), Soutine (two), Gleizes (two), Delaunay, Schiele, Kirchner (three), Jawlensky, Severini, Klee (six), Beckmann, Bissier (two), De Staël, Derain (two), Feininger, and another by Nolde. This was a frenetic year indeed. We don't know how we did so much, nor can we say what instinct drove us, but in retrospect we realize that we were fortunate because unconsciously we were buying exceptional works ahead of the market. We had taken the "tide" at the "flood."

At this point in our lives, we had been married only three years. Between us we had seven children and a spacious house in Bexley full of tropical fish tanks and empty walls. Howard was a practicing heart surgeon and a professor of surgery at The Ohio State University. Babs was busily involved with the children, family and friends, and community affairs. Nevertheless, in whatever spare time we could find, we would avidly study art in books, magazines, transparencies, and, when traveling, in art museums. Whenever we went to New York, we were transformed: we became—and became known as—art people. This enabled us to see other collections and meet well-known people in the art world. One opportunity led to another. Each purchase seemed to expand our contacts so that the quest became a thrilling adventure. Our lives were enriched by our friendship with Sam Salz, a great and famous art dealer, who opened to us

Sam Salz

Babette and Howard Sirak, January 1991

the beautiful world of Impressionist art. Similarly, there was Ulfert Wilke, an artist, collector, and museum director, who seemed to know all the other collectors, art dealers, and many of the contemporary artists whom we subsequently met. These vigorous art-collecting years continued until 1977 when we bought our last painting from Sam Salz: Monet's *Weeping Willow.*

From the time of the purchase of our first painting and through all the years of buying pictures, we worked very hard to improve our "eyes" so that we could confidently differentiate between the various levels of quality. Whenever we traveled, whether in the United States or Europe, we spent most of our time in museums or in churches (especially in Italy) or visiting private collections. One of many satisfactions came from fine-tuning our taste and seeing this become recognized by dealers and the various other art people whom we encountered. We developed faith in our collective "eye," and thus we would be satisfied with only the best examples of an artist's work. We were never tempted to buy just for the name. We had become, as Sam Salz put it, *collectionneurs sérieux.*

For many years we have lived surrounded by these great and powerful works of art. We have felt a tremendous sense of responsibility for their well-being as well as a sense of obligation to the artists themselves. We believe that they are meant to be seen and shared with others—not just with family and friends but with the whole community, and thus for years we opened our home to people from far and near who wished to view the art. Moreover, we recognized that these great paintings have a life of their own—they had existed long before they became a part of our home and our life, and with tender and proper care they would exist for centuries more. Thus, even though they had become part of us, we knew that we were only their temporary custodians. We wanted them always to be together in our city, Columbus, and for this reason the arrangement was made with the Columbus Museum of Art to assure that generations to come would enjoy this great art.

We hope that those who experience "our" works in the museum will receive from their beauty and their various personal messages about life some moments of joy and peace and an appreciation of man's creative genius and its enduring spirit, which somehow enable us all to survive the worst.

Howard and Babette Sirak
January 24, 1991

# FRENCH PAINTING AND THE EUROPEAN VANGUARD

RICHARD BRETTELL

For many, French painting between 1850 and 1930 *is* modern art. The great German historian of modern art, Julius Meier-Graefe, in his landmark book of 1906, devoted his attention to French painters almost exclusively, relegating his own countrymen to the background. The English have been little different, and their more prominent critics, Roger Fry and Quentin Bell, were utterly francophile in their writing, in spite of the fact that they admitted English artists into their personal collections. Even the ever-nationalist Swiss have become fanatical collectors and worshipers of French art, as the American exhibition of paintings from the Bürhle Collection in 1990 makes patently obvious. Given the international adulation of French art, it is surely no accident that the foremost twentieth-century historian of French Impressionism and Post-Impressionism, John Rewald, is German born, was trained in France, and has been active for most of his working life in the United States.

That the French came to dominate the consciousness of the world with their art did not happen through their own efforts exclusively. Many, probably most, of the path-breaking collectors of French modernism were foreigners. Collectors in Moscow, Basel, Manchester, Boston, Chicago, London, and Tokyo dominate the history of Impressionist collecting, and the first great French dealer of modern French painting, Paul Durand-Ruel, made a large portion of his money from clients in England and America and opened profitable offices in both those countries. If French painting is modern art, foreigners played a large role in making it so.

The reasons for this widespread acceptance of a national art have not yet been seriously explored. Certain students of collecting have chosen to analyze international collectors of French painting in terms of their economic backgrounds, stressing their membership in the most modern of so-called social classes, the industrial and commercial bourgeoisie. Others simply worship the wisdom and forward-thinking acumen of these early collectors, neglecting to link them or their tastes to larger cultural systems. Few have treated these early collectors in any way more subtle than mere economic determinism. In addition, there have been remarkably few analyses of the critically important "middle men" in art transactions: the French dealers with international clientele, the foreign dealers with French connections, and the network of critics and tastemakers who worked with them. What linked these men and women? How did they succeed in creating a shared taste for the works of no more than thirty artists throughout the capitalist world? Why is it that English, German, Italian, or American artists of this vital—and intensely productive—period in the history of world art have had so little international attention paid to them as compared to that lavished on their French colleagues?

To begin with, the history of the international collecting of French art coincided absolutely with a period of international exhibitions of art, science, technology, and production—exhibitions in which artists were most often classified by national origins and in which prizes and criticism were dominated by intense national rivalry. Some modernist artists, however, chose to be judged not as French artists but as individuals or members of unofficial artistic groups. Both Courbet and Manet exhibited independently in connection with the international exhibitions of 1855 and 1867 in Paris, and, later in the century, the ever-entrepreneurial Gauguin exhibited with his young friends inside a café on the grounds of the great Exposition Universelle of 1889. The individuality of these artists and their self-conscious struggle against national, bureaucratic, and official culture endeared them to a strata of international capitalists who were wary of government control of individual freedom. Men such as Potter Palmer of Chicago, Horace Havemeyer of New York, Alexsei Morosov of Moscow,

and Karl Osthaus of Essen built their collections on a foundation of new capital, without interference from governments and bureaucracies. The collectors themselves, then, were as original, as individual, and as antinational as the artists whose works they collected.

One still must ask why all these men bought the same kinds of works of art at a time when a record number of artists had gained public attention. Why Monet, Manet, Renoir, and Degas for Palmer and Havemeyer; why Gauguin, Vuillard, and Matisse for Morosov and Osthaus? The answer must surely be sought in the works of art themselves and not merely in the system of dealers, critics, historians, and, finally, museums who have promoted them. There were many other collectors of contemporary art who developed their tastes simultaneously with the Palmers and the Morosovs and whose tastes were more reflective of the larger art scene in the late nineteenth and early twentieth centuries. Yet we remember these other collectors poorly, and many of the fundamentally academic paintings and sculptures they donated to the great museums of Europe and America languish in storage or, alternatively, are installed in galleries by revisionist curators anxious to show off rarely seen works. That very few galleries in the major museums of European art include both Monet and Rossetti, Vuillard and Beckmann, Gauguin and Munch, seems an oversight, or miscalculation of not insignificant proportions, for the French painters belong to the larger milieu of European painters in the years before and after the turn of the century.

It is, for that reason, doubly exciting to analyze the French paintings in the Sirak Collection because they belong to a group of works that reflects the broader spectrum of European vanguard art during this most fertile period. With Ensor and Rosso from the nineteenth century and Kirchner, Nolde, Klee, and Severini from the twentieth, the collection challenges the dominant position of French art with a healthy sampling of works from other regional and national traditions of Europe. The underlying thesis of the collection is that European vanguard art is more important than any national style. The Sirak Collection recognizes by its very composition both the internationalism of European vanguard movements and the centrality of the city of Paris to that international artistic system.

## THE IMPRESSIONIST DECADE: 1875—1885

The Sirak Collection of French painting has its roots in what might be called the Impressionist decade, 1875–1885, rather than in the realist paintings of Courbet and Manet, which are often thought to be the precursors of vanguard painting in France. With major works in this collection by Cézanne, Monet, Pissarro, Renoir, Rodin, and Sisley from that period, the breadth, variety, and individuality of Impressionist artists is made clear. The group of works includes small and large paintings as well as a critically important drawing by Renoir (*The Gypsy Girl*, cat. no. 55) which demonstrates that the idea of Impressionism as a movement dominated by plein-air landscape painting is at once naive and inaccurate.

The small, compact seated bather by Cézanne (cat. no. 5) is a powerful embodiment both of the interplay between drawing and painting in that artist's career and of the earliness of his investigation of the bather as a principal subject. Indeed, the artificiality of this subject is proof that the Impressionists were painters of the imagination as well as of real landscapes and people. By analyzing a single figure in a particular pose, Cézanne worked toward a grammar of the nude, and he used and reused this figure in other related works, allowing its rhythms to interact with those of adjacent figures taken from varied contexts. This small painting is part of a sequence of related paintings and drawings that investigate the female nude, a series that Cézanne contrasted with a simultaneous but separate investigation of the male nude.

The landscapes of Pissarro, Renoir, and Monet from the late 1870s and early 1880s are clear proof of the range of Impressionism. Pissarro's wonderfully fresh and windblown *Landscape near Pontoise* (cat. no. 51) was painted in a hamlet called Le Chou, near the artist's home in Pontoise, just north of Paris. Here market gardens with vegetable plots and fruit trees filled the alluvial plane formed by the nearby river Oise. Rural workers walked up and down the paths and roadways of this traditional agricultural country and tended the gardens, taking their best produce to the weekly markets in nearby Pontoise. The rhythms of Pissarro's paintings from Pontoise are quotidian and rural, very different from the suburban Impressionism of Renoir, Monet, and Sisley. And Pissarro's

pictorial surfaces are more "labor intensive" than those of his colleagues, for here hundreds of strokes overlay and intermingle to form a deliberate, "handmade" appearance, at once as complex and as common as the subject.

The Romantic appeal of the sea as a subject for—and challenge to—the Impressionists is very clearly seen in the superb seascapes of 1882 by Monet and Renoir (see cat. nos. 39 and 56). The sea as a subject for painting had just been reasserted in the major retrospective of the works of Gustave Courbet, held in the spring of 1882 at the Palais des Beaux-Arts. Renoir responded by painting the sea, in this instance the Mediterranean, as a limpid field on his famous Italian voyage in the summer of the same year. Monet spent the summer in the northern parts of France and painted the English Channel (known to the French as La Manche) near the Norman resort town of Pourville as a green churning surface affected by the clouds above and the sand beneath. For Renoir, the Mediterranean was eternal and changeless. For Monet, the surface of La Manche was constantly in motion, alternately trembling or greatly agitated.

These two glorious seascapes also tell us much about the varieties of Impressionist technique. Renoir, with his training as a porcelain painter, was attracted most to lustrous, glazed surfaces, which seem to have their own depths. For him, the sea was built up of layer upon layer of thinned, liquid paint, each drying like a glaze fired separately in a kiln by a master ceramicist. We sink into Renoir's sea. By contrast, Monet was moved by rugged, painterly surfaces, built up by gesture upon gesture so that the painting has the character of a colored relief sculpture. Each line of pale green, each stroke of gray, pink, or salmon is palpable, recording a separate painterly act, and the surface is never unified under the veil of Renoir-like glazes.

It is fascinating, then, to approach the calligraphic painted surface of Sisley's 1885 *Boatyard at Saint-Mammès* (cat. no. 68). Sisley shows us a scene of labor, not the modern industrial labor of the second half of the nineteenth century but an older, more traditional form of work along the banks of the river Loing. Great tree trunks have been cut down in a forest and floated to the site. From this material, sawed and planed on the banks of the river, the volumetric mass of a ship is to be created. Sisley described all of this without distracting details, employing a series of interpenetrating painted gestures that have their technical origins in pencil sketching and etching. First he built each form with short strokes, defining the edges, and then he filled in the forms with rhythmic gestures. Hence, the creation of the ship in the painting and the creation of the painting itself are contrasted—the first is slow and methodical, the second is quick and seemingly impulsive. The first is a form of construction, the second of evocation.

Pissarro's *The Stone Bridge and Barges at Rouen* (cat. no. 52) changes the scene from the country to the city—not Paris, the capital of art, but the Norman capital city of Rouen. Pissarro visited Rouen in 1883, as part of a search for a new home. When he arrived, its picturesque streets, old half-timbered houses, and Gothic ecclesiastical buildings both fascinated and depressed him. How could he paint them afresh, after so many earlier artists of the nineteenth century had succeeded in doing so? His answer was to treat Rouen not as an ancient but as a modern city, stressing its important industrial port and the factories lining its edges. Pissarro's Rouen allowed the famous cathedral only cameo appearances, as a distant form in certain river landscapes. But, in the Sirak painting, there is no hint of picturesque Rouen in what has become a relentlessly modern and industrial landscape. How different it is from Sisley's scene of boat building on the river. For Pissarro, the boats are large barges that ply a Seine with no pretty hills, no fluffy white clouds, and no leisure.

Even Pissarro's technique contrasts with that of Sisley, Renoir, and Monet. Whereas the other artists used a single dominant technique throughout their landscapes, Pissarro varied his approach to painting depending on the visual character of the subject. The sky and river are smoothly brushed and subtle, with carefully blended strokes of grays, pale browns, whites, violets, and grayed blues. There is even a hint of glazing in these areas. By contrast, the boats as well as the buildings on the banks of the Seine are built up in the manner of a painted drawing with linear strokes that cling to the forms they describe. There is none of the nervousness and fascination with the process of painting so evident in works by Sisley or Monet.

## THE 1890s:

## BEYOND IMPRESSIONISM

The final Impressionist exhibition of 1886 contained the seeds of the destruction of the movement. Seurat and the young Neo-Impressionist painters have been accorded the lion's share of twentieth-century discussions of the dissolution of Impressionism, but it should not be forgotten that Gauguin and Redon also represented important challenges to its waning supremacy. The former spoke of a new form of primitivism and the latter of a pictorial conquest of the imagination; both were alien to Impressionist pictorial ideology.

French vanguard painters split into many, small groups in the 1890s; some survived the decade, but most dissolved after one or two years. An abundance of little magazines and intellectual art journals were also founded—and foundered—throughout the nineties, demonstrating that painting and the plastic arts had become increasingly allied to literature. There is perhaps no greater indication of this alliance than the funeral of the great poet Stéphane Mallarmé in 1896, an "intimate" gathering dominated by writers, musicians, and artists. If the Impressionist decade had been devoted almost exclusively to the pictorial arts, in the 1890s such achievements belonged to the larger context of the decorative arts, literature, and music. Art became The Arts.

The Sirak Collection describes the 1890s in a wonderfully idiosyncratic way. There are no major masterpieces by Van Gogh, Seurat, Gauguin, or Cézanne, the dominating talents of the decade, nor are we treated to an "intimist" painting by Vuillard or a scene in Montmartre by Toulouse-Lautrec. Rather, it is the work of the elderly Degas, the dean of Impressionist figure painters, that defines the decade for the Siraks. Two wonderful pastels, *Seated Dancer* (cat. no. 8) and the earlier *Breakfast* (cat. no. 6), probe the female form that Cézanne had described so powerfully in the small bather of the 1870s already discussed. Degas grounded his art completely in observation, but these pastels show how far he had come in the realization of figure paintings since his carefully constructed genre scenes of the Impressionist decade. The ballerina in *Seated Dancer* is not dancing, nor is she shown in the company of other dancers. Instead, she poses in costume, her gesture telegraphing deeply imbedded messages of enticement and protection. There are many levels in Degas's "reality" of the 1890s.

Yet the extent to which Degas departed from the directness of Impressionism in his later work is felt most clearly in the Siraks' great late landscape, *Houses at the Foot of a Cliff* (cat. no. 7). There is little doubt that this painting is Degas's greatest landscape, joining two groups of landscape monotypes as his major contributions to the genre. But how completely this painting differs from an Impressionist landscape. The village near the cliff is so precisely described, we know that it must exist, yet the gentle glow of pink light, the softness of colors, the apparent blur of forms, and the physical inaccessibility of the subject—all of these visual qualities cloak the painting in memory, as though it were an image in the mind more than a real place. In painting this village, which latter-day scholars have identified as Saint-Valéry-sur-Somme, Degas has approached the literary world of Proust more closely than any other painter, a world in which the tangibility of form is less important than its memory.

At the same time that Degas evoked the lost world of rural France, the young painter Henri Matisse, who worked in the Symbolist tradition of Gustave Moreau, was making his earliest contributions to painting. His impressive *Still Life with Self-Portrait* of 1896 (cat. no. 37) is as mysterious, as evocative of various states of mind, as is Degas's landscape. In a darkened room with no visible source of light, a table is laden with books, pitchers, papers, fabrics, and works of art. Only the fresh flowers and the painted images on a ceramic vase bring life to the interior. All the books are closed, the painting in the background is turned around, forever inaccessible to the viewer. The pitchers conceal rather than reveal their contents, and the papers are rolled and arranged so that their messages cannot be read. Even the self-portrait of the title peers at the viewer from behind both the vase of flowers and its protective (and reflective) glass, preventing a deep look into the eyes of the artist. The ultimate message of the painting is mysterious, and the artist protects us from it, allowing us to make what we wish to of its meaning. Matisse's world is like the late poetry of Mallarmé in its discreetness and ambiguity. Matisse in 1896 was a young man making the art of an old world.

## THE TWENTIETH CENTURY

In circa 1900, Odilon Redon made a tiny painting called *The Two Graces* (cat. no. 54), in which two women clad in costumes of uncertain date seem to reflect together on the nature of time and of man. In what place or historical epoch they exist is not known; their dresses are at once Empire and medieval, classical and resolutely modern. In painting them in their austere, asymmetrical setting, Redon seems to have been striving toward a kind of modern timelessness that has often been sought in this century. One thinks of the interiors of Mies van der Rohe and Auguste Perret, of the furniture of Ruhlman, of the music of Stravinsky in the 1920s, and of the dances of Nijinsky, Martha Graham, and George Balanchine. For Redon, as for these other modern classicists, all of time and all of space seem accessible in the twentieth century and, for that reason, he thought he could create a timelessness more vast and ultimately more satisfying than previous civilizations had been able to imagine.

Yet the new century envisioned by Redon was not to be. The collapse of colonialism, the bloodiest wars in human history, and the wild oscillations of the international markets created a global civilization with little of the apparent stability for which Redon— and all classicists—yearned. The history of twentieth-century art is a history of rapid inventions, of manifold vanguard groups, of an art that embraces chaos, disorder, and instability just as readily as Redon sought to create calm, mystery, and quiet. Indeed, anxieties are more apparent in the Siraks' choice of twentieth-century art than are celebrations of the glorious disorder of the times.

For one thing, the Siraks embraced the most visually conservative of vanguard movements, the Fauve movement, with two major paintings by Derain from around 1905 (cat. nos. 11 and 12). Aside from a superb Cubist oil and collage by Juan Gris of 1913 (cat. no. 19), the more analytical experiments in Cubism are unrepresented, as are the paintings of Léger. Instead, a scaffolding of concern for visual appearances and for the integrity of the artist's gesture marks the Siraks' collection of French art from this century. The existence of the Redon as a bridge between the Symbolism of the nineteenth century and the modern classicism of the twentieth indicates that, for these great collectors, there is more of continuity than change in modern civilization.

Perhaps the most interesting and diverse group of works in the collection was made during or just after World War I. This war, which can be called the first global event, far from being a national or regional conflict, was a vast international struggle that affected not only Europe but the entire postcolonial world, and the newly created world of global communications forced citizens of the world to experience the war simultaneously. Whether Monet in his garden, Gleizes in his suburban Parisian house, or Delaunay in the comparative safety of Portugal, the artists of the world read daily newspapers about the same battles, the same broken negotiations, the same failed alliances, the crumbling of world order.

Their responses were various. The Cubist Albert Gleizes made a wonderful portrait of Jacques Nayral in 1917 (cat. no. 18), his head broken into planes of color in the Synthetic Cubist manner and his hair turning into smoke. Shafts of light, meaningless numbers, smoke from guns or explosions, a smile turned over to become a frown—all of these elements of the painting must be interpreted not merely in artistic and theoretical terms, but as an image of a specific man who was killed during war.

Curiously, Robert Delaunay, an artist who had celebrated the modern world and its technological brilliance, fled from the war to live in the colorful rusticity of Minho, the most northern province of Portugal. His wartime pictures look like the resolutely cheerful depictions of nineteenth-century peasants dressed by an Orphist designer from twentieth-century Paris. Patterns of peasant embroidery interested this "regressive" Delaunay as much as the airplanes and iron buildings of the modern Paris he left behind.

The most profound—and profoundly ambivalent— reaction to World War I is Claude Monet's great *Weeping Willow* (cat. no. 43). Painted throughout 1918, the picture was signed and dated on Armistice Day and offered shortly thereafter to the French government, which seems either to have rejected the painting or to have been uninformed about Monet's offer. In this painting, a garden tree becomes a writhing, weeping figure, flinging its arms in the air, while its foliage trembles in agitation. The tree, like France and like Monet, had survived the war, but not without physical wounds or psychic scars.

Monet's powerful use of a tree as an emblem of civilization was echoed after the war by Édouard

Vuillard, who must have seen Monet's painting in 1919 at the great Monet-Rodin exhibition at Bernheim-Jeune's Parisian gallery. At least a decade later, around 1930, he began a very large pastel, *The Big Tree* (cat. no. 78), the effect of which is extraordinary in juxtaposition to Monet's *Weeping Willow*. No photograph can ever do Vuillard's pastel justice, because the sheer scale of the tree trunk in the pastel makes it appear larger than the full tree in Monet's painting. Vuillard seems always to have been at odds with the twentieth century, in which he lived most of his life. Unlike most artists, his painting becomes more and more conservative as time progresses, and it is clear that he consciously sought to repudiate much of the twentieth century through the making of an intensely traditional art.

As much as anything, *The Big Tree* is about time. An ancient tree, as old if not older than Vuillard when he drew it, anchors this unusual landscape, its roots imbedded deeply in the earth. At its base, delicate white flowers dance, fluttering like butterflies in the summer air. For Vuillard, the continuity of the life of the tree is contrasted with the seasonal brevity of the flowers at its base. The flowers will die, while the tree will live on, not forever, but for a long duration. Vuillard deliberately omitted the foliage of the tree— perhaps because he didn't want the temporal specificity of seasonal leaves to disturb his visual rumination on time.

Art, more than most forms of human activity, attempts to transcend time. The central paradox of modern art, particularly the sequence of modern movements in France, is that artists have attempted to make modern reality timeless, to suspend our history in time. The Siraks have formed a collection of modern art that succeeds remarkably in being transcendent. Utrillo's street in Paris (cat. no. 73) could have been painted in the 1920s just as well as in 1909, when it was made; moreover, it celebrates the small, quiet, quotidian parts of Paris, those pockets of the city loved by Utrillo and Eugène Atget alike that are far removed from the twentieth century. Vuillard's *Nude Seated before a Fireplace* (cat. no. 77) of circa 1899 could have been sitting in the anonymous Parisian room at almost any point in the past two centuries; only her Gibson Girl hairstyle and the ubiquitous upholstered chair puts her into modern, urban time.

The triumph of the Siraks' collection is that, like all great collections, it celebrates particular works of art in a perpetual conversation. That we can rewrite a narrative of modern art with works from the collection makes clear our official histories are not yet, nor ever will be, finished and works of art speak and will always speak more powerfully than words.

# GERMAN EXPRESSIONISM
# IN THE CONTEXT OF
# THE EUROPEAN AVANT-GARDE

PETER SELZ

The paintings collected by Howard D. and Babette L. Sirak, and now an integral part of the collection of the Columbus Museum of Art, contain a number of excellent examples of the German avant-garde in the early years of the twentieth century. Frequently this art is labeled "Expressionist," but a perusal of the very different paintings by Emil Nolde, Ernst Ludwig Kirchner, Lyonel Feininger, and Paul Klee in the Sirak Collection indicates at once that there is no such thing as an "Expressionist style." The term "Expressionism" was introduced originally by critics to distinguish new ways of painting from the Impressionist mode that preceded it. Impressionism itself was, of course, much more than mere rendition of optical appearances: it was a very subjective way of seeing and painting. When Vasily Kandinsky encountered one of Monet's grain stacks in a Moscow exhibition and was not able to recognize the subject, he began to think that a recognizable object was not a necessary element of painting, an observation that led him to move toward total abstraction. To most observers at the time, Impressionism seemed concerned with little but the fleeting effects of light and atmosphere on a given object. Artists of the next generation, Seurat, Cézanne, Gauguin, and Van Gogh, felt that a more substantial art was in order, an art that was simultaneously more universal and more personal. Their paintings opened exciting possibilities for the artists who rose to prominence after the turn of the century.

The term Expressionism gained currency because it differentiated a sensibility and attitude concerning the nature of art which was unlike that adopted by the Impressionists, who, after all, still devoted themselves to the representation of the appearance of nature. Originally the term defined the early twentieth-century European avant-garde and was applied initially to Matisse, Derain, and Vlaminck after they first exhibited their "color explosions" in Germany. Paintings by Picasso were included as well. Soon, however, the term was used to designate a new generation of German painters who had formed avant-garde groups in Dresden (Die Brücke) and in Munich (Der Blaue Reiter). There is no doubt that the term was used both to identify and to market a type of painting that was new and at the same time also related to the emerging canon of modernism. Expressionism was seen as the latest manifestation in a historic progression of modern art. But unlike Cubism or Futurism it was never a school, and it lacked the formal coherence of a style. It was, rather, a state of mind that found artistic expression by a number of artists who stressed individualistic authenticity, but who, at the same time, also helped to establish a new communal spirit. They were certainly an important part of the ferment that questioned the established order early in the century.

On the surface, culture in the German Empire and the Austro-Hungarian Dual Monarchy seemed to assure continued peace, prosperity, and progress. But underneath this illusionary overlay, a whole set of institutions—imperialism, colonialism, laissez-faire capitalism, established religion, positivist philosophy, the concept of cultural evolution, even the belief in the infallibility of science and reason—began to be questioned. Friedrich Nietzsche not only announced the demise of God but also questioned the validity of objectivity in the sciences and proposed a more relativistic, even subjective, view as well as a new reliance on instinct and intuition. The *fin de siècle* brought about profound changes of ideas and attitudes that began to sweep through European intellectual and artistic circles. As religious belief systems were being rejected, Karl Marx taught that materialist factors and the class struggle were the underpinnings of human history; Sigmund Freud submitted that sexual drives were primary determinants; and Albert Einstein demonstrated the equivalence of mass and energy, thereby postulating a new and more relativistic interpretation of the physical universe. Politically the old world was

breaking asunder. By the summer of 1914 Europe exploded into all-out war.

In the early years of the century the artists who came to be called Expressionists were very much aware of the changes that permeated all aspects of life. They were, indeed, among the animators of the fracture. For some time, writers, philosophers, poets, composers, architects, painters, and sculptors throughout Europe had been convinced of the need to shatter the bourgeois complacencies of their age. Some turned their creative energies toward seeking renewed authenticity for myth, ritual, and the nonrational. There was a search for a new religiosity that resulted in congeries of esoteric religious and spiritual persuasions, or in attitudes that already were reflected in the spiritual values of Expressionist art and theory.

The Expressionist artists, driven by an inner need to utter their personal feelings and emotions and to confront unresolved conflicts within society, saw their work as a meaningful declaration about life. Although they continued to look to Paris as the center of artistic endeavor, they rejected the decorative and primarily formal aspects of the School of Paris. In 1888, during his first trip to Paris, Edvard Munch, the Norwegian painter who exerted a substantial impact on the German movement, wrote in his notebooks: "No longer should you paint interiors with men reading and women knitting. There must be living beings who breathe and feel and love and suffer."[1] And years later, in his eulogy to Munch, Oskar Kokoschka described Expressionist art as "form-giving to the experience, thus mediator and message from self to fellow human. As in love two individuals are necessary, Expressionism does not live in an ivory tower, it calls upon a fellow human whom it awakens."[2]

Munch was one of the chief progenitors of Expressionism. He exhibited in Berlin as early as 1892 in an exhibition that was closed by the intervention of the Kaiser. But twenty years later he was honored with a comprehensive display of thirty-two works in the International Exhibition of the Sonderbund, held in Cologne in 1912, at the height of Expressionist activity. A grand survey of the modernist enterprise, the exhibition consisted of 577 paintings by 160 artists from nine countries. This first major international exhibition of modern art was organized not in Paris but in Germany, where critics, dealers, and artists hoped to stimulate interest in the exposition and acquisition of the new art. Subtitled International Art Exhibition of the Federation of West German Art Patrons and Artists, it was very carefully organized to establish the credibility and importance of modernist art. Among the organizers were Alfred Flechtheim, an outstanding gallerist in modern art, and Carl Ernst Osthaus, the director of the avant-garde Folkwang Museum. The honorary council included other vanguard museum directors and curators, a number of painters, members of the Cologne city council, leading industrialists, government officials, university professors, and other prominent intellectuals from the Cologne area. The exhibition was seminal for the organizers of the Armory Show, who, after seeing the Cologne exhibition, decided to arrange a similar event in New York. Eventually the American version presented a large number of contemporary French works, but very few by German artists. This, certainly, is one of the reasons for the strong French orientation among public and private collections of modern art in the United States. Another reason has been an earlier dislike for heavy emotionalism in art. And, not to be forgotten, there was the very plausible anti-German sentiment arising from World War I, and greatly reinforced by Nazism and World War II. Until recently, excellent private collections of modernist German art have been rare in this country.

The Sonderbund exhibition set a landmark for the visibility and acceptance of modernist art in Germany, featuring, in addition to Edvard Munch, Vincent van Gogh with no fewer than 125 stunning works. Paul Ferdinand Schmidt, one of the advocates of the new movement, asserted that "with Van Gogh the new era begins. All that the artists are now concerned with is either implied or fulfilled in his work."[3] Another featured artist was Cézanne, whose works were given an entire gallery. The Cologne critic Ludwig Coellen observed that whereas Van Gogh's space and the relationship of objects in his paintings were still Impressionist formulations, it was Cézanne's space engagement that pointed toward the Expressionists.[4]

There was also a large collection of Gauguin's works, and the Pointillists and the Fauves were well represented. The young Pablo Picasso had sixteen works in the show. Clearly the organizers of the exhibition had made brilliant selections and neglected few of the important artists from Germany and abroad who heroically changed the face of art during the years before World War I.

A surprising oversight in the Sonderbund exhibition was James Ensor, who had been in the foreground of the Belgian avant-garde and was one of the original members of the progressive Les Vingt in the early 1880s. Ensor's masks, skeletons, religious paintings, and still lifes are characterized by bizarre fantasy and painted with a light palette of iridescent colors. The Sirak Collection includes two excellent works by the Belgian modernist: *The Assassination* (cat. no. 14), with its morbid satire, typical of Ensor, and the erotically suggestive *The Sea Shells* (cat. no. 15). Ensor's paintings predicted much of the art of the early twentieth century, including Fauvism and Expressionism. Among the Germans, Paul Klee became familiar with Ensor's distorted world as early as 1907 and was impressed with what he saw.[5] Emil Nolde visited the reclusive Ensor in his native Ostend in 1910 and, after seeing the grotesque folk masks which Ensor had collected and painted, almost immediately began working on his own paintings of primitive masks.[6] During World War I, while serving in Flanders, Erich Heckel, one of the founders of Die Brücke, also established contact with the Flemish precursor of Expressionism.[7]

The Fauves' violent chromatics, without regard for the color of actual objects, and their use of flat planes and vigorous brushwork found equivalence among the Germans, especially the Dresden Die Brücke painters. A work such as Ernst Ludwig Kirchner's *Girl Asleep* (cat. no. 21) is greatly indebted to Van Gogh in its brushwork and to Matisse in its palette, but its conjoined spatial composition and its vehemence of the brush is even more daring than the work done in Paris around 1905–1906, when it was painted. Kirchner, who inscribed this picture 1901, sometimes predated paintings to claim chronological priority among his French and German contemporaries.

Kirchner and the Brücke painters would often go to the Saxon lakes or to the Baltic with their young models. There they painted the nude human body freely moving through natural surroundings. The subject of the nude in open air, of course, had been an important genre in modern painting prior to its treatment by Expressionist artists. But when Manet painted his *Déjeuner sur l'herbe* of 1863 (Musée d'Orsay, Paris), he presented a very posed, indeed artificial, arrangement in which two elegantly dressed gentlemen share a picnic while a nude woman sits with them. Manet here related modern life to historic art, taking his theme from Titian's (until recently thought to be

Giorgione's) *Concert* of 1508 (Musée du Louvre, Paris) and Marcantonio Raimondi's print, the *Judgment of Paris* (second half of the sixteenth century). Cézanne in his series of bathers (see cat. no. 5) depicted women who are hardly natural in their awkward stances, apparently seeking pictorial logic within the European tradition. Matisse's *La Joie de vivre* (1905, Barnes Collection, Merion, Pennsylvania) depicts abstracted human beings enjoying themselves in a pastoral Golden Age. A proto-Cubist painting by Picasso such as *Three Women*, 1908–1909 (Pushkin Museum, Moscow), finally, depicts three powerful female figures whose volumetric forms are influenced by African sculpture in a work that is primarily concerned with the dynamic interaction between structure and movement. In contrast to these paintings, Kirchner's *Landscape at Fehmarn with Nudes* (cat. no. 22), painted in 1913, is amazingly innocent in its relation of the nude to the outdoors. Here the androgynous nude bodies are an integral part of the landscape and are rhythmically repeated in the tall thin forms of the trees. This sense of unity between humans and the natural world is echoed in Emil Nolde's *Sunflowers in the Windstorm* (cat. no. 50) as blossoms evoke human emotions.

The German painters resented urban restrictions; in fact, the city to them was a confining and decadent place of oppression and alienation. Like the wayfarers of the contemporaneous German youth movement, they fulminated against the confinement of the body in the corset as much as the stifling of the mind by the Prussian school system. The Baltic island of Fehmarn was one of Kirchner's favorite escapes. The year after he painted his landscape with nudes, he painted the *Tower Room, Fehmarn (Self-Portrait with Erna)* (cat. no. 23). The room in the lighthouse is greatly distorted, and we seem to be looking down on the artist from a high view. Then the angle of vision is shifted, and we see Erna, his model and the object of his desire, in frontal view, exposing her body and shifting her head toward the artist. Such frank and guiltless eroticism is a strong statement against the moral taboos in Germany in the Wilhelmine era. Among the Viennese artists— Klimt, Kokoschka, Schiele—there is much concern with sexuality and the theme of love, which finds expression in art that is sometimes filled with anxiety and conflict and related to suffering and death. But other works such as Klimt's fine drawing *The Embrace* (cat. no. 35) convey a sense of tranquil tenderness.

As we have seen, many German artists responded to the radical trends across the Rhine. Alexej Jawlensky left St. Petersburg for Munich in 1896—the year that his compatriot Vasily Kandinsky arrived there. Both artists were very much aware of the developments in Paris. Jawlensky took frequent trips to the French capital and had considerable admiration for Matisse. His brilliant *Schokko with Red Hat* (cat. no. 20) bears a debt to the French master, but it is even bolder in its use of contrasting primary color, more abstract in its asymmetry, more intense in its luminosity, and more passionate in its emotion. Lyonel Feininger, born in New York but living in Germany since 1887, was thoroughly familiar with Cubism and Delaunay's color spheres as well as with the Futurist breakup of volumes by lines of force; all this is evident in his *Cathedral* (cat. no. 16), which was completed soon after his appointment as a "master of form" at the newly created Bauhaus in Weimar. In *Cathedral* Feininger has developed a unique sense of space in which forms are transparent and monumental at the same time and in which all formal elements are subjected to musical pictorial rhythm. Feininger—like Klee, who was appointed to the Bauhaus faculty a year later—did not subscribe to the Bauhaus creed that the individual work of art was becoming obsolete and the artist or craftsman was to design primarily utilitarian artifacts and objects of aesthetic quality for the common good.

Paul Klee is the artist most comprehensively represented in the Sirak Collection, with eleven works, dating from 1914 to 1939. The Sirak Klees provide a valuable insight into the artist's intimate world. Klee never employed the violent brushstrokes and gestural energy associated with Expressionist painting. Belonging to no group and subscribing to no movement, he was engaged in constant experimentation with new and untried techniques. He painted on a wide variety of unusual supports. Above all, he created an imagery never before dreamed of. There is also a sense of play in his work; there is humor, satire, and often irony. Working in a minor scale Klee was always inventive; his was a unique and personal universe in which essences become visible.

The earliest Klee work in the Sirak Collection is *View of Saint Germain* of 1914 (cat. no. 24), one of many watercolors produced in Tunisia. Twenty-five years later, before his death in 1940, he painted *Fire Spirit* (cat. no. 34), in which forms have become dismembered and a new organic creation is put forward. Art

for Klee, after all, was nothing less than a "parallel of creation." Contemplating the world of nature, Paul Klee was able to claim autonomy for the world of art.

It seems appropriate that the Sirak Collection extends to the second half of the century with works by two artists who can be seen as heirs to the German Expressionist generation. Julius Bissier, whose brush paintings, temperas, and watercolors add the technique and aesthetic of Chinese brush painting to the kind of inwardness exemplified in the work of Paul Klee, produced quiet compositions of controlled fluency. And Jan Müller, born in Hamburg but active in New York, drew inspiration from Gothic altarpieces, from German Expressionist art, and from Hans Hofmann's teaching to produce art that was "one of the hopes of painting in America," as Meyer Schapiro wrote, adding that "he composed an impassioned imagery of nakedness and joyous nature, of the innocent and the demonic, often in mythical terms."[8]

Certainly, the search for the evocation of innocent and demonic myth was a basic concern of the artists associated with German Expressionism. Moreover, as the paintings in the Sirak Collection illustrate, the avant-garde German painters at the beginning of the twentieth century destroyed the conventions surrounding such myths by their life-affirming and personal expression. They created a new world of form and color, related to the modernist enterprise, but also unique in their adventurous journey.

1. Edvard Munch, "St. Cloud Diaries," quoted in Frederick Deknatel, *Edvard Munch* (exh. cat., Museum of Modern Art, New York, 1950), p. 18.
2. Oskar Kokoschka, "Edvard Munch's Expressionism," *College Art Journal* 12 (1953): 32.
3. Paul Ferdinand Schmidt, "Die Internationale Ausstellung des Sonderbundes in Köln, 1912," *Zeitschrift für Bildende Kunst*, N.F. 23 (1912): 230.
4. Ludwig Coellen, *Die neue Malerei* (Munich, 1912), pp. 39–40.
5. Georges Malier, "Paul Klee," *Cahiers du Belgique* (February 1929): 78.
6. Donald E. Gordon, *Expressionism, Art and Idea* (New Haven, Conn., 1987), p. 96.
7. Peter Selz, *German Expressionist Painting* (Berkeley, Los Angeles, 1957), p. 303.
8. Meyer Schapiro, Foreword to *Jan Mueller* (exh. cat., Hansa Gallery, New York, 1958), n.p.

# CATALOGUE OF THE COLLECTION

All works have been acquired by the Columbus Museum of Art as the generous gift of the collectors and through supplemental purchase funds provided by donors. Each bears the following credit: Gift of Howard D. and Babette L. Sirak; Donors to the Campaign for Enduring Excellence; and the Derby Fund.

Artists are listed in alphabetical order; their works, following their names, are in chronological order.

In dimensions, height precedes width. In the case of sculptures, only the height is given.

# MAX BECKMANN

German, 1884–1950

## 1. TWO NEGROES IN A CABARET

*Zwei Neger im Varieté*
1946

Oil on canvas, 27¹¹/₁₆ × 20⅛ in. (70.3 × 51.1 cm)
Signed and incorrectly dated lower right: *Beckmann 47*

Neither the genesis of this painting nor its precise date of completion is entirely certain. On July 5, 1945, Beckmann—who since 1937 had been living in exile in Amsterdam—celebrated the end of World War II by calling on friends and visiting a restaurant and bar frequented by blacks.[1] The idea for the Sirak painting may have originated there. Not until February 24, 1946, however, while noting in his diary the beginning of several new pictures, did Beckmann mention the subject of "two negroes." He recorded progress on the painting on June 23; another entry from July 28 may again refer to work on the same painting, although the list Beckmann kept of his paintings indicates that it was finished on June 20.[2] This discrepancy may lie in Beckmann's tendency to work on several paintings simultaneously; apparently he continued working on *Two Negroes in a Cabaret* for some time after the date he had originally marked as the date of completion. That he finished the painting in the summer of 1946 is fairly certain. Yet not until the autumn of 1949 did he sign and date the canvas—incorrectly, as it turned out—when he sold it from his New York studio to Ulfert Wilke.[3]

The two men, each wearing a black suit and tie, are seated on a banquette. A dark-skinned woman in a white exotic hat and dress appears at the right, partly cropped by the picture frame. In the wall behind her and in the low table in the foreground the plum-colored hue of the banquette darkens to a deep red. There are additional accents of yellow, and all the colors are contained within heavy outlines in black paint. Due to the prevalence of black, accented only sparingly with white, the colorism is unusually subdued yet—typical of this stage in Beckmann's development—possesses a darkly glowing intensity reminiscent of stained glass. Both men gaze in unison at the spectator, and there is a similar accord in the closely related gestures. Poignantly vulnerable in their baggy

suits, they are sitting stiffly upright and close together, as if seeking comfort in each other's proximity. The two drinks on the table further underscore the impression of a nearly identical mode of outlook and demeanor.

Throughout his life Beckmann was struck by the irony of involuntary self-revelation in the anonymity of social gatherings and depicted perfunctory social discourse in scenes from the café, the cabaret, and the dance club, usually with emphasis on the ultimate futility of human relationships. While living in Holland in relative isolation, indeed almost in hiding, he was touched by the essential solitude of man and inspired to create several symbolic compositions, such as *Odysseus and Calypso*, of 1943, and *City of Brass*, of 1944.[4] In both paintings the theme of loss and isolation is reinforced by allusion to yet another human dilemma: the irreconcilable conflict between the sexes. Enforced isolation also informs the meaning of the enigmatic triptych *Blind Man's Buff*, of 1944–1945,[5] in the two outer wings of which a man and a woman find themselves alone amid a throng of cabaret or café habitués.

*Two Negroes in a Cabaret* is devoid of such overt symbolism. Yet Ulfert Wilke, the first owner of the painting, correctly sensed in it too a similar sentiment: "Immediately it came to my mind that nobody can feel more isolated from the world, more lonesome than while in a crowd, and the painting of two stiff, well-dressed people sitting next to each other in a cabaret seemed to reflect this isolation very much."[6] When Wilke mentioned his impression to the painter, Beckmann, who was always reluctant to explain his intentions, replied: "Das ist ein Bild für Kenner!" (This is a picture for people who understand!).[7]    —HU

1. Lothar-Günther Buchheim, *Max Beckmann* (Feldafing, 1959), p. 163.
2. Erhard Göpel and Barbara Göpel, *Max Beckmann: Katalog der Gemälde* (Bern, 1976), vol. 1, no. 725, pp. 433–434; Erhard Göpel, ed., and Mathilde Q. Beckmann, comp., *Max Beckmann: Tagebücher 1940–1950* (Frankfurt, 1965), p. 47.
3. Göpel and Beckmann, p. 186.
4. Göpel and Göpel, nos. 646, 668.
5. Ibid., no. 704.
6. Ulfert Wilke in a 1965 letter to Howard Sirak, quoted in ibid., p. 434.
7. Ibid.

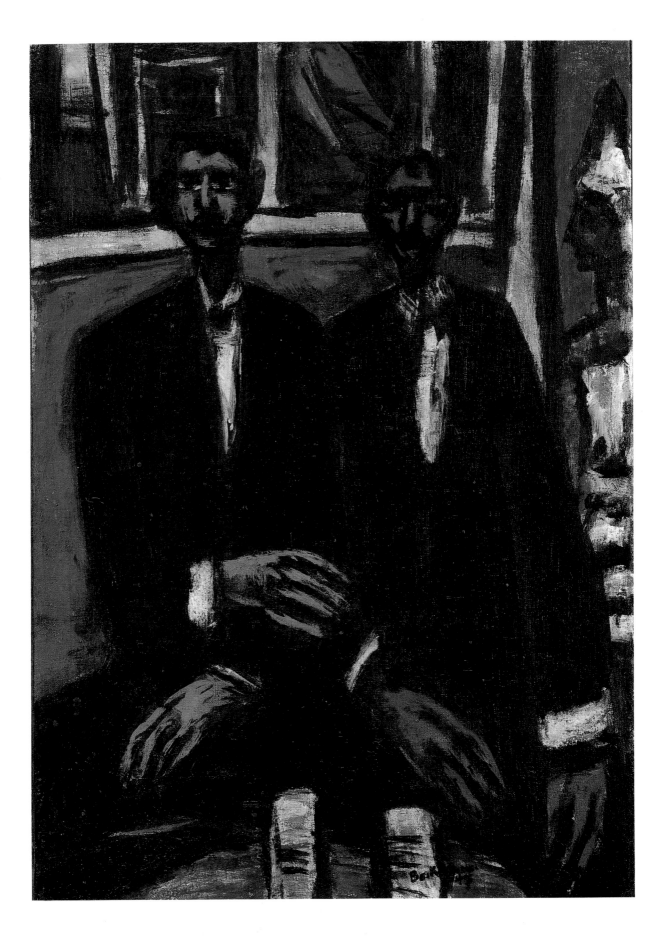

# JULIUS BISSIER

German, 1893–1965

2. USQUE AD FINEM
1961

Brush and watercolor on off-white paper, 5⁷⁄₈ × 9¹⁄₂ in.
(14.9 × 24.1 cm)
Inscribed, dated, and signed lower right: *Rondine
9.11.61.x / Jules Bissier.* Inscribed upper right: *usque
ad finem*

Most of Bissier's early work was lost in a fire in 1934. Willi Baumeister, a German abstract painter and teacher whom Bissier met in 1929, urged him to reevaluate his art and to begin again. His so-called second career produced more thoughtful, even philosophical, paintings. The two works by Bissier in the Sirak Collection were created near the end of his career and represent the culmination of his thinking about art.

*Usque ad finem* (meaning "until the end") is typical of the miniatures Bissier began in the late 1940s. He had discovered Asian art much earlier, had become entranced by the possibilities of calligraphic brush painting, and before World War II, had begun to work on small monochromatic ink paintings. Painting in secret during the Nazi reign, he developed a complex visual language based on both gestures and abstract signs. After the war, he introduced color into these small-scale paintings and experimented with different materials and surfaces. By the late 1950s, when the miniatures were first shown, his works had attained a high degree of formal and expressive perfection. One sees in these works the artist's Expressionist heritage and the influence of the Bauhaus.

In particular, *usque ad finem* is composed of active and energetic brushstrokes contrasted with tight, precisely defined forms. The relation between these elements creates a visual tension and vitality that is surprising for such a small-scale work. Yet the language of the work is quiet and introspective, a language of the unspoken word. Some of the forms suggest still-life objects, without being literally descriptive. The ambiguity of these forms invites interpretation on both a personal and a universal level. Organic shapes perhaps reflect Bissier's early interest in microscopic organisms; letter forms point to his interest in calligraphy; and the simple gestural brushstrokes are a reflection of the Chinese ink paintings that inspired him. But beyond the forms and shapes is another level of reference. From Kandinsky and Klee, Bissier learned to use art to express metaphysical concepts. Among his friends were a number of artists concerned with the spiritual values of art, like Oskar Schlemmer, Hans Arp, and Mark Tobey. Thus, Bissier learned that the visual language of painting can communicate values that are found not in the forms themselves but in their referents. The forms become signs rather than objects. This is exactly the function of the tiny color areas in the Sirak painting.

The small scale of this work forces the viewer to experience not some powerful and immediate emotional reaction but a moment of intimate and focused meditation. Bissier himself, a retiring and anxiety-ridden man, felt that these small paintings were more demanding, physically and emotionally, than large-scale paintings. In a sense, the microcosm described by these works is that of the artist's self: the confines of the studio, the psychic isolation of the individual. The tensions of the work relate to the angst of the German Expressionists earlier in the twentieth century without embracing their exterior roughness. But ultimately paintings like *usque ad finem* do not reflect the despair that characterized the work of Bissier's predecessors. His works triumph over anxieties by their beauty. Even the irregularity of the surfaces, the ragged edges of the ground, speak of natural beauty rather than artifice. His paintings affirm life rather than reject it. The intensity one feels from the crowded shapes and fragile gestures in the Sirak painting is a celebration of the living. As Bissier wrote in his journal in 1947, when the first miniatures were produced: "He who bears witness to life must have the courage to speak the language of life, to show the images of life unvarnished, and first of all and above all to create with the intensity of life."[1]             —GW

1. Thomas M. Messer, *Julius Bissier, 1893–1965, A Retrospective Exhibition* (exh. cat., San Francisco Museum of Art, 1968), p. 12. The quotation is from Bissier's unpublished journals.

27

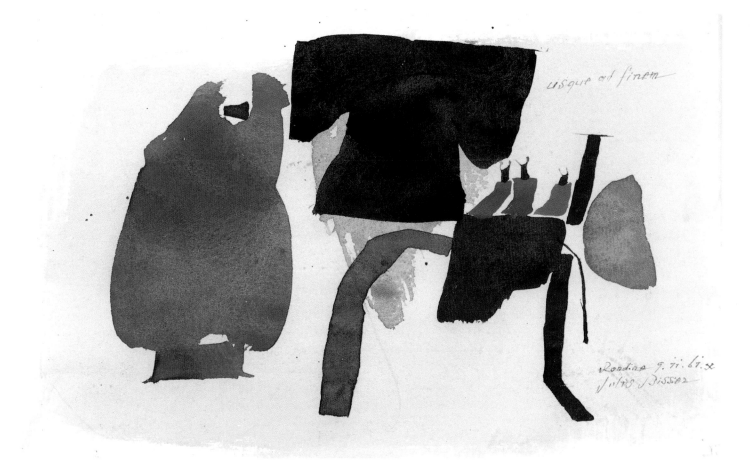

3. A.31.OCT.62
1962

Watercolor on linen, 8⅝ × 9¹³/₁₆ in. (22 × 25.1 cm)
Inscribed and signed lower left: *A.31.Oct.62/Jules Bissier*

It is perhaps inevitable that Julius Bissier should be compared to Paul Klee. The small scale of the works of both artists, their philosophical inclinations, the intensity with which they pursued their art, and the sophistication of their formal vocabulary all mark them as kindred spirits. Bissier himself denied this relation, saying, "There is no comparing Paul Klee's work and my symbols. For Klee deals in travesties (grotesque disguises) while my works aim to be true 'signs.'"[1] His reference to true signs makes the distinction clear enough: Klee described the realm of signs for their meaning; Bissier worked with the signs themselves. Klee's art is an act of exploration, Bissier's an act of acknowledgment.

One can understand why he should call paintings like *A.31.Oct.62* symbols rather than pictures. Bissier wrote that "content is everything," but we must assume that he meant "content" in the most general sense rather than in a literal or literary way.[2] The specific title of this work is typically unrevealing, and the artist's reticence is perhaps a reflection of his personality as much as it is an artistic decision. Klee's paintings are poetically ambiguous, but Bissier preserved the mystery of his creations through another, less literary ambiguity. The forms of his paintings in general are abstracted and their references obscure. When Bissier talked of signs and symbols, he did not mean that his paintings are to be "read"; they are instead to be perceived intuitively. And here is another reason why Bissier differs from Klee: Klee's art lays bare the structure of nature for our inspection in a quasi-scientific manner, whereas Bissier's retains the aura of mystery that science had forgotten.

The small scale of Bissier's paintings gives them an iconic or talismanic quality. They are not magical, but they are the focal point of a certain contemplative state—"icons without an iconography," as Werner Schmalenbach has suggested.[3] In the Sirak painting, pure forms—circle, square, line—suggest universal constants. The more complex shapes in the work, such as the letter forms of the calligraphic gestures or the hourglass shape that dominates the middle of the composition, evoke external objects. The shapes are balanced within the irregular contours of the fine linen ground, suggesting a kind of psychic equilibrium. This is not the formal balance of a still life, but a kind of spiritual harmony within an uncertain nature, a unity of outer and inner. It is well to remember that Bissier's career began in the midst of German Expressionism and postwar Neue Sachlichkeit realism, and something of that era's anxiety continues through his later works. While Bissier's format is formally precious and attractive, it is also demanding on both artist and spectator. Balance in Bissier's works is both formal and emotional, is achieved by the most subtle nuances of color, line direction, and texture, and the work in its totality presents the viewer with a complex system of signs that are to be understood in a metaphysical sense.

While Bissier's works challenge, they also delight. In this, Bissier shares with Klee a sense of wonder in the face of nature. *A.31.Oct.62* is a beautiful work in its gemlike precision and picturesque irregularity. The elegance of touch and the sheer beauty of surface and color affirm the triumph over adversity. If Bissier's paintings are spiritual, and their roots are in suffering and anxiety, then the result is a transcendence over material limitations.[4] Bissier exorcised the ghosts of his Expressionist past through the meditative introspection and discipline of the post–World War II works. The touches of pigment and the variations of surface evoke the serenity of Eastern art rather than the trauma of Western art. If color here is marginal, even suppressed, it is because Bissier was always loath to express his ideas forcibly or loudly. The tone of the painting is best observed in quiet meditation.

—GW

1. Diary entry of May 30, 1944. Published in Thomas M. Messer, *Julius Bissier, 1893–1965, A Retrospective Exhibition* (exh. cat., San Francisco Museum of Art, 1968), p. 41.
2. The Arts Council of Great Britain, *Julius Bissier, 1893–1965: An Exhibition from the Kunstsammlung Nordrhein-Westfalen, Düsseldorf,* introduction by Werner Schmalenbach, essay by Peter Cannon-Brookes (London, 1977), p. 6.
3. Werner Schmalenbach, *Bissier* (New York, 1963), p. 22.
4. Ibid., p. 8.

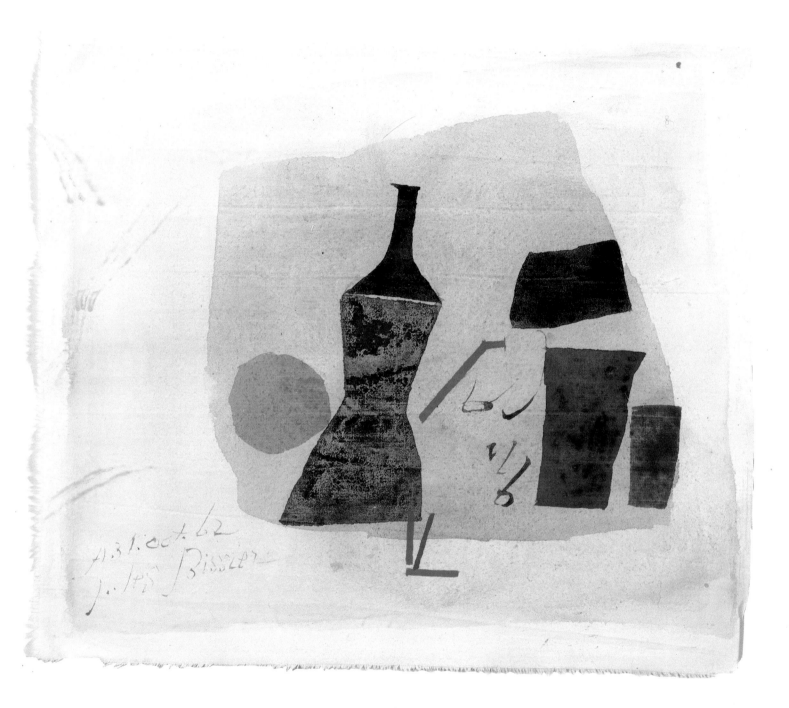

# PIERRE BONNARD

French, 1867–1947

4. PORTRAIT OF THADÉE NATANSON
1897

Oil on board, 17 × 16½ in. (43.1 × 41.9 cm)
Inscribed and dated lower left: *Bonnard à Thadée Souvenir de l'été 97*

Pierre Bonnard painted this portrait of art critic Thadée Natanson at the latter's vacation home at Villeneuve-sur-Yonne during the summer of 1897. He painted a dedication to Natanson in the lower left and presumably gave it to his friend at the time. Natanson, in turn, wrote an early biography of Bonnard, *Le Bonnard que je propose, 1867–1947*.[1]

Natanson and Bonnard became friends in the early 1890s through their work on *La Revue blanche,* or *The White Magazine,* so named because white contains all the colors of the spectrum, just as this eclectic journal sought to include all views. Natanson edited the legendary biweekly magazine of the scientific, literary, and artistic avant-garde. Among its illustrators were Bonnard, Henri de Toulouse-Lautrec, Édouard Vuillard, and Félix Vallotton. In his publication Natanson identified Bonnard, Ker-Xavier Roussel, and Vuillard as part of an emerging group of artists called the Nabis, a Hebrew term meaning prophet. The group searched for a path away from Impressionism, away from its scientific approach and its belief in inevitable progress in the material world. Their main theorist, Paul Sérusier, advocated Gauguin's unmodeled colors and nondescriptive surface pattern.

Bonnard, dubbed *"le Nabi très japonard,"* took much inspiration from Japanese prints in which he found decorative and antinaturalistic precedents and devices. By various methods, the Nabis rejected illusionism, the aim of high art since the rediscovery of perspective in the Renaissance. They sought visual equivalents, not representations, of mood and feeling and thus were an important step in twentieth-century abstraction and an inspiration to the German Expressionists. The portrait of Natanson is one of many bridges between French Impressionist and German Expressionist works in the Sirak Collection.

Bonnard, Vuillard, Toulouse-Lautrec, and Vallotton, denizens of the Natansons' home in Paris during the Belle Epoque when it was a center of intellectual and rowdy social activity, visited the Natansons at their new summer home in 1897. Like Bonnard, Vallotton painted a portrait of Thadée (Petit Palais Musée, Geneva), and Toulouse-Lautrec twice painted Misia, Thadée's wife, that summer. Both Vuillard and Bonnard painted them on other occasions. Natanson owned the portrait by Bonnard until 1908, when financial difficulties compelled him to auction many works, including nineteen by Bonnard. The picture remained for a time in the Nabis orbit, in the possession of Vuillard, who purchased it at auction and owned it until his death.

According to Natanson's book on Bonnard, the portrait was painted beneath a chestnut tree. The background may refer to that tree and the ivy-covered stables on the property, although for the most part local details, which in Impressionist portraits reveal the sitter's habits, taste, and milieu, are here omitted or abstracted. Painting at the height of his *japonisme,* Bonnard collapses the space around and above the sitter by rendering the branch dark and unmodeled. The handling of the figure, however, respects conventions of representation. A black outline around the body prevents its recession in space, but subtle modeling suggests a torso that curves toward the viewer. Unlike many of his more willfully artificial pictures of the decade, this covers the entire cardboard support, leaving no exposed surface that would call added attention to the artifice of the depiction. Instead, the picture is given over to a "speaking likeness." Natanson purses his lips, lowers his eyes, and indulges his friend by sitting for the portrait, as he continues to talk and to gesture with his left hand. The 1908 sale catalogue describes the picture as a portrait of a "meticulous storyteller." —TP

1. Thadée Natanson (Geneva, 1951).

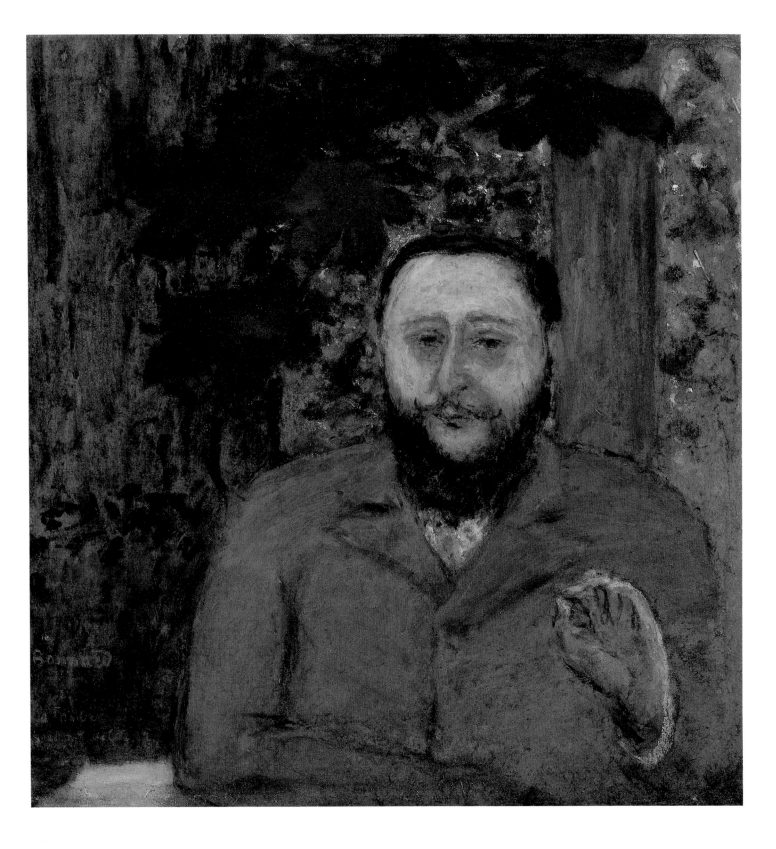

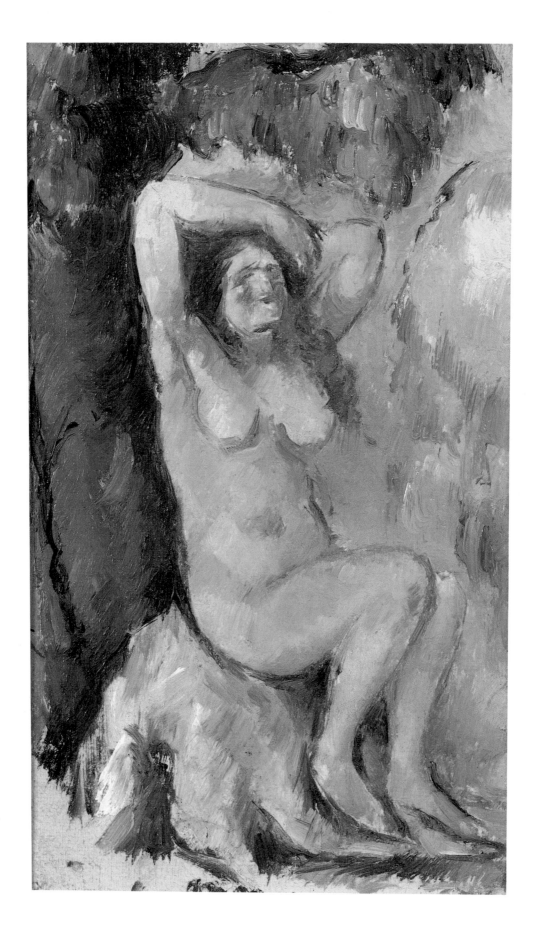

# PAUL CÉZANNE

French, 1839–1906

5. SEATED BATHER

*Baigneuse assise*
ca. 1873–1877

Oil on canvas, 8¼ × 5⅛ in. (21 × 13 cm)

Within its small surface, the *Seated Bather* contains the principal characteristics of Cézanne's mature style of the mid- to later 1870s. The dark palette, sweeping brushstrokes, and emotional turbulence of his earlier work have been replaced here by small strokes of lighter blues, greens, and yellows to create a composition of classical calm, energized primarily by abrupt juxtapositions of colors and tones.

Cézanne, dissatisfied with the Impressionist concern for capturing only the surface effects of light reflecting from objects, strove to give his works a solid sense of structure. Color became his language; he used color not only to describe objects and to indicate light but also to suggest space and volume. He dispensed with traditional linear perspective as a means of achieving the illusion of space, and with traditional modeling of forms through value. Space in this work is suggested by the strokes of cool green and blue in the trees and sky. The bather is rendered in a simplified, abstract manner, rather than faithfully recorded from nature. The swelling volume of her hip is effected through patches of warm yellow that appear to advance toward the viewer, while the undersides of her breasts, arms, and legs are rendered in cooler, receding greens. Color harmonies and the rhythm of the brushwork unite the composition, integrating the bather with the landscape.

Both male and female bathers are a major theme in Cézanne's oeuvre. In all, he created more than two hundred oils, watercolors, drawings, and lithographs of nudes in landscapes. About half were made between 1872 and 1882. *Seated Bather,* then, belongs to one of the periods of Cézanne's greatest interest in the theme. His treatment of the subject was a radical break from the great pastoral tradition of Giorgione, Titian, and generations of artists who followed. Cézanne's bathers are not representations of physical beauty set in an illusionary three-dimensional space; rather, they are structural elements, like trees and rocks. Harmonious proportions and details such as the indication of bones and joints beneath the skin are sacrificed to the demands of pictorial unity. The beauty of the *Seated Bather* lies not in the anatomical proportions of the figure but in the rhythm of the entire composition of which it forms a part.

Three other works from this same period are related. One is a preparatory sketch from *Page of Studies, Women Bathers* in pencil and pen (1873–1877, Kunstmuseum Basel).[1] Another is a pencil drawing (present whereabouts unknown), to which Lionello Venturi assigns the same dating as that of *Seated Bather.*[2] The drawing, which measures 11¹³⁄₁₆ × 7⅞ inches, is slightly larger than the Sirak painting; its composition is similar, though the figure and ground in the painting are rendered in a more simplified, abstract fashion. A third work from this period, *Nude by the Seashore* (1875–1876, Barnes Collection, Merion, Pennsylvania),[3] is a similar small-scale (9¼ × 8¾ inches) oil painting, believed by Sidney Geist to depict Hortense Fiquet,[4] whom Cézanne later married. If this identification is correct, the similarity of the figure to that of *Seated Bather* suggests that the model for it too was Hortense Fiquet.

The nude female figure with one or both arms raised over the head is a pervasive element in Cézanne's thematic repertoire beginning as early as 1870 in *Pastorale* (Musée d'Orsay, Paris)[5] and culminating in the masterpiece *Grandes Baigneuses* of 1900–1906 (National Gallery, London).[6] The motif appears to have been inspired by the similarly posed figure of Bellona in Rubens's *Apothéose de Henri IV* in the Louvre, which Cézanne copied often.[7] The pose is erotic, yet does not detract from the solemnity and monumentality of the work.          —SK

1. Adrien Chappuis, *The Drawings of Paul Cézanne, A Catalogue Raisonné,* trans. Paul Constable and M. and Mme. Jacques Féjoz, 2 vols. (Greenwich, Connecticut, 1973), 1:126–127.
2. Lionello Venturi, *Cézanne* (New York, 1978), p. 41, illus.
3. Sidney Geist, *Interpreting Cézanne* (Cambridge, Mass., and London, 1988), p. 128.
4. Ibid., pp. 162–163.
5. Illustrated in Mary Louise Krumrine, *Paul Cézanne: The Bathers* (Basel, 1989), p. 69.
6. Ibid., p. 210.
7. Ibid., p. 255, n. 12.

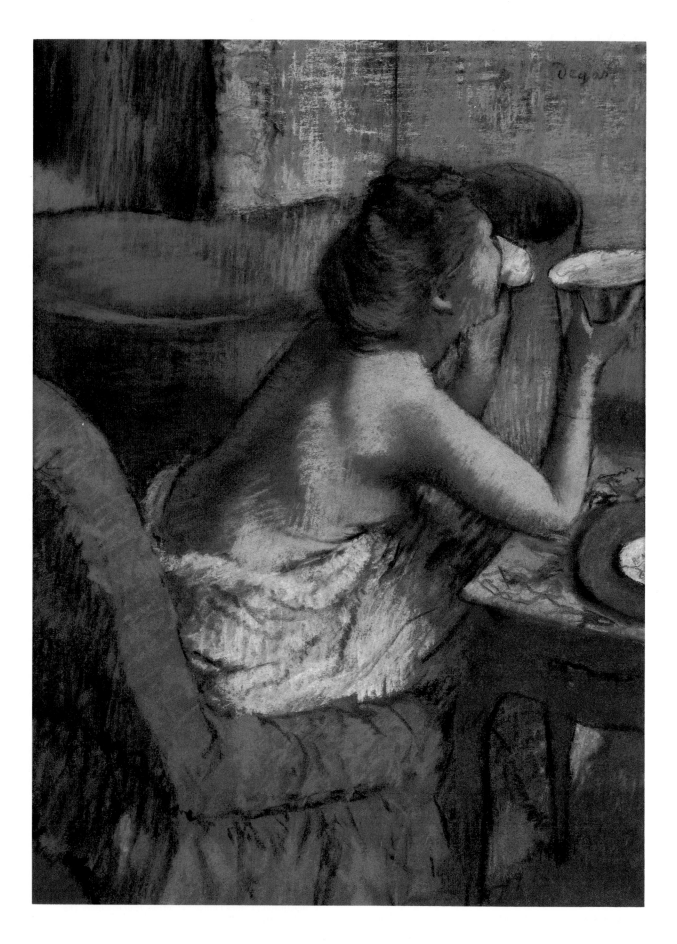

# EDGAR DEGAS

French, 1834–1917

### 6. THE BREAKFAST
*Le Petit Déjeuner*
ca. 1885

Pastel and graphite over monotype on cream paper, laid down, image size: 15⁵/₁₆ × 11⁷/₁₆ in. (38.7 × 29 cm); mount size: 17⁵/₈ × 13⁷/₈ in. (44.8 × 34.5 cm)
Signed upper right: *Degas*

Edgar Degas was a founder of the Société Anonyme des Artistes, whose members came to be called Impressionists. He exhibited in all but one of the group's eight exhibitions, and he introduced new members to the group. While his colleagues painted the changing effects of light and atmosphere in the modern suburban landscape, Degas doggedly pursued the habitual gestures of human subjects in contemporary urban scenes—at the ballet, at races, in brothels, and in cafés.

In his pastel *The Breakfast,* a partly nude woman is engaged in the simple act of sipping a cup of coffee. The figure leans forward and bends slightly to the right, toward the viewer. Her right arm is propped on a table in a position parallel to her left arm. The fingers of her right hand create a tripod to balance a saucer, while her left hand tips the cup so that it merges with her featureless face. Together the cup and head form an irregular oval that is humorously repeated and exaggerated by the bathtub in the background. Thus, a most ordinary and fleeting action is captured in a highly ordered structure.

The rigor of the composition reveals just how studied was Degas's conception of this ephemeral subject. The viewer looks down upon the bather, who is closely surrounded by the tub, chair, and table. All of the furnishings are cut off at the edge of the picture. In framing the figure, they maximize her importance. The backs of the armchair and figure, the bent right arm of the woman, and her right hand create a pattern of rhyming triangles whose effect is to flatten space and contain the figure on the sheet. Thus, while the momentary nature of a sip of coffee is perfectly in keeping with the philosophy of the Impressionists, the artist's willful execution demonstrates the artifice that must serve the illusion. It was Degas, after all, who said, "Of spontaneity, I know nothing," and likened the execution of a great work of art to the planning and trickery required for a great crime.

Traditionally dated around 1894,[1] this small jewel-like pastel may instead date from a decade before, in the mid-1880s, when the artist consciously set out to make small and highly finished pastels appropriate for the tastes and apartments of a new class of patrons—industrialists, merchants, and intellectuals.[2] This signed work would have pleased then as it does now, for it is a technical tour de force. The pastel is applied diversely—drawn, rubbed, and crosshatched—to evoke a multiplicity of surfaces such as wall coverings, metal tub, upholstered chair, linen, flesh, hair, marble, and porcelain.

Clearly, *The Breakfast* stands between the artist's early and late work, summarizing previous ideas and announcing a new direction. In a series of paintings, drawings, prints, and sculptures begun in the late 1870s, women prepare for the bath, often assisted by a maid. Here, however, the maid is not included, and the narrative is deemphasized. In Degas's later pictures his bathers are removed from the contemporary interior altogether and fused to a timeless landscape. The figure becomes classical and symbolic, linked at once to Michelangelo's heroic nudes and the symbolic figures of Degas's younger contemporaries, Maillol and Matisse.

The Sirak pastel is a vital reminder of the profound influence of Degas's art in the nineteenth and twentieth centuries. Degas's frank approach to his subject modernizes the traditions of the eighteenth-century pastel and the academic drawing of Ingres. Paradoxically, Degas's naturalist search for unusual vantage points, his attempt to see his subjects literally and figuratively from different angles, leads to a complex and artificial spatial arrangement that ultimately informed the pioneers of twentieth-century abstraction.

—TP

1. P.-A. Lemoisne, *Degas et son oeuvre,* 4 vols. (Paris, 1946–1949), 3: no. 1153.
2. Philippe Brame and Theodore Reff, with assistance of Arlene Reff, *Degas et son oeuvre: A supplement,* vol. 5 (New York and London, 1984), p. 128.

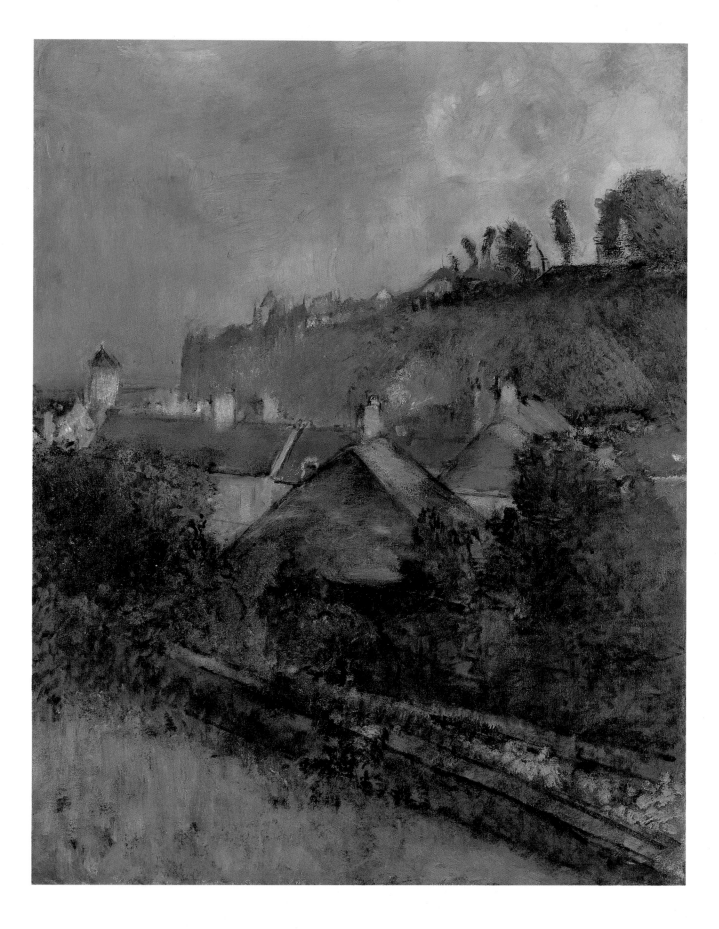

## 7. HOUSES AT THE FOOT OF A CLIFF

*Maisons au pied d'une falaise (Saint-Valéry-sur-Somme)*
ca. 1895–1898

Oil on canvas, 36¼ × 28⅝ in. (92 × 73.2 cm)
Stamped lower left: *Degas*

Landscapes comprise about seven percent of Degas's enormous oeuvre, and he most likely would have painted more were it not for his recurring eye problems.[1] He devoted three major campaigns to the genre. Accompanied by Manet in 1869, he went to Boulogne, where he painted an extensive series of small seascapes. In 1890 he traveled through Burgundy by tilbury with Albert Bartholomé, and on his return proceeded to print sixty monotypes from memory of this and other trips, an extensive and daring project by any measure. The works in oil, heightened with pastel, are so abstract that Degas referred to them as his "imaginary landscapes."[2]

From 1895 to 1898, Degas created a third series of landscapes during trips to Saint-Valéry-sur-Somme, a French town on the English Channel, where as a youth he vacationed with his family.[3] He was lured there both by his friendship with a local landscape painter, Louis Braquaval, a disciple of Eugène Boudin, and by the residence of his brother René, with whom he had recently become reconciled. In Saint-Valéry-sur-Somme, Degas undertook thirteen landscape paintings. More rooted in visual reality than his 1892 landscape monotypes, the pictures vary in motif, in size, in palette, and in structure, and they display a haunting emptiness. They are all cliff, town, path, always beneath the turbulent Channel sky, sometimes with a few lonely cows, never with any human figures.

The brooding quality of *Houses at the Foot of a Cliff* is compounded by a less-than-natural palette, in which a lavender sky transforms some of the buildings. The houses are the most prominent forms, clustered beneath a hill in the distance and viewed from an elevation above the town. In the foreground stretches a band of vegetation, which grows over a path or perhaps a railroad track. The town occupies the middle ground. Along the ridge of the cliff in the background is a ribbon of houses and trees. Vegetation, houses, and cliff define the three gently converging bands that energize the composition. The triangle at the bottom rises and flattens, in contrast to the deeper space shown in the town and the sheer verticality of the cliff.

In the landscape of Saint-Valéry-sur-Somme, as in *The Breakfast* (cat. no. 6), Degas's realism generates a tension between observed reality and abstract design.

The Sirak painting is a dramatic example of Degas's late monumental projects, which are more widely represented by the late bather scenes. Only one other work from the 1895–1898 series, *View of Saint-Valéry-sur-Somme* (Metropolitan Museum of Art, New York), is similarly panoramic, and only *The Return of the Herd* (Leicestershire Museums and Art Galleries, Leicester) is as large.[4] The Sirak and Leicester landscapes are the largest Degas ever painted. The Metropolitan painting is less resolved than the Sirak oil; its complex spatial and structural ambiguity and limited palette match contemporary works by Cézanne and prefigure Cubism. *Houses at the Foot of a Cliff,* on the other hand, recalls the source of this abstraction in Degas's fresh approach to seeing. —TP

1. In a letter to Henri Rouart of December 5, 1872, Degas wrote from New Orleans: "The light is so strong that I have not yet been able to do anything on the river. My eyes are so greatly in need of care that I scarcely take any risk with them at all. A few family portraits will be the sum total of my efforts...." See *Degas Letters,* ed. Marcel Guérin (Oxford, 1947), p. 25.
2. Quoted in Jean Sutherland Boggs, "Late Landscapes at Saint-Valéry-sur-Somme," *Degas* (exh. cat., Metropolitan Museum of Art, New York, National Gallery of Canada, Ottawa, 1988), pp. 566–568.
3. Evocations of family vacations are found in Degas's notebooks of around 1859–1860. See *The Notebooks of Edgar Degas,* ed. Theodore Reff (Oxford, 1976), Notebook 14A and Notebook 18. The Bibliothèque nationale, Paris, lists these as BN Carnet 29, pp. 40–41; and BN Carnet 1, p. 1613.
4. These two works and a third from the series were exhibited in the 1988–1989 exhibition, *Degas,* cat. nos. 354–356. The dimensions of the Leicester painting are given as 36¼ × 28 in. (92 × 71 cm).

## 8. SEATED DANCER

*Danseuse assise*
ca. 1898

Pastel and charcoal on tan paper, laid down, 21 × 19⁷/₁₆ in.
(53.2 × 49.4 cm)
Stamped lower left: *Degas*

Degas's *Seated Dancer* complements other works by the artist in the Sirak Collection, adding a late depiction of his most frequent subject, the ballet, in his most accomplished technique, drawing. It also adds an element of mystery, for there are many conflicting and tantalizing clues about the purpose of this work.

In the bottom left-hand corner of the drawing is a stamp, in red ink, representing Degas's signature. It is a *vente*, or sale, stamp, placed on the works remaining in the artist's studio after his death and sold in one of the four sales of 1918 and 1919. Although the stamp places the work in Degas's studio at his death, it does not tell us much more, for the artist virtually hoarded his works, great and small, from his most ambitious paintings to his most personal working drawings.

This sheet is not elaborately finished, but we would misrepresent Degas's technique and working method were we to dismiss it as merely a sketch. The drawing is composed carefully and works successfully as an independent object. The figure of the dancer fills most of the page. Her skirt fans out behind her, bordering the top edge of the paper. The fan shape is the decisive compositional device. It creates an open ellipse which is cradled by the upper-left corner. It is echoed by the contour of the dancer's back, a line extending from the waist and curving in the other direction at the neck. These two principal curves, of the skirt and the back, are contrasted to the sharp angles created by the right arm, which reaches to pluck the necklace, and the left arm, which rests on the raised left leg. Pastel touches are spare but effective in highlighting the dancer's hair, skin, and skirt.

*The Seated Dancer* is closely related to three pastels with two dancers, *Grandes Danseuses vertes, Deux Danseuses,* and *Deux Danseuses aux repos,*[1] and to one other single-figure drawing, *Danseuse assise.*[2] The single-figure work is a counterproof of the Sirak drawing, that is to say, an exact reversal of it. Typically, Degas would wet a clean sheet, press a charcoal drawing like this against it, and run the two sheets through a press. He might have used another technique, such as tracing, to transfer the figure to other

pastels from around 1898. These two-figure compositions are more elaborately finished, with the second figure to the right of the seated dancer. But we cannot say for certain if the Sirak drawing was made before or after the more elaborate pastels. Degas was just as capable of deriving a single figure from his own multi-figured compositions as he was of making a single-figure study for a more complex composition. His working method was complicated and often experimental; sometimes it remains mysterious. Although he clung to drawing as the basis of his art, he subverted its traditional role.

The *Seated Dancer* is equally compelling for the treatment of its subject. Degas's dancers practice in his earliest dance scenes, take the stage in the mid-1870s, and continue to practice. Frequently, they do not dance at all but stretch, rest, scratch, and primp. In his latest works there is a weariness to his dancers and a gravity to his depiction, both of which are expressed very forcefully in the Sirak drawing. The posture itself evokes a sense of the figure's contemplation and melancholy. The dancer props up one leg and, on that leg, rests her arm which supports her head. Her right arm seems heavy, as if she needs to support it by grasping her necklace. And the curving back seems compressed by the corner of the paper as though by weight. Above all, the dancer's countenance reveals strain, if not quite despair. The face is mostly in shadow; the eyes are dark pockets.

At times Degas identified with dancers, especially with the continual and grueling rehearsal required of them. When the *Seated Dancer* was drawn, probably in the late 1890s, Degas knew he was at the end of his career. His vision was failing. He had become more gruff and recalcitrant. He had tightened the circle of his associations. And his thoughts turned very much to the past and to his family. In 1897 he severed ties with some of his oldest and closest friends because of his anti-Semitic stand on the Dreyfus Affair.[3] Like Degas himself, many of his latest ballet dancers suffer a sad isolation.
　　　　　　　　　　　　　　　　　　　　　　—TP

1. P.-A. Lemoisne, *Degas et son oeuvre,* 4 vols. (Paris, 1946–1949), 3: cat. nos. 1330, 1331, 1331bis.
2. Ibid., cat. no. 1332bis3.
3. For a recent and thoughtful account of these events, see Linda Nochlin, "Degas and the Dreyfus Affair: A Portrait of the Artist as an Anti-Semite," in *The Politics of Vision: Essays on Nineteenth-Century Art and Society* (New York, 1989), pp. 141–169.

# ROBERT DELAUNAY

French, 1885–1941

## 9. PORTUGUESE WOMAN

*Portugaise*
1916

Oil on canvas, 53½ × 61⅜ in. (135.9 × 155.8 cm)
Signed and dated lower right: *r. delaunay 1916*

In his 1913 *Les Peintres Cubistes,* Guillaume Apollinaire attempted to create distinctions between two types of Cubism. For him, the movement had two characters: one formal and analytical, the other expressive and coloristic. This latter category Apollinaire called "Orphic" Cubism, including among its chief practitioners Robert Delaunay.[1] Unlike the Cubism of Pablo Picasso, Georges Braque, or Juan Gris, Delaunay's Cubism extended into the realm of nonobjective art. While Delaunay drew inspiration from some of the same subjects that interested other Cubists—still lifes, portraits, the human figure—his works after about 1910 were no longer exclusively bound to the representation of the object. Color became his primary means of expression; as he put it, "Color is form and subject."[2] Delaunay found the power of color gave a sense of monumental grandeur to his paintings even when the object was not readily apparent. *Portuguese Woman* fulfills his vision of painting as an emotional yet rational construction of form and color. It combines representational elements with active and colorful nonobjective forms.

Caught in Spain at the outbreak of World War I, Delaunay spent the years 1914 through 1917 first in Madrid and then in northern Portugal. While he was cut off from the activities of Paris, he pondered the advances he had made in his own art of previous years. The works he completed during this period are both a reflection of his surroundings and a consolidation of his ideas. The stay in Spain and Portugal proved to be an important step in his development, especially in his conception of color and in the relationship of natural and nonrepresentational forms in painting. *Portuguese Woman* is one of a number of similar paintings that combine still life, human figure, and abstract forms.[3] A related version of this composition (possibly private collection, Cologne) differs only in a few details and color.[4]

The richly colored Sirak painting gives full expression to the theories Delaunay had developed around 1912 about "simultaneity" and color in art. The complex coloration of *Portuguese Woman* is its most striking feature. The play of warm and cool hues draws the eye back and forth across the canvas and in and out as well. At the junction of warm and cool color areas—for example, in the apron and skirt—a strong visual tension results. In the abstract elements of the painting, Delaunay uses arbitrary disks and bands of similar colors to unite the work compositionally. The result is an exciting pulsation of widely different hues and values which energize the work overall.

The strong coloration and excitement of *Portuguese Woman* were directly inspired by Delaunay's experience of Portugal, in particular the town of Minho, which he described as having the "atmosphere of a dream."[5] Everywhere there were luminous color relationships, in the glazes of local ceramics, in the houses, and in the brilliant folk costumes of the women in Minho, which were also noted with interest by Sonia Delaunay.[6] These *costumes populaires* seemed a real life confirmation of Robert Delaunay's experiments with "simultaneous color" in the previous years. In this picture still life and figure are merged into a dazzling play of light, color, and form. The impressions of color in movement under the brilliant light of the sun, everywhere contrasting and interacting with surrounding objects, are translated by the artist into both literal and abstract forms in his painting. While the figural and still-life elements of *Portuguese Woman* anchor the image in objective experience, the disks and abstract bands of color reflect the more subjective experience of the brilliant sunlight of Portugal.

—GW

1. Guillaume Apollinaire, *The Cubist Painters,* trans. Lionel Abel, Documents of Modern Art, vol. 1 (New York, 1962), pp. 17–18.
2. Robert Delaunay, *Du Cubisme à l'art abstrait,* ed. Pierre Francastel, with a catalogue of Delaunay's work by Guy Habasque (Paris, 1957), p. 67.
3. A number of Portuguese still lifes and depictions of Portuguese women from 1915 to 1916 are listed in the catalogue by Guy Habasque, some of which include the same objects seen in the Sirak *Portuguese Woman;* see Delaunay, pp. 277–280. For reproductions of some of these, see also Guy Habasque, *Robert Delaunay, 1885–1941* (exh. cat., Musée national d'Art moderne, Paris, 1957), pp. 61–63, nos. 52, 53, 55, 59–60; Michel Hoog and

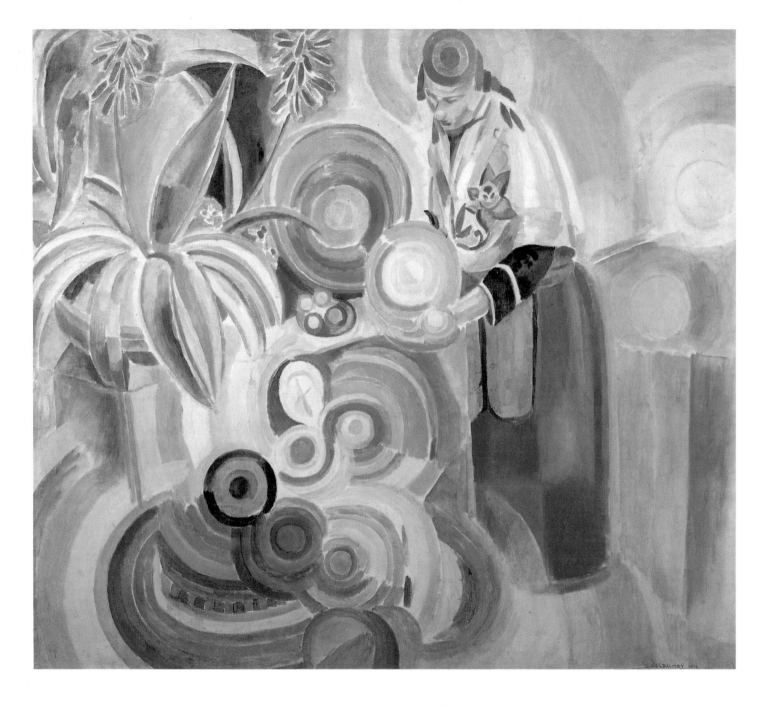

Hans Albert Peters, *Robert Delaunay* (exh. cat., Orangerie des Tuileries, Paris, 1976), pp. 81–82, no. 56.

4. See Habasque, no. 177.

5. Delaunay, p. 127.

6. See, for example, Sonia Delaunay's *Marché au Minho,* 1916; reproduced in Michel Hoog, *Robert et Sonia Delaunay* (Paris, 1967), p. 157, no. 99. Also relevant is Sonia's *Nature morte portugaise,* 1916, reproduced in Hoog, p. 157, no. 104. Like Robert, Sonia Delaunay was working with the coloristic aspects of both natural and abstract form in her paintings. Her later work in costume and fashion design may have been partly inspired by such contacts with color-rich folk costume.

## 10. AIR, IRON, AND WATER

(study for the mural in the Pavillon des Chemins de Fer, Exposition Internationale, Paris, 1937)

*Air, fer et eau*
1936–1937

Casein on paper, mounted on canvas (in 1951), 38$^{7}/_{16}$ × 59$^{7}/_{16}$ in. (97.6 × 151 cm)

Robert Delaunay's art expresses a monumental quality, even when it is small in scale, due in part to simplicity of form and bold color, especially in the artist's mature works. One also finds an ambitious choice of subjects, a grand vision of modernity, a faith in progress, and a celebration of the technological achievements of the day. For Delaunay, the commission to create a large-scale mural installation for the Railroads Pavilion of the International Exposition in Paris in 1937 was the opportunity to express his ideas about the heroic character of the modern world.

In addition to the mural, the project included ten large bas-reliefs and other decorative panels. With the help of some fifty workers, the installation was completed in the short span of two months. *Air, Iron, and Water* from the Sirak Collection is one of several studies made for the mural of the same title.[1] The motifs of the work are familiar in Delaunay's oeuvre: Eiffel Tower, railroad, female personifications, abstract disks. The three elements of the title refer to three modes of transportation: air, land, and waterway, which are represented by the images of a parachute and propellerlike forms, a train engine, and a boat with female personifications of the Seine. Yet there is also another metaphorical significance to the title. With analogies to the four elements of the Classical world—air, earth, fire, and water—the three elements of Delaunay's title define the character of the modern world in terms of technology and nature. The Eiffel Tower and the river Seine recur throughout Delaunay's work as emblems of the universe—the modern world manifested symbolically with the city of Paris at its center. The triptychlike composition completes this universal vision as it projects a quasi-religious character, emphasizing the relationship of material and spiritual values.

Alongside representational elements in the painting are abstract forms of arcs, disks, and other colorful shapes. These abstract motifs are derived from images whose origins lie in Delaunay's pre–World War I works.[2] The spinning disks—a common motif of the entire decorative project, appearing also in reliefs on adjacent walls of the Railroads Pavilion—create energetic movement throughout the composition. These circular forms are echoed in the train engine, the parachute, and the arch of the Eiffel Tower. Indeed, this integration of abstract and representational forms gives Delaunay's style its unique character.

Though it is a study, the Sirak *Air, Iron, and Water* is a complete and finished work itself. One of Delaunay's most significant compositions, it is a summation of his ideas about the role of color, shape, and movement in painting. The subject, the relationship between abstraction and representation, and the judicious use of symbol and metaphor give this work its great power of expression.

—GW

1. For a discussion of the mural project, see Robert Delaunay, *Du Cubisme à l'art abstrait,* ed. Pierre Francastel, with a catalogue of the artist's works by Guy Habasque (Paris, 1957), p. 44; Michel Hoog, *Robert et Sonia Delaunay* (Paris, 1967), pp. 91ff; Peter Klaus Schuster, ed., *Delaunay und Deutschland* (exh. cat., Haus der Kunst, Munich, 1985), pp. 385–387. See also Michel Hoog and Hans Albert Peters, *Robert Delaunay* (exh. cat., Orangerie des Tuileries, Paris, 1976), pp. 127–130, cat. nos. 117, 118. The latter (118) is Habasque cat. no. 469; the other (117) is not in Habasque. The Habasque catalogue lists five works with the same title as the mural: nos. 329–331, 469, 470.

2. The Simultaneous Disks and Sun Disks of 1912–1913 are the origin of many of the circular motifs found in Delaunay's later work. See works like *Simultaneous Contrast: Sun and Moon,* 1912–1913 (Museum of Modern Art, New York), illustrated in John Golding, *Cubism, A History and an Analysis, 1907–1914* (Cambridge, Mass., 1988), fig. 80b; or *Le Premier Disque,* 1912 (Collection Mr. and Mrs. Burton Tremaine), reproduced in Hoog and Peters, p. 71.

The Disks of 1912–1913 evolved into a number of works in which arcs and concentric circles of color play a major compositional and symbolic role, as in Delaunay's well-known *Homage to Blériot* of 1914 (Kunstmuseum Basel); reproduced in Robert Rosenblum, *Cubism and Twentieth-Century Art* (New York, 1976), pl. 26.

On the evolution and philosophy of Delaunay's circular motifs, see Sherry A. Buckberrough, *Robert Delaunay: The Discovery of Simultaneity* (Ann Arbor, Mich., 1982), especially pp. 133–150 and pp. 181–233.

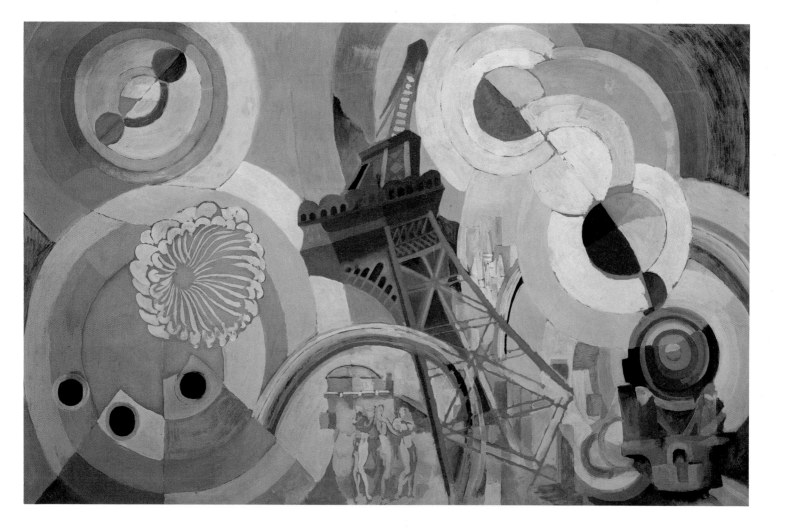

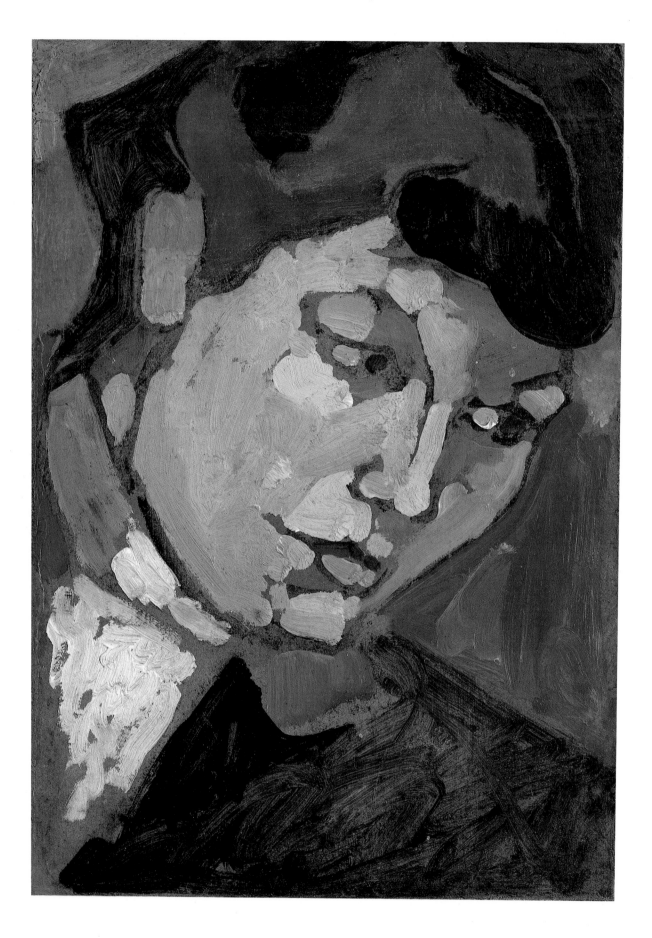

# ANDRÉ DERAIN

French, 1880–1954

## 11. PORTRAIT OF MAUD WALTER
ca. 1904–1906

Oil on board (cradled), 14⁷/₈ × 10¹/₂ in. (37.7 × 26.6 cm)

André Derain and Henri Matisse studied together in the studio of the Symbolist Eugène Carrière at the turn of the century. In 1901 Derain introduced Matisse to Maurice de Vlaminck, a fellow artist and friend from Derain's hometown of Chatou, in the Paris region. Thus came together the artists who established the core group of one of the most explosive and influential artistic movements of the twentieth century: Fauvism.

In the painting *Portrait of Maud Walter* Derain experimented with the art of the recent past as he contributed to the new art of the Fauves. His artistic development had been interrupted by military service from 1901 to 1904. In a great burst of activity upon his return, he avidly tried to assimilate and surpass the lessons of Seurat, Cézanne, Gauguin, and Van Gogh. He probably painted this portrait of Maud Walter, a friend from Chatou, in late 1904 or early 1905, for it certainly accords with other works of this time.[1]

In the upper-right corner of the *Portrait of Maud Walter*, Derain juxtaposed orange, russet, and violet forms. In these decorative and abstract surfaces, he adapted Gauguin's techniques to his own purposes. Throughout the rest of the picture, the effect is even more modern and typically Fauve. The succession of color blocks that run along the right edge of the canvas, from violet to orange to pink to green, announces the Fauves sensational color, now liberated from description. In the face, large passages of thin pink paint seem to hover over the cheeks, unable to rest comfortably in illusionistic space. Where flesh tones are employed, they do not describe facial structure. Unnatural colors, such as the long green line covering the right jawbone, denote the plasticity of a human visage. Here Derain's *Portrait of Maud Walter* bears close comparison to Matisse's more famous *Woman with a Green Stripe* of late 1905 (Royal Museum of Arts, Copenhagen).

Derain's experiments with a bold and abstract surface geometry are as daring as his colors. Flat polygons surround the more three-dimensional head, fixing it at the center of the board. Maud Walter's left shoulder is separated from her body by a band of unpainted support. Seen two-dimensionally, the green triangle of the sitter's left shoulder seems to support the head like a sculpture's pedestal. Presumably, Derain's spatial treatment was inspired by his study of Cézanne, whose works were presented in a retrospective exhibition at the 1904 Salon d'Automne.

Amid the searching and inventions of a young artist, there is in the portrait a sort of classicism that represents Derain's lifelong interest in the Old Masters. Even in this most avant-garde phase of his career, Derain charged the *Portrait of Maud Walter* with tremendous power based on classical methods. Although the face is arbitrarily colored green, lavender, and pink, it is severely modeled. The shock of hair over the forehead casts a hard shadow over sharp-edged features that recall Archaic Greek sculpture. Later in his career Derain would return to the grand tradition after this inspired and critical decade of painting on the leading edge.　　　　—TP

1. A photograph of the painting, at one time attached to the back of the panel, bears a handwritten notation by the artist's widow stating that the portrait was painted about 1906.

45

## 12. PORTRAIT OF THE PAINTER ÉTIENNE TERRUS
1905

Oil on canvas, 25 3/4 × 19 1/2 in. (65.4 × 49.5 cm)
Signed lower left: *A. Derain*

In the summer of 1905 Derain accompanied Matisse to Collioure, where, as it happened, the two artists painted the definitive Fauve pictures, among these, Derain's *Portrait of the Painter Étienne Terrus.* Their enterprise has a historical significance comparable to Renoir and Monet's invention of Impressionism at Bougival in the summer of 1869.

At Collioure, Derain met Étienne Terrus, a fellow painter and follower of Paul Signac, who came from this Mediterranean region near the Spanish border. Terrus introduced Derain and Matisse to Aristide Maillol, who lived in a nearby town, and to a friend of Gauguin, who showed them many of the latter's previously unseen Tahitian canvases. And they painted. Derain estimated that by the end of the summer he would complete thirty canvases, twenty drawings, and fifty sketches.[1] Matisse painted *Open Window Collioure,* an icon of Fauvism. They painted dramatic portraits of each other; and later Matisse recalled that Derain "knew more about [Fauvism] than anyone."[2]

The pairing of the *Portrait of the Painter Étienne Terrus* with the *Portrait of Maud Walter* (cat. no. 11) demonstrates Derain's tight painting from Chatou and his loose or flexible painting from Collioure. In the earlier picture, a dozen or so circumscribed forms contain blocks of color. In the portrait of Terrus, Derain used vibrant, irregular dashes and patches of highly keyed color. He also eliminated shadow, a step he recognized at the time as one of his most important breakthroughs of that summer. Heavily built up in some areas, the paint shines still more due to the unprimed canvas, much of which is revealed. The painting's aggression is evoked in Derain's description of this phase of his career: "For us," he recalled, "Fauvism was a trial by fire. Colors became cartridges filled with dynamite to be exploded through contact with light."[3] The power and energy of these brilliant colors and bold brushstrokes are compounded by the gravity of the subject and the monumentality of the composition. Because of this, the portrait is even more impressive than the familiar landscapes of the same period. The sitter's brooding expression, crossed arms, and long beard lend him an aura of severity tantamount to that of an Old Testament prophet. His right hand clutches a walking stick and protrudes through the picture plane toward the viewer. Derain has filled the canvas with the figure, which extends to all four edges, and he has given Terrus a cubic massiveness, juxtaposing his head and the side of a sea wall so that they appear equal in size.

Derain did not exhibit the *Portrait of the Painter Étienne Terrus* until the spring of 1906, at the Salon des Indépendants. Some paintings from Collioure were, however, shown at the 1905 Salon d'Automne. Critics identified the radicalism of these works, and some sought to come to terms with the new painting. "To put ourselves in contact with the young generation of artists," one critic wrote, "we must be free and willing to understand an absolutely new language." This new language, Fauvism, was perfected at Collioure and in the *Portrait of the Painter Étienne Terrus.* Such a confrontation with entirely new vocabularies has remained the central challenge of modern art.
—TP

1. André Derain, *Lettres à Vlaminck* (Paris, 1955), pp. 154–157 (letter from Collioure, July 28, 1905).
2. Francis Carco, "Conversation avec Matisse," *L'Ami des Peintres* (Paris, 1953): 219–238, from Jack D. Flam, *Matisse on Art* (London, 1973), p. 78.
3. Gaston Diehl, *Derain,* trans. A. P. H. Hamilton (New York, 1964), p. 33.

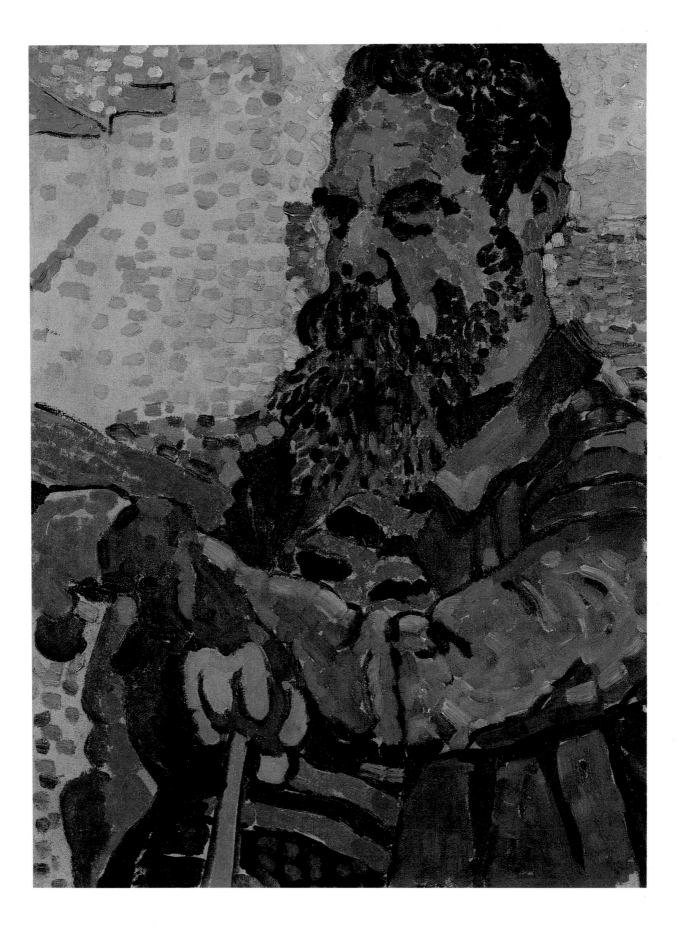

# CHARLES DESPIAU

French, 1874–1946

*13.* MADEMOISELLE GISÈLE GÉRARD
1942–1943

Bronze, H. 17 3/4 in. (45.1 cm)
Signed and inscribed on the back: *C. Despiau, Valsuani, Paris 5/10*

Not given to flamboyant technique, facile effect, or slavishness to modes, Charles Despiau developed an art characterized by continuity, subtle relationships of forms, classical calm, and quiet beauty. Works such as the Sirak portrait of Mademoiselle Gérard were created through painstaking hours of contemplation, observation, and manipulation of materials. The artist said that he never hurried, that his work on a given piece could last years if necessary.[1] Believing as he did that the greatest progress was not made quickly, Despiau reworked and refined his sculptures until it seemed they would never be finished.[2] He required of his models as many as sixty sittings in the course of one project. Nevertheless, a prolific output of portrait busts attests to his ability to find willing sitters.

The portrait of Mademoiselle Gérard, completed just a few years before Despiau's death in 1946, represents a continuation of the style he developed as early as the 1920s and, with some changes in nuance, used throughout his career. The frontal composition, simplification of form based on geometric shapes, and subtle transitions in the planes of the face and head are typical of his approach. In his portraits, as in his nude figures of classical and biblical personages, Despiau was less interested in capturing specific physical features or fleeting emotions than he was in creating a sense of the universal. He said that when he analyzed a head, his goal above all was to discover its essential rhythm, to organize the parts and to link them by the correct transitions, to realize relationships among sculptural elements, and never to force himself to describe picturesque details or states of mind.[3] He relied on the play of light on articulated surfaces to dramatize volume, shape, and line, an interest

he shared with Auguste Rodin, with whom he had worked as an assistant from 1907 to 1914.

A related terracotta bust of circa 1944 is in the collection of Madame Gisèle Gérard Zijlstra (Paris).[4]

—SK

1. Claude Judrin, Monique Laurent, Claude Roger-Marx, *Charles Despiau sculptures et dessins* (Paris, 1974), n.p.
2. Ibid.
3. Ibid.
4. Ibid., illus. no. 96.

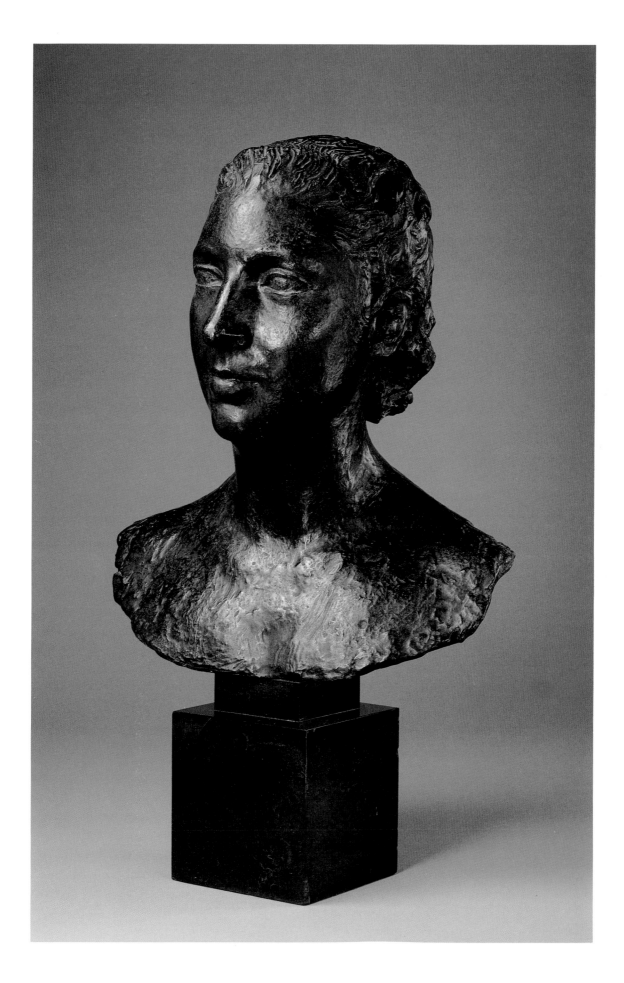

# JAMES ENSOR

Belgian, 1860–1949

## 14. THE ASSASSINATION

*L'Assassinat*
1890

Oil on canvas, 23 13/16 × 30 3/8 in. (60.5 × 77 cm)
Signed and dated lower right: *Ensor 90*

James Ensor's artistic production, which spans more than seven decades, identifies the artist as an important precursor of modern Expressionism through an art that is often radical and hallucinatory, with solitary images of alienation and self-mockery and crowd scenes filled with sardonic grotesqueries.

Criticism and rejection characterized Ensor's early artistic career, and attacks continued throughout his most productive years. In 1877 he entered the Brussels Royal Academy where he endured three years and was disparaged as "an ignorant dreamer." In the 1880s, rejections by Belgian salons, as well as by his peers in the avant-garde associations L'Essor and Les Vingt, occurred regularly. During this period masks became a leitmotif for much of Ensor's art; and the psychological implications of the mask, as well as the tradition of Belgian carnivals and religious festivals, were meaningful in the development of his iconography. Concurrently, Ensor formulated an artistic vision based upon his beliefs concerning nationalism and an impending disintegration of contemporary European society. His vision was expressed in an art that often shocked and repelled through increasingly vulgar and vicious caricature.

*The Assassination* belongs to the last decade of the nineteenth century—to that period in which Ensor utilized caricature for its most powerful expressive potential and in which his pessimistic view is most devastating. In this macabre composition three masked and costumed figures restrain a fully clothed victim while a fourth performs a bloody procedure upon his chest, perhaps the removal of his heart. This gruesome activity, accompanied by the music of a horn player in partial view on the left and a skeleton who attempts to beat a broken drum on the right, occurs in a stage setting: a horizontal composition in which the room's only furniture is the table upon which the prisoner is bound. On the otherwise bare floor next to the table a large plate catches a copious stream of blood pouring from the wound; two bloody handprints on the floor suggest a violent struggle. The action is compressed into the foreground of the picture plane by a flat expanse of wall behind the figures. At ceiling level two slanted windows frame the crude faces of several witnesses who regard the scene with varying degrees of interest. Directly below them and centered on the pale blue wall are faint designs evocative of a child's scribbles.

Ensor had used this figural arrangement before, in an 1888 etching also titled *The Assassination*.[1] The print illustrates a murder in Edgar Allan Poe's short story "The Facts in the Case of M. Valdemar," and it may have been influenced by Alphonse Legros's earlier etching of the same scene.[2] In Ensor's print the victim is held on a table and restrained at his arms, legs, and feet in a manner identical to that in the painting. A plate on the floor catches the stream of blood, but in this case the wound is from a slit throat. Ensor colored a few rare prints with red and yellow watercolor,[3] the same primary colors that dominate the painting (especially red, which serves to make the victim's face indistinguishable from his clothing).

Despite these similarities, the painting differs from the print in its remarkable wedding of the tragic and the comic. The murder performed in the print is darkly foreboding in spirit, and the huge headdresses worn by the four protagonists enhance the scene's ominous mood. The painting's tone is mocking; the deed is repellent, but the masked murderers are ludicrous. In its reliance on the burlesque and its inclusion of violence the painting pays homage to the political cartoons of the late eighteenth-century English artist James Gillray and shares a similar spirit with Ensor's 1891 *Skeletons Fighting over the Body of a Hanged Man* (Koninklijk Museum voor Schone Kunsten, Antwerp),[4] a painting in which he used mockery, farce, and insult to make his point.

Ensor's elimination of the barriers between high

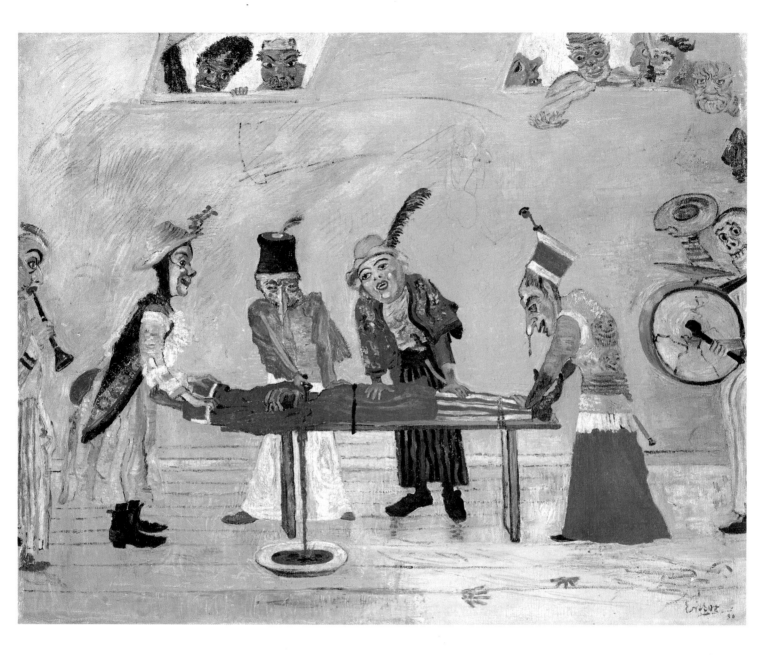

and low art and his deliberate assault on the viewer's sensibilities coincided with his appreciation of a specific Belgian art called *l'art zwanze. Zwanze* meant "joke" in the local dialect of Brussels, and its use implied strong mockery or farce. There were exhibitions of *l'art zwanze,* and Ensor showed in the one held in 1887. To understand these exhibitions and the artistic climate from which they emanated is to realize that anarchy played an important role: "anarchy could, on a social level and in a general way, be placed in parallel with the artistic overthrow of an age,"[5] as revealed in the aspirations of the avant-garde.

Given the years of rejection and humiliation that Ensor suffered, and the attacks from friends, family, and foes, it is possible that the victim of this black comedy—in which the two female masks represent his mother and sister—is Ensor himself. —DL

1. Illustrated in James Elesh, *James Ensor, The Complete Graphic Work,* vol. 141 of The Illustrated Bartsch, ed. Walter L. Strauss (New York, 1982), p. 71.
2. Ibid., p. 127.
3. Auguste Taevernier, *James Ensor, catalogue illustré de ses gravures, leur descriptions critiques et l'inventaire des plaques* (Ghent, 1973), p. 103.
4. See Diane Lesko, *James Ensor, The Creative Years* (Princeton, 1985), p. 49, fig. 44.
5. Jacques van Lennep, "Les Expositions burlesques à Bruxelles de 1870 à 1914: l'Art zwanze—une manifestation pré-dadaiste?" *Bulletin des Musées Royaux des Beaux-Arts de Belgique* 19 (February 1970): 132.

## 15. THE SEA SHELLS

*Les Coquillages*
1895

Oil on canvas, 32⁵/₁₆ × 43 in. (82.2 × 109.2 cm)
Signed and dated lower right: *ENSOR 1895  J. Ensor*
[painted over, indistinct]

Ensor's earliest works, from the late 1870s, were of the sea and dunes of Ostend, the artist's birthplace in Belgium and his lifelong home. These marine paintings were executed with a light touch and a sense of grace remarkable for a young artist. Love of the sea continued throughout his life.

In an essay of 1931 Ensor described the sea in universal terms as a life force that combines sexuality and creativity: "Medicinal sea, worshipped Mother, I should like to offer one fresh, simple bouquet celebrating your hundred faces, your surfaces, your facets, your dimples, your rubescent underparts, your diamond-studded crests, your sapphire overlay, your blessings, your delights, your deep charms."[1]

From the 1880s on, in addition to seascapes, Ensor painted still lifes of fish, crustaceans, and shells. In 1882 and 1892 sting rays became the subject of two important marine still lifes (Koninklijk Museum voor Schone Kunsten, Antwerp; and Musées Royaux des Beaux-Arts de Belgique, Brussels).[2] The earlier work is painted in an academic style that pays homage to Chardin and the eighteenth century, yet the ray reclines in a precarious position, its head and side protruding over a table's edge from a bed of shining straw that seems to crackle with electricity. Ensor's compositional arrangement includes a provocative detail: the ray's erect tail points directly into the opening of a tilted wicker basket. In the painting of 1892 Ensor's style changes, but the undercurrent of sexuality remains. In its second appearance the ray is propped up and looking out at the viewer. The body is soft and pliant, and a flaccid tail droops over the table's edge. Although the ray dominates the composition, a large conch shell, positioned to reveal its deep red and pink interior, is equally evident.

It is to the later style that *The Sea Shells* belongs. As in the 1892 still life, thick pigment of iridescent blue, pink, yellow, and ocher is smeared to form the background, in this case a vast empty sky; in the foreground sea creatures are spread across the canvas. With bodies composed of wiggly strokes, each specimen is clearly identifiable, including a *Charonia tri-*

*tonis* at the right, a *Cassis tuberosa* in the center, and a *Strombia gigas* at the left.[3]

*The Sea Shells* is a still life without a tabletop; each object is carefully positioned on the sand at the water's edge. At the center, four large mollusks form a triangular shape whose apex is the top of a large shell that sits upon another shell or a rock. Even though this configuration implies stability, Ensor creates a subtle contradiction because the top shell lists precariously to its right and toward the open red-pink interior of the conch shell. Adding to the painting's ambiguity is a reference to nature's destructive power: it is low tide and the sea has receded, leaving marine life uncovered and vulnerable to predators. This situation links the painting to an early work, the 1877 *Cabin on the Beach* (Koninklijk Museum voor Schone Kunsten, Antwerp),[4] painted when Ensor was just seventeen. There a solitary bathing cabin stands shuttered and alone on the sand at the water's edge, like a shell hiding a silent inhabitant who fears the dangers of nature.

The landscape setting in *The Sea Shells* is as compelling as the still-life arrangement: through the sky, sand, and sea Ensor imbues the picture with a seductive mystery that hints at hidden dialogues. Although formed from paint, these shells and crustaceans, as Paul Haesaerts has observed, ". . . seem to owe their existence, their fantastic forms . . . to the sand, wind, waves, and light."[5]

—DL

1. Quoted in Paul Haesaerts, *James Ensor*, trans. Norbert Guterman (New York, London, 1959), p. 105.
2. See Diane Lesko, *James Ensor, The Creative Years* (Princeton, 1985), p. 10, fig. 4, pl. 8.
3. See Hugh and Marguerite Stix and R. Tucker Abbott, *The Shell: Five Hundred Million Years of Inspired Design* (New York, 1968), n.p., fig. 14.
4. See Lesko, pl. 1.
5. Haesaerts, p. 71.

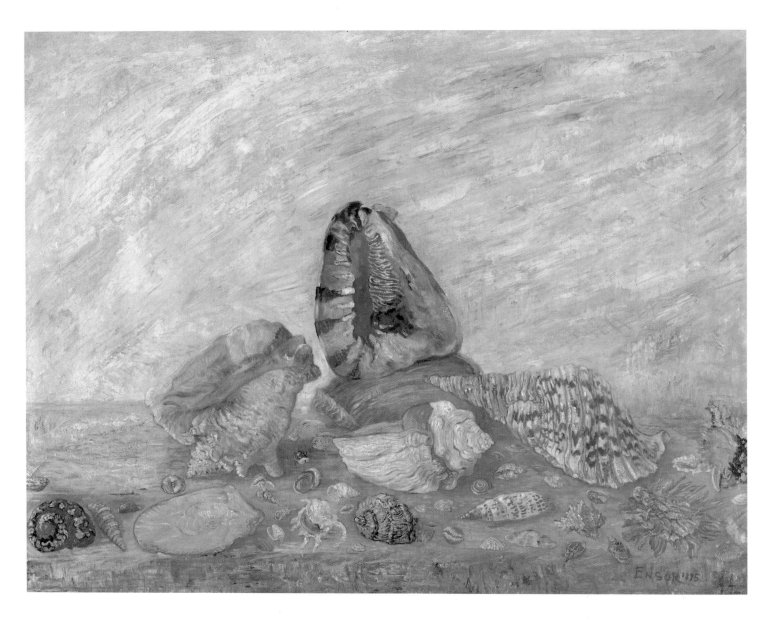

# LYONEL FEININGER

American, 1871–1956

16. CATHEDRAL

*Der Dom*
1920

Oil on canvas, 35 5/8 × 45 1/4 in. (90.5 × 114.9 cm)
Signed and dated lower right: *Feininger 20*

Churches and gabled houses are among Feininger's most persistent motifs. He wrote to Alfred Barr in 1944 that as a child, while visiting the Metropolitan Museum of Art in New York, he developed a special fondness for late medieval panels depicting "Gothic architecture with figures bright and beautiful in color and clearly silhouetted."[1] During the fifty years he lived in Germany, he never tired of painting the churches and half-timbered houses in the villages of Northern Thuringia. He first visited that region in 1906, making many drawings, among them his earliest sketches of the church in Gelmeroda, perhaps his most famous subject, to which he subsequently devoted no fewer than thirteen paintings. Even after his return to the United States in 1937, he continued to reflect nostalgically on these German themes.

Architecture appealed to Feininger's innate sense of precision and order. Yet his response to architecture was also profoundly romantic. Writing about his experiences in Thuringia, he described the church towers there as "among the most mystical" he had ever seen.[2] A corresponding blend of technical control and spiritual content is at the heart of Feininger's mature style. Not surprisingly, his art appealed both to the Expressionists of the Blaue Reiter group and to the architect Walter Gropius, who in 1919 invited Feininger to be the first painter to join the faculty of the Bauhaus.

As early as 1907 Feininger expressed a need to move away from purely sensory perception. "What one sees," he wrote that year to Julia, the woman who would become his wife, "must be *transformed in the mind* and crystallized."[3] While his early work as a caricaturist had paved the way to this recognition, the real turning point in Feininger's development came in the spring of 1911, when he first saw paintings by the French Cubists at the Salon des Indépendants in Paris.

In April of 1912 Feininger most likely also saw paintings by the Italian Futurists in Berlin. Cubism and Futurism form the basis of his mature style, which he first evolved fully in 1914 by "crystallizing" the images of his visual perception into transparent pictorial structures. In these paintings light, too, takes on tangible prismatic form. Yet this light is never a merely physical phenomenon; it possesses both aesthetic and spiritual appeal. Seeking to define the difference between his paintings and those of the French Cubists, Feininger himself made a similar point when he wrote to a friend in 1913: "Cubism . . . may easily be degraded into mechanism. . . . My 'cubism'. . . is *visionary,* not physical."[4]

Feininger saw a more valid comparison between his prismatic compositions and the structural laws of music, particularly the fugue.[5] His mature paintings are indeed reminiscent of such elements of fugal construction as inversion, overlapping, and repetition. Music, too, may be said to be "visionary" insofar as it appeals to the emotions. Parallels between painting and music also preoccupied Vasily Kandinsky, and music played an important part in the life of Paul Klee. Both were members of the Blaue Reiter group and closely associated with Feininger at the Bauhaus and (after 1924) in the exhibition association Die Blaue Vier. In Feininger's case the analogy of music and painting is particularly apt. The son of professional musicians, he originally set out to be a violinist and was sent to Germany in 1887 to complete his music education. When music became an avocation for Feininger rather than a profession, it nonetheless remained an integral part of his life, culminating in the composition of thirteen fugues for piano written between 1921 and 1926.

Feininger's *Cathedral* of 1920 exemplifies his fully developed "fugal" style, or his "prismism," as he himself liked to call it.[6] The dynamic pictorial structure derives from the extension of the contours of the individual forms beyond the shapes to which they belong and from their interpenetration with contours belonging to other forms. The buildings seem to have grown outward, the way a crystal grows, giving definition to

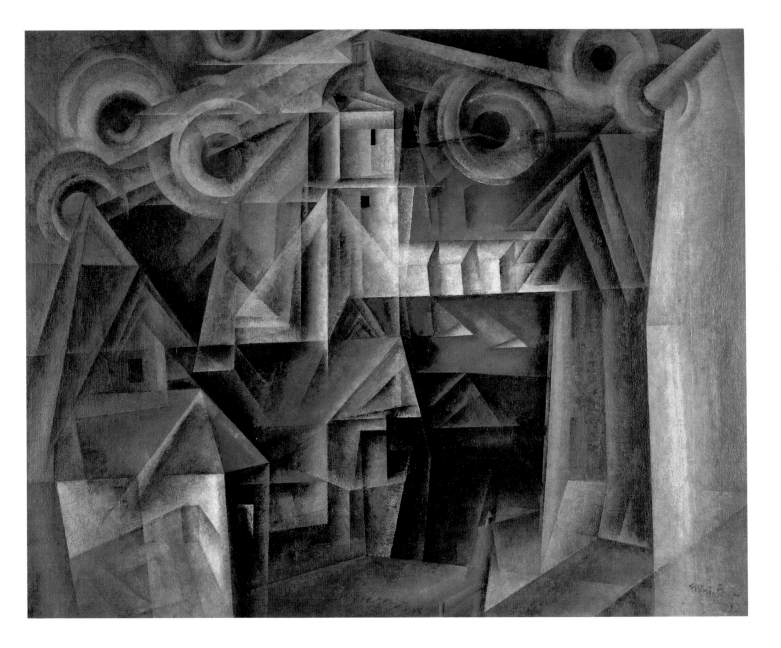

the surrounding space through a series of inter-penetrating projections. Light and atmosphere, too, are active forces creating an architecture of space. Even the male figure hurrying across the square in the lower foreground has been accommodated to the structural idiosyncrasies of the transparent composition. The circular and spiraling forms in the upper part of the painting obey a different rhythm. As the Futurists were wont to do, Feininger most likely intended these to convey an aural, rather than a visual, experience: the sound of ringing bells.[7]

The prevalence of the church as a subject in Feininger's oeuvre has led to comparisons with German painters of the Romantic period, especially Caspar David Friedrich (1774–1840).[8] Feininger rejected these comparisons, insisting that he did not see paintings by Friedrich until long after he had painted his own.[9] Be that as it may, like his nineteenth-century German predecessors, Feininger depicted medieval churches metaphorically on several occasions: as a symbol of human aspirations, for example in the soaring, star-enveloped cathedral of his 1919 title-page woodcut for the Bauhaus program,[10] and as a melancholy reminder of man's impotence against the ravages of time in his representations from the 1920s and mid-1930s of the remains of a Gothic church near Hoff, on the Pomeranian Baltic sea coast.[11]

In the Sirak painting Feininger's gentle romanticism is less specific, largely because his pictorial intentions were here primarily aesthetic, although he

evidently wished to underscore the "visionary" character of the church by giving the painting the generic title *Cathedral*. The real subject of the painting is the village church in Mellingen, near Weimar, transformed in Feininger's prismatic composition into a lofty edifice. Another painting of the church from the same year is in the Von der Heydt-Museum in Wuppertal; it too bears a generic title: *Church*.[12] Feininger first visited Mellingen in 1906 and returned there in 1913 and 1920. His various depictions of the church and the old, half-timbered houses of the Thuringian village are variations of structural relationships. Their dates do not necessarily coincide with the dates of his visits, for Feininger tended to work from sketches that were often done years earlier. Three etchings of Mellingen date from 1911 and 1912, three woodcuts from 1918 and 1919.[13] And besides the versions in Wuppertal and Columbus, there are at least two earlier paintings: *The Church Tower, Mellingen (Mellingen II)*, dating from 1915, and *Mellingen V* from 1918. Feininger's numbering suggests that there may have been more. In 1922 Feininger painted *Mellingen VI*. A painting of the village from 1931 was destroyed by the artist. The village continued to haunt Feininger's imagination as late as 1949, when he turned to the subject for the last time in his New York studio.[14]                                    —HU

1. Hans Hess, *Lyonel Feininger* (New York, 1961), p. 5.
2. Ulrich Luckhardt, *Lyonel Feininger* (Munich, 1989), p. 33.
3. Ibid., p. 29.
4. Ernst Scheyer, *Lyonel Feininger: Caricature & Fantasy* (Detroit, 1964), p. 170.
5. Paul Vogt, *Expressionism: German Painting 1905–1920* (New York, 1980), p. 102.
6. Scheyer, p. 170.
7. Hess, p. 96.
8. Alfred Werner, "Lyonel Feininger and German Romanticism," *Art in America* 44 (1956): 23–27.
9. Luckhardt, p. 122, and Eberhard Ruhmer, *Lyonel Feininger: Zeichnungen, Aquarelle, Graphik* (Munich, 1961), p. 19.
10. Leona E. Prasse, *Lyonel Feininger, A Definitive Catalogue of his Graphic Work: Etchings, Lithographs, Woodcuts* (Cleveland, 1972), W144.
11. Eila Kokkinen, *Lyonel Feininger: The Ruin by the Sea* (New York, 1968).
12. Hess, no. 214.
13. Prasse, E28, E29, E51, W90, W180, W185.
14. Hess, nos. 145, 187, 225, 334, 485.

## 17. SHIP IN DISTRESS
### 1946

Watercolor on light tan paper, 9½ × 11³/₈ in. (24.2 × 28.9 cm) Signed lower left: *Feininger*. Inscribed lower center: *Ship in Distress*. Inscribed and dated lower right: *18. x. 46.*

Feininger was as fascinated by the design of paddle steamers and the complex rigging of schooners and yachts as he was by the structural lines of medieval architecture. Indeed, he found all modes of mechanization and transportation irresistible. Always a tinkerer, he once confessed that had he not become a painter, he "most likely would have become an engineer or chosen some other technical profession."[1] Growing up within walking distance of the East River, he spent many a day at the Manhattan waterfront, spellbound by the spectacle of sloops, schooners, and more modern crafts using both sail and steam. At home the boy built model yachts and set them afloat on the pond in Central Park, a lasting hobby which Feininger, even at eighty, still shared with his sons and grandson. Not surprisingly, ships were for the painter a favorite theme, especially from 1924 on, when he first visited the village of Deep, on the Pomeranian coast of the Baltic Sea. His first major paintings of the subject, *Sidewheeler I* and *Sidewheeler II*, both from 1913,[2] played an important role in the evolution of his mature style, most likely since the unique interaction of the moving ships with the transparent texture of sky and waves offered a close analogy to the prismatic pictorial structures he had begun to explore. As he subjected his sensory perceptions to a premeditated pictorial order, Feininger inevitably blended fact and imagination. Like his pictures of medieval houses and churches, his luminous paintings of ships at sea are pervaded by an air of mystery. Feininger's vessels are phantom ships seemingly headed for unknown ports.

In the mid-thirties, and especially after his return to the United States in 1937, Feininger gradually abandoned the prismatic character of his earlier work, emphasizing instead colored planes, usually in conjunction with graphic structures. *Ship in Distress* exemplifies this final stage in his development. Using a ruler, Feininger neatly drew the image of the boat in thin lines—without shading and without real perspective—and gave structural definition to the sea and sky in the same way. The view is no longer conventional in the sense that the spectator can imagine entering the composition on the level of the fore-

ground. Instead, the image appears miraculously suspended from a diaphanous net. The lines are repeatedly interrupted and thus invest the composition with a degree of transparency still reminiscent of Feininger's earlier work, an impression that is reinforced by the delicate pale blue and gray tones of the watercolor wash. The diagonal lines that circumscribe the colored field—especially pronounced at the right margin—form an essential part of the pictorial structure, providing balances and counterbalances for the slanted forms within the composition while underscoring the labile equilibrium that is an integral part of the motif.

There is a close relationship between the Sirak watercolor and two of the artist's earlier paintings in oil, *Mid-Ocean* (also known as *The Black Wave*), of 1937, and *Phantom Ship* (*The Black Wave II*), of 1942.[3] In both paintings, ships ride the crests of dark waves, though serenely, with masts set at full sail. Nineteenth-century Romantic painters often turned to this subject so as to conjure up the dread of hostile nature. In *Ship in Distress* Feininger sublimated the danger in the clear logic of his design. —HU

1. Eberhard Ruhmer, *Lyonel Feininger: Zeichnungen, Aquarelle, Graphik* (Munich, 1961), p. 20.
2. Hans Hess, *Lyonel Feininger* (New York, 1961), nos. 105, 107.
3. Ibid., nos. 385, 420.

# ALBERT GLEIZES

French, 1881–1953

*18.* TO JACQUES NAYRAL
*À Jacques Nayral*
1917

Oil on board, 29⅞ × 23⅝ in. (75.9 × 60 cm)
Inscribed, signed, and dated lower right: *à jacques nayral/AlbGleizes/17*

*To Jacques Nayral* was painted in memory of Gleizes's friend and colleague Jacques Nayral (1879–1914), a writer who was married in 1912 to Gleizes's sister Mireille. Nayral's death in action in World War I affected the artist profoundly. A member of L'Abbaye de Creteil, which he helped to found in 1906, Nayral subscribed to the group's idealistic social aims and communal efforts, embracing a late Symbolist belief in the power of art to express the complexities of the modern world. With Alexandre Mercereau, Nayral wrote about "Les Artistes de Passy,"[1] with whom Gleizes had frequent contact: among these, the Duchamp brothers, Jean Metzinger, and Frantisek Kupka. Nayral defended the Cubist movement, and as editor-in-chief of Figuiere publishers was responsible for the publication of Apollinaire's *Les Peintres Cubistes* and Gleizes and Metzinger's *Du Cubisme.*

A 1914 gouache on paper study (art market, New York) for this portrait of Nayral foreshadows the analytical character of the oil portrait. In this earlier work, the gridlike structure of lines is clearly articulated; in the final work, the emphasis shifts to the planes that form the head, changing the character of the image. The painting combines the formality of Analytic Cubism with the broader and more expressive forms of Synthetic Cubism, although it lacks the bright color associated with other Synthetic Cubist works.

Gleizes's 1917 painting offers interesting parallels to the Cubist portrait and figure paintings of 1913–1914 by Picasso and Braque. The gridlike structuring of lines and the large general shapes seen in works like Picasso's *Head of Man*, 1913 (Richard S. Zeisler Collection, New York),[2] for example, are the same basic elements that are found in the Nayral portrait. But whereas Gleizes's work is densely concentrated and static, with an emphasis on the formal harmony of shapes, Picasso's work is loose and almost capricious, relying upon the play of open and closed planes and spaces on the surface. Picasso's *Smoker* of 1914 (Musée Picasso, Paris),[3] with its richer and darker coloring, spare letter forms, and more densely packed planes, also foretells certain components of Gleizes's style, but the added elements of pattern and the references to representational objects make Picasso's portrait a more subjectively emotional piece. Braque also used a lighter and less static approach to the figure in this period. His 1913 *Woman with a Guitar* (Musée national d'Art, Paris),[4] though it is organized around a grid, nevertheless has a greater sense of action and movement in the central forms of the figure. Gleizes's memorial portrait is, appropriately, more sober and quiet than the Cubist experiments of Picasso and Braque, yet one senses in his other works as well a conscious strategy of intellectual and emotional fusion, a determination to balance expression and formal structure.

For all of its formal qualities, *To Jacques Nayral* shows the expressive possibilities of Cubism beyond the analysis of space and form, and it embodies the essential character of Gleizes's mature Cubist style, which ultimately owes little to other Cubists. It is revealing to compare this memorial portrait to Gleizes's *Portrait of Jacques Nayral* of 1911 (private collection),[5] which is not Cubist but "cubic"—a painting in which the influence of Paul Cézanne is paramount. Though it is representational, this earlier portrait lacks the intimate nature and expressive quality of the 1917 work. The earlier painting is busy and active; the later, posthumous, portrait is focused, with a carefully reasoned balance and classical harmony. —GW

1. *Paris-Journal* (October 17–30, 1911).
2. For an illustration, see William Rubin, *Picasso and Braque: Pioneering Cubism* (New York, 1989), p. 281.
3. Ibid., p. 326.
4. John Golding, *Cubism: A History and an Analysis, 1907–1914* (Cambridge, Mass., 1988), fig. 55.
5. See Daniel Robbins, *Albert Gleizes, 1881–1953* (exh. cat., Solomon R. Guggenheim Museum, New York, 1964), no. 27. See also nos. 25 and 26, which are sketches for this 1911 portrait.

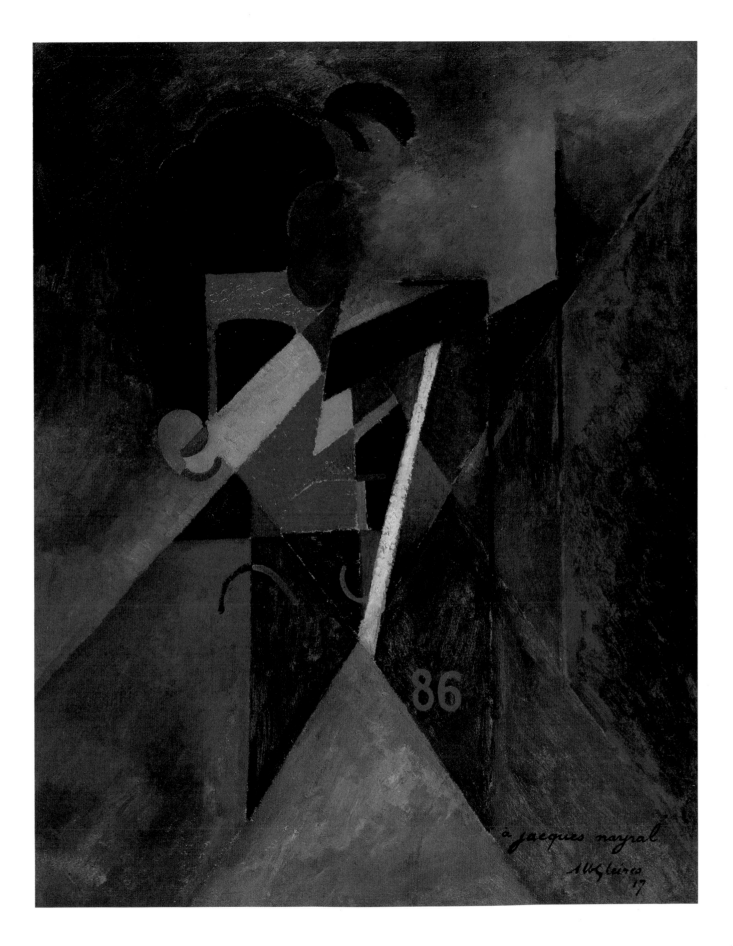

# JUAN GRIS

Spanish, 1887–1927

### 19. SHEET OF MUSIC, PIPE, AND PEN
*Musique, plume et pipe*[1]
1913

Oil and collage on canvas, 10³/₄ × 13⁵/₈ in. ( 27.3 × 35.2 cm)
Signed and dated on verso: *Juan Gris 5-13*

Juan Gris believed Cubism to be an aesthetic that is "inevitably connected with every manifestation of contemporary thought."[2] His commitment to the complexities of this "new way of representing the world"[3] led him to develop a personal form of Cubism which was at once more poetic in feeling and more rigorous in structure than that of either of his mentors, Picasso or Braque. Gris imbued each of his still lifes with a somber dignity, an almost spiritual quality—the result of his reverence for the material world. He sought to create a synthetic reality in his works that would maintain the integrity of the object and hold in equilibrium the forces generated by his predetermined geometric "architecture" and the world of appearances from which his subjects were drawn.

*Sheet of Music, Pipe, and Pen,* dating from May 1913, the year Gris emerged as an independent leader within the Cubist coterie, shares with other canvases of that time a refined coloristic and compositional subtlety. Here Gris has concentrated on systematically integrating geometric structure and recognizable objects. In this work, as in many other Cubist works, space is as solid and palpable as the objects that inhabit it. As realistic details assert their three-dimensionality within the flat geometric grid, visual tension arises, only to be countered by harmonious rhythms that reverberate throughout the composition (echoes of the pipe bowl appear in the scroll-edge below it on the right; the rectangle of the sheet music is repeated often and in various colors; the angle of the pipe stem is echoed in the pattern of diagonal blue lines). The strong vertical strips that will become the dominant compositional device of other 1913 works, such as the museum's *Playing Cards and Glass of Beer*,[4] are seen here at the right and left sides of the painting.

Although collage did not become his principal medium until 1914, by 1913 Gris had begun to explore the interplay between painting and collage as he moved toward greater visual complexity in his work. The patterned rose-colored strip at the right and two similar squares in the corners at the left are pieces of actual wallpaper. Like Picasso and Braque, who developed the collage technique in 1912, Gris was drawn to the deliberate ambiguities between art and reality suggested by collage. In particular, collage added new dimensions to his attempts to integrate subject and structure. Wallpaper—both real and representative—was already one of his favorite visual motifs by 1913, used by the artist to flatten and solidify space. In some early works the wallpaper is a trompe l'oeil element, the result of meticulous illusionistic painting. In this work, real wallpaper acts as a frame of sorts for the painted portion of the canvas. Unlike other artists, Gris attempted to conceal collage elements, asserting their abstract qualities and drawing attention to the painted fragments of identifiable still-life objects.

The power of Gris's work ultimately derives less from his formal innovations than from his ability to reconcile modern experience with the historic tradition of still life, to imbue prosaic objects with majesty and solemnity, as did Zurbarán and Chardin. Like his predecessors in the art of still life, Gris developed a repertoire of objects of personal significance and repeated them frequently in his oeuvre. But Gris aspired to more than simple symbolism. It is through the still-life objects, in what Gris called his art of synthesis, that the abstract is made concrete. By ritualizing ordinary objects, Gris sought to express them as poetic metaphors within his "imaginary reality."[5]

—NVM

1. Douglas Cooper, in the catalogue raisonné of Gris's oeuvre, titles the work *Plume et pipe*. See *Juan Gris*, 2 vols. (Paris, 1977), 1: cat. no. 41.
2. Juan Gris, "Reply to the Questionnaire: Chez Les Cubistes," *Bulletin de la vie artistique* (Paris, January 1, 1925), in Daniel-Henry Kahnweiler, *Juan Gris: His Life and Work* (New York, 1946), pp. 201–202.
3. Ibid.
4. Mark Rosenthal, *Juan Gris* (exh. cat., University Art Museum, University of California, Berkeley, 1983), p. 39, cat. no. 12.
5. Rosenthal, p. 141.

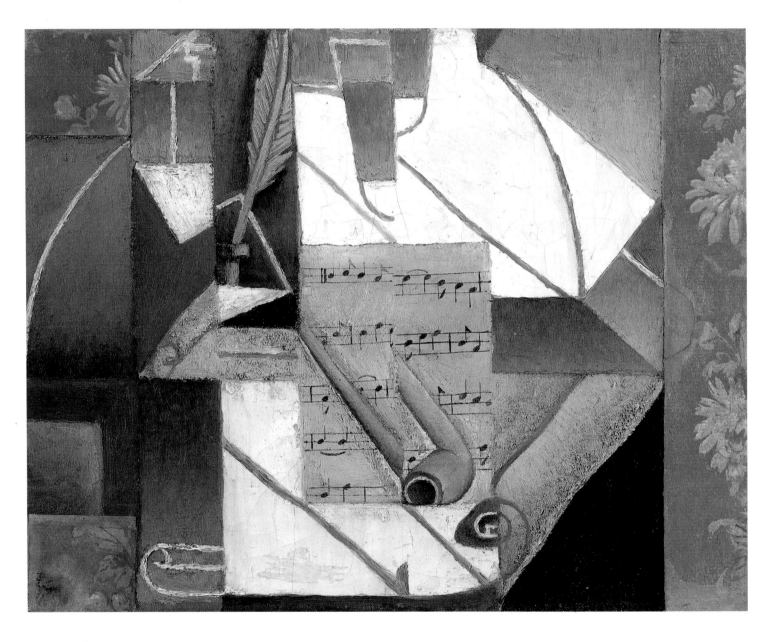

# ALEXEJ JAWLENSKY

Russian, 1864–1941

## 20. SCHOKKO WITH RED HAT

*Schokko mit Rotem Hut*[1]
1909[?] or 1910

Oil on board, 29³/₄ × 25⁷/₈ in. (74.7 × 65.7 cm)
Signed and dated lower left: *A. Jawlensky 190*[?]

Intrigued by the expressive potential of role-playing imagery, Alexej Jawlensky painted a series of exotically costumed women from 1909 to 1914. *Schokko with Red Hat*, one of the early works in this series, radiates a starkly theatrical effect reminiscent of the artist's earlier portraits of Russian dancer Alexander Sacharoff.[2] The masklike image makes the model appear artificial, yet she possesses a provocative erotic power. Precedents for the yellow-green face exist in other Jawlensky portraits, such as *Girl with Gray Apron*, 1909 (private collection, Switzerland),[3] and *Woman with Fan*, 1909 (Museum Wiesbaden).[4] Works by Gauguin and later Matisse and the Fauves were certainly prototypes for Jawlensky's exaggerated use of color in the Sirak picture. Schokko's pose resembles but does not repeat that of the model in Matisse's *Woman with Hat* of 1905 (San Francisco Museum of Modern Art), shown in the Salon d'Automne in Paris that same year.[5] Jawlensky, who also exhibited in the Salon, must have seen the Matisse painting, and although he claimed he did not understand the French painter at that point,[6] by 1909 he was incorporating similar shocking warm and cool color contrasts in his own painting.

The Sirak portrait of Schokko was probably painted in Munich during the winter of 1909–1910. Schokko was the nickname of a young model who sat for a number of costumed portraits by Jawlensky in the period 1908–1910. The nickname derived from the model's eager acceptance of a cup of chocolate (*schokolade*) when she sat for her portrait in Jawlensky's studio. She is also the subject of *Schokko*, 1910 (Leonard Hutton Galleries, New York),[7] originally painted on the opposite side of *Schokko with Red Hat*,[8] and the likely model for other paintings by the artist of young women with narrow, elongated faces, high cheekbones, and almond eyes, such as *Girl with Gray Apron*, 1909, *Girl with Peonies*, 1909 (Museum Wuppertal),[9] and *Girl with Turban*, 1910 (Leonard Hutton Galleries, New York).[10]

*Schokko with Red Hat* is an elegant image of a young woman wearing a full-brimmed red hat and holding a decorative fan that echoes the countering curve of the hat. Dramatic lighting casts the model's face in a vivid yellow-green glow, which strongly contrasts with the colors of her costume. The essential compositional elements in *Schokko with Red Hat* are strongly outlined in black paint, emphasizing in particular the model's strong facial features. The dominant red of the hat is reinforced by the red lips, the loosely brushed red scarf, and the decorative accents on the fan below. This bold use of reds contrasts directly with the thinly painted green background and the several intense greens of the model's face.

Since this painting was originally one side of a double-sided work, speculation arises as to which was painted first. *Schokko with Red Hat* reveals more descriptive detail in the articulation of facial features and pose. *Schokko* is a more assertive, strident image, in which color and form have been further intensified. Since Jawlensky tended to progress toward more forceful solutions to visual problems in his painting before 1914, *Schokko* may be the later work.[11]   —AM

1. Clemens Weiler, in *Alexej Jawlensky* (Cologne, 1959), p. 230, titles the work *Mit Rotem Hut*.
2. See Armin Zweite, ed., *Alexej Jawlensky 1864–1941* (Munich, 1983), cat. no. 53, p. 164; and Weiler, cat. no. 42, p. 229.
3. See Zweite, cat. no. 55, p. 166.
4. See Weiler, cat. no. 44, p. 229.
5. See Jack D. Flam, *Matisse, The Man and His Art 1869–1918* (Ithaca and London, 1986), pl. 132, p. 141.
6. Letter of 1918 to patron Galka Scheyer, Archives of American Art, Smithsonian Institution, Washington, D.C., roll no. 2031.
7. See Zweite, cat. no. 67, p. 176.
8. Angelica Jawlensky, the artist's granddaughter, provided information on the painting from the Alexej Jawlensky Archive, Locarno, Switzerland (correspondence with the author of December 15, 1989).
9. See Zweite, cat. no. 52, p. 163.
10. See Zweite, cat. no. 69, p. 179.
11. The Sirak picture is inscribed lower left with the year 190[?], and on the verso 1910. Clemens Weiler, p. 230, cat. nos. 56 and 57, dates both the Sirak and Hutton pictures 1910.

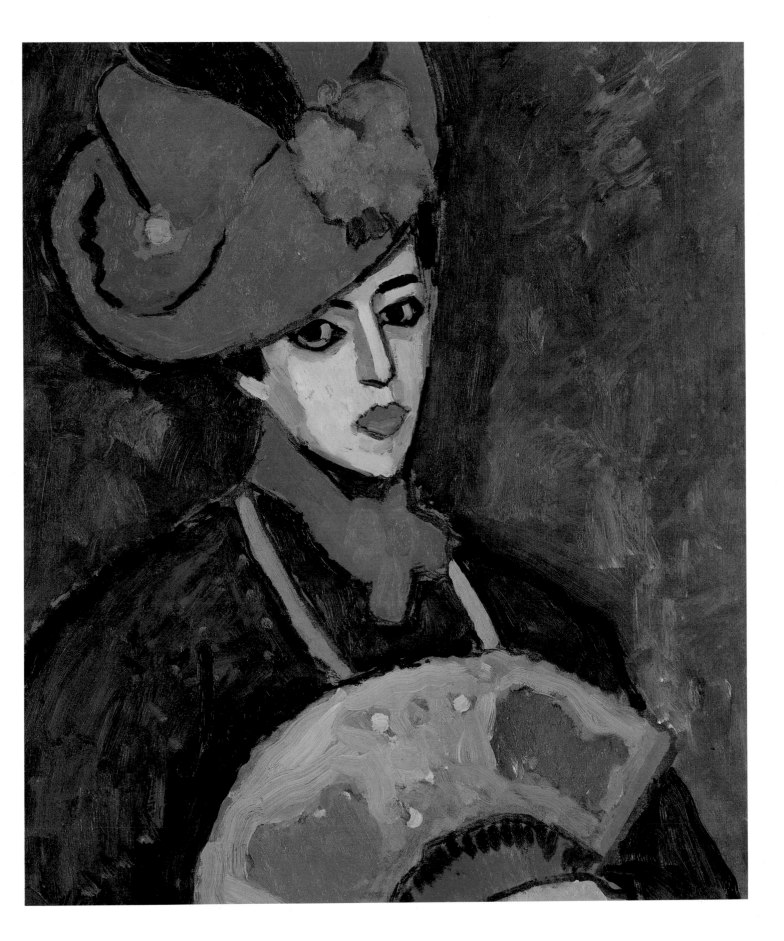

# ERNST LUDWIG KIRCHNER

German, 1880–1938

### 21. GIRL ASLEEP

*Schlafendes Mädchen*
1905–1906

Oil on board, 20³/₈ × 17¹/₈ in. (51.9 × 43.5 cm)
Signed lower right and incorrectly dated: *E.L. Kirchner
1901*. Signed lower left (scratched): *ELK*

*Girl Asleep* belongs to the earlier Dresden phase of Kirchner's art, which is characterized by a greater vibrancy of color and voluptuousness of form than are found in later works for which Kirchner is perhaps better known (see cat. nos. 22, 23). The sharp, linear style and ascetic manner that developed after his move to Berlin in 1911 contrast with the vitality of works such as *Girl Asleep*, not only in the handling of the brush but also in the choice of colors. Unlike Kirchner's later style in which he emphasized earth tones and an almost transparent application of paint, here he produced a heavily impastoed, unrestrained painted surface of electrifying color juxtapositions.

The Sirak painting dates to the first years of Die Brücke, when Kirchner's subjects showed the vestiges of a tempered Post-Impressionist influence. Here the harmonious forms and colors create an expressive arrangement of bold arabesques articulating the spiritual substance of the work. The closely woven tapestrylike pattern unifies the surface in a rigorous pictorial structure. Like Édouard Vuillard, Kirchner demonstrated a bold disregard for traditional rendering of pictorial space and chose instead a panoply of rhythmic units that animate the picture surface.

In *Girl Asleep*, the viewer observes the hermetic interior almost voyeuristically, only accidentally discovering the figure that blends so passively with the boldly depicted surroundings. The uniformly darkened treatment of the dress makes the languid presence of the girl's body only slightly apparent amidst the angled furniture and the overly decorated room. The girl is represented as a blue bulk, outlined in sharp greens, surrounded by broad strokes of vivid color, suggesting at once ornamental detail and material texture. Gradually, Kirchner turned from depersonalized models such as the anonymous girl in this picture to identifiable figures of personality and character as in *Tower Room, Fehmarn* (cat. no. 23).

The compulsion to turn the frenzied excitement of a visual experience into a controlled decorativism perhaps affirms Kirchner's absorption with Van Gogh, whose works he no doubt came to know during an exhibition in Dresden in November 1905. It is thus possible that even though the painting is signed and dated 1901 (Kirchner often predated his own work), it actually dates to circa 1905–1906.[1] In its diagonal composition and disregard for perspectival depth the work resembles *Girl under Japanese Umbrella* (Dr. Frederic Bauer, Davos),[2] and in its arbitrary and acrid color choices it recalls the famous *Fränzi in Carved Chair* (Thyssen Bornemisza Collection, Lugano),[3] both of 1905–1906. The informality with which the sitter is presented in these paintings, the odd perspective of the furniture, and the claustrophobic space of the scenes exemplify an important aspect of Kirchner's personal style. Like fellow Brücke artist Erich Heckel, who frequently used reclining nudes (oftentimes a sleeping negro woman) as subjects for metaphysical rumination, Kirchner, too, chose not the fleeting impression of the sitter nor an indulgence in decorative patterns of color, but rather, in keeping with the philosophical orientation of Die Brücke, focused on and reveled in a kind of spiritual dignity. The motif of the sleeping maiden was used only as a pretext to produce a sonorant expressivity and not simply sumptuous decor. Thus that which may seem only transient is made solemn and permanent. —MMM

1. Donald E. Gordon, *Ernst Ludwig Kirchner* (Cambridge, Mass., 1968), p. 48.
2. Illustrated in Will Grohmann, E. L. Kirchner, W. Kohlhammer, *E. L. Kirchner* (Stuttgart, 1958), p. 13.
3. Illustrated in *La Collection Thyssen-Bornemisza: Tableaux modernes* (exh. cat., Musée d' Ixelles, Brussels, 1972), pl. 43.

## 22. LANDSCAPE AT FEHMARN WITH NUDES (FIVE BATHERS AT FEHMARN)

*Fehmarnlandschaft mit Akte (Fünf Badende auf Fehmarn)*
1913

Oil on canvas, 47 7/8 × 35 3/4 in. (121.6 × 90.8 cm)
Signed lower right with monogram (indistinct). Inscribed on verso: *E. L. Kirchner*

After his permanent move from Dresden to Berlin in the autumn of 1911, Kirchner began to focus more attention on outdoor subjects, especially scenes on the Baltic island of Fehmarn, which he first visited in the summer of 1908 and to which he returned for extended visits during the summers of 1912, 1913, and 1914. *Landscape at Fehmarn with Nudes* typifies this change of subject in Kirchner's art and also illustrates a style that is markedly different from that of his Dresden paintings. The bursting color and rich brushwork of his former manner have given way to a dry and transparent handling of paint and a palette limited to low-value earth tones, mostly greens. Furthermore, his exposure to the jagged silhouettes of the Ajanta carvings and the contoured tenuity of African tribal sculpture which he saw at the Ethnological Museum in Dresden helped to define the economical treatment of form typical for most of the Brücke artists, but for Kirchner, African art offered the means of "arresting a movement in a few bold lines."[1]

Notwithstanding this drastic change in artistic handling, Kirchner's bond with Die Brücke tendencies is intensified. Inspired by the gripping naturalistic references in Friedrich Nietzsche's writings and Walt Whitman's poetry, Kirchner explored fundamental truths that are discovered in simple nature. The theme of the nude in the landscape was central for the Brücke painters in their collective pursuit of existential unity discovered in communion with nature. In Kirchner's personalized quest, the rendering becomes stark, severe, monumental, as if striving to be symbolic. His works express freedom and unabashed naturalness but also seriousness of the kind that suggests singularity of purpose, strong will, and universality. Nature and man in complete harmony, man and woman, hill and valley, sky and water, sinewy trees and stretched human forms—all combine to give a strong sense of cosmogony, harmony, and power. *Landscape at Fehmarn with Nudes*, like *Tower Room, Fehmarn* (cat. no. 23), is a search for self-identity, an attempt to offer a meaningful declaration about life—qualities that define the entire character of German Expressionism.

Through the paintings executed at Fehmarn, Kirchner devoted himself to an intensive probing of modern man and the anxieties of modern civilization, wrestling with the extremes of urban vacuity in the presence of the raw profundity of a primitive state of mind and being. Making the figures an inherent part of the environment, the artist sought to describe a kinship between art and nature. Utilizing the effects of a more primitive medium such as woodcut to bridge the two worlds, he shows us the simple euphoric condition of man in his natural state, naked and innocent, amidst the free-flowing forces of a landscape. The tawny colors, the light and dark contrasts, along with the attenuated treatment of the figures and forms in nature undoubtedly derive from a careful study of graphic techniques. Not by chance does the evocation of the graphic medium relate to the resuscitation of the spirit of Gothic medievalism and a large-scale revival of German art.

Unlike Kirchner's subsequent paintings, which are filled with the melancholy of the big city that dehumanizes its inhabitants, here the flesh remains flesh in texture and color. The free and uninhibited relationship between the sexes in *Landscape at Fehmarn with Nudes* contrasts greatly with the tormented divisiveness between the male and female worlds of Kirchner's Berlin street scenes, in which the artist's fashionably dressed people are depicted in a style that is caustic, ravaging, and electrifying (see *The Street*, ca. 1913, Museum of Modern Art, New York).[2] For the artist, the Fehmarn paintings offered a release from the psychic pressures of big-city life. Very much a key part of the subjects and style of fellow Brücke artists Karl Schmidt-Rottluff and Max Pechstein, pastoral pleasures disassociated from guilt or accountability, along with a sense of communal reciprocation with nature, preceded the tumult of the coming war and the ensuing cynicism toward mankind that was to engulf Kirchner after 1914.

—MMM

1. Letter from Ernst L. Kirchner to Curt Valentin (April 17, 1937), translated and quoted in *Ernst Ludwig Kirchner* (exh. cat., Curt Valentin Gallery, New York, 1952), p. 11.
2. See Will Grohmann, E. L. Kirchner, W. Kohlhammer, *E. L. Kirchner* (Stuttgart, 1958), p. 93.

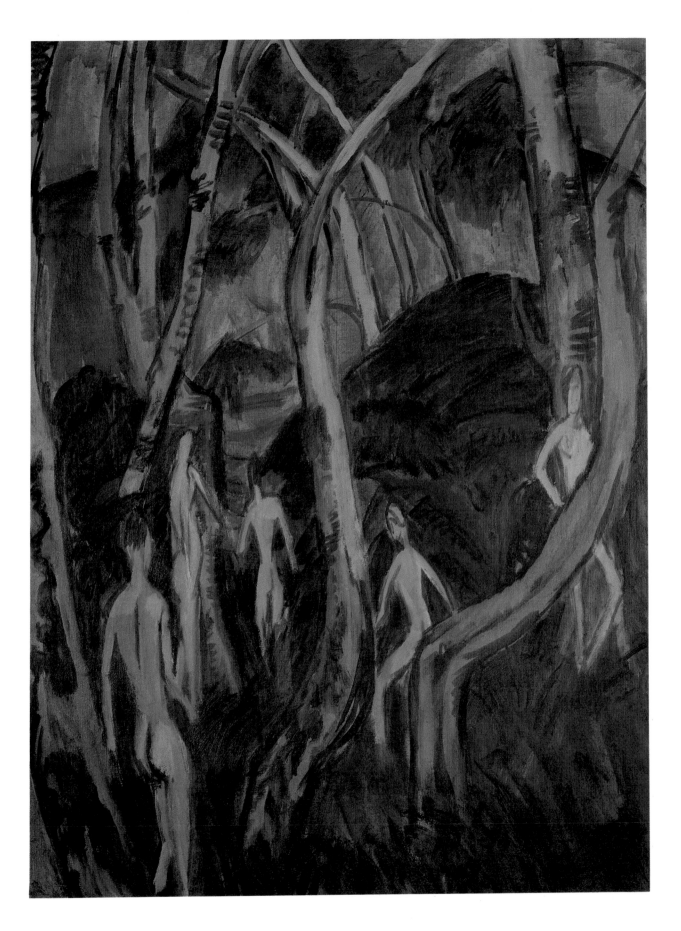

23. TOWER ROOM, FEHMARN
(SELF-PORTRAIT WITH ERNA)

*Turmzimmer, Fehmarn (Selbstbildnis mit Erna)*
1913

Oil on canvas, 36 × 32¼ in. (91.4 × 81.9 cm)
Signed lower right: *E.L. Kirchner*. Signed, dated, and
inscribed on verso: *E.L. Kirchner/1913/Turmzimmer*

In 1911 Kirchner met Erna Schilling, who would later become his model and lifetime companion. This double portrait of the artist and his model was painted during the summer they spent on the Baltic Sea island of Fehmarn—a setting which allowed Kirchner to distance himself from middle-class urban living in order to delve deeply into elements of the universal human condition. Kirchner's Fehmarn paintings document the artist's longing to express his love of humanity, and they are the fulfillment of his compulsion to get nearer to a more primitive state of mind and feeling.

The ramshackle effect of the tower room calls forth the acute angles of the woodcut medium, and equally "medieval" is the deeply recessive perspective created by turning nascent and implied orthogonals into a flattened pattern. The arrangement of the composition recalls the tilted shapes of Northern Renaissance art, as, for example, in the *Mérode Altarpiece*, of circa 1425–1428 (Metropolitan Museum of Art, New York),[1] which, like *Tower Room, Fehmarn*, also includes a lit candle that does not produce light. The idea of the tower as a setting for the scene further underscores the evocation of Northern medievalism, but the tower also relates the work specifically to other landmarks on Fehmarn identified in paintings of the previous year by Kirchner (for example, *Staberhuk Beacon, Fehmarn*, 1912 [Museum of Art, Carnegie Institute, Pittsburgh]; *Bather between Rocks*, ca. 1912, [Frau Irene Eucken, Jena]; and *Striding into the Sea*, ca. 1912 [Staatsgalerie Stuttgart]).[2]

The perspective of the table and furniture, moreover, and Kirchner's rapid hatchmark brushwork relate to a common practice of the Brücke artists to train their eye and hand by drawing and recording the model in rapidly changing poses. Hence, the energy and vitality in this scene that seems to cave in toward the center is the result of an acquired hieroglyphic style in which the zigzags of the composition, and the deep and incisive Vs of the edges of the table, chair, bowl, and body of the model presage the shardlike

fragmentation of the forms in Kirchner's paintings of Berlin prostitutes executed during 1913–1915.[3]

Some would impose eroticism, sexual desire, and male domination on the reading of this work,[4] and yet the work seems to transcend such banal interpretations, and, whether true or not, rather presents the more existential theme of two distinct beings brought together by fate—initially by mutual physical attraction but ultimately by a high regard for each other. Such a theme reinforces the pervasively philosophical nature of Kirchner's work. Kirchner himself stated that his focus on male-female relationships is a subject that "implies a pure intercourse with nature and a notable comradeship in full equality gained through struggle and understanding."[5] Indeed, the flesh and mauve tones utilized by Kirchner in *Tower Room, Fehmarn* create a sensuality that is at once evocative and sobering within the cosmic blue space. Furthermore, the chair, which cordons off the nude, serves as a *repoussoir* effect that leads the viewer past the personal relationship between the two figures into the landscape beyond, where the wispy sailboat and mountain in the atmospheric distance offer an escape into philosophical contemplation.　—MMM

1. See Mojmir S. Frinta, *The Genius of Robert Campin* (The Hague, 1966), figs. 11–13.
2. Donald E. Gordon, *Ernst Ludwig Kirchner: A Retrospective Exhibition* (Greenwich, Conn., n.d.), pp. 62–63, 65, figs. 30–32.
3. See *Rote Kokotte*, 1914 (Staatsgalerie Stuttgart), reproduced in Will Grohmann, E. L. Kirchner, W. Kohlhammer, *E.L. Kirchner* (Stuttgart, 1958), p. 44.
4. See Carol Duncan, "Virility and Domination in Early 20th-Century Vanguard Painting," *Artforum* 12 (December 1973), p. 33.
5. Quoted in Wolf-Dieter Dube, *Expressionists and Expressionism* (Geneva, 1983), p. 20.

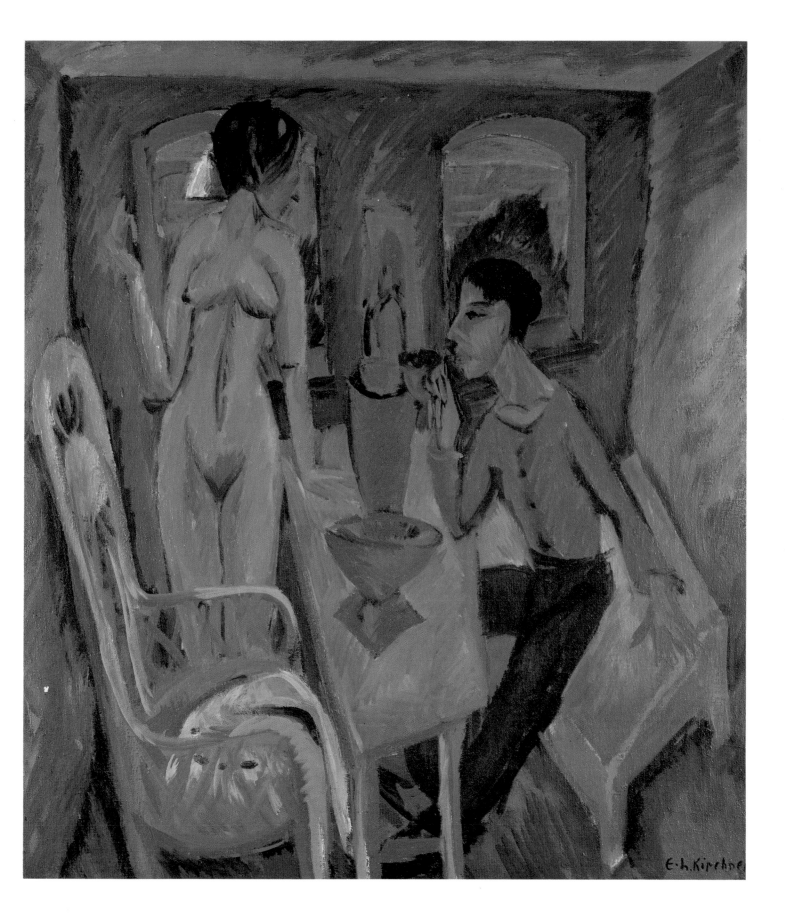

# PAUL KLEE

Swiss, 1879–1940

*24.* VIEW OF SAINT GERMAIN
*Ansicht von Saint Germain*
1914

Watercolor on tan paper, laid down, 9 × 11⅛ in.
(23 × 28.4 cm)
Signed upper left: *Klee.* Dated and inscribed at bottom:
*1914.41.Ansicht v. St. Germain*

Generations of European artists recorded the exoticism of North Africa in their journals and in their works, expressing remarkably similar avowals of permanent aesthetic transformations. Delacroix and Matisse, for example, portrayed the light, color, landscape, architecture, and ornament of the region long after they had returned from their travels. Among the best documented of artists' pilgrimages to North Africa is Paul Klee's journey to Tunisia in April 1914. Klee's almost rhapsodic diary passages describe the eccentric gardens of "green-yellow-terracotta" with "birds singing in the hedges," the pungent aromas of the markets, and the melancholy "off-pitch" music.[1] Indeed, his narrative takes on the character of a heroic quest culminating in his triumphant—often quoted—declaration, "Color and I are one. I am a painter."[2]

*View of Saint Germain,* a milestone in Klee's grasp of color usage, faithfully captures the hues of this coastal suburb of Tunis in the swelter of late morning.[3] The yellowish sandy soil, the dusty olive of the sparse vegetation, the pink cast of the plaster houses, the cobalt of the water pools, the red-orange of the terracotta roofs, and the modulation of the sky from aqua to sapphire are all scrupulous pictorial equivalents of the effect of intense sunlight on the colors of a landscape view. Gratified by the results of *View of Saint Germain,* Klee wrote that during the process of its creation he had "encountered Africa for the first time. The heat overhead probably helped."[4]

Klee had been prepared for the Tunisian revelation of color in part by his assimilation of the geometric color constructions of Robert Delaunay, whom he met in Paris in 1912 and whose essay on light he translated into German for the periodical *Der Sturm* in 1913. Delaunay had introduced a broad color spectrum into the rigidly monochromatic structure of the

Cubism of Picasso and Braque. This fusion of abstract color and form had a strong impact on Klee's own developing expression. Desert colors shimmer and play in the harsh light and heat of North Africa, where Klee found validation of Delaunay's statement, "Light in Nature creates the movement of colors."[5] The power of his direct encounter no doubt inspired him to reconstruct the environs of Saint Germain in terms of Delaunay's rhythmic juxtaposition of color planes.

In the foreground of the Sirak watercolor, broad irregular squares of green, ocher, and pink converge, producing a pale light. In the middle ground, the light flickers and deepens as the colors of the foreground, accented by red, are repeated in various tonalities in smaller, often overlapping patches representing walls, roofs, fences, and garden plots. In the background, mountains and sky are expressed by means of large triangular shapes in the hazy purples and blues of a distant horizon. As in Delaunay's works of the same period, space is ambiguous, oscillating between the atmospheric quality of washes and transparent planes and an assertion of the picture plane established by an overall pattern of colored shapes.

The concentration of representational planar elements and abstract signs in the center of the picture, surrounded by more spare zones of quadrilaterals and triangles, recalls the centralized composition of Analytic Cubism.[6] The works of Picasso and Braque from around 1911–1914 in which largely open space circumscribes a fragmented and schematic central motif were certainly available to Klee during his visits to Paris in 1911 and 1912. However, Klee's application of Cubist picturemaking depended on the direct experience of the matrices of native architecture clustered against barren expanses of North African desert.

While *View of Saint Germain* deftly consolidates various strains of French Cubism, it does so in terms of Klee's highly personal vision. This watercolor contains the seeds of much of the artist's future development. Klee internalized the colors and structure of North Africa, and, after returning from his journey, painted landscapes of the place from memory. Works such as *Carpet of Memory* (1914, Kunstmuseum Bern)[7]

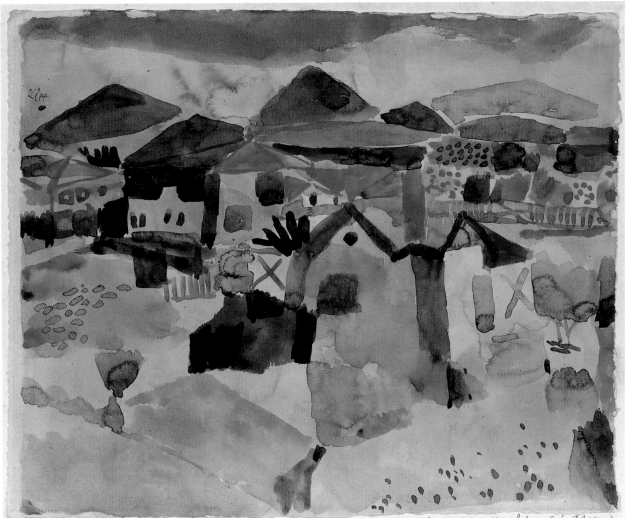

and *Southern Gardens* (1919, private collection, Paris)[8] are Tunisian otherworlds drawn from the less three-dimensional, more chimerical world of remembrance. Even Klee's wholly abstract compositions of the Bauhaus years, the Magic Square paintings, are descendants of his nascent steps toward pictorial construction with colored planes in *View of Saint Germain*. The X-marks, which in this watercolor represent architectural ornamentation and a gate in the fence, evolve in the late works into hermetic, non-referential glyphs.

As the picture of his initial encounter with Africa's essence and the bearer of future pictorial directions and motifs, *View of Saint Germain* is a pivotal work in Klee's oeuvre. Its creation in the context of the Tunisian journey has assumed almost mythical proportions, not unlike the creation of *Les Demoiselles d'Avignon* following Picasso's discoveries amongst

the African sculpture in the Trocadero Museum. An important difference, however, lies at the core of Klee's creative method: for Klee, a personal experience of the forces of nature was necessary before pictorial expression was possible.    —KK

1. Paul Klee, *The Diaries of Paul Klee, 1898–1918*, ed. Felix Klee (Berkeley, Los Angeles, London, 1964), pp. 283–323, nos. 926–965.
2. Ibid., p. 297, no. 926o.
3. Ibid., p. 290, no. 926i.
4. Ibid.
5. Robert Delaunay, "Light," in Herschel B. Chipp, *Theories of Modern Art* (Berkeley, 1968), p. 319.
6. See Jim Jordan, *Paul Klee and Cubism* (Princeton, 1984), pp. 125–128, for a discussion of Analytic Cubism and *View of Saint Germain*.
7. Illustrated in Jordan, pl. 3 (color).
8. Illustrated in Alain Bonfand, *Paul Klee, L'Oeil en Trop*, 2 vols. (Paris, 1988), 2: pl. 9.

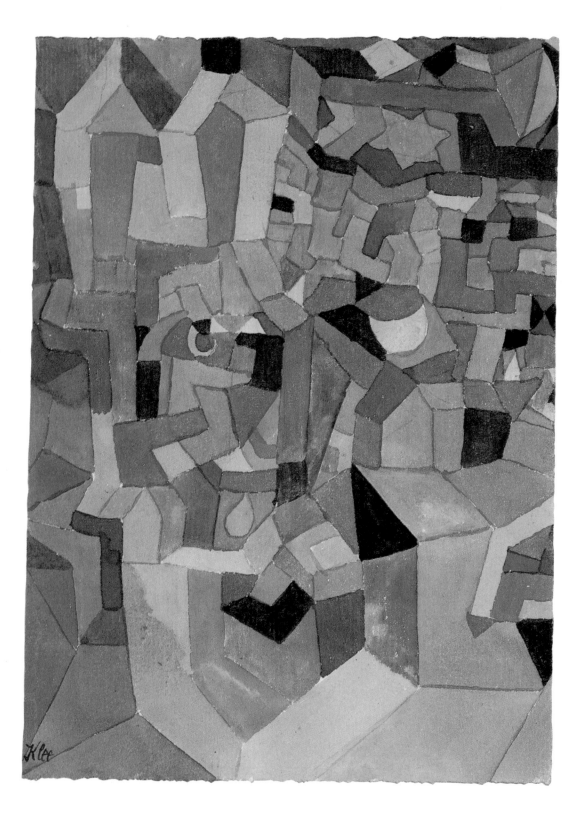

## 25. WITH THE YELLOW HALF-MOON AND BLUE STAR

*Mit dem gelben Halbmond und blauen Stern*
1917

Watercolor on paper, laid down, 7⁵⁄₈ × 5⁵⁄₈ in.
(19.5 × 14.3 cm)
Signed lower left: *Klee*. Dated and inscribed at bottom:
*1917/51*. Inscribed lower right corner: *A.K.18*.

On March 11, 1916, infantry reservist Klee reported to District Command Barracks in Munich. Judging from his diary entries, his often amusing record of the life of a lowly recruit was somehow beneficial to artistic contemplation. While endlessly circling the ammunition storehouses on guard one night, Klee reflected upon the source of his inspiration, and subsequently wrote, "I place myself at a remote starting point of creation, whence I state a priori a formula for [the artistic representation of] men, beasts, plants, stones, and the elements, and for all the whirling forces."[1]

By early 1917 he was producing works in a new style that resulted in the first real critical and financial success of his career and which present visually what he would develop discursively in his pedagogical notes of the Bauhaus years. This new direction still comprised certain Cubist qualities that are particularly apparent in the Tunisian watercolors of 1914–1915, such as ambiguous spatial relationships and centralized composition, but it abandons Cubism's prototypical tonal modulations and overlapping planes in favor of distinct, luminous planes of color. In the innovative works of 1917, Klee very nearly forsakes the recognizable motif, thus substantially exceeding Cubist abstraction. In fact, as Klee expounded his pictorial thinking during the Bauhaus years, the difference between his and Cubism's approaches to abstraction—despite the visual resemblance—becomes apparent. For Klee, abstraction is not dissection and analysis of a subject, as it is for the Cubists, but a rendering of the subject's germination. Klee likened the genesis of form to the process of crystallization,[2] whereby a mineral such as quartz develops progressively and geometrically. Years before he systematized his aesthetics at the Bauhaus, Klee referred to the "crystalline" nature of his creation in much more poetic terms in his diaries.[3]

The Sirak watercolor, with its centered cluster of faceted planes surrounded by larger facets, and its prismatic color range of yellow, green, blue, and violet,

seems to sparkle like a crystal. Elements such as the star and crescent moon on the right and the raindrop form in the center suggest a landscape, but the work is basically nonrepresentational. Klee's interest in color brought about by the experience of Tunisia remains a preoccupation, but what was enthrallment in 1914 is more methodical in 1917: the color theories Klee formulated while a professor at the Bauhaus are foreshadowed in this and other works of the late teens. Klee developed the "spectral color circle" after he observed that on the standard linear color spectrum violet occurs at the beginning as red violet and at the end as blue violet. He suggested that the two violet ends be joined.[4] On the circle that results, violet and yellow are complementaries, and blue and green fall between. In the Sirak work, Klee explores the pictorial tensions created by these complementary colors and their intervening hues.

*With the Yellow Half-moon and Blue Star* was once part of a larger composition. Klee cut the picture in half,[5] a device he used in more than two hundred works.[6]

—KK

1. Paul Klee, *The Diaries of Paul Klee, 1898–1918*, ed. Felix Klee (Berkeley, Los Angeles, and London, 1964), p. 345, no. 1008.
2. Klee's theoretical system relating to abstraction and many other aspects of his aesthetics is outlined in his notes for his Bauhaus lectures. These notes have been published in part by Jürg Spiller in a two-volume work entitled *The Notebooks of Paul Klee*, vol. 1: *The Thinking Eye*, trans. Ralph Manheim et al. (London, New York, 1961); vol. 2: *The Nature of Nature*, trans. Heinz Norden (London, New York, 1973).
3. In his *Diaries*, nos. 945–958, Klee uses the analogy of the crystal to describe the purity of formation at the point of creation. He sometimes uses the word to imply a certain remoteness in his character, but even in this sense "crystalline" relates to abstraction as an adjective for detachment and emotionlessness. In a very telling entry that reads as an indictment of the kind of abstraction which dissects rather than fosters form, Klee writes of "broken fragments" which "provide abstraction with its material. A junkyard of unauthentic elements for the creation of impure crystals" (no. 951).
4. *The Thinking Eye*, p. 469.
5. The other part of this work is illustrated in Leopold Zahn, *Paul Klee: Leben, Werk, Geist* (Potsdam, 1920), p. 56.
6. For a discussion of this technique, see Wolfgang Kersten and Osamu Okuda, "Die inszenierte Einheit zerstuckelter Bilder," in *Paul Klee: Das Schaffen im Todesjahr* (exh. cat., Kunstmuseum Bern, 1990), pp. 101–109.

## 26. CITY BETWEEN REALMS

*Stadt im Zwischenreich*
1921

Transfer print with black ink and watercolor on paper, laid
down, 12¼ × 18⅞ in. (31.3 × 48 cm)
Signed lower left: *Klee*. Dated and inscribed at bottom:
*1921/25 Stadt im Zwischenreich*

In November 1920 Paul Klee was invited to join the faculty of the Bauhaus in Weimar. He assumed his post as Master of Forms there the following January, embarking on a decade of rewarding teaching, fruitful theorizing, and prolific art-making. Above all, this was a time of daring experimentation, especially in matters of technique. A fervor for discovering the most expressive union of form, subject, and medium led Klee to explore a range of unusual painting surfaces, such as chalk- or stucco-grounded linen, muslin, shirting, and pasteboard. In addition, he routinely applied his unorthodox fusions of oil, tempera, pastel, and watercolor, often abrading dried oil paint with pumice, varnishing pastels, or even spray-painting. Klee's diverse technical experiments led his biographer Will Grohmann to comment that his studio "looked like a chemist's shop."[1]

*City between Realms* reflects one of Klee's methodological innovations: a technique he called "oil transfer."[2] Briefly, the oil transfer technique involved sandwiching paper covered with black oil between a sheet of paper with a drawing on it and a blank sheet. The drawing would then be traced with a stylus and thus reproduced on the blank sheet in velvety, blurred lines of black. Chance blotches of oil paint from the pressure of Klee's hand as he traced added to the hazy effects of the transferred drawing. Klee would next apply layers of watercolor washes. The resulting medium of the composition defies classification: part engraving, part drawing, and part painting, it belongs to a realm of technical cross-breeding, a locale to which Klee makes reference in the title of this work. Klee developed his oil transfer method around 1919, and the disciplined atmosphere of praxis that was a Bauhaus hallmark encouraged him to refine the technique in more than 240 works by 1925.

Besides alluding to the picture's mixture of technique, the word *zwischenreich* in the German title (literally, "between realms") may refer to the depicted town's location between two points, as indicated by the arrow pointing downward on the left and the one

pointing upward above the airplane on the right. Yet this is also a term Klee concocted to suit his need to characterize the source of his creativity, which he designated as a world existing between, yet also merging with, some of the qualities of polar opposites. In an interview conducted by his Bauhaus colleague Lothar Schreyer, Klee discussed this creative wellspring as a realm of possibilities where such opposites as the visible and invisible, the imaginary and the real, and the unborn and the dead intermingled: "An in-between world. I call it that because I feel that it exists between the worlds our senses can perceive, and I absorb it inwardly to the extent that I can project it outwardly in symbolic correspondences."[3] Considered in this context, *City between Realms* depicts a symbolic metropolis that exists outside of the real world but parallel to it. Klee's internalized images express not the *forms* of nature but the *forces* of nature. As Klee himself said, "Art does not render the visible, it makes visible."[4]

—KK

1. Will Grohmann, *Paul Klee* (New York, 1954), p. 161.
2. For a discussion of Klee's development of the oil transfer technique, see Sabine Rewald, *Paul Klee: The Berggruen Klee Collection in The Metropolitan Museum of Art* (New York, 1988), pp. 95–97.
3. See Lothar Schreyer, *Erinnerungen an Sturm und Bauhaus* (Munich, 1956), p. 171.
4. From Klee's essay "Creative Credo" in 1920; see Jürg Spiller, *The Notebooks of Paul Klee*, vol. 1: *The Thinking Eye*, trans. Ralph Manheim et al. (London, New York, 1961), p. 79.

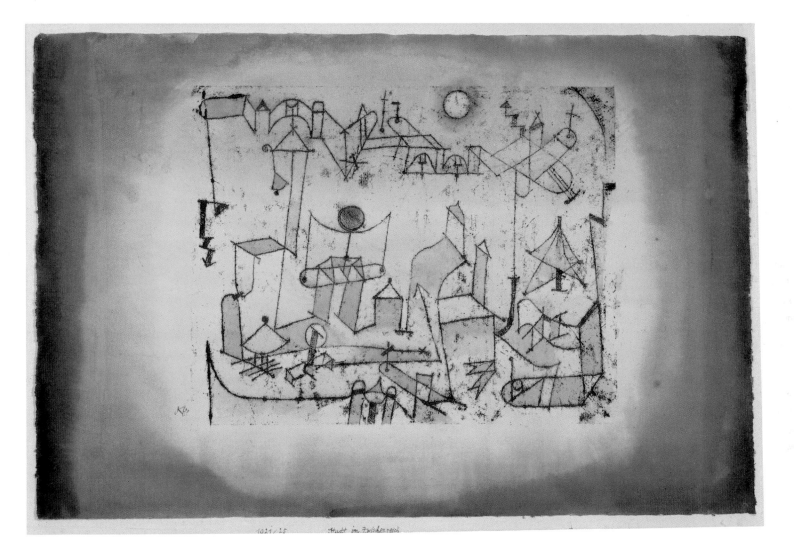

## 27. DREAM OF A FIGHT
*Traum von einem Kampf*
1924

Graphite on light tan paper, laid down, 11 1/8 × 8 7/8 in.
(28.2 × 22.6 cm)
Signed, dated, and inscribed lower left: *Klee/1924 4/12.*
Dated and inscribed on mount, bottom center: *1924 84*
*Traum von einem Kampf*

Drawing was one of Paul Klee's greatest strengths. Even works from his childhood reveal an unusual mastery of draftsmanship. The series of etchings known as "Inventions," which he executed from 1903 to 1905, emphatically secured his reputation as a skilled graphic artist. At the end of his life, Klee wrote in his Oeuvrekatalog (the record of his body of works itemized according to a classification system he developed), "never a day without line."[1] From 1911 he concentrated on developing his sense of color and planarity under the influence of Cubism, and between 1914 and 1916, he developed a very personal Cubist vocabulary in a series of exquisite watercolors. The philosophical and experimental atmosphere of the Bauhaus, where Klee taught from 1920 to 1931, encouraged him to combine his seasoned command of line and his newfound expertise in color and form. He began to produce pictures that explored his theories of the complex interrelationship between line, plane, tonal value, and color.

*Dream of a Fight* exemplifies one of Klee's notions of the "physical-spatial tension processes," which he outlined in his notes for teaching the properties of linear figuration.[2] The process involves smudging tiny hatch marks around the lines of the drawing which gives the images an effect of three-dimensionality comparable to the amplitude Renaissance painters achieved through sfumato. The fine mist of tiny lines surrounding the contours of the dreamer and dream objects in *Dream of a Fight* and many other works from 1924 to 1926 could even be considered as diagrams of sfumato, exemplary of the Bauhaus affinity for schematizing formal analyses of technical conventions.

In the drawing from the Sirak Collection, a figure in the lower half of the composition is dreaming the dream illustrated in the upper portion. The combative nature of the dream is implied in the title and is depicted not in the "dream cloud" overhead but rather in the writhing, fragmented figure of the dreamer.

Perhaps Klee is attempting to show the origins of the dream's imagery in the depths of the psyche. In 1924, when Klee created this pencil drawing, the Surrealist poet André Breton published "Manifesto of Surrealism,"[3] which discusses the visual potential of Freud's ideas regarding the manifestation of the unconscious in dream imagery. Despite the compelling coincidence of dream aesthetics in this 1924 drawing and in Breton's treatise of the same year, Klee might not have been referring to Freudian theory in his drawing. His own deliberations about the nature of dream, fantasy, and memory as aspects of the mind's unconscious mechanisms date from his earliest diary entries. For example, in the first part of his *Diaries*, which comprises his recollections of childhood, Klee describes his imagination's "bent for the bizarre" in its ability to pick out human grotesqueries among the traceries of lines in the marble tabletops of his uncle's restaurant.[4] In another entry he describes a dream in terms that recall Freudian (and Surrealist) association: "Dream: I find my house: empty, the wine drunk, the river diverted, my naked one stolen, the epitaph erased. White on white."[5]

The illustration, moreover, may be seen as a memory image of the horrors of World War I. Klee's memories of war were as enduring and forceful as his Tunisian experience and shaped his art until the end of his life. The figure could be a former soldier, broken up by war injuries, his cane cast down at his side on the right, recollecting the battle in which he was injured. Whatever its meaning to Klee, the fragmented human body remained a potent image for him from this point on, recurring as one of the principal images of his late work.

—KK

1. Will Grohmann, *Paul Klee, Handzeichnungen*, vol. 3: *1937–1940* (Bern, 1979), p. 25.
2. Jürg Spiller, *The Notebooks of Paul Klee*, vol. 2: *The Nature of Nature*, trans. Heinz Norden (London, New York, 1973), p. 257.
3. André Breton, "Manifesto of Surrealism" (1924), in *Manifestos of Surrealism* (Ann Arbor, Mich., 1972), pp. 3–47.
4. Paul Klee, *The Diaries of Paul Klee*, ed. Felix Klee (Berkeley, Los Angeles, London, 1964), no. 27.
5. Ibid., no. 946.

*28.* THOUGHTFUL
*Nachdenksam über Lagen*
1928

Watercolor and graphite on cream paper, laid down,
15⁹/₁₆ × 8⁷/₈ in. (39.6 × 22.5 cm)
Inscribed and dated lower right: *Nachdenksam über
Lagen 1927* [badly faded]. Dated and inscribed lower
left: *1928 9n9*

In December 1924, increasing hostility to the Bauhaus's progressive ideals and curriculum within the traditional art establishment and conservative community of Weimar forced the school to close and move to Dessau, where it reopened in April 1925. Klee liked his new quarters in Dessau, but political harassment continued to plague the school, and now there was also growing internal strife. Klee felt disheartened and creatively thwarted. Many of his writings and works from this time until he joined the faculty of the Düsseldorf Academy of Fine Arts in 1931 indicate a certain frustration with the theoretical postulations and technical form experiments of his Bauhaus career. In *The Limits of the Intellect* (Bayerische Staatsgemälde Collections, Munich),[1] painted in 1927, Klee constructed a complex tower which stops just short of the sun, thus leading nowhere. Regarding the final disruptive years at the Bauhaus, Klee complained to his biographer, Will Grohmann, that he was "losing the greater part of these precious years of productivity."[2]

The watercolor *Thoughtful* reflects the pessimism of that tumultuous period in the artist's life. Although highly abstract, the subject—a figure with an oval-shaped head, widely-spaced round eyes, aquiline nose, and small mouth—somewhat resembles Klee. The colored stripes banding the forehead give the figure an anxious expression. Klee's title for this watercolor, *Nachdenksam über Lagen*, hints at the source of his agitation. The German can be translated as "pondering over situations" as well as "pondering over layers." By superimposing his fretful likeness over a background of layered stripes, Klee wittily combined the two meanings of *lagen* while expressing his doubts about situations at the Bauhaus and his concern for public acceptance of experimentation in art.

The stripes, or layers, in the watercolor represent not only the objects of the figure's musing but also processes of reflection. The layers vary in width, and their graduated tonal values create a sense of movement, suggesting a rippling development of thought in the layers of consciousness. Klee made this connection between the layers of the watercolor and the figure's mind by emphasizing the stripes in the area of the figure's brain and positioning this area against a dark background. The outcome of the artist's "pondering over layers" would be to maintain his formalism yet place it at the service of greater expressive content. Certainly the mystical effects of the colored stripes in his Egyptian pictures of the early 1930s demonstrate that the formal lessons of the Bauhaus were not abandoned but evocatively adapted instead.

*Thoughtful* is an example of one of Klee's most common subjects, the masklike face. Though he rendered few actual portraits, he showed an abiding interest throughout his career in capturing physiognomic traits in a recurring theme of heads and faces. Actors' masks, the ceremonial masks of primitive art, and the "masks" of insanity attracted Klee as subjects more than the normal human likeness, perhaps because of their potential for a wider range of expression in terms of deception, contortion, and grotesquerie. Klee was well acquainted with African, Oceanic, and American Indian art dating at least from his association with the Blaue Reiter group. Although it is problematic to link Klee's motifs to any source but his own primal realm of creativity, certain similarities may be seen between the head in *Thoughtful* and African Luba masks, especially in the mouth formed by the triple bands.[3]            —KK

1. Illustrated in Christian Geelhaar, *Paul Klee: His Life and Work,* trans. W. Walter Jeffe (Woodbury, New York, 1982), p. 58, fig. 52.
2. Will Grohmann, *Paul Klee* (New York, 1954), p. 79.
3. For a discussion of Klee's sources in primitive art, see Jean Laude, "Paul Klee," in *Primitivism in 20th Century Art* (exh. cat., Museum of Modern Art, New York, 1984), pp. 487–501.

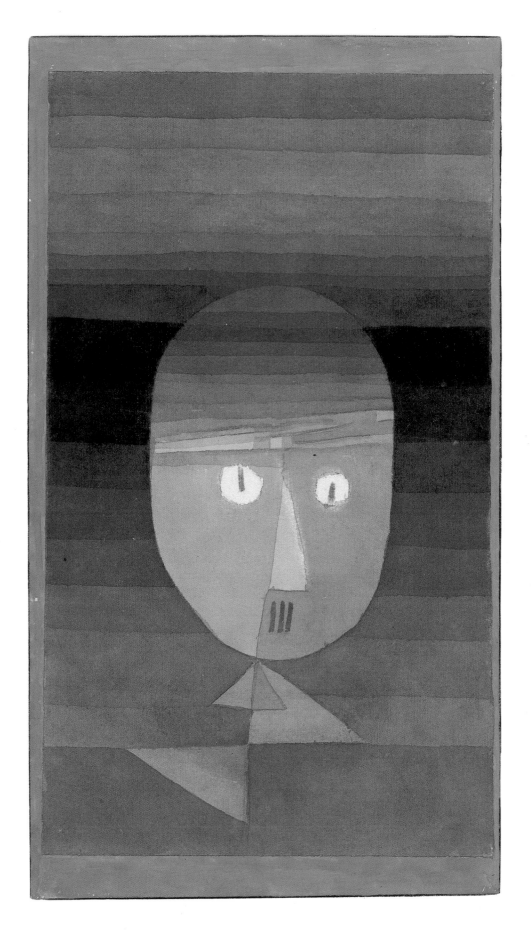

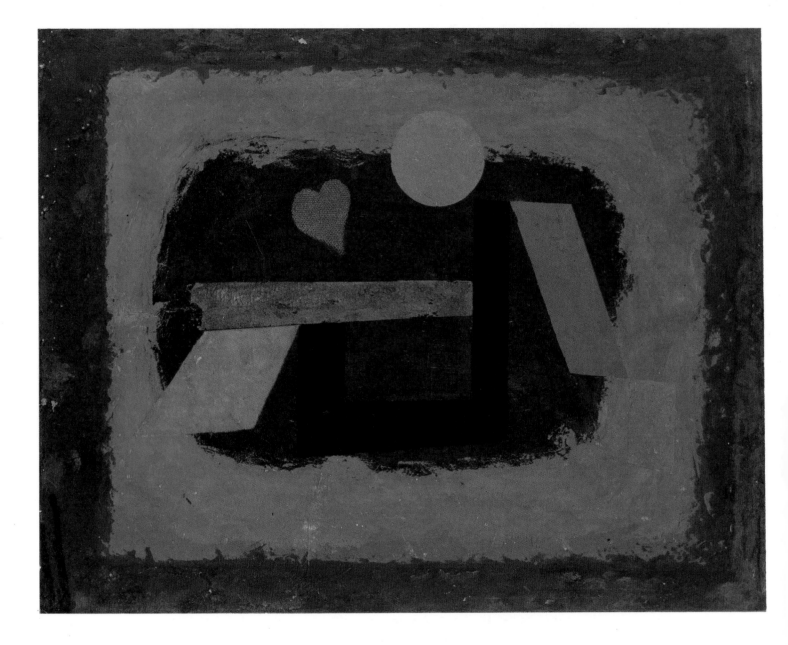

## 29. COMPOSITION
1931

Encaustic on board, 21½ × 27⅜ in. (54.6 × 69.3 cm)

*Composition* (originally the verso of *Still Life with Dove*, cat. no. 30, also an encaustic) is more akin to Klee's post-Bauhaus drawings, in which he gave freer reign to abstraction, than it is to other paintings of this period by the artist. In various degrees Klee's work always borders on abstraction; *Composition* is a rare example of his ventures toward pure abstraction.

Here a balanced arrangement of forms floats against an indefinable ground, suggesting enigmatic bodies drifting in infinite space. The heart, which appears in the upper left quadrant of this work, with its implications of a human presence, is the one motif that would deliver this composition from the realm of absolute abstraction. A sign of the primordial point, as in "the heart of creation," which Klee continually strove to discover in his art, the heart was a potent symbol for the artist, one that recurs throughout his oeuvre. Yet he also appreciated the heart shape as an abstract figuration, describing it in his pedagogical notes as a "mediating form between circle and rectangle."[1] In these terms, then, the heart is not a divergence from the otherwise strict geometry of *Composition*, for its place among the green circle and various rectangles and parallelograms could very well allude to its perceived role as mediator. In addition, Klee regarded the heart's capacity to activate the body's entire circulatory system as the "epitome of moving activity."[2] Perhaps the heart's involuntary force is represented in *Composition*, as the image floats, unrestricted by contact with other forms, apparently launched forward by some propellent action of its own.

Human element, symbolic nucleus of creation, mediator of abstraction, and originator of motion, the manifold symbolism of the heart is similar to that of the arrow in this painting's verso, *Still Life with Dove*. The strategy of endowing a single sign with multiple meanings imparts a liveliness to *Composition* and unequivocally situates the work solidly within the parameters of Klee's style. —KK

1. Jürg Spiller, *The Notebooks of Paul Klee*, vol. 2: *The Nature of Nature*, trans. Heinz Norden (London, New York, 1973), p. 106.
2. Ibid., p. 103.

## 30. STILL LIFE WITH DOVE

*Stilleben mit der Taube*
1931

Oil and encaustic on board, 22¼ × 28¼ in. (56.4 × 71.8 cm)
Signed lower left: *Klee*

A summation of much of Klee's work up to 1931 and a harbinger of what was to come, *Still Life with Dove* was executed during the artist's tenure as professor at the Düsseldorf Academy of Fine Arts from 1931–1933. Like other compositions of the period, this consists of overlapping, transparent planes. Discernible images such as a fruit compote, a letter, and a mortar and pestle on a table recall the artist's Cubist still lifes from about 1915 to 1920. This assembly of conventional still-life objects is confounded by the inclusion of a dead dove that lies head down in a vertical presentation through the center of the picture, and an arrow that points to nothing in particular. The fusion of green and pink accented with ocher, pale blue, and silvery white re-creates a translucence reminiscent of the Tunisian watercolors. Yet the layered application of these contrasting colors and the rippling, textural effects of the encaustic project the impression of shimmering light through a filter more magical than optical. At this point, Klee is working away from his Bauhaus concern with color relationships based on a scientific analysis of light and conducting instead an intuitive investigation of radiance.

The mottled texture and the golden hues of *Still Life with Dove* conjure the glow of revery, a psychological state Klee had investigated pictorially since at least 1914 when he painted *Carpet of Memory* (Kunstmuseum Bern).[1] Will Grohmann aptly characterizes the aura of *Still Life with Dove* as elegiac.[2] He also discounts classifying this painting as still life, grouping it with other somewhat disquieting works, such as *Plants in Still Life by Window* (1927, private collection, Bern)[3] and *Colorful Repast* (1928, private collection, United States),[4] which he termed "disguised" still lifes.[5] Certainly, a standard still life includes no fluorescent green arrow, hovering near the upper center, calling attention principally to itself. Even the bird—while not unfamiliar to still-life painting, as countless pictures of this genre containing dead game birds attest—seems out of place. If one assumes that the bird is dead, as its context and bluish pallor imply, then its formation in a darting descent is contradictory.

The operations of the arrow and the dove in this picture recall that of the heart in *Composition* (cat. no. 29), which Klee painted on the opposite side of *Still Life with Dove*. In each work, these elements seem alien to the composition. The heart, because it is an identifiable and evocative symbol, is out of place in a geometrical abstraction; the arrow seems too abstract to be a part of a still life; and the dove is too unsettling. However, like the heart, both bird and arrow have a long history in Klee's oeuvre that gives them a special logic in *Still Life with Dove*. The arrow has appeared in Klee's work as an indicator of direction (*City between Realms*, cat. no. 26), of movement (*The Ships Set Sail*, 1927, private collection, New York),[6] of place (*The Arrow in the Garden*, 1929, Musée national d'Art moderne, Paris),[7] of metamorphosis (*Separation in the Evening*, 1922, private collection, Switzerland),[8] and even of romantic yearning (*Mural from the Temple of Longing*, 1922, Metropolitan Museum of Art, New York).[9] Because none of these meanings is assured in *Still Life with Dove*, they all resonate. Similarly, birds abound in Klee's art. For Klee, the bird in flight is a living embodiment of the arrow's signification of direction and movement.

Thus Klee included elements of movement and change in a genre traditionally circumscribing the stationary. Perhaps he was expressing his fear of the loss of artistic freedom through the increasingly constrictive policies of the German government in the early thirties. In such a context the dead dove was likely a comment on the precarious state of world peace. What is certain is that *Still Life with Dove* incorporates signs of static and dynamic states, polarities that lie at the heart of creation. Throughout his pedagogical writings, Klee proclaims that the interaction between being and becoming and the unification of this dualism result in the activation of being (for him a fundamentally static condition) which generates formation (for him a fundamentally dynamic condition).    —KK

1. Illustrated in Jürgen Glaesemer, *Paul Klee, The Colored Works in the Kunstmuseum Bern*, trans. Renate Franciscono (Bern, 1976), p. 98.
2. Will Grohmann, *Paul Klee* (New York, 1954), pp. 310–311.
3. Ibid., cat. no. 148.
4. Carolyn Lanchner, ed., *Paul Klee* (New York, 1987), p. 231.
5. Grohmann, pp. 310–311.
6. Illustrated in Grohmann, cat. 120.
7. Illustrated in Lanchner, p. 235.
8. Illustrated in Lanchner, p. 178.
9. Illustrated in Lanchner, p. 175.

*31.* ROCK FLOWER
*Felsen blume*
1932

Watercolor and pen and ink on paper, laid down,
17³/₈ × 12³/₄ in. (44.4 × 32.3 cm)
Signed upper left: *Klee.* Dated and inscribed at bottom:
*1932 M4 Felsen blume / M4*

Throughout the early 1930s, Klee continued to experiment with abstract formalist constructions and studies in pictorial light effects. Frequently these experiments reflect his strong disposition toward endowing the picture with a subjective content, as in *Ad Parnassum* (1932, Kunstmuseum Bern),[1] in which stark linear forms interact with planes of color and a mosaic of colored dots, conjuring a pyramid or a mountain. The evocation of ancient Egyptian culture as well as the title's reference to the mythological home of Apollo and the Muses lend a mystical aura to the composition. In *Rock Flower*, the light-filled palette and mountainous formation of *Ad Parnassum* is repeated, but the mysticism is much less ambivalent. Here, emerging from the rocks, is a full-length figure that could be a "mountain spirit" like those in German folklore.

*Rock Flower* is a product of Klee's animist conception of nature. The nineteenth-century Romantic notion that all matter incorporated spirit, to which Klee refers in so many early diary entries, strongly infuses his expression from this point to the end of his life. In his landscapes throughout the thirties, clouds are wispy air sprites; gleaming eyes peer from dark forests; plants bleed; and fruit dances. Besides being a congenial basis for Klee's particular approach to creation, this manner of investing objects in nature with corporeal spirits was nourished by the artist's increasing contact with — and celebration by — Surrealist writers and artists, who also extended the idea of animism to man-made objects.

While the title *Rock Flower* suggests a particularly robust breed of flower growing amid rocks, or perhaps a fantastic rock formation resembling a flower, the image itself is of a full-length figure rising from a rock, holding a spherical object with a rather delicate gesture, as if proffering a gift. The scale is ambiguous, but the backdrop of the sky makes the rock appear mountainous and endows the figure with colossal proportions. Most likely the figure is a kind of spirit, which Klee referred to as a "geist" or "genie," who inhabits the mountain and allows flowers and other gifts of nature to flourish.

*Rock Flower* can also be considered in the light of Klee's ardent interest in studying the growth of colorful algae, moss, and lichen on rocks.[2] In this particular case, the vegetation has taken on a figural form for the artist, much as the veins of marble tabletops did for him as a boy. This lifelong preoccupation culminated in the late work *Flora on the Rock* (Kunstmuseum Bern, 1940), in which the growth upon the rocks appears as highly schematized pictograms. —KK

1. Illustrated in Jürgen Glaesemer, *Paul Klee, The Colored Works in the Kunstmuseum Bern,* trans. Renate Franciscono (Bern, 1976), p. 281.
2. See Richard Verdi, *Klee and Nature* (New York, 1985), pp. 10–12, for a discussion of Klee's study of nature specimens.

*32.* LONELY FLOWER
*Einsame Blüte*
1934

Watercolor with pen and black ink on tan paper, laid
down, 18⁷/₈ × 12³/₈ in. (47.8 × 31.5 cm)
Signed lower left: *Klee.* Dated and inscribed on verso:
*VI 1934 5 einsame Blüte*

Throughout the Düsseldorf period (1931–1933), Klee continued the layering of stripes in image and background that he often used in the 1920s (see *Thoughtful*, 1928, cat. no. 28). The stratified pictures of the 1930s, however, possess a more calibrated quality than similar pictures of the previous decade. In *Lonely Flower*, the languid, coiling strata in various pinks effect a contrapuntal contrast with the measured horizontals in cool shades of blue, green, and purple. As in *Thoughtful*, the background invades the image, formally uniting figure and ground, while playing a witty part in the meaning of the work. In *Thoughtful*, the layers pass through the figure's brain, seemingly affecting the workings of the mind, whereas in *Lonely Flower* it is the colors of the background that permeate the image, apparently representing the sad, "blue" heart of the forlorn flower.

The image in *Lonely Flower*, like that in *Thoughtful*, is presented as a portrait. The blossom fills the field and is slightly turned on its axis, much as a head is turned in a three-quarter view in many portraits. Klee, moreover, invested the flower with an emotional presence, characterizing it as lonely both in the title and in its drooping, downcast appearance. To further emphasize the mood of the painting, he attenuated the pink color from bright in the innermost layers to pale in the outermost layers to signify a dwindling of zest, and by casting the background in predominant blues that seep into the center of the image, he lent an overall tone of dejection as well.

Klee's attribution of human emotion to plants and other forms of life throughout his oeuvre reflects his deeply held belief that all creation is linked together at its deepest level. Klee's aesthetic could be concisely described as a lifelong exploration of the similarities between the human and nonhuman worlds. The quest for unity at the base of all creation is at the heart of the archetypal quality of this flower portrait. Botanical accuracy is superfluous here, just as it is in almost all of Klee's renderings of flora.[1]

Klee often used a spiraling line for his floral and vegetal formations to suggest the cycle of plant life from germination to budding, growth, and death.[2] A centrifugal spiral expanding away from the center expresses growth, whereas its opposite, the centripetal spiral, expresses dying.[3] The predominant inward movement of the blossom in *Lonely Flower* suggests that this flower's peak has passed.

—KK

1. For a discussion of Klee's preference for the typical in nature, see Richard Verdi, *Klee and Nature* (New York, 1985), pp. 23–24.
2. For a discussion of the spiral as it relates to plant growth, see Carola Giedion-Welcker, *Paul Klee* (New York, 1952), p. 95.
3. Paul Klee, "The Spiral," *Pedagogical Sketchbook*, trans. Sibyl Moholy-Nagy (London, 1953), p. 53.

*33.* ILFENBURG
1935

Gouache on paper, 11⅞ × 10⅜ in. (30.3 × 26.2 cm)
Signed lower left: *Klee*

In 1935, when *Ilfenburg* was painted, Klee was taking stock of his life and art. Two years into his Nazi-enforced exile in Switzerland, full of doubts about his work, and experiencing the onset of the disease that would end his life five years later, he wrote: "Is Europe limping, or am I?"[1] During this time, Klee curtailed his customarily substantial output of work. The works he did produce were largely derivative of earlier works from which he appropriated motifs or themes.

*Ilfenburg,* while still rooted in the past, contains the seeds of new directions in Klee's art. Like other works of this period, *Ilfenburg* is a retrospective borrowing of both form and subject matter from pictures of the early Dessau period in which Klee built up his forms using a system of parallel lines that entwined and interlocked, creating an overall mazelike structure. This system of parallel figuration is employed with mysterious resonance in landscapes depicting otherwordly gardens in which darkened portals frame passageways that appear to lead downward, as in *Garden for Orpheus* (1926, Kunstmuseum Bern)[2] and *Portal in a Garden* (1926, Kunstmuseum Bern).[3] Such pictures represent the beginning of Klee's shift to an esoteric expression that would increasingly dominate his work to the end of his life.[4] With its structure of plaited bands of brown and its murky entranceway, *Ilfenburg* recalls the haunting landscapes of 1926 with portals executed in parallel figuration. *Ilfenburg* also foreshadows Klee's subsequent work: its interwoven strips are much broader than their antecedents of 1926 and anticipate the wide bars and beams of the later work. Moreover, the application of gouache over a dark ground to create a gloomy atmosphere is especially associated with the pictures Klee created in the last years of his life (see cat. no. 34).

*Ilfenburg,* though not demonic, is certainly eerie. Its structure suggests an abandoned mine shaft, which emits a purplish glow. The light source seems to come from the phosphorescence of the strange plants that grow around and on top of the structure, as if it were a ruin. The nocturnal luminosity does not penetrate the darkness of the entrance, and its obscurity adds a sinister note.

The title suggests a place, though no such name as "Ilfenburg" exists on any map. Most likely this work is one of Klee's fantasy landscapes, part memory and part fairy tale. Given Klee's great love of wordplay and care in titling his work,[5] perhaps "Ilfenburg" is an inventive combination of "elfen," German for "elves," and "Ilsenburg," a peak among the Hartz Mountains of Germany known in German folklore as dwelling place of subterranean miners, usually elves or dwarfs.[6]

—KK

1. Quoted by Jürgen Glaesemer in *Paul Klee, The Colored Works in the Kunstmuseum Bern,* trans. Renate Franciscono (Bern, 1976), p. 298.
2. Illustrated in Christian Geelhaar, *Paul Klee and the Bauhaus* (New York, 1973), pl. 69.
3. Ibid., pl. 70.
4. Ibid., pp. 145–147.
5. For example, he combined the Latin words "dulcis" (sweet) and "amarus" (bitter) into the single word "dulcamara" for the title of the painting *insula dulcamara* (1938, Kunstmuseum Bern) to describe a "bittersweet" island, which Christian Geelhaar interprets as a paradisiacal land where death none-theless prevails (see Christian Geelhaar, *Paul Klee: Life and Work* [New York, 1982], p. 89).
6. See Lotte Motz, *The Wise One of the Mountain: Form, Function, and Significance of the Subterranean Smith* (Stuttgart, 1983), for the folklore related to the legendary denizens of the Hartz Mountains. In "The Hartz Journey," from *Pictures of Travel, 1823–1826* (vol. 3 of *The Works of Heinrich Heine,* trans. Charles Godfrey Leland), Heinrich Heine, whom Klee had read, also refers to the fables of the subterranean elf-smiths who lived and mined in the Hartz Mountains and cites the legend of the water nymph Princess Ilse who lived in a crystal castle deep within the granite Ilsenburg mountain.

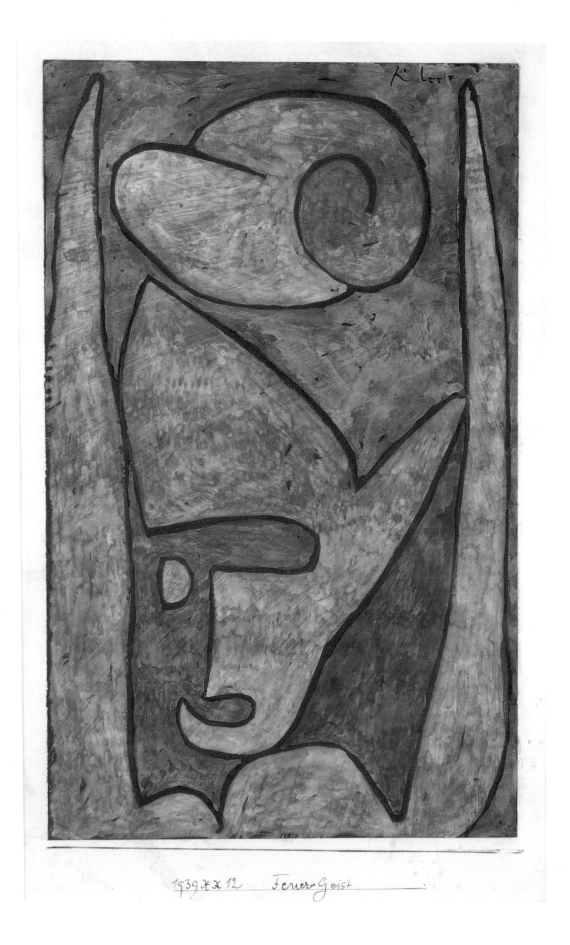

1939 ⅹ 12   Feuer-Geist

## 34. FIRE SPIRIT

*Feuer-geist*
1939

Gouache on paper, laid down, 13 × 8⅛ in. (32.9 × 20.8 cm)
Signed upper right: *Klee*. Dated and inscribed at bottom:
*1939 xx 12 Feuer-geist*

By 1939 Klee knew he was losing his battle with the fatal disease scleroderma, and his subject matter increasingly reflected thoughts of the hereafter. Death masks, phantoms, demons, angels, and underworld landscapes abound in his work from this point until his death in 1940. Even as a young man he thought about death. An early diary entry declares: "I glow amidst the dead."[1] Indeed, demonic beings occur in Klee's works from the beginnings of his oeuvre. As a boy of fifteen, for example, Klee drew fiendish monsters in the margins of a copy of Dante's *Inferno*, which he was studying in school. In another early diary entry, he lists the devils of Swiss folklore.[2] Chimerical wraiths and grotesqueries recur in his works, even throughout the early Bauhaus years of experimentation with technical form. As premonitions of his life's end grew stronger, during the years 1939–1940 he focused his expression almost exclusively on the subject of death as a primitive, immediate force. His eulogist, Basel Museum Director Georg Schmidt, characterized his last works as "a variation on the theme: The End—period."[3]

*Fire Spirit* is one of a series of representations of angels and demons that Klee executed in his final months. There is little doubt that the figure in *Fire Spirit* is a creature from the lower regions. The tumescent form above the spirit is such a common motif in Klee's underworld landscapes of 1939 that it could almost be considered emblematic of the nether realms. Similar swollen forms constitute the landscape elements in the gouache *Infernal Park* (private collection, Switzerland)[4] and the series of drawings leading up to it.

Yet there are also terrestrial references in the setting of *Fire Spirit*; in the brown of the background on the right and in the atmospheric blue above the figure. It would seem that this denizen of hell inhabits the earth. Thus *Fire Spirit* could be interpreted as a commentary upon the moral state of the world, especially Germany in 1939, but it also makes sense in terms of Klee's own cosmic sensibility, in which he allows that evil can be a positive, creative force in the world as long as it is balanced by its polar opposite, good. In his essay "Creative Credo," Klee wrote: "Evil should not be an enemy who triumphs or who shames us, but a power contributing to the whole. A part of conception and development."[5] In *Fire Spirit* and in so much of his late work, Klee transforms archetypal underworld figures into dwellers in a realm of his own invention, an "in-between realm" inhabited by strange subterranean beings with earthly attributes.    —KK

1. Paul Klee, *The Diaries of Paul Klee, 1898–1918*, ed. Felix Klee (Berkeley, Los Angeles, London, 1964), p. 308, no. 931.
2. Ibid., p. 139, no. 496.
3. Hans Bloesch and Georg Schmidt, *Paul Klee zu sein Todestag, 29 Juni 1940* (Bern, 1940), n.p.
4. Illustrated in Andre Kuenzi, *Klee* (exh. cat., Foundation Pierre Gianadda, Martigny, 1985), p. 109, fig. 75.
5. Paul Klee, "Creative Credo," in Jürg Spiller, *The Notebooks of Paul Klee*, vol. 1: *The Thinking Eye*, trans. Ralph Manheim, et al. (London, New York, 1961), p. 79.

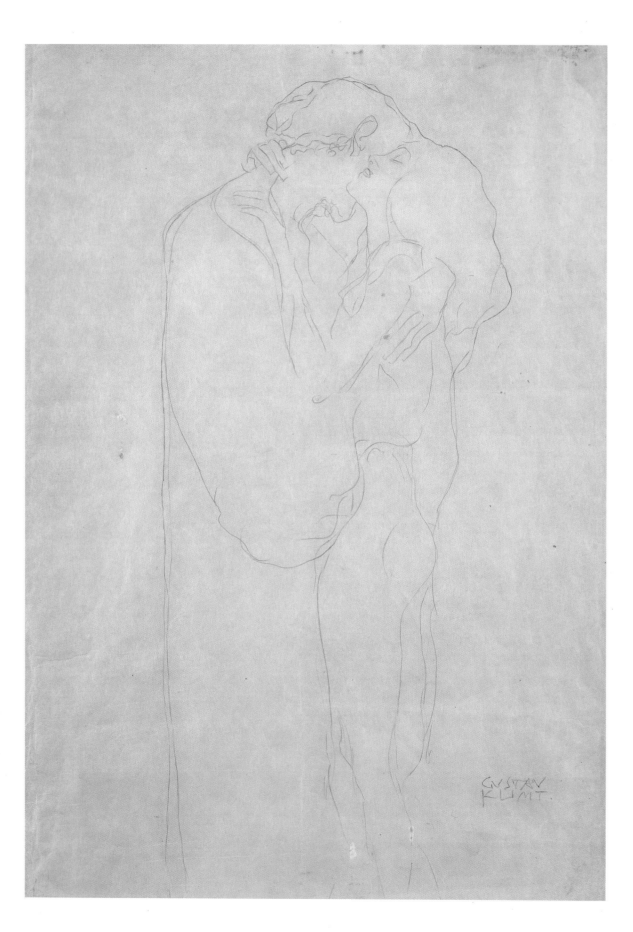

# GUSTAV KLIMT

Austrian, 1862–1918

## 35. THE EMBRACE
*Das Liebespaar*
ca. 1910

Graphite on tan paper, 20³/₄ × 14¹/₂ in. (52.9 × 37 cm)
Signed lower right: *Gustav Klimt*

Klimt's art, created at the end of the nineteenth century and the first two decades of the twentieth, documents the Viennese *fin de siècle* through a combination of the sensual and ethereal. This spirit is most easily perceived in the drawings. Unlike the paintings, they are unencumbered by ornamentation or, for the most part, color. Line is transformed into human shapes that speak to us directly, without spatial ambiguity and idiosyncratic surface details.

The importance of drawing to Klimt is evident from the beginning of his career, when hundreds of sketches could be seen in his studio.[1] Before 1904 Klimt generally drew in black chalk on inexpensive paper; by 1906 he used pencil on large-format imitation Japanese paper.[2] Besides the preparatory sketches for paintings, there is a significant body of totally independent drawings and new adaptations of motifs that relate to earlier investigations,[3] each of which can stand on its own.

The theme of an embracing couple is central to Klimt's oeuvre. He used the motif as early as 1895 in a painting titled *Love* (Historisches Museum der Stadt Wien, Vienna),[4] and in the 1902 *Kiss*, detail of the *Beethoven Frieze* (Österreichische Galerie, Vienna).[5] In 1908 he returned to the theme with *The Kiss* (Österreichische Galerie, Vienna),[6] a work that from its inception was one of his best known and most popular paintings; and in that same year he began *Fulfillment* (Österreichische Museum für Angewandte Kunst, Vienna), a full-sized cartoon finished in 1910 for the frieze in the dining room of the Palais Stoclet, the Brussels home of Adolf Stoclet.[7] Klimt's fascination with the theme continued, and drawings were produced as late as 1917.[8]

With a date of circa 1910 the Sirak *Embrace* stands approximately at the midpoint of these investigations. It may have been directly inspired by *Fulfillment*, with its pose of a male robed figure holding a female in his arms. Visually the drawing is quite different, however, with both figures in profile and the female nude, except for the suggestion of a light cloth covering her upper torso. Inspiration for the development of Klimt's art has often been linked to Fernand Khnopff, Jan Toorup, and Auguste Rodin. In this instance Edvard Munch's numerous adaptations of *The Kiss*—which he began in 1890–1891—come to mind, especially in Klimt's sensitive fusion of the outline of the two heads and the intertwining of the hands and arms.[9]

In the drawing there is a direct reference to the artist through the male robed figure, whose appearance is similar to that of the figure in *Fulfillment* and *The Kiss*. Klimt was often photographed in a full-length, voluminous robe with wide sleeves. In the paintings, the neck and torso of the male are massive forms like Klimt's own physiognomy; in the drawing the figure is thinner, in keeping with his companion's lithe figure.

As a tender image of love, the embracing couple both represents and transcends earthly eros. Their union also suggests a symbolic spiritual embrace, Klimt's affirmation of the bond between himself and his muse.                              —DL

1. Noted by the contemporary critic Arthur Roessler and cited in Frank Whitford, *Klimt* (New York, 1990), p. 197.
2. Ibid., p. 198.
3. For Klimt's drawings see Alice Strobl, *Gustav Klimt: Die Zeichnungen*, 4 vols. (Salzburg, 1980–1984).
4. Fritz Novotny and Johannes Dobai, *Gustav Klimt, with a Catalogue Raisonné of His Paintings* (New York, 1968), cat. no. 68, p. 299.
5. Ibid., cat. no. 127, p. 326. Klimt's *Beethoven Frieze* (a symbolic paraphrase of Beethoven's Ninth Symphony) was created for an exhibition of Max Klinger's statue of Beethoven at the Viennese Secession, April–June 1902.
6. Ibid., cat. no. 152, p. 342.
7. Ibid., cat. no. 154, p. 344. For a discussion of whether the Stoclet frieze was begun earlier than *The Kiss*, see no. 153, Stoclet frieze (execution), p. 344.
8. Illustrated and dated in *Gustav Klimt*, introduction and notes by Dr. Johannes Dobai (London and New York, 1973–1974), cat. no. 63.
9. Munch's depictions of *The Kiss* are compared with Klimt's in Patricia McDonnell, "*The Kiss*: A Barometer for the Symbolism of Gustav Klimt," *Arts Magazine* 60 (April 1986): 65–73. McDonnell observes that "Both pare the image to absolute essentials so that the commonplace transforms to symbolize the eternal" (p. 72).

*36.* PORTRAIT OF ADELE BLOCH-BAUER
*Bildnis Adele Bloch-Bauer*
1910–1911

Graphite on light cream paper, 22¼ × 14⅝ in. (56.6 × 37.2 cm)
Signed lower right: *Gustav Klimt*

Adele Bloch-Bauer was the only woman Klimt was commissioned to paint twice, in 1907 and in 1912 (both paintings are in the Österreichische Galerie, Vienna).[1] This elegant sketch, made with an extremely light touch, is one of numerous preparatory drawings for the 1912 painting *Portrait of Adele Bloch-Bauer II,* in which the subject is depicted standing, facing the viewer in a full frontal pose. In this drawing her elongated figure is turned slightly and fills the page. At the top edge of the paper, the head is cut off just above the temples, where a few pencil strokes define an upswept hairdo. Sensuous lips dominate a strong ovoid face; a nose is formed by the vague impressions of two wavering lines, but there are no eyes. Here Bloch-Bauer appears in the long fur-trimmed coat or shawl she wears in the painting and holds a small evening bag, a detail omitted in the painting. In other preliminary sketches and in the painting a large round black hat is included.

Two other drawings of Bloch-Bauer, also meant as preparatory studies for the second portrait and reproduced in the Klimt catalogue raisonné,[2] reveal a heavier hand. The lines are thicker, darker, and more plentiful, and body proportions are shorter; consequently the clothing appears heavier and the body underneath stronger. In each, the black hat appears, shown in two sizes, with the larger chosen for the painting. These drawings, along with the Sirak sketch, demonstrate Klimt's greatness as a draftsman. The chronology of their creation is not apparent vis-à-vis the painting. They are linked to each other rather than to the finished product, yet each is unique.

Klimt's relationship with Adele Bloch-Bauer may have added a personal element to his depictions of her and enhanced the psychological complexity of the works. It has been asserted that the artist and Bloch-Bauer were involved in a twelve-year relationship known only to her maid and physician, during which time her likeness was suggested in the erotically charged 1901 *Judith and Holofernes* (Östereichische Galerie, Vienna) and in the second version painted in 1909 (Galleria d'arte moderna, Venice).[3]

A comparison of Bloch-Bauer's features with those of Judith is most striking if the Sirak drawing is used. In the drawing the tilt of the head, the strong squared jawbone, the sensuous, slightly parted lips, and the long neck all relate to Judith and show Bloch-Bauer in one of Klimt's most flattering depictions. In the *Portrait of Adele Bloch-Bauer II* an awkward figure stands locked in the grip of floating decoration, her fur-trimmed wrap undulating with the falling flowers that surround her lower body. Sad and vulnerable, her presence lacks the essence of the preliminary Sirak sketch and its reference to an earlier time.   —DL

1. Klimt's 1907 *Portrait of Adele Bloch-Bauer I,* painted during the height of the artist's "golden period," is the better known. For a discussion of the two paintings, see Jane Kallir, *Gustav Klimt, 25 Masterworks* (New York, 1989), pp. 32–33, and Frank Whitford, *Klimt* (New York, 1990), pp. 9–16, 147–150.
2. Fritz Novotny and Johannes Dobai, *Gustav Klimt, with a Catalogue Raisonné of His Paintings* (New York, 1968), pp. 90–91; p. 91 contains two figures of different scale, both representing Bloch-Bauer.
3. Salomon Grimberg, "Adele," *Art and Antiques* (summer 1986), p. 70.

# HENRI MATISSE

French, 1869–1954

37. STILL LIFE WITH SELF-PORTRAIT
*Nature morte à l'autoportrait*
1896

Oil on canvas, 25⁵/₈ × 31³/₄ in. (65.1 × 80.5 cm)
Signed lower left: *H. Matisse*

Henri Matisse was first a painter of still lifes. His earliest painting, dated June 1890, was a simple composition of books, candle, and newspaper, which he "preciously saved" throughout his lifetime.[1] From 1892, under Gustave Moreau's tutelage, he copied pictures in the Louvre, including still lifes by Jan Davidsz de Heem and Jean-Baptiste-Siméon Chardin. His own works, then indebted to the realist aesthetic of the Dutch and French schools, concentrate on the various textures and reflective surfaces of objects chosen from the traditional subject matter of Northern painters, whose discreet modulations of warm tones or silvery light Matisse also studied and admired.

The year 1896, when *Still Life with Self-Portrait* was painted, marked a major turning point in Matisse's early career. At the age of twenty-seven, while still a student of Moreau, Matisse exhibited publicly for the first time at the Salon of the Société nationale des Beaux-Arts and, shifting his focus away from the disciplined restraints of museum studies, began to assert his own personality in more original works. "I wanted to understand myself," Matisse said.[2] *Still Life with Self-Portrait*, a wise and complex painting, mirrors the artist's search for self-knowledge, as he stands cautious yet decisive on the threshold of his calling as a painter. Reflecting the prevailing Symbolism of the 1890s, the picture is as shrouded in uncertainty and mystery as it is secured in the foundations of a strong artistic heritage. The influence of De Heem and Chardin is clearly seen in the intimate view of domestic objects; their arrangement across a shallow, draped tabletop; the solemn ambience of muted colors, soft illumination, and warm tonalities. Yet a kind of Symbolist introversion penetrates this work. The objects are disassociated from their domestic origins, and the interior they now occupy is an ambiguous space. The meaning of objects remains elusive; their contents are concealed from view. The illumination of the darkened room, its source unknown, seems to emanate from the center of the composition, making its radiance all the more mysterious, even spiritual. A great silence, at once serene and disturbing, evokes feelings of absence, isolation, and anxiety.

In the sometimes lonely world of the artist, Matisse's companions were often his own familiar objects, which accompanied him throughout his life and appear again and again in his paintings. The floral tablecloth, the humble copper and earthenware pitchers, and the elegant blue and white porcelain vase have been transformed from attributes of a bourgeois interior in his *Woman Reading* of 1895 (Musée national d'Art moderne, Paris) to essential subjects in the Sirak picture. The self-portrait appears in *Woman Reading* and *Interior with a Top Hat* of 1896 (private collection), and in many other framed and mirrored variations in the artist's oeuvre. In the Sirak painting, the self-portrait is to the left of the central grouping of vessels, braced between two books—the well-worn volumes that salute the artist's past as a student of law. The face, turned toward the viewer, peers out from behind the very things that both fortify and imprison the artist. Like the drape that covers a painting in the background, the reflective glass protects the portrait, blurring the details and expression of its subject. Matisse's ghostly countenance peers from the uncertain shadows at the edge of a revealing, omniscient light.

About Matisse's resolve to become a painter, Moreau remarked: "I was struck at the sight of his interior. He really has arranged his life around painting."[3] And so, in this profound still life, Matisse has arranged the objects of his vocation, of his ultimate devotion, around his own image. The framed portrait reminds us that we are in the domain of painting, where artist and viewer are both participants in and observers of the painted and real worlds. Matisse chose painting above other arts, and his life was to be governed by his work. The seeds of a discrete personal iconography, expressing his self-determined removal from ordinary life, are sown in this work. As Matisse himself said, "A painter is all there in his first pictures."[4]            —EJC

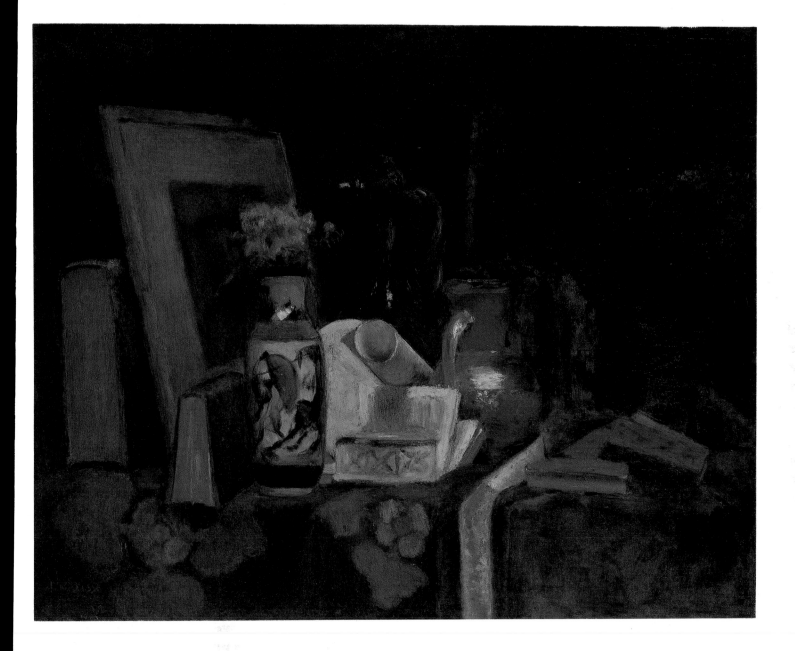

1. From "Interview with Jacques Guenne, 1925," quoted in Jack
   D. Flam, *Matisse on Art* (New York, 1978), p. 54.
2. From "On Modernism and Tradition, 1935," quoted in Flam,
   p. 72.
3. Cited in Pierre Schneider, *Matisse*, trans. Michael Taylor and
   Bridget Strevens Romer (New York, 1984), p. 429.
4. Ibid., p. 27.

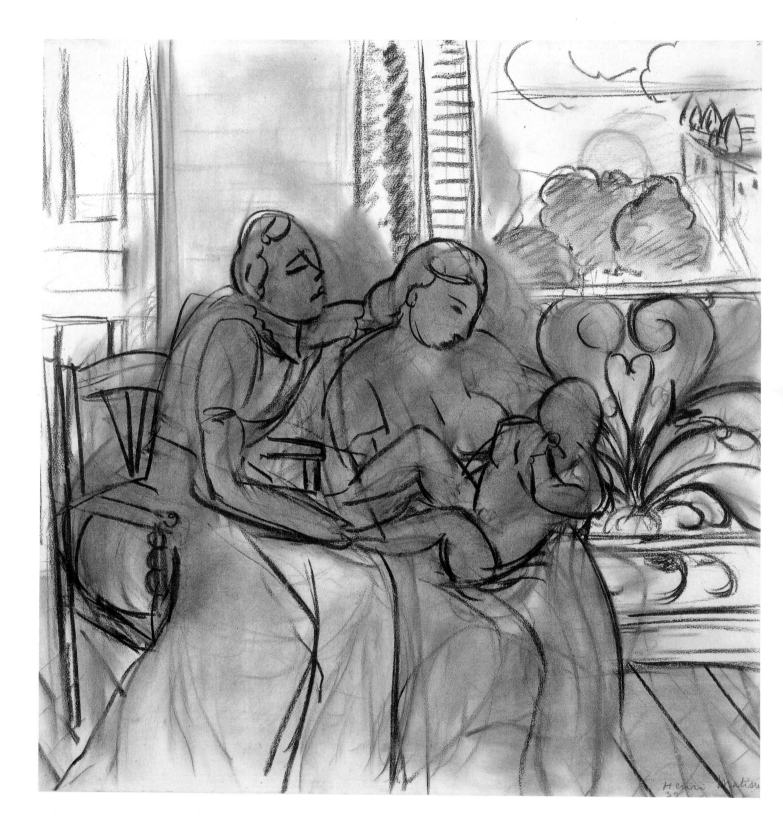

*38.* MATERNITY
*Maternité*
1939

Charcoal on tan paper, 24 × 24 in. (60.9 × 60.9 cm)
Signed and dated lower right: *Henri Matisse 39*

Henri Matisse was a devoted draftsman, producing thousands of drawings throughout his career to create an autonomous body of graphic work in a variety of media, from pencil, ink, or charcoal to crayon, gouache, and prepainted paper cutouts. In 1939, Matisse wrote:

> My line drawing is the purest and most direct translation of my emotion . . . the drawings are always preceded by studies made in a less rigorous medium than pure line, such as charcoal or stump drawing, which enables me to consider simultaneously the character of the model, the human expression, the quality of surrounding light, atmosphere and all that can only be expressed by drawing. And only when I feel drained by the effort, which may go on for several sessions, can I with a clear mind and without hesitation, give free rein to my pen. Then I feel clearly that my emotion is expressed in plastic writing.[1]

That same year (1939), *Cahiers d'art* published a number of charcoal drawings by Matisse that fully express the vital pulse of his creative process.[2] *Maternity* was one of four studies among these on the subject of mother and child, a theme assimilated by Matisse from his studies of the Old Masters. The work incorporates yet another major motif in Matisse's oeuvre — that of figures seated near a window.

The Sirak drawing represents the essence of a method used by Matisse especially in the 1930s and 1940s, in which the evolution of a subject over time is made visible and palpable. Yearning for a new monumentality and spontaneity in his painting in which his emotional response to a subject could be expressed through a boldly reductive linear script, he would develop a subject through a series of charcoal studies that he continually refined until — understanding the subject intuitively beyond its physical properties — he could evoke an essential sign quite literally in the single stroke of the pen. The fervor of the artist's search for a definitive representation is seen here in successive states of drawing superimposed one over the other on a sheet of white paper. Forms are observed, drawn in charcoal, analyzed, rubbed out or blurred, amended, and explored again. Each new study draws strength from the old. For example, Matisse refined the pose of the mother from its former angularity to a graceful S curve. He then smoothed the profile of her face and aligned the fullness of her breast with the baby's head to echo exactly the heart-shaped arabesques nearby. Matissse also repositioned the mother's companion so that she leans forward, her chair embracing her as the mother does the child.

The ghostly memories of previous states, which both conform to linear contours and act independently of them, surround the figures in a luster of gray tones. Bound not so much to the real object as to the subjective act of creation, the charcoal grays suggest modeling, color, and texture, and concentrate the intensity of the subject at the center of the page. As the sun shines through the window and fills the interior with light, so the white paper generates light and encircles the triad of mother, child, and companion. To liberate the essence of doting affection in a sun-filled room was the challenge of this drawing. The page became the terrain of an artist's search. The essential line would be his reward. —EJC

1. Henri Matisse, "Notes of a Painter on His Drawing," from Jack D. Flam, *Matisse on Art* (London, 1973), p. 81.
2. Christian Zervos, "Dessins récents de Henri Matisse," *Cahiers d'art*, nos. 1–4 (1939), pp. 5–24, illus. p. 22.

# CLAUDE MONET

French, 1840–1926

*39.* SEASCAPE AT POURVILLE

*Marine à Pourville*
1882

Oil on canvas, 23⅝ × 39⁷/₁₆ in. (60 × 100.2 cm)
Signed lower right: *Claude Monet*

This seascape—at once windswept and gentle—was painted by Monet in the summer of 1882, just after he had seen the great Courbet exhibition at the Palais des Beaux-Arts. There the superb sequence of north-coast seascapes painted by Courbet in the 1860s and 1870s was shown to full effect, and both Monet and Renoir were moved to reinvestigate the sea as a subject and to inject a dose of mid-century Romanticism into the modernity of their landscapes. Yet, unlike Renoir, who rarely painted the sea and for whom the precedent of Courbet was more important, Monet was consistently drawn to the sea as subject and had, in fact, painted an important series of seascapes in the two years preceding the Courbet exhibition.

Historians of French landscape know of the comparatively recent rise in coastal tourism in France. By 1882, when Monet painted this seascape, sea bathing had been an acceptable pastime for no more than a generation, and pleasure boating was just as new. In celebration of these new forms of summer recreation, Monet followed the lead of his teacher, Eugène Boudin (1824–1898), and painted the beaches and sailboats of the north coast of France, often giving new denizens of the Norman coast pride of place. Boaters and *promeneurs* dominate Monet's beach paintings of the 1860s and 1870s, when the hotels, houses, restaurants, and cabanas of the leisure class had begun to crowd out the small houses, fishing docks, and rough village structures of long-time inhabitants. Monet—as always—was as modern in what he represented as in how he represented it.

In the Sirak painting, however, the presence of Courbet is clearly felt. The pleasure boats that dominate Monet's great seascapes of the 1860s are so distant in this seascape as to be recessive components of the painting, much less important than the clouds or the expansive, multicolored surface of the sea.

For Monet—as for Courbet—the sea itself was more powerful and more of a pictorial challenge than the boats that temporarily plied its waters. That most of the boats in this picture are pleasure boats rather than fishing craft is scarcely the determining factor in interpreting the painting.

Like many of Monet's sweeping works of the 1870s and 1880s, the present painting is signed but not dated, a practice that has been plausibly interpreted by several art historians as a signifier that the painting was executed in several stages but not worked up in the studio to become a completely "finished" easel painting designated for exhibition. The simple signature suggests that there is as much apparent spontaneity in the act of painting as there is actual spontaneity in the subject. Monet was attracted to the motif, "seized" it, and, after two or three sessions, felt that he had gone as far as he needed to go. When compared to the labor-intensive, multilayered surfaces of Courbet's seascapes, the technical simplicity of Monet's painting is all the more remarkable.

If Courbet's sea is an emblem of power and impenetrability—of nature ever apart from man—Monet's is less daunting and more accessible. Although its surface trembles, there are none of the agitated waves and whitecaps that Courbet loved. Far from being endangered by the sea, Monet's viewers are standing safely on the land, unthreatened by its power. For Monet, as for his master, the wonderful green color of the English Channel was the principal fascination. If we could see the same apple green on Monet's palette that he used to paint the water, we would never believe that it could become a plausible sea, but as he subtly blended the green with strokes of violet, pink, pale yellow, and deep blue, it took on a completely believable character.

The viewer, clinging visually to the edge of the land, looks out into Monet's sea and is treated to a kind of dance of boats and clouds. At least six boats head out to sea, almost as if they are led by a fleet of small clouds. The artist reveals little, if anything, about their size, riggings, passengers, or the purposes of their voyage. In fact, the sailboats are no more knowable

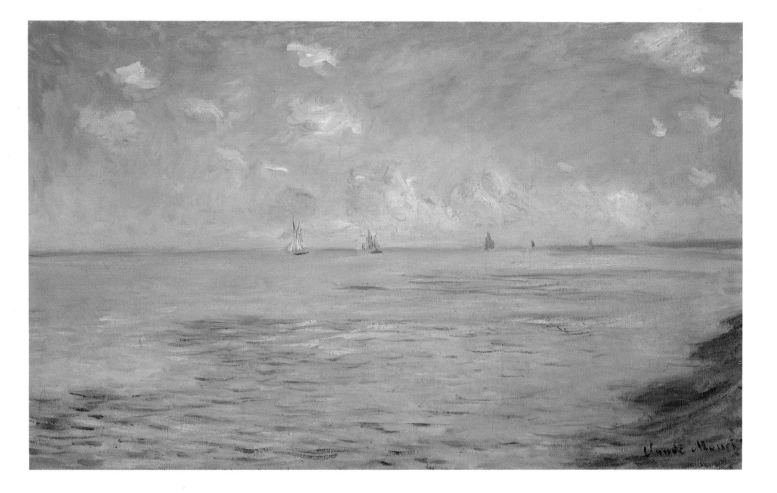

than the clouds above them, and Monet teases the viewer with the knowledge that, in a minute, every form and every reflection will have changed position.

Perhaps the most interesting aspect of this superbly constrained seascape is its format. Rather than using a standard Impressionist rectangle, Monet painted on a very long, almost panoramically proportioned, canvas that can be linked to the landscapes and seascapes of another mid-century master, Daubigny. Monet used this format in three other paintings of 1882,[1] two of which were exhibited immediately.[2] In fact, the four paintings would hang so well together that one wonders whether Monet conceived of them as a group of seascape decorations linked, in their way, to the superb paintings of the four seasons made by Pissarro in 1872–1873 for Achille Arosa.[3]

—RB

1. See Daniel Wildenstein, *Claude Monet, Biographie et catalogue raisonné*, vol. 2: *1882–1886, Peintures* (Lausanne, Paris, 1985), nos. 751, 776, 778. The Sirak painting is no. 775.
2. Ibid., nos. 776, 778.
3. See Ludovic Rodo Pissarro and Lionello Venturi, *Camille Pissarro—son art, son oeuvre*, 2 vols. (Paris, 1939), cat. nos. 183–186.

102

## 40. THE SEINE AT PORT-VILLEZ
## (A GUST OF WIND)

*La Seine à Port-Villez (Le Coup de vent)*[1]
1883 or 1890

Oil on canvas, 23³/₄ × 39¹/₄ in. (60.3 × 99.7 cm)
Signed and incorrectly dated lower left: *Claude Monet 84.*
Inscribed on verso in Monet's hand: *À mon ami Sacha
Claude Monet*

The subject of this remarkably simple—and remarkably well-preserved—landscape by Monet is a group of ordinary willow trees lining an ordinary stretch of the Seine near Giverny. There are no houses, boats, figures, bridges, or clouds to lend a picturesque air to the painting. Indeed, it almost seems as if the subject of the painting is blurred, so apparently hasty was its execution. Yet, for all this, Monet first signed his full name and then dated the painting, indicating that it is to be read as a fully resolved easel picture and not as a trial or sketch. In addition, the painting was chosen by Monet around 1924 as a gift to his younger friend, the great actor, playwright, and producer Sacha Guitry, and a dedication to him in Monet's hand appears on the original stretcher.

The Sirak painting is one of a group of landscapes made in Port-Villez in 1883, 1885, and 1890. Monet seems to have avoided the suburban and village landscapes of the Île-de-France almost obsessively in the decade following the death of his first wife, Camille, in 1879. He preferred to paint isolated places, free, for the most part, of human presence. Although its title is certainly accurate in a geographic sense, clearly, the subject of the picture is *un coup de vent*, or a gust of wind. The elements of the landscape—water, trees, and sky—are all in motion.

The wind as subject matter in art has its origins in the Romantic paintings of the mid-century, particularly in the landscapes of Corot; the subject was used by the Impressionists with some regularity, notably in the landscapes of Renoir and a lost work by Pissarro. Yet it was Monet who was the master of motion, whether in the ever-changing shifts of light throughout the day, the trembling surface of water, or wind whipping through foliage.

This superb picture was painted either in 1883 or 1890, when Monet painted several river scenes at Port-Villez. It can be linked to two other canvases of identical dimensions, one signed and dated 1883[2] and sold to Durand-Ruel in December of that year and the other

signed and dated it later, perhaps when he gave it to Sacha Guitry.

The wind rushes through the delicate, gray-green foliage of the willow trees that grow on sand bars in the center of the Seine near Port-Villez. If Monet painted landscapes about the instantaneous, this one comes as close to absolute success as any other. Because the canvas has never been lined, its surface has a life that matches its subject. Before this picture, we are witnesses of Monet's struggle to trap time in paint.

—RB

1. Daniel Wildenstein, in *Claude Monet, Biographie et catalogue raisonné*, vol. 3: *1887–1898, Peintures* (Lausanne, Paris, 1979), no. 1264, p. 136, titles the work *Le Coup de vent*.
2. Wildenstein, vol. 2: *1882–1886*, no. 834, p. 106.
3. Wildenstein, vol. 3: *1887–1898*, no. 1262, p. 136.

## 41. BASKET OF GRAPES

*Panier de raisins*[1]
1883

Oil on canvas (one of six panels for a door), 20⅛ × 15 in.
(51.2 × 38.1 cm)
Signed upper left: *Cl. Monet*

This wonderfully composed still life looks very strange when it hangs on the wall. Is the basket of grapes on the floor or on a table? Why do we look so insistently down on the still life?

The answer to these questions has little to do with the originality and "modernity" of Monet as a painter and everything to do with the fact that this exquisitely fresh painting was part of a commissioned decoration for the lower right panel of a doorway in the apartment of Paul Durand-Ruel at 35, rue de Rome, in Paris. In 1882 Durand-Ruel asked Monet to paint canvases that would be mounted in a series of doorways opening into a large salon in the family's spacious apartment. Monet worked on the commission for at least three years, finishing the paintings as he found time. Of the six doorways in the salon, five were installed by 1885. The sixth doorway, for which the Sirak painting was made, seems never to have been assembled, and the paintings were sold by the family in 1898.

All six doors were double and were to be hung with six paintings: two tall vertical panels on top, two small horizontal panels beneath, and two vertical panels at the bottom. As his subjects Monet chose flowers and fruit; three doors were dominated by flowers, and for the other three he devised a sort of dialogue between flowers and fruit. All the paintings celebrate the unprecedented growth of the horticulture industry in late nineteenth-century Europe. On the vertical panels above the doors' hardware were glorious effusions of peonies, chrysanthemums, sunflowers, dahlias, gladiolus, azaleas, morning glory, and lilies; in the central and lower panels were peaches, jonquils, lemons, anemones, daisies, roses, apples, tulips, azaleas, pears, and grapes. The colors, tastes, and scents mingled in the mind, and the presence of vases, flower pots, and garden baskets gave a delightfully domestic air to the decorations, evoking a world in which everything had just been brought indoors, at the peak of perfection.

The Sirak panel was most likely destined to be the lower right panel of the sixth door that was never installed. To its left was to have been a vase of white roses (private collection, France),[2] above it a group of five ripe peaches (private collection, France),[3] picked and arranged on peach leaves, and above that a pair of stems on which Japanese irises bloom in profusion (private collection, France).[4] There is an air of warmth, of exoticism, of comfort, of high summer, all of which would have been welcome during the fall and winter seasons when the Durand-Ruels stayed in Paris.

The importance of this group of thirty-six decorative paintings within the whole of Monet's career has never been properly recognized, and this is surely due to the fact that only the private visitors to the Durand-Ruel apartment ever saw the ensemble together. The paintings were, in many ways, Monet's first decorative cycle. Although he painted large canvases that he called *panneaux décoratifs* (decorative panels), he had never had the opportunity to combine painting with interior decoration in such a complete way. Given that he had long thought of his easel paintings in groups or, as he came to say, series, this commission must be seen as part of the gradual process of integrating individual paintings into coherent groups that transcend their parts. Here Monet brought the outside inside. He came to terms with the idiosyncratic pictorial surface on which he worked, playing, in delightful ways, with angles and curves so as to encourage the opening and the closing of the doors he decorated. Indeed, the basket of green grapes in the Sirak picture sits on the floor in such a way as to suggest that we will pick it up as we walk through the doors. How easy to imagine having come in from the garden with a basket of grapes, two almost ripe pears, and bunches of deep purple grapes. The casualness and ease of Monet's arrangement is so complete that we almost forget how artful it is—the rhyming curves of the pears and the basket, the way in which the stem of the purple grapes reaches up as if to touch the basket, the delightful dance of the pears on the floor. Monet's artfulness is almost as casual as his arrangement of fruit, making this small still life as great as any easel painting by Matisse or Bonnard. —RB

1. Daniel Wildenstein, in *Claude Monet, Biographie et catalogue raisonné*, vol. 2: *1882–1886, Peintures* (Lausanne, Paris, 1979), no. 954, titles the work *Panier des raisins, coings, et poires.*
2. Ibid., no. 953.
3. Ibid., no. 952.
4. Ibid., no. 950.

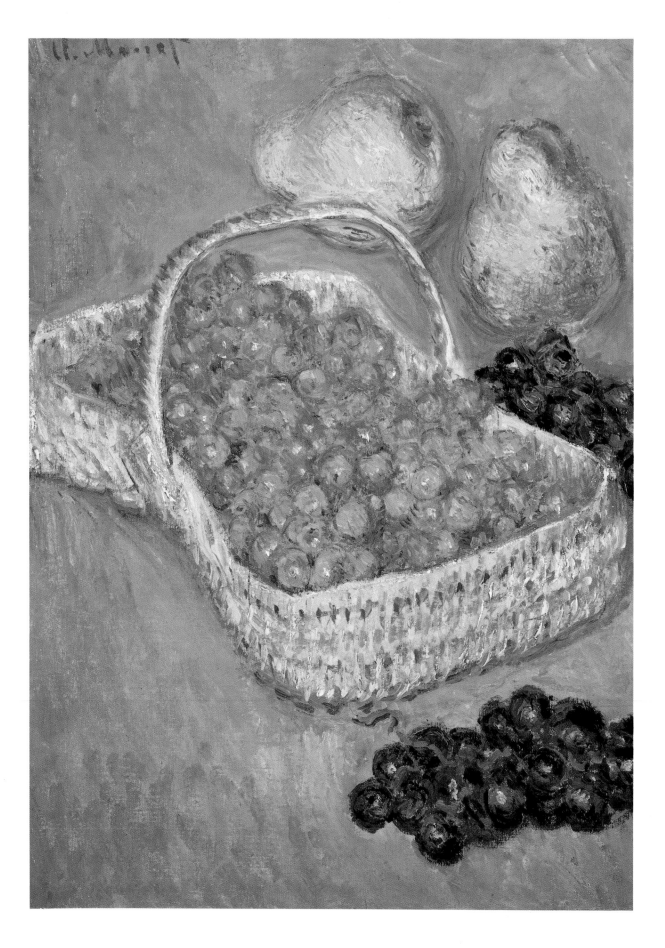

*42.* VIEW OF BENNECOURT
*Vue sur Bennecourt*[1]
1887

Oil on canvas, 32⅛ × 32⅛ in. (81.6 × 81.6 cm)
Signed and dated lower left: *Claude Monet 87*

Claude Monet declined to participate in what came to be the final Impressionist exhibition, in 1886. His own career had taken shape independently, and he had become increasingly detached from the cadre of painters who had formed the movement. Even his age was a factor in the separation: at forty-six, one is a good deal less rebellious than one is at thirty-four, Monet's age when the Impressionists had their first exhibition. And there is no doubt that Monet was more than a little disturbed by the increasingly "scientific" tenor of the movement, especially among young painters like Seurat who had been brought into the Impressionist fold by Pissarro in 1885. Yet, as this wonderful picture indicates, Monet went to the final exhibition and was challenged by the intensely optical paintings of Signac, Seurat, and Pissarro.

*View of Bennecourt* was painted in 1887. Its subject is a rhythmically charged grove of trees near the village of Bennecourt, just a ten-minute walk from Monet's home at Giverny. Clearly the picture was painted during the early months of the year, either in late winter or early spring, when the trees in France begin to show foliage, and the grass, watered with plentiful winter rains, is a brilliant green.

For the painting, Monet chose a square format, unusual for landscape painters but of increasing interest to Monet. He had begun to paint square canvases only in the mid-1880s, allowing himself two or three a year until the end of the 1890s, when square, almost square, and circular canvases became more common in his oeuvre. Here he created a formal interplay between the clarity and discipline of the perfect square format and the freely flowing curves of the trees and their shadows. Indeed, it is the shadows of the trees that dance almost frenetically through Monet's field, intensifying in their blue-black meanderings the gentler curves of the trees themselves. The effect of brilliant midday sun is absolute, making the shadows more "real" than the forms themselves and creating an optical flickering that easily competes with the sun-filled landscapes of the young Neo-Impressionists around Seurat.

There is little doubt that Monet was proving to young artists his superiority as a painter of light. Cheerfully ignoring the scientific theories of perception and light that inform the paintings of Seurat, Signac, and Pissarro, Monet put his eye and his experience as a translator of light perceptions into color to the test—and won. A juxtaposition of this painting by Monet with any of the light-filled Neo-Impressionist landscapes of Seurat would favor the Monet. Seurat's classical compositions, his scientifically detailed surfaces, and his desire for stability are no match in drama and pictorial verve for the thickened paint, the liberated gestures, and the seemingly instinctive compositions of Monet. If Seurat's landscapes are a sort of painted quadrille, Monet's are a Moroccan dance!

An interesting aspect of *View of Bennecourt* is that the village of Bennecourt is scarcely noticeable. Were it not for the church steeple in the background, we might miss seeing the huddled roofs of this modest Norman village. In this painting, as in most of his landscapes of the 1880s, Monet was unconcerned with topography. The churches, inns, and villages of France are little more than incidental presences in his landscapes and seascapes, giving over pride of place to images of the raw power of nature or of the beauty of French agriculture. Today we tend to forget that many forests are as artificial—as agricultural—as fields. Because forests are harvested infrequently, we do not notice that they are planted. Here, we see a group of trees, scarcely more than fifteen years old, growing in formation. Irregularities of spacing suggest that already some have been harvested.

Yet there is more to the subject than a simple description will allow. Monet surely chose to paint the trees because of the great swooping curves of their trunks that slice through the scene rather than because he wanted to teach a lesson about forestry. Like his friends Pissarro and Cézanne, Monet favored certain landscapes in which trees and foliage form a screen between the viewer and the ostensible subject of the picture. As Wildenstein's title makes clear, it is the screen of trees rather than the village of Bennecourt that is the true subject of the painting. From this work, it is easy to move forward to Monet's poplars and then to the linear geometries of Mondrian and other masters of the painted line. Or, alternatively, we can take yet another pictorial path

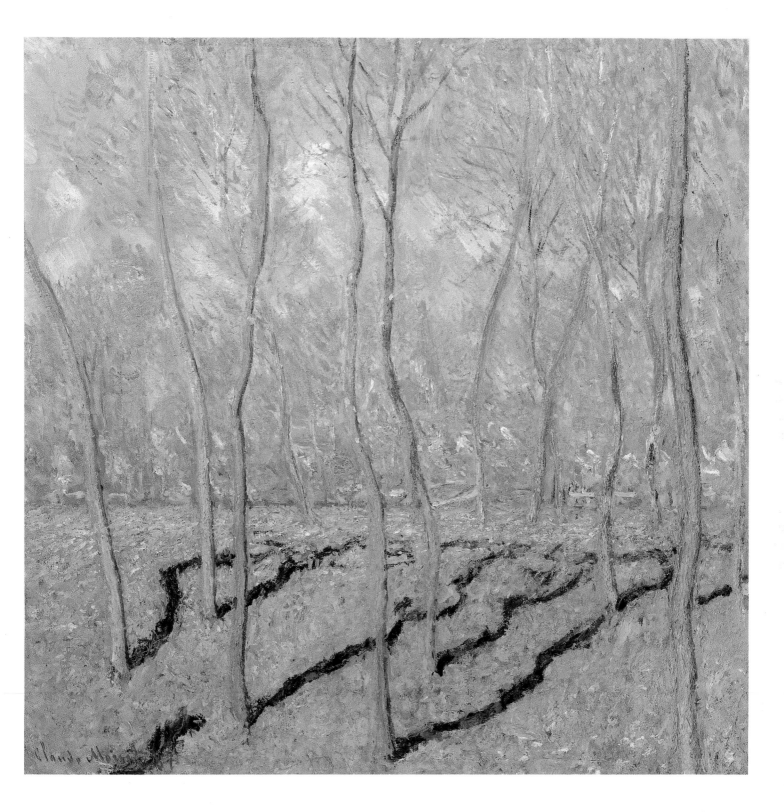

that leads us through many turns from this linear pat-
tern of branches through the curvilinear pictorial
fields of Matisse directly to Jackson Pollock and
Morris Louis.                                    —RB

1. Daniel Wildenstein, in *Claude Monet, Biographie et catalogue raisonné*, vol. 3: *1887–1898, Peintures* (Lausanne, Paris, 1979), pp. 6, 31, cat. no. 1125, titles the work *Arbres en hiver, vue sur Bennecourt*.

*43.* WEEPING WILLOW
*Saule pleureur*
1918

Oil on canvas, 51⅝ × 43⁷/₁₆ in. (131.2 × 110.3 cm)
Signed and dated lower left: *Claude Monet 1918*

In 1918, the world waged war while Monet worked in his garden. The aerial warfare, the casualties—all the horrors of war—were reported daily in the newspapers, and Monet was surely not oblivious to the great battles that changed the world. Yet his correspondence from that year is almost mute on the subject. Aside from complaints about minor inconveniences in the flow of supplies, food, and gardening materials to his center of self-imposed exile at Giverny, the many letters from 1918 hardly allude to the war.

In 1918 Monet finished, signed, and dated two great paintings of the smaller of two weeping willows that grew next to his now-famous water garden.[1] Both of these pictures were painted out-of-doors as well as in the vast, glass-roofed studio Monet had constructed in 1915 so that he could work on a large scale in full natural light throughout the year. Each work represents a single tree, whose rhythmic trunk and branches gesture as freely as did Monet's hands and arms when he painted it. The tree in the Sirak painting rises in the midst of weeping foliage, as though to defy gravity. Painted lines and strokes seem almost to scream in a tortured chorus.

Gone forever in Monet's art is the optimism and clarity of Impressionism, of those summer days along the Seine, saturated with sun and filled with boaters, flowers, and lovely ladies. Gone too is the sense of the tangibility of form suffused with light that fills Monet's great series. Here all space has mass, and what is behind the tree is as palpable as the tree itself. Are those frantic lines of yellow, deep purple, plum, and green-blue leaves or the spaces between leaves? Is the foliage real or reflected?

There were, in essence, two Monets in the twentieth century. One created limpid, serene views of the reflective surface of his pool, as calm, soothing, and deeply meditative as any landscapes ever painted. Another created flowers and foliage with such passionate conviction that it is almost impossible not to call the resulting canvases "Expressionist." To find a Monet closer in spirit to Kirchner than to Corot, closer to Munch than to Matisse, is to find the other side of one of the greatest geniuses in French art.

Monet finished very few canvases in his later years. He was financially secure and had no real need to sell his recent paintings. The handful of paintings that he did sign and date in the last decade of his life, of which the Sirak picture is one, tells us about the triumph of an aged artist who, like Titian, Rembrandt, and Goya, transformed the entire history of art, an artist for whom age had become a new, agonizing, and troubled reincarnation. In addition to the uncertainties of war, Monet endured the loneliness and despair of failing eyesight and dying friends (Pissarro and Cézanne had been dead for thirteen and ten years respectively, and Degas had just died in 1917).

The ultimate meaning of the Sirak painting lies in its imagery as interpreted in the context of its signature and date. Because Monet signed and dated so few paintings in his later years, this painting and the other, slightly smaller, painting (private collection, Switzerland) of the same motif are surely the "two decorative panels that I signed on the day of Victory and would like . . . to offer to the state"[2] about which Monet wrote in a letter dated November 12, 1918, the day after the Armistice was signed. The recipient of the letter was none other than Monet's own friend, the French statesman Georges Clemenceau.

Yet Monet seems to have changed his mind, perhaps as a result of an unrecorded conversation with Clemenceau, because he instructed Georges Bernheim-Jeune, one of his dealers, to offer only one of the two paintings to the French state in honor of what Monet called "that beautiful victory." No record of an offer by Bernheim-Jeune survives. It is an accident of fate that neither of the two paintings has remained in France and that the intended gift by the greatest artist then living in France to his own nation commemorating the Allied victory was either not made by his dealer or not accepted.

The two paintings were exhibited in 1919 in a small reprise of the famous Monet-Rodin exhibition that had rocked the aesthetic foundations of Europe thirty years earlier in 1889.                                    —RB

1. See Daniel Wildenstein, *Claude Monet, Biographie et catalogue raisonné*, vol. 4: *1899–1926, Peintures* (Lausanne, Paris, 1985), nos. 1868 (private collection, Switzerland), and 1869 (the Sirak painting). For a series of similar paintings, see ibid., pp. 280–284, nos. 1866–1877. Only three are signed and dated, two in 1918 and one in 1919.
2. Wildenstein, no. 2287, p. 401.

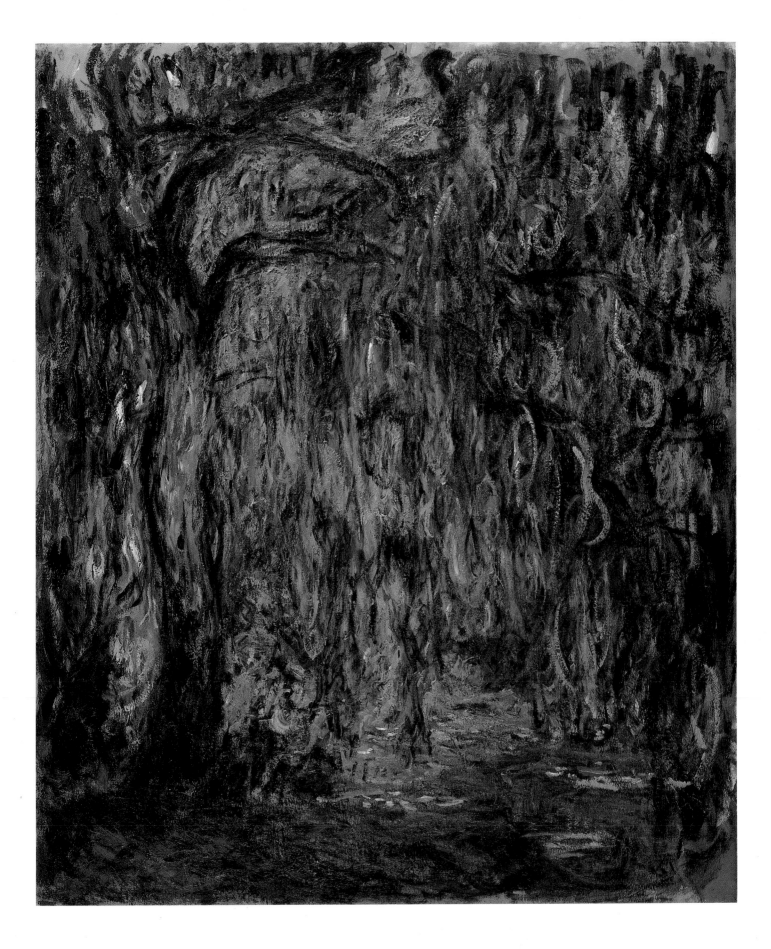

# GIORGIO MORANDI

Italian, 1890–1964

## 44. STILL LIFE WITH STATUETTE

*Natura morta con la statuina*
1922

Etching on light brown paper, image size: 2³/₈ × 2⁷/₈ in.
(6 × 7.4 cm); paper size: 4³/₄ × 6¹/₂ in. (12.1 × 16.5 cm)
Signed and dated lower right: *Morandi 1922*. Numbered
lower left: *17/30*

*Still Life with Statuette* is a relatively early example
of Morandi's work in etching. It marks the beginning
of an intense period of printmaking that continued
with vigor into the mid-1930s.

The small scale of the work may reflect Morandi's
desire to focus on the technical problems inherent in
the printmaking process.[1] Here he explores a wide
range of tonal and textural effects relying on etching
techniques alone rather than combining these with
either drypoint or aquatint to achieve certain effects.
The softly blurred lines of the middle background are
created by an unusual method of wiping the plate in
preparation for the printing process; in some areas,
globs of black ink were deliberately left on the plate,
adding an aged appearance to the work. The lightly
etched lines of the background indicate recessive
space, while the thicker lines that model the forms of
the bottles and other objects in the foreground project
these toward the viewer.[2] This sort of experimenta-
tion, which is to be expected during the period when
the artist was defining the limits of his medium, is
different from the even tonality and greater clarity
that characterize his later works, such as *Still Life with
Seven Objects in a Tondo* of 1945 (cat. no. 45).

Morandi's artistic development points to specific
external influences in the early years. Stylistically, the
Sirak still life relates to his association with the Scuola
Metafisica painters Giorgio de Chirico and Carlo
Carrà, whom he met in 1919 and with whom he later
exhibited in a group associated with the avant-garde
periodical *Valori Plastici*. Their influence is especially
noted in the emphasis on solid tangible form. As
Frances M. Daly has pointed out, "the dark tonalities
and dense blacks" in the Morandi prints "correspond
to the deepened colors and impasto surfaces of his

contemporary *Valori Plastici* paintings."[3] Even the
subject matter, which combines a classical statue
with mundane objects, may be related to earlier meta-
physical paintings such as De Chirico's *The Incerti-
tude of the Poet* of 1913 (collection of Roland Penrose,
London).[4] But whereas De Chirico's work juxtaposes
unlikely still-life components—classical motifs, ordi-
nary objects, and modern trains and factories—the
objects that populate Morandi's still lifes contain little
of the extraordinary; in fact, they are so often repeated
in other compositions that they become familiar.

For all the familiarity one encounters in Morandi's
work, there is yet a sense of mystery and enigma. In
1922, when Morandi made this etching, De Chirico
commented on the character of Morandi's art:

> He observes with the eye of a believer and the
> intimate skeleton of these objects, whose still-
> ness makes them seem dead to us, is captured by
> him in its more consoling aspect, *in its eternity.*
> By so doing, he participates in the great lyricism
> styled by the latest current of European art,
> namely *the metaphysics of everyday objects*, of
> those objects we have become so accustomed to
> that we tend to observe them with the eye of
> someone *who looks without being aware of it.*[5]

Nevertheless, some scholars tend to de-emphasize the
metaphysical aspect of Morandi's work and focus
instead upon its formal qualities and compositional
subtleties—qualities that make his art seem very mod-
ern, transcending the otherwise traditional and even
conservative aspects of a twentieth-century painter
devoted to still life.

Norman Bryson in his recent book contemplating
the "overlooked" art of the still life,[6] confronts these
enigmas directly, seeing them not as features peculiar
to Morandi alone but as suitable propositions for
framing a larger discussion of still life as a discrete
category of painting. Certainly Morandi's work
indicates the great profundity possible in such un-
assuming works as this, created with great care and
consummate workmanship.                              —LSC

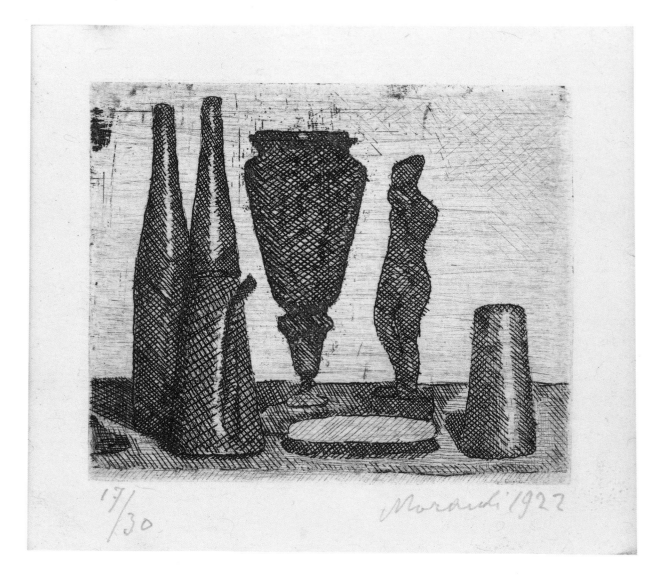

1. Frances M. Daly, Terry Rothschild Neff, and John Hallmark Neff, *Giorgio Morandi, 1890–1964* (exh. cat., Busch-Reisinger Museum, Harvard University, 1968), p. 23.

2. For one of the best discussions of Morandi's technical approach to etching, see Amy Namowitz Worthen, "Giorgio Morandi as an Etcher," in *Giorgio Morandi* (exh. cat., San Francisco Museum of Modern Art, 1981), pp. 47–55.

3. Daly et al., p. 23.

4. Illustrated in Charles Sterling, *Still Life Painting: From Antiquity to the Twentieth Century* (New York, 1981), pl. 122.

5. Giorgio de Chirico, introduction for *Primaverile Fiorentina* (exh. cat., Palazzo Sangallo, Florence, 1922), quoted in *Morandi,* trans. Andrew Ellis (New York, 1988), p. 141.

6. Norman Bryson, *Looking at the Overlooked: Four Essays on Still-Life Painting* (Cambridge, Mass., 1990). See pp. 97–98 for a brief discussion of Morandi.

45. STILL LIFE WITH SEVEN OBJECTS
IN A TONDO
*Natura morta con sette oggetti in un tondo*
1945

Etching on light tan paper, 10½ × 11¾ in. (26.7 × 29.9 cm)
Signed and dated lower right: *Morandi 1945*. Numbered
lower left: *48/50*. Plate signed and dated: *Morandi, 1945*

As early as 1921, Morandi began etching on copper plate. Copper was more expensive than the zinc he had previously used, but it was also harder and allowed the artist more control of line depth. By 1927 Morandi was using Dutch mordant, a corrosive substance that bites the design into the plate; for earlier works he had used nitric acid. The difference in the two approaches can be seen by comparing the two Sirak etchings. In the earlier *Still Life with Statuette* of 1922 (cat. no. 44), the lines are somewhat blurred, and the crosshatched areas create a dark, dense effect. The lines in the 1945 *Still Life with Seven Objects in a Tondo* crisscross each other throughout the print, but the effect is one of greater subtlety and softer modulation between light and dark. Moreover, in the later work, the lines are cleaner and more precise because the Dutch mordant bites the line deep rather than wide.[1]

Much of the magic of Morandi's *Still Life with Seven Objects in a Tondo* derives from the way the objects gently emerge from the network of lines, and then fade back again. Norman Bryson has commented on these effects: "Modernist still life knows this space well: the work of Morandi is made up of such vibrations in vacancy, of 'seeing solid in void and void in solid,' and of interresonating intervals eventually so fine that it takes a lengthy viewing to analyze their discriminations."[2] Close contemplation of Morandi's print calls attention to how much we take for granted the remarkable process by which we "read" objects among the overall pattern of crosshatching. Morandi's participation in this mystery is dramatized by the way he intertwined a date and signature into the web of lines, for these are barely perceptible at the lower edge of the picture.

An unusual feature of *Still Life with Seven Objects in a Tondo* is the circular format, which Morandi used for only three other prints. No doubt this afforded him the opportunity to deal with the problem of integrating rectilinear and curved shapes within a predetermined format. The viewer's eye is first attracted to a series of vertical accents at the left edge of the composition, beginning with the long-necked vessel and continuing to the highlighted handle of the neighboring pitcher, and then to the more subtle vertical highlights on the tall goblet at the extreme right. The slightly cropped edge of the goblet causes the eye to travel down, and then back across the open space of the horizontal tabletop, and beyond to the long horizontal box. The delicate relationships of the various curved lines within the composition slowly become more obvious. The handle of the pitcher in the background closely follows the silhouette of the neighboring pitcher, and both lines respond to the shapes of the antique vase second from right.

As with so much of Morandi's art, the longer we look the more we appreciate the purposiveness and power of his compositional arrangement. And yet, no matter how often we return, there are always new mysteries to explore. Any attempt at rational analysis ultimately crumbles before the beauty and simplicity of his visual poetry. —LSC

1. Amy Namowitz Worthen, "Giorgio Morandi as an Etcher," in *Giorgio Morandi* (exh. cat., San Francisco Museum of Modern Art, 1981), pp. 54–55, n. 5.
2. Norman Bryson, *Looking at the Overlooked: Four Essays on Still Life Painting* (Cambridge, Mass., 1990), pp. 97–98. Bryson related Morandi's still lifes to the stark Minimalist interiors that characterize the modernist house. He contrasts both with the clutter of the Victorians, who loved "rooms crammed with objects" or, by extension, to certain seventeenth-century Dutch still-life paintings filled with consumable goods.

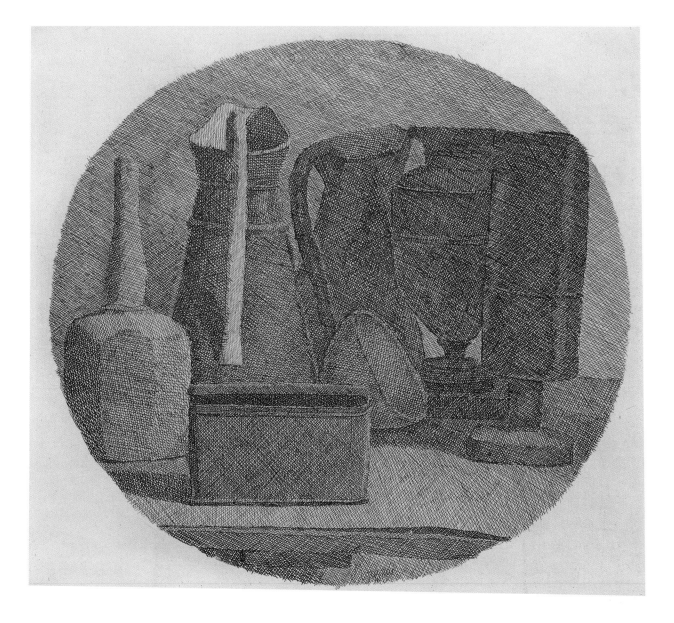

*46.* STILL LIFE
*Natura morta*
1945

Oil on canvas, 15⅝ × 19⅜ in. (39.5 × 49.2 cm)
Signed and dated, left of center: *Morandi 1945*

Few artists in the twentieth century have been identified as closely with a single genre as Giorgio Morandi. Although the still life has been one of the mainstays of modern painting, in works by Paul Cézanne, for example, and the Cubist still lifes by Braque and Picasso, few artists at any time have pursued the genre with the single-mindedness that Morandi brought to the subject. While he acknowledged earlier sources, his still lifes are unique in their individual expressive character and their general treatment of forms in space.

*Still Life* dates from a transitional period in Morandi's career. After 1943, a productive, and in many ways climactic, year in which he painted some seventy oils, Morandi paused to take stock of his work. In 1945, the year of *Still Life*, he painted fewer than a dozen canvases. This juncture marked the division between the middle period of his career and the late phase. The long exploration of the possibilities of formal invention that guided Morandi from the late 1910s gradually gave way to an examination of the abstract essence of forms themselves.

*Still Life* is an excellent example of Morandi's mature style and is representative of the complex simplicity of his work. Here the familiar objects of the artist's studio have become transcendent rather than mundane. Morandi often repeated certain basic forms in other works to gain a more thorough understanding of those forms. The striped vase to the left of center in the Sirak work, for example, is found in his oeuvre as early as the etching *Vaso a striscie con fiori* of 1924[1] and the *Still Life* of 1929.[2] The square-bodied, narrow-necked bottle at the center of the Sirak work can be found in Morandi's still lifes beginning in the mid-1930s.[3]

The careful modulation of forms, values, and colors in *Still Life* emphasizes the role of balance and tension in Morandi's work. For every force there is a counterforce. The slight forward thrust of the objects, culminating at the lower corner of the central bottle, is countered by the gentle arc of the tabletop behind and above the still-life arrangement. The sharp angularity of the central bottle and the box to the right of it is softened by the rounded objects at the far left and right.

The rapid visual motion generated by the closely spaced stripes of the vase is counterbalanced by the broad expanse of unmodulated light on the bottle to the right of it. These features are more than formal exercises. Morandi invests his objects with a gravity other than physical weight, a significance that points outside the work to some truth about the nature of things. These bottles, vases, and cups occupy a double existence, one physical, the other metaphysical.

In this profundity lie the seeds of Morandi's late works and references to his earlier "metaphysical period." As a member of the Scuola Metafisica in Bologna, with Giorgio de Chirico and Carlo Carrà, Morandi had already professed an interest in expressing the mystery of existence through everyday objects. In all his later still lifes, he continued to invest the most banal of objects with an otherworldly significance.                            —GW

1. Lamberto Vitali, *Giorgio Morandi* (exh. cat., Galleria d'arte moderna, Bologna, 1975), graphics cat. no. 7.
2. Lamberto Vitali, *L'Opera grafica di Giorgio Morandi* (Turin, 1964), cat. no. 23.
3. Ibid., cat. no. 299, for example.

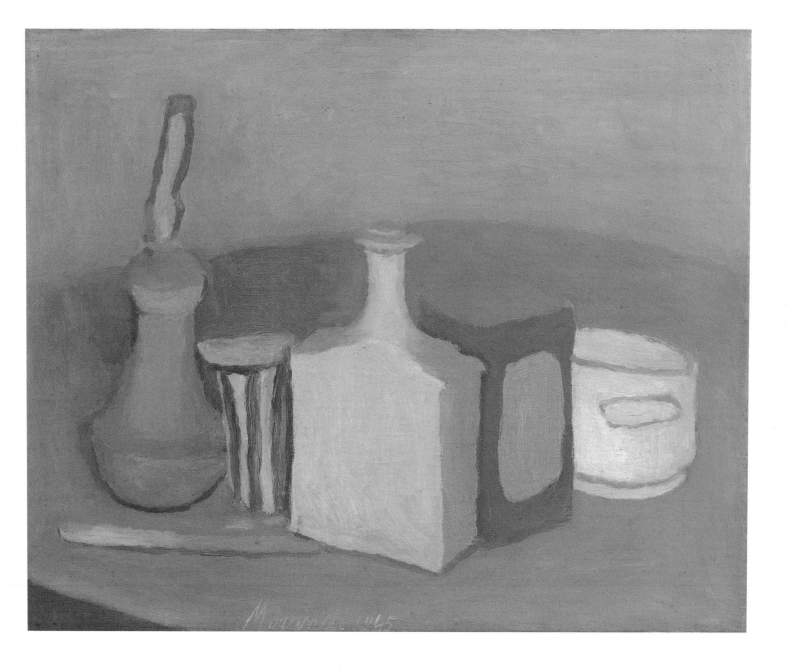

# JAN MÜLLER

American, born in Germany, 1922–1958

### 47. APPARITION FROM HAMLET
1957

Oil on wood, 11 × 16⅝ in. (28 × 41.5 cm)
Painted on verso: *Abstract (Mosaic)*

Painted only twelve years after Müller started his art studies in the United States, *Apparition from Hamlet* is a hybrid of pre–World War I German Expressionist tendencies and the Anglo-Saxon heritage which Müller adopted after leaving Germany with his family at the age of eleven. As indicated by the title, the subject refers to the opening act of Shakespeare's tragedy, when the ghost of the murdered king appears at the midnight changing of the guard. Everything here is Shakespearean: the time between nightfall and dawn when agonizing decisions are made; the heightened emotion contrasted with the starkness of nature; the despair, or, at best, innermost spiritual need and hesitation, expressed through the voyeuristic postures and grotesque expressions; and the ominous layering of sorcery and deceit.

The only knowing face in the group is that of Hamlet, the protagonist, who sits, as if enthroned, holding in his left hand a white-haired mask (or severed head)—a portent of his vow to avenge his father. Indeed, the idea of masks is appropriate to the theme of Hamlet's dilemma, for as the hero feigns madness, he puts on the mask of madness.[1] Behind Hamlet, four white-smeared heads emerge out of the darkness, looking at the crouching naked figure on the ground. This is not the armored king but more like the "glow-worm" that announces the approach of dawn as he bids farewell and disappears. Müller was known to adopt images from a variety of sources, typically the Bible and the classics of world literature, especially those from medieval, chivalric literature. The figure on all fours—a recurrent theme in his oeuvre (for example, *Hanging Piece*, 1957, collection of Horace Richter)—is most often rendered in a playful posture with a figure on its back. Its inclusion here could be a reference to the last act of Shakespeare's play, in which Hamlet contemplates his own mortality among the gravediggers as he clenches the skull of Yorick, the jester "who had borne me upon his back a thousand times."

The theatrical narrative and dramaturgic description in *Apparition from Hamlet* boldly contrast with the abstract, nonobjective elementarist approach in the painting on the reverse of the panel, which, though not unusual for a student of Hans Hofmann (with whom Müller studied between 1945 and 1950), puts him within the sphere of those Bauhaus artists who analyzed color relationships and their spiritual values: Paul Klee, Johannes Itten, Vasily Kandinsky, or Lyonel Feininger. Not incidentally, it was László Moholy-Nagy, a Bauhaus teacher and family friend, who first introduced Müller to modern art.[2]

Although neither side is signed or dated, it is reasonable to assume, based on other works by Müller exhibited during a retrospective of his work at the Solomon R. Guggenheim Museum in 1962,[3] that *Apparition from Hamlet* is the more recent of the two paintings, as it confirms the artist's preoccupation with profound philosophical subjects shortly before his death. The free-form organicism of his last works contrasts sharply with the careful emphasis on geometric organization of the earlier abstractions.

As distinct as these two styles are, they inform us of Müller's full abandonment to the art of painting. The figurative side demonstrates a brisk handling of leafage and brushwork laid down horizontally from side to side; the geometric units on the reverse side, although tightly ordered, are nonetheless painted with the same breadth of aggressive handling. Whether exploring formal issues or focusing on profound subject matter, Müller remains a painter in the realm of pure painterly form and visual poetics.     —MMM

1. This idea is discussed by Jan Kott, *Shakespeare Our Contemporary*, trans. Boleslaw Taborski (Garden City, New York, 1966), pp. 61–63.
2. Martica Swain, "Jan Müller: 1922–1958," *Arts Magazine* 33 (February 1959): 38.
3. Thomas Messer, "Jan Müller's Art," in *Jan Müller 1922–1958* (exh. cat., Solomon R. Guggenheim Museum, New York, n.d.), n.p.

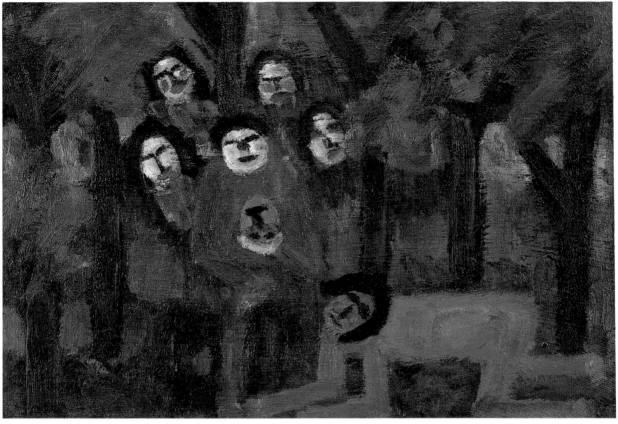

APPARITION FROM HAMLET

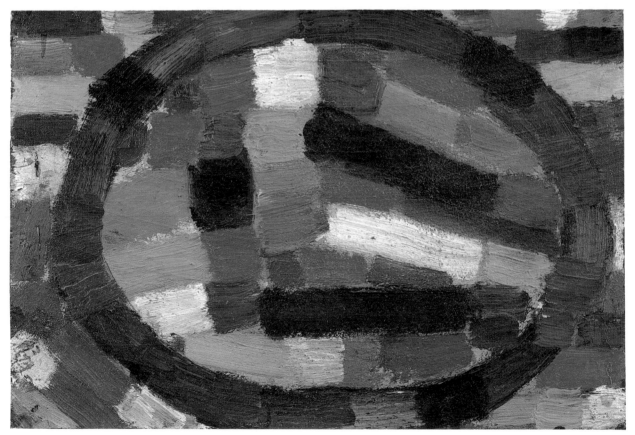

Verso: ABSTRACT (MOSAIC)

# EMIL NOLDE

German, 1867–1956

*48.* STEAMBOAT AND SAILBOAT
*Dampfer und Segler*
1913

Watercolor on tan paper, 10⁷/₁₆ × 15⁷/₈ in. (26.6 × 40.4 cm)
Signed lower right: *Nolde.* Dated lower left: *1913*

Born in the marshy lowlands of the German-Danish border, Emil Hansen, who in 1902 took the name of his native village, Nolde, lived nearly all his life close to the sea. Not surprisingly, ships at sea and the sea itself are among his most persistent subjects. Nolde's earliest depictions of this subject were inspired by a brief stay in Hamburg in early 1910. The Sirak watercolor was executed during a more exotic journey that, beginning in October 1913, took him to the South Pacific, via Russia, Korea, Japan, and China. Nolde and his wife Ada traveled as members of a small expedition organized by the German Colonial Ministry to study health conditions in the German colonial possessions, in particular the possible reasons for a notable decline in the birthrate among the natives, an alarming development for the colonists who depended on a steady supply of local labor. Nolde's role was essentially that of a pictorial reporter.

Although the precise locale depicted in the Sirak watercolor cannot be determined, the light-toned waves, set off against a vermilion sky, bring to mind Nolde's surprise upon seeing that the Yellow Sea off the China coast "is indeed yellow."[1] Similar in conception and technique, though not in color, is a watercolor preserved at the Nolde Foundation in Seebüll depicting junks on the River Han.[2] Even more closely related are three oil paintings executed upon Nolde's return to his studio in 1914: *Sailing-Boats on Yellow Sea, Sailing-Boats on Yellow Sea II (Small Pointed Sails)*, and *Stormy Sea (2 Sailing-Boats and 1 Small Steamer).*[3]

Nolde painted the watercolor on delicate Chinese rice paper that characteristically absorbs the paint so that in the saturated parts the paper itself is pure color. Once the initial watercolor wash had dried, Nolde reinforced the imagery—the boats, the plumes of smoke, and the cresting waves—by swiftly dragging a drier brush across the colored ground. As recounted in his memoirs, Nolde's watercolor technique had its origins in a chance discovery he made in 1908 during a visit to Cospeda, a small town near Jena. On a cold winter day he was working out-of-doors when snow fell on the watercolor sketches that lay scattered around him, altering the texture and saturation of the colors in an unexpected way. On another occasion the wet colors froze on the paper, forming random patterns. Nolde was fascinated by the autonomous behavior of the colors and welcomed the manner in which nature imposed its laws on his work.[4]

The Cospeda watercolors were painted on cardboard. Beginning in 1910, when Nolde first started to use the absorbent Chinese rice paper, he consciously strove to duplicate the accidental effects brought about by the earlier intervention of snow and frost by allowing the colors to spread across the sheet and merge with one another, forming edges and color concentrations that often gave rise to unexpected pictorial structures. These Nolde encouraged to emerge, alternately reinforcing the individual lines and deepening or lightening the saturations through further admixtures of color or water. Occasionally he supplemented the watercolor medium with tempera, colored inks, and pastel.

Nolde's intuitive method accorded with his deep-seated yearning to allow color to evolve in the painterly process "as nature herself forms ores and crystals, the way moss and algae grow, and flowers open and bloom under the rays of the sun,"[5] and stands in sharp contrast to Feininger's cool pictorial logic, which even in an image as potentially suspenseful as a ship in distress (see cat. no. 17) sublimated the dramatic element inherent in the subject in terms of more consistently aesthetic considerations. Nolde's ships always plow the sea with expressive force. —HU

1. Emil Nolde, *Mein Leben,* with an epilogue by Martin Urban (Cologne, 1976), p. 253.
2. Martin Urban, *Emil Nolde Landscapes: Watercolors and Drawings* (London, 1970), pl. 2.
3. Martin Urban, *Emil Nolde, Catalogue Raisonné of the Oil Paintings,* vol. 1: *1895–1914* (London, 1987), nos. 606–608.
4. Nolde, p. 144.
5. Ibid., p. 148.

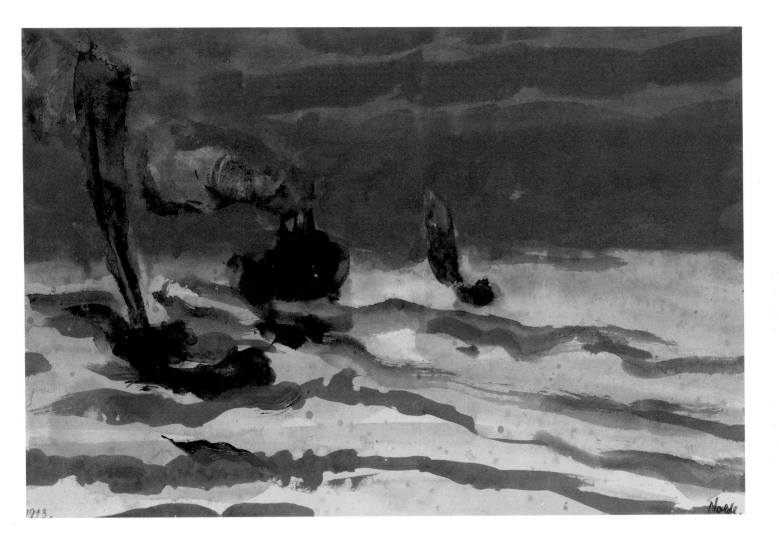

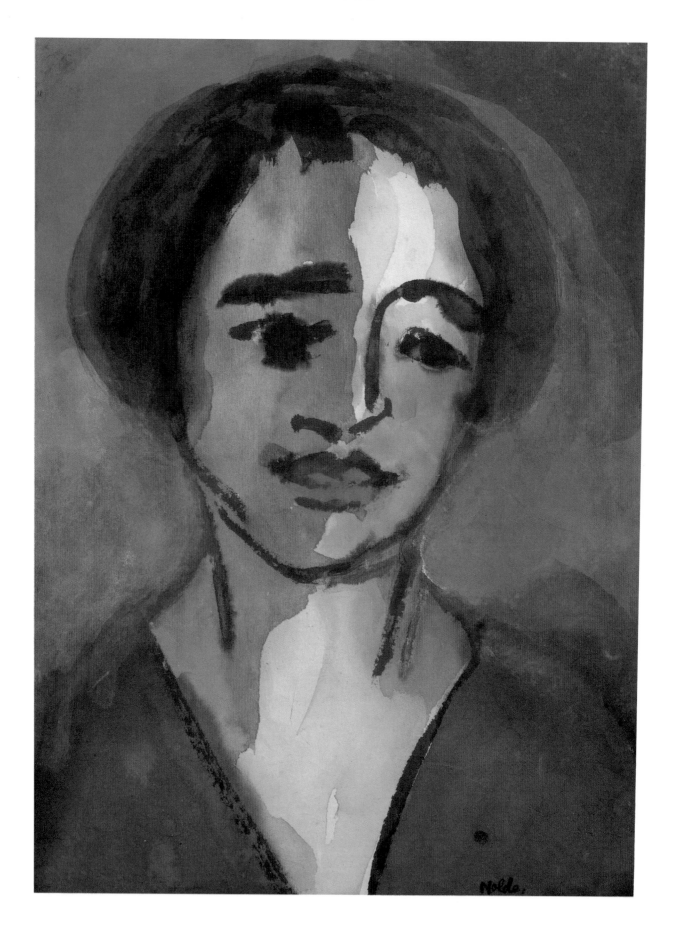

## 49. YOUNG GIRL
*Junges Mädchen*
1920

Watercolor on paper, 18½ × 14⅛ in. (46.9 × 35.8 cm)
Signed lower right: *Nolde*

Nolde was by nature a reticent man. Indeed, he was painfully shy, especially as a young man, and even in his later years he did not make friends quickly. This no doubt explains why he painted so few portraits or, for that matter, self-portraits, which are equally rare in his oeuvre. While he was able to express his feelings in figure compositions, landscapes, and flower paintings, his retiring personality apparently prevented both psychological analysis of others and self-revelation in the form of the conventional self-portrait. Nolde himself suggested that much when he wrote in his memoirs of his early efforts to make drawings of young girls: "Mostly I sat there full of inhibitions, and there was no real human contact between me and the young girls. I did not have the gift for small-talk and pleasant conversation." As to his early self-portraits, which he drew as if he were "a vase or some other object," he felt that they "led nowhere."[1]

Nolde's most interesting portraits are the two watercolor double portraits he painted of himself and his wife in 1932. These, however, Nolde did not paint from life, but from his imagination. They were intended to be symbolic. As he explained to his wife with reference to one of the two works: "This is our best portrait of our superior being."[2] And Nolde expressed this symbolic intent entirely through pictorial means—through color, posture, and gesture. When facing other sitters, he was similarly guided foremost by pictorial considerations. As a consequence, Nolde painted types, rather than individuals, whose anonymity is reinforced by the generic names he gave to his portraits. Even his portrait of Gustav Schiefler (1915, Brücke-Museum, Berlin), the famous collector of prints by Edvard Munch and the German Expressionists and the author of the catalogue of Nolde's graphic work, is simply entitled *Herr Sch.*

The portrait of a young girl in the Sirak Collection is not quite so detached. The inclined head, for instance, and averted gaze communicate an air of introspection, perhaps even of melancholy. Yet while the bust-length format and close-up view of the life-size head would have allowed the fullest exploration of facial expression, psychological distance is maintained as a consequence of the generalized face, which most likely bears only a typological resemblance to the sitter's real features.

Technically, the watercolor illustrates a pictorial problem that had occupied Nolde since 1914: how best to achieve an overall tonality in a painting without sacrificing the independence of the individual colors. In the Sirak watercolor he accomplished this through a carefully contrived alliance of blue and red. Instead of being sharply contrasted, these colors have been applied in intermediary hues and arranged so as to form transitions from red to blue and vice versa. Balancing each other in a subtle way, they unify the picture surface in a darkly glowing harmony of colors. The graphic elements were added after the initial watercolor wash had dried. *Head of a Woman,* a watercolor of about 1920 preserved in the National Gallery in West Berlin, possibly depicts the same sitter.[3] The Berlin watercolor is slightly smaller than the example in Columbus but is similar to it in terms of the general relationship of height to width.      —HU

1. Emil Nolde, *Mein Leben,* with an epilogue by Martin Urban (Cologne, 1976), p. 44.
2. Peter Selz, *Emil Nolde* (New York, 1963), p. 69; Horst Uhr, *The Collections of the Detroit Institute of Arts: German Drawings and Watercolors* (New York, 1987), pp. 196–197.
3. Peter Krieger, ed., *Meisterwerke des Expressionismus aus Berliner Museen* (Berlin, 1982), pp. 124–125, no. 89.

## 50. SUNFLOWERS IN THE WINDSTORM
*Sonnenblumen im Sturmwind*
1943

Oil on board, 28⅝ × 34⅝ in. (72.6 × 88.1 cm)
Signed lower right: *Emil Nolde*

"I believe in the moon and in the sun, I feel their influence. I believe in the fire that is blazing in the bowels of the earth and that it influences us mortals."[1] This credo is only one of several passages in Nolde's memoirs and letters that demonstrate his mystical identification with nature. Once, as an adolescent, lying face down in a field, he imagined making love to "the entire large, round, wonderful earth."[2] And in a letter of September 7, 1901, to his fiancée Ada Vilstrup he spoke of his hands and feet "taking deep root down in the sand," and of his toes, having "grown about twice their length," soon to "turn into great trees, flowering in strange colors."[3] Nolde expressed this union with nature throughout his career not only in landscapes of epic breadth but also in flower pictures imbued with intensely personal feeling. It was also in a series of vigorous flower pictures that between 1904 and 1908 he first approached color for its own sake. Nolde loved flowers, "in their fate," as he writes, "shooting up, blooming, radiant, glowing, enchanting, bending down, decaying, and thrown away into a pit. Our own life is not always so logical, but it too always ends in the fire or in the grave."[4]

Wherever he lived Nolde surrounded himself with a luxurious garden. His lushest garden grew at Seebüll, where he lived from 1927 on. Filled with a great variety of flowers and protected from the wind by reed fences, hedges, and the gentle slope of the mound upon which he had built his studio, the flower beds—in yet another instance of nature identification—were planted to form the initials *A*, for his wife Ada, and *E*, for Emil. This blooming paradise, reminiscent of Monet's garden at Giverny, provided an important source of inspiration for many of Nolde's finest paintings and watercolors from the last thirty years of his life.

In the Sirak painting three sunflowers struggle to survive a storm that has swept heavy clouds from the nearby sea, while four sailboats, visible against the last glimpse of a sunset, bravely cleave the waves. The ominous mood is reinforced by both the somber color scheme, dominated by tones of black, blue, and dark

violet, and the heavy impasto of the brushstrokes. Removed from the environmental context of the nurturing soil, the flowers are seen up close, mercilessly exposed to the vast mournful sky that fills more than half of the composition.

The foreboding character of the painting would seem to be at odds with the tranquil setting of Nolde's garden described above. But Nolde's imagination is known to have been especially receptive to the elemental forces in nature irrespective of the conditions of his surroundings. Reporting on the progress of his work at Lildstrand, a small fishing village on the lonely coast of north Jutland, he wrote to Ada during the early months of their courtship in 1901:

> I stood peacefully behind the dunes, painting two small houses, their outlines growing indistinct in the dusk. The wind began to blow, the clouds grew wild and dark, a storm blew up, and the gray sand swirled high above the dunes and the little houses. A raging storm—then, suddenly, a powerful brush ripped through the canvas. The painter came back to himself and looked around. It was still the same quiet and beautiful evening hour. Only he had been carried away and lived through a storm in his imagination. The image disappeared. . . .That's the kind of thing that happens to me.[5]

Painted in 1943, the Sirak sunflowers date from the most difficult period of Nolde's career. Although he had joined the National Socialist Party in 1923, he was not spared Hitler's fanatic vilification of modern art. More than a thousand of Nolde's works were confiscated in 1937 from German museums, and nearly thirty were included in the infamous Degenerate Art exhibition that opened in Munich in July of that year. In August of 1941, Nolde was forbidden to paint or to engage in any related professional activity on the grounds of cultural irresponsibility. It was under these conditions that he set to work in a tiny room in his isolated house at Seebüll, producing what eventually amounted to more than 1,300 small watercolors, usually measuring no more than eight by six inches, his "unpainted pictures," as he called them. Only rarely did he dare to paint in oil, for fear that the smell of the pigments might betray him in the event of a surprise inspection by the Gestapo. In 1943, for instance, he painted only five canvases; all are of flowers, including

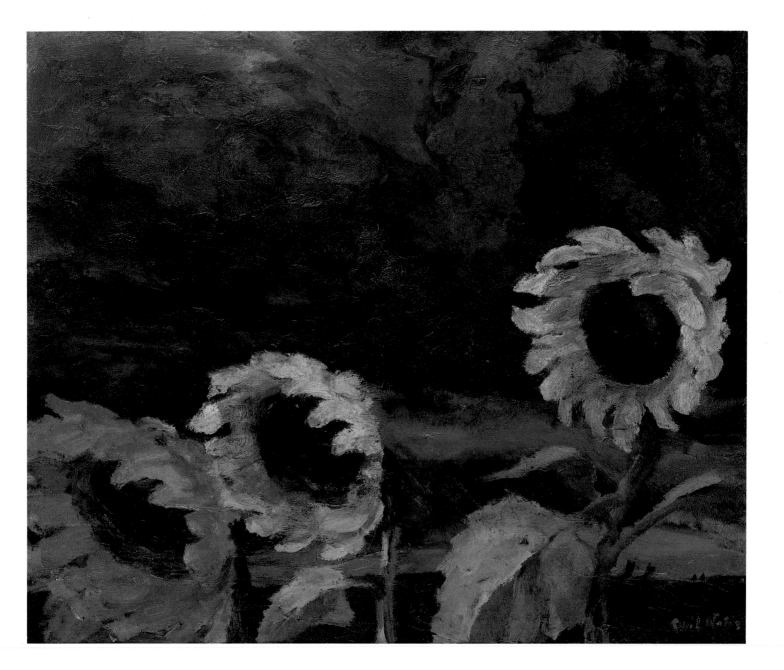

*Sunflowers in the Evening Light* (art market, London, 1966),[6] a painting that bears perhaps the closest relationship to the Sirak work of the same year. In this context, and especially given Nolde's mystical identification with nature, it is difficult not to see his *Sunflowers in the Windstorm* as a poignant autobiographical statement. —HU

1. Emil Nolde, *Mein Leben,* with an epilogue by Martin Urban (Cologne, 1976), p. 66.
2. Ibid., p. 26.
3. Martin Urban, *Emil Nolde Landscapes: Watercolors and Drawings* (London, 1970), p. 14.
4. Nolde, p. 148.
5. Quoted in *Emil Nolde: Gemälde, Aquarelle, Zeichnungen und Druckgraphik* (Cologne, 1973), p. 39.
6. See *Emil Nolde* (exh. cat., Marlborough Fine Art, 1966), p. 16, no. 4.

# CAMILLE PISSARRO

French, 1830–1903

### 51. LANDSCAPE NEAR PONTOISE
*Paysage près Pontoise*
1878

Oil on canvas, 21¼ × 25⅝ in. (53.9 × 65.1 cm)
Signed and dated lower right: *C. Pissarro. 78*

In 1878 the Impressionists gathered together expecting to form the fourth Impressionist exhibition. However, the project was postponed until the following year, for the artists encountered problems that impeded the organization of the exhibition. First there was the defection of Renoir, who decided to participate in the Salon. Another obstacle was the World's Fair to be held in Paris from June to November 1878, which would draw away most of the scarce attention given to the Impressionists.

Camille Pissarro, one of the eldest and most loyal members of the Impressionists, stood firmly against the temptation of the Salon and preferred rather to be seen as a radical, fiercely convinced of his own choice, than as one who compromised in any way. He felt bitter and cynical about the abandonment of the exhibition in 1878, but, in spite of his difficulties, in his letters expressed strong optimism about his painting — something seldom to be found in his correspondence. On October 5, 1878, he wrote to Eugène Murer, one of his few purchasers at the time: "I brought back a few new canvases, among others two with figures: would you like to come and see them here? You will also see landscapes, haystacks, and other carefully done landscapes. I believe that I have worked well."[1] Here Pissarro could have been referring to a group of works that includes the Sirak painting, indeed a carefully executed painting (the French term in Pissarro's letter is *soigné*). In another letter of 1878 to Murer, Pissarro described the same paintings: "I think they are exceptional, and you know how one is seldom satisfied."[2] For an artist who was hardly prone to any form of self-congratulation, such a label as "exceptional" was rare enough to be taken seriously. While Pissarro was not writing about any given painting, he conveyed a definite mood of optimism and joy concerning his own work in general that year.

More than a century later the Sirak painting can still be termed exceptional in Pissarro's oeuvre. The texture of the paint surface appears to be the product of a variety of extraordinary painterly devices: long sweeping brushstrokes in the right-hand portion of the foreground; minute commalike touches extending in all directions, especially in the foliage of the tree on the right; rather thick splashes of dense and almost shapeless blobs of paint, for example in the cabbages; thick and solid-looking encrusted impasto in the chalk-washed walls of the small house on the left; and the very thin lines of paint, hardly substantial enough to leave a mark on the canvas, seen in the scant poplars at the top of the hill.

An overall sense of harmony keeps the composition together, as various elements echo each other, conferring a certain unity to the whole canvas. One can observe, for instance, the various semirounded shapes that point upward; the plot of cabbages in the left foreground; the rounded hillside to the left, with scant sticks on top to emphasize the painting's ascending vertical dimension; the dome of whitish clouds that crowns the rounded shape of the foliage of the tree, also stretching skyward. This sense of verticality is strengthened by the rooftops and by the path which leads from the lower-left corner to the very center of the composition.

Chromatically, the work is organized around an apparently simple opposition: the blues and whites of the sky versus the greens and browns of the earth. However, on closer observation, the scheme appears to be more complex. The speckled green and yellow leaves of the tree to the right penetrate the background of the sky; the off-white pastiness of the clouds is echoed in the chalk facade of the house nestled against the earth tones of a hill. The composition offers a remarkable equilibrium based on a sophisticated system of interrelationships: between sky and earth, between wild nature and cultivated nature, between verticality and horizontality, between flatness and relief.

There is something human and universal about this painting, yet the picture is conspicuously devoid of

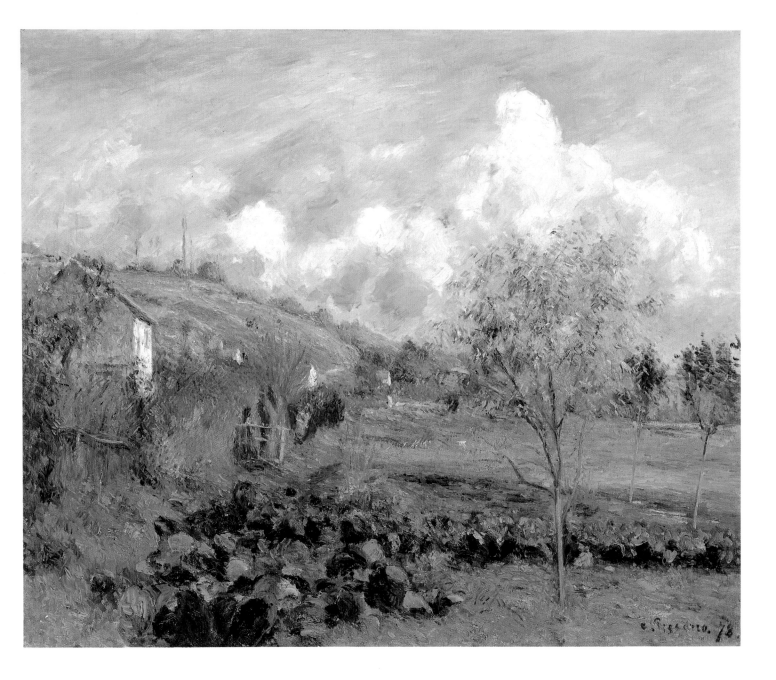

any figure. This, in fact, is exceptional, since nearly all the landscapes painted in 1878 by Pissarro include figures. Nevertheless, a human presence is signified by the organization imposed on nature: a path, nearly overwhelmed with weeds; dividing lines between plots of land; trees planted here and there; a cabbage garden; houses. The artist's role here was to provide a pictorial sense of the lively and always changing balance between man and nature—a complex, multi-faceted tension that results in a gratifying harmony, perhaps an apt metaphor for the act of painting itself.

—JP

1. See Janine Bailly-Herzberg, *Correspondance de Camille Pissarro*, 5 vols. (Paris, 1980–), 1: p. 128.
2. Ibid., p. 124.

## 52. THE STONE BRIDGE AND BARGES AT ROUEN

*Le Pont de pierre et les péniches à Rouen*
1883

Oil on canvas, 21³/₈ × 25⁵/₈ in. (54.3 × 65.2 cm)
Signed and dated lower right: *C. Pissarro 1883*

In 1883 Camille Pissarro traveled from his home in Osny to Rouen, a trip that was "arguably the most important of his life."[1] The pictorial results of his trip were remarkable. *The Stone Bridge and Barges at Rouen* provides fresh and exciting evidence of the strength of his artistic explorations during the short time he remained in the city. In less than two months he painted thirteen canvases and made numerous studies of urban scenes and river scenes, many of which formed the basis for prints.[2]

A few months before Pissarro went to Rouen, he visited an exhibition of Monet paintings organized by Durand-Ruel which included Monet's *View of Rouen* of 1872.[3] There is little doubt that Pissarro was impressed by Monet's dauntingly beautiful painting; it is even plausible that this work may have influenced Pissarro's decision to go to Rouen in October 1883 to broaden his range of subject matter. In any event, the visit to Rouen had far-reaching consequences for Pissarro's working procedures and triggered what one might call a "pictorial dialogue" between Monet and Pissarro that was to last approximately fifteen years, resulting in a core of Impressionist imagery drawn entirely on Rouen motifs—from Gothic subjects in the old city to industrial motifs on the south bank. The artists produced several series of works that culminated in 1892–1893 with Monet's paintings of the Rouen Cathedral, and subsequently in 1896 and 1898 with Pissarro's paintings of Rouen bridges and harbors.

The notion of series, in the wider sense, implies a group of works depicting similar, if not identical, subjects under varying conditions of light, weather, and seasons. Pissarro and Monet explored the pictorial possibilities deriving from this shared concern in very individualistic ways; each tended to complement, rather than duplicate, what the other had done or was doing. Pissarro's individual mark in the Rouen series is that he interlocked a larger web of variations: the movement of pedestrians, the carriage traffic of the street, the barge traffic of the Seine, or puffs of smoke that visually conflicted with or gradually dissolved into the clouds. In addition, Pissarro quite systematically shifted his vantage point from one painting to the next.

The Sirak painting belongs to a series of four industrial river landscapes depicting the surroundings of the same stone bridge that appears in each.[4] These four paintings comprise the largest initial series executed by Pissarro in Rouen in 1883. Mention of this series is found in Pissarro's letter from Rouen to his son Lucien on October 11, 1883. "I have started a motif alongside the riverbank toward the Saint-Paul church; as you look toward Rouen you can see to your right all the houses on the quay, lit up by the morning sun, in the background the stone bridge, to your left the island with its houses, factories, boats, barges, to your right a clutter of barges of all colors."[5] This can be read as a specific reference to the Sirak painting, since among the four works in this series, it is the only one that encompasses all the visual components described in the letter. Pissarro's description of the painting starts with the houses in the right background and ends with objects in the foreground, where one would normally be tempted to start. If we follow his visual order, our gaze crosses the picture, from right to left, and from left to right, from the background to the foreground and vice versa, thus circulating visually and pleasurably throughout this masterly work as he must have intended.

Although it is a horizontal view, the painting has strong vertical elements: the masts, the smokestacks, the trees, the houses rising above the bridge into the sky. That Pissarro must have planned his composition quite rigorously can be seen in the traces of charcoal along the taller of the two barge masts. Another more obvious indication of this is the carefully designed unity of the color scheme throughout the canvas, with mainly subtle greens, grays, and browns in the lower half of the composition and equally subtle grays, blues, and mauves in the sky above. Thus a wide gray harmony, founded on a shimmering variety of undertones, suffuses the whole canvas with extraordinary chromatic cohesion. This picture, the founding piece for one of the first series executed in Rouen, can thus be seen as emblematic of that most important trip in Pissarro's life.

—JP

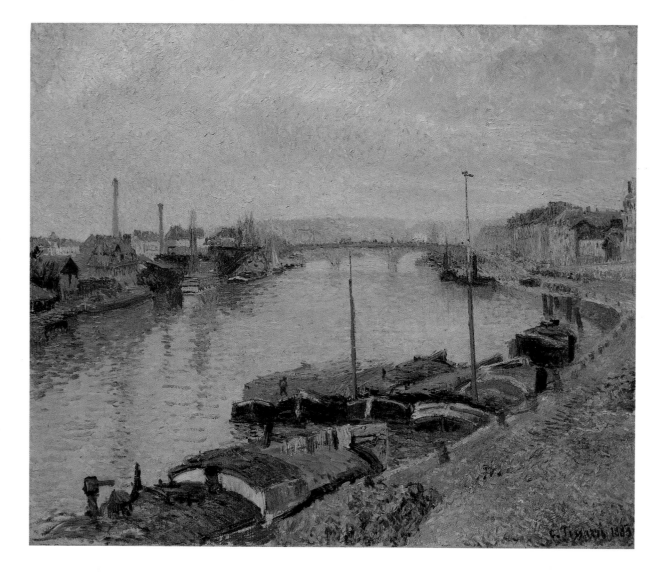

1. Richard Brettell, "Camille Pissarro: A Revision," in *Camille Pissarro 1830–1903* (exh. cat., Hayward Gallery, London, 1980), p. 29.
2. Ibid.
3. Daniel Wildenstein, *Claude Monet, Biographie et catalogue raisonné*, vol. 1: *1840–1881, Peintures* (Lausanne, Paris, 1974), no. 217. Also C. Lloyd, "Camille Pissarro and Rouen," in *Pissarro Studies* (London, New York, 1986), p. 91.
4. See Ludovic Rodo Pissarro and Lionello Venturi, *Camille Pissarro—son art, son oeuvre*, 2 vols. (Paris, 1939), 1: cat. nos. 604 (present whereabouts unknown), 605 (Columbus Museum of Art), 606 (Philadelphia Museum of Art), 607 (Acquavella Galleries); 2: pl. 126.
5. Janine Bailly-Herzberg, *Correspondance de Camille Pissarro*, 5 vols. (Paris, 1980–), 1: p. 238.

## 53. THE MARKETPLACE AT PONTOISE
*Le Marché de Pontoise*
1887

Brush and black ink, with gouache and watercolor,
heightened with white lead, on tan paper, laid down,
(sight) 12³/₄ × 9³/₄ in. (32.6 × 24.8 cm)
Signed and dated lower left: *C. Pissarro. 1887*

Camille Pissarro left Pontoise in December 1882 to
settle first in Osny, on the outskirts of Pontoise, and
then in 1884, in a little village called Eragny at equal
distance from Pontoise and Rouen. In Eragny there
were few distractions—a small village store and little
else. On Mondays, Julie (the artist's wife) went to
the market in the neighboring town of Gisors, often
accompanied by Paul-Émile and Cocotte (the two
youngest children) and occasionally by the artist him-
self, who joined them to sketch in the busy market
square.[1]

Pissarro created his first market scenes in 1881[2]
and continued the theme throughout his work, from
the 1880s onward.[3] Pissarro's market scenes were not
meant to function as mere illustrations suiting his
own ideology, but in a rather more complex and richer
fashion they offered a web of compositional possibili-
ties which he exploited and developed into various
groups of market scenes. The Sirak gouache belongs
to a group of three works that includes a brush draw-
ing in gray wash called *Compositional Study for Le
Marché de Pontoise* (Ashmolean Museum, Oxford)[4]
and the painting *Le Marché à la volaille, Gisors* of 1885
(Museum of Fine Arts, Boston).[5] The study was titled
on the basis of the name given the Sirak gouache in
the catalogue raisonné. Because all three seem to
represent the same location (in different formats and
media), all three should carry similar titles. Gisors,
rather than Pontoise, seems the most logical identifica-
tion since one of these works—the Boston tempera—
was exhibited during Pissarro's lifetime,[6] and the artist
himself most likely titled it, identifying the location as
Gisors. A fourth work, a watercolor from which the
artist quoted the figure on the right in the three related
works, was inscribed by Pissarro *Marché à Gisors,
1885.*[7] Further research is needed to resolve the ques-
tions, since it is not likely that Pissarro was careless
about such matters. Possibly he drew from visual remi-
niscences of Pontoise and more recent observations of
the Gisors market, which resulted in compositions not
specifically linked to a single location.

Also perplexing is the chronological order of the
three works. That the Boston painting came before
the Sirak gouache raises several questions. Usually a
larger tempera on canvas, such as the Boston work,
follows a smaller work, such as the Sirak gouache.
Here, however, the smaller gouache on paper was cre-
ated after, and resolved from, the larger tempera on
canvas. The first possible explanation was given by
Pissarro himself in a letter to his son Lucien dated
June 1, 1887: "Impossible to work outside, because of
storms all the time; so I am grinding out gouaches."[8]
Because gouaches were created indoors and in all
likelihood after other works, the Sirak gouache, far
from being a preparatory study, is a conscientiously
resolved and final work, even though it is of a smaller
format than the Boston tempera. The Ashmolean
wash, then, seems to be a clear attempt to adapt the
large, square Boston composition to the much smaller
vertical format of the Sirak gouache.[9]

Thus these three works, with the Sirak gouache at
the end of the chain, are to be seen as a group of com-
positions that modulate variations around a common
theme. In this sense, they have more to do with music
or, in the case of Pissarro, with the technique of prints.
The choice of media and formats and the freedom of
his brush offered Pissarro a far wider array of visual
and plastic possibilities, however, than was possible in
the print medium.
—JP

1. Ralph Shikes and Paula Harper, *Pissarro, His Life and Work* (New York, 1980), p. 202.
2. See Ludovic Rodo Pissarro and Lionello Venturi, *Camille Pissarro—son art, son oeuvre*, 2 vols. (Paris, 1939), 1: cat. nos. 1346–1348.
3. At least thirty-four market scenes are recorded in the cata-logue raisonné, most of them works on paper. To these should be added several paintings among the series of Dieppe (show-ing the Église Saint-Jacques on a market day), eight prints, and a number of drawings, watercolors, and paintings that are not included in the catalogue raisonné (to be published in the supplement to the catalogue raisonné being prepared by John Rewald).
4. See Richard Brettell and Christopher Lloyd, *A Catalogue of the Drawings by Camille Pissarro in the Ashmolean Museum* (Oxford, 1980), no. 178, p. 161.
5. Illustrated in *Camille Pissarro 1830–1903* (exh. cat., Hayward Gallery, London, 1980), cat. no. 61, p. 123.
6. Paris, Galerie Boussod et Valadon, *Exposition d'oeuvres récentes de Camille Pissarro*, February 25–March 15, 1890, cat. no. 17.
7. Pissarro and Venturi, no. 1401.
8. Janine Bailly-Herzberg, *Correspondance de Camille Pissarro*, 5 vols. (Paris, 1980–), 2: p. 179, no. 178.
9. The Ashmolean wash carries a few posthumous inscriptions, among these the date 1885, which should be discarded in favor of a date just prior to that of the Sirak gouache, i.e., 1887.

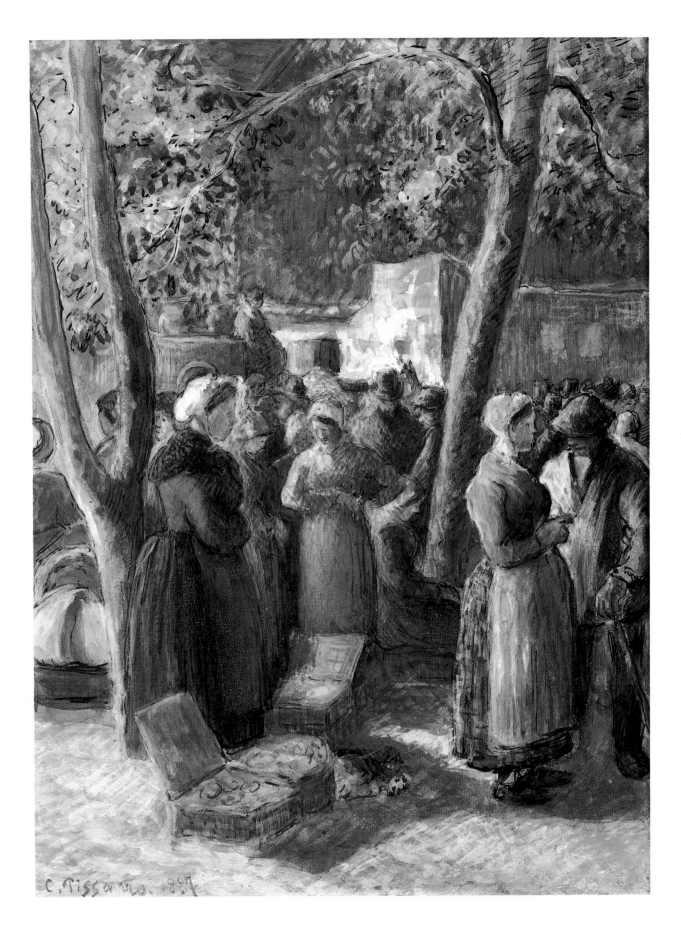

C. Pissarro. 1887

# ODILON REDON

French, 1840–1916

## 54. THE TWO GRACES

*Les Deux Grâces*
ca. 1900

Oil on canvas, 16½ × 11⅜ in. (41.3 × 28.3 cm)
Signed lower left: *Odilon Redon*

Art historians often divide Redon's oeuvre neatly into his early and late work, but a strong self-referential thread links the dark, haunting charcoals and lithographs of the first half of his career with his later beatific oils and pastels. *The Two Graces*, executed around 1900, when Redon was sixty, is based on the artist's earlier lithograph *The Priestesses Were Waiting*, the fifth plate in his 1886 lithograph album *Night (La Nuit)*.[1] The figures in the lithograph may have been inspired by similar subjects in Puvis de Chavannes's works, which, like the Sirak painting, are marked by simplicity of style.[2]

Redon's oil retains the print's enigmatic mood of expectation and melancholic resignation. Whereas the lithograph has three figures, the oil has only two—perhaps intentionally heightening the painting's atmosphere of wistful uncertainty for those familiar with the artist's works. If the painting's title is the artist's—and it may not be, since Redon often dismissed the titles associated with his works as "superfluous"—the lack of a third figure is all the more striking, for the priestesses have been transformed into the Graces, an almost inseparable trio in classical mythology, the frequent source of Redon's inspiration. In 1891 Jules Destrée, author of the first catalogue raisonné of Redon's lithographs, found the literary counterpart to the print's foreboding mood in Maurice Maeterlinck's nearly contemporary Symbolist play *La Princesse Maleine* and identified the women as three virgins, "wisdom," "purity," and "love." According to Destrée's interpretation, then, it is the solitary figure of love that has been omitted from the later oil. Perhaps it is love for whom the other two keep their vigil. In any case, the mood Redon intended to capture in both the lithograph and the oil is manifest in the emphasized words of a Mallarmé-inspired prose poem, which is

formed by the titles Redon wrote for his 1886 lithographs: "In OLD AGE," "The man was solitary in the NIGHT LANDSCAPE," "The lost angel then opened BLACK WINGS," "The Chimera looked at everything with terror," "The Priestesses were WAITING," "And the seeker was engaged in INFINITE SEARCHING."[3]

The painting, unlike the lithograph, is suffused with a delicate lyricism that characterizes the new serenity found in Redon's work beginning in the late 1890s. Color, Redon believed, rejuvenated him: "Colors contain a joy which relaxes me; besides they sway me toward something different and new."[4] The nuances of color have enabled Redon to achieve a very different poetic expressiveness. The pseudo-historical trappings of costume and architectural setting, so reminiscent of Gustave Moreau, have been abandoned. The two figures, now isolated at the right, inhabit an ineffable space, punctuated with inexplicable touches of crimson, which are also found in the silhouettes of the two women. Shrouded in palpable stillness, the figures exist out of time and space altogether. The space itself is made intangible by the compositional play of simple abstract shapes and a strange textural surface, which alternately seems solid or elusive, like a mirage. Golden rays lend the figures an aura, evoking an ethereal timelessness reminiscent of medieval icons. The painting, however, transcends such associations—just as it transcends the literary allusions with which it is linked. Like so much of Redon's work, it emanates from the artist's own mysterious universe on the frontier between the real and the unreal.

—NVM

1. See André Mellerio, *Odilon Redon* (Paris, 1913), no. 66; reprinted (New York, 1966).
2. Richard J. Wattenmaker, *Puvis de Chavannes and The Modern Tradition* (Toronto, Art Gallery of Ontario, 1975), p. 161.
3. Richard Hobbs, *Odilon Redon* (Boston, 1977), p. 48. For the original French, see Hobbs, p. 170.
4. Letter to Edmond Picard, 1894, translated in Michael Wilson, *Nature and Imagination: The Work of Odilon Redon* (Oxford, 1978), p. 54.

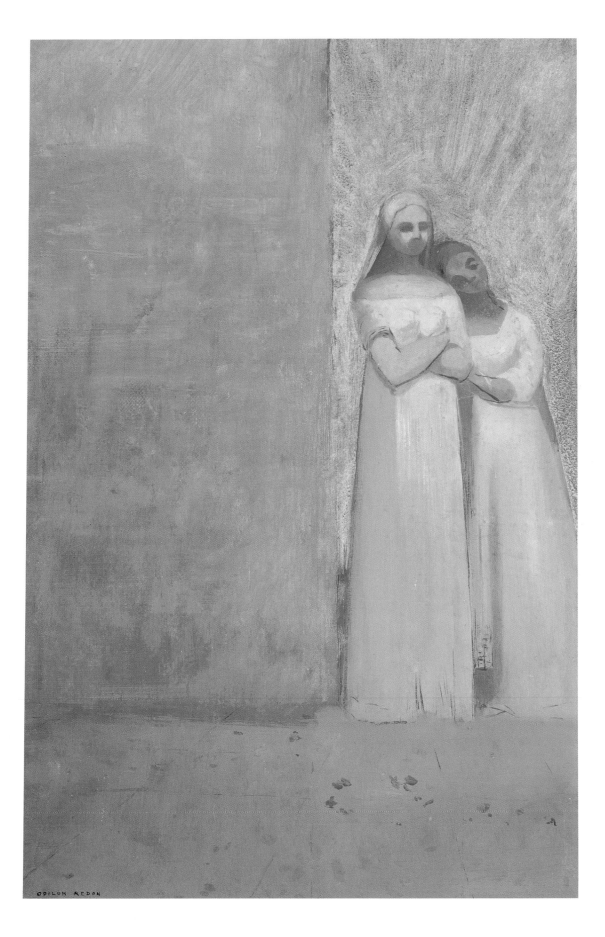

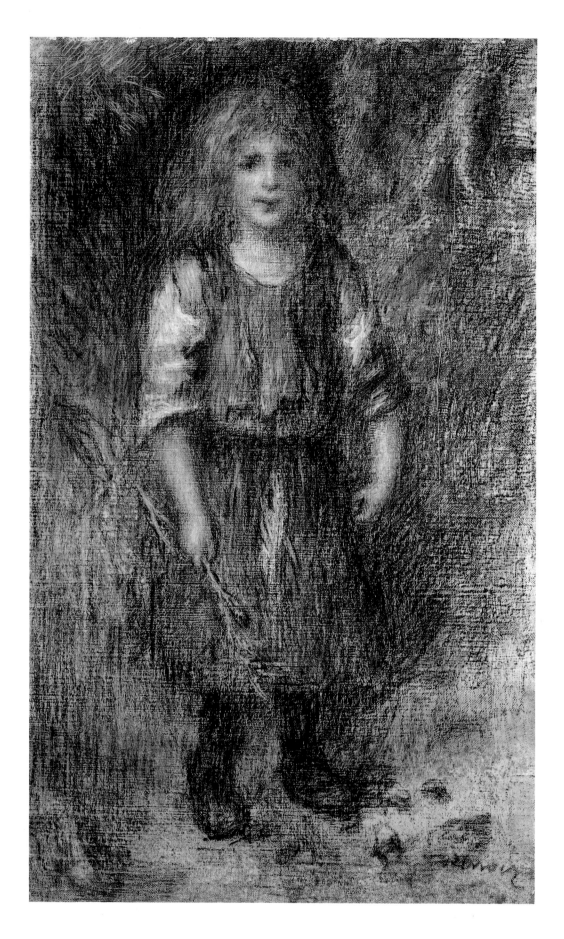

# PIERRE-AUGUSTE RENOIR

French, 1841–1919

## 55. THE GYPSY GIRL
*La Bohémienne*
1879

Pastel on prepared canvas, 23 × 14⅛ in. (58.6 × 36 cm)
Signed lower right: *Renoir*

Pierre-Auguste Renoir, the son of a tailor, was born in Limoges. After the family moved to Paris, Renoir was apprenticed to a porcelain painter and trained to be a craftsman, like his father. From these humble beginnings, he was accepted into the École des Beaux-Arts, where he studied under the academic master Gabriel-Charles Gleyre. Renoir sought favor at the government-sponsored Salon, virtually invented Impressionist painting with Monet, exhibited with the Impressionists, periodically abandoned them to curry favor with a wealthy bourgeois clientele, and received the French Legion of Honor in 1900. After a long career vacillating between his working-class origins and high-class ambitions, he died in 1919, saying about painting, "I think I'm beginning to understand something about it."

The pastel drawing *The Gypsy Girl* signals the beginning of Renoir's most dramatic attempt to reform his art and expand his market. In 1879 he bypassed the fourth Impressionist exhibition, having shown in the first three. Like his Impressionist colleagues, the always restless Renoir was beginning to question the value of Impressionism. He sought greener pastures, submitting his works to the Salon and cultivating wealthy, middle-class patrons. In the spring of 1879 Renoir met Paul Bérard, a diplomat who asked him to paint a portrait of his daughter. Consequently, Renoir visited the family vacation home at Wargemont, near Dieppe, and over the years executed forty paintings for the family.

During his first summer at Wargemont, Renoir also took the opportunity to paint genre scenes, such as *The Gypsy Girl* (private collection, Canada) and the *Mussel-Fishers at Berneval* (Barnes Foundation, Merion, Pennsylvania), which he exhibited at the Salon of 1880.[1] The Sirak pastel was apparently made in preparation for the painting of the same name. Renoir

had already painted accomplished portraits of girls, beginning with one of his first major canvases, the 1864 *Portrait of Mademoiselle Lacaux* (Cleveland Museum of Art). In the two 1879 Wargemont paintings, however, he took up the sort of genre scene that featured happy or curiously primitive peasants—an approach that had become popular at the Salon. In both the painting and drawing, a young, forlorn peasant girl, her hair disheveled and her skirt torn, stands against a backdrop of vegetation. Ultimately, the figure type is a descendant of eighteenth-century moralizing paintings of fallen girls by Jean-Baptiste Greuze (1725–1805).

Renoir's painting is distinguished by an even more Rococo palette than that of Greuze, and his drawing differs significantly from his own painted *Gypsy Girl*. In the drawing the figure is more formidable, seen in full, not cropped at the knees as in the painting. Her left hand makes a fist, and her right hand holds a thistle. Using black pastel with a few color highlights, Renoir drew directly on the canvas, revealing its whiteness to represent light and to contrast with many degrees of shadow. This effect is similar to printmaking experiments of the same years by Edgar Degas, Camille Pissarro, and Mary Cassatt. Renoir did not begin making prints until the 1890s, and he did not place great importance on his drawings, which generally are in the linear tradition of Raphael and Ingres. But in this drawing—which is especially rare for the 1870s—Renoir created a very lush and painterly work that refers to his current painting style but produces a much more powerful image.               —TP

1. Susan Ferleger Brades, *Renoir* (exh. cat., Hayward Gallery, London; Grand Palais, Paris; and Museum of Fine Arts, Boston, 1985), pp. 215, 254.

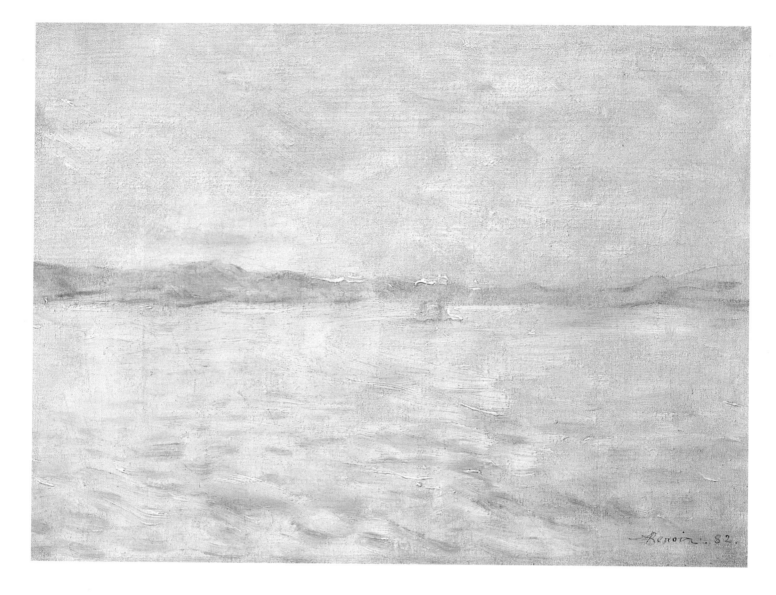

### 56. THE BAY OF NAPLES

*La Baie de Naples*
1882

Oil on canvas, 11½ × 15⅜ in. (29 × 38.9 cm)
Signed and dated lower right: *Renoir 82*

The Impressionists first exhibited together in 1874, in part, to sell their works. As an entrepreneureal venture, independent of official channels, the exhibition was audacious, even anarchistic to some. By 1880 most of the original members deemed the effort a failure. This was the crisis of Impressionism, and Renoir's was most acute. He, more than anyone, blamed the failure on stylistic grounds. *The Gypsy Girl* of 1879 (cat. no. 55) and other works of that year had marked only the beginning of Renoir's search for new subjects, techniques, and patrons, a quest that led him to embark on a three-year tour (1881–1884) of the Channel Islands, southern France, Algeria, and—most important—Italy. It was in Italy that Renoir encountered the works of Raphael and the ancient Pompeian frescoes, seeing firsthand what he called "the grandeur and simplicity of the ancients." In response, he tempered his Impressionist brushwork with classical draftsmanship, rejected the ephemeral subjects of the 1870s, and undertook figure paintings. But these changes did not occur until after his return, culminating in the great *Bathers* of 1887 (Philadelphia Museum of Art).

On his first visit to Venice, an obligatory stop on the Grand Tour for more than a century, Renoir painted at least eight views of the city. He knew that

the views were clichés, telling a friend that when he painted the Doge's Palace from across the canal, artists were lined up six deep.[1] Two of the Venetian canvases sent back to Paris to Durand-Ruel were exhibited in the seventh Impressionist exhibition. Their subjects, at least, must have announced the re-education of the artist, now at middle age. Later, in Naples, he painted seven city views, six of which are no less scenographic than the Venetian pictures. *The Bay of Naples* alone departs from this format.

There is no road in the foreground of *The Bay of Naples*. And there are no famous sites—not the city, not even Vesuvius looming in the background. Over a blue ground, Renoir has painted three bands, representing the sea, coast, and sky. Only the vague impression of a boat hints of a human presence in the seascape. The palette is severely restricted to yellow, white, and palest blue to capture the gentle movement of the sea and the pervasive sunshine of the south. Renoir, like his colleagues, had abandoned the social urban and suburban scenes of contemporary Parisian life, had moved away in fact from representing the here and now. In *The Bay of Naples* the artist looks to distant shores; later, his attention will turn inward.

Renoir, who traveled to Italy to find a path away from Impressionism and to absorb classical art, does not reprise the touristic view of cities on the Grand Tour, nor does he employ the traditional structure of a classical landscape in his *Bay of Naples*. Rather, he paints a picture that is extremely spare and firmly rooted in the most innovative painting of the previous twenty-five years. Courbet, Degas, and Whistler, whom Renoir met the year before, had themselves experimented with landscapes similarly stripped to the essential. Typically, Renoir's landscape is drenched with sunlight, an indication of optimism even during a trying period. In search of the "grand tradition," Renoir took with him the fundamentally anticlassical discovery that was the most revolutionary innovation of the Impressionists: that light can dissolve, as well as define, form.                   —TP

1. Letter to Charles Deudon, quoted in Barbara E. White, "Renoir's Trip to Italy," *Art Bulletin* (December 1969): 346.

## 57. CHRISTINE LEROLLE EMBROIDERING

*Christine Lerolle brodant*
ca. 1895–1898

Oil on canvas, 32⅛ × 25⅞ in. (82.6 × 65.8 cm)
Signed lower left: *Renoir*

Renoir's trip to Italy had an enormous effect on his work, resulting in particular in his dry, linear approach of the mid-1880s. When he returned to the painterly tradition in the 1890s, he achieved a grand synthesis of the techniques, subjects, and ambitions of the Impressionists with those of the Old Masters. As a modern descendant of Titian and Rubens, he earned the official recognition and financial security that he had long sought. In 1892 Durand-Ruel in Paris held a major retrospective of his work, and he was heralded as one of the great modern masters.

In *Christine Lerolle Embroidering*, Renoir used a warm palette of yellows and reds. The painting exemplifies the ample figures of his late works while revealing the artist's pursuit of "respectability" in subject matter. Christine Lerolle is presented as a monumental figure, occupying a full three-quarters of the canvas. Presented in three-quarter view, she bows her head as she embroiders. The strong vertical of the yellow curtain behind her blocks off a third of the background. Nevertheless, the background scene tells the viewer that this is a respectable and wealthy household. The girl's father, Henry Lerolle (not pictured), was a collector, not only of Renoir's but also of Degas's works. To his daughter's left are the sculptor Louis-Henry Devillez and collector, industrialist, and close friend of Degas's, Henri Rouart, who owned Renoir's *A Morning Ride in the Bois de Boulogne* (1873, Kunsthalle, Hamburg). The two men scrutinize Renoir's *Le Bain* of 1890 and two pictures by Degas, while Christine Lerolle, who appeared in an 1897 portrait at the piano with her sister, engages in an activity equally appropriate for a young woman of her station.

Not only does Renoir present a respectable bourgeois interior, he also invokes hallowed works by the revered Spanish master Velázquez (1599–1660), whom he had admired even before his visit to Madrid in 1892. Renoir's *Gypsy Girl* of 1879 (cat. no. 55) pays homage to the master's *Infanta Margherita* (1654, Musée du Louvre, Paris),[1] which Renoir cherished. In *Christine Lerolle Embroidering*, the central figure vividly calls to mind Velázquez's *Needlewoman* (1640, National Gallery of Art, Washington, D.C.),[2] in which the central

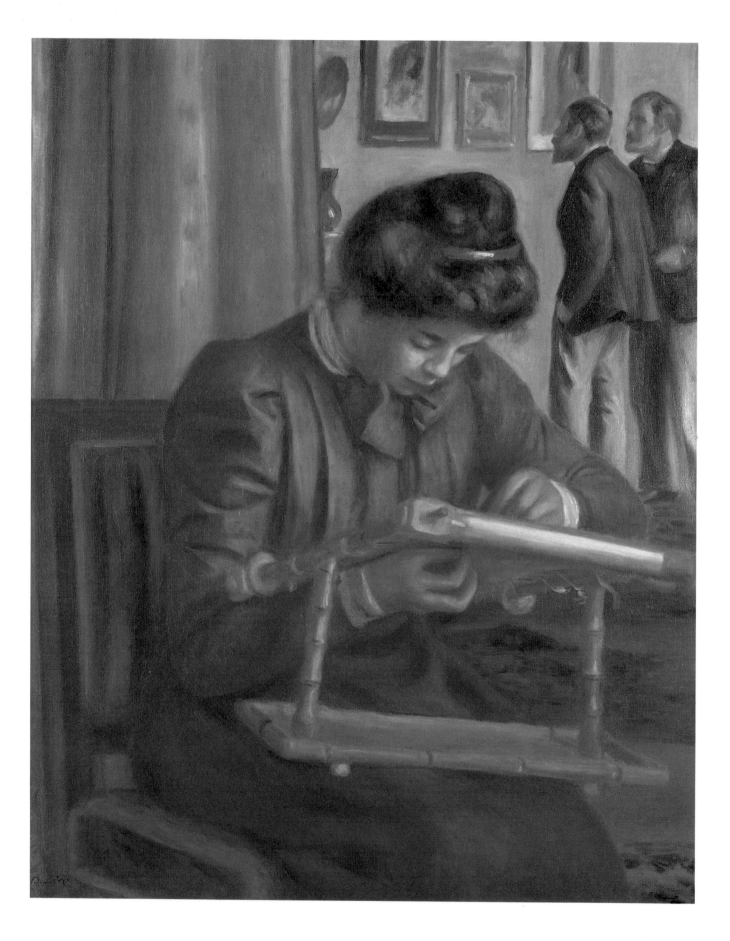

figure has the same monumentality, shape, and posture. In comparison, Renoir's figure is chastened, modernized, and reversed (perhaps he knew the Velázquez prototype from prints, even though the painting was in Paris where he might have seen it). The figures of Rouart and Devillez recall, though less closely, two of Vulcan's helpers in Velázquez's *Forge of Vulcan* (1630, Museo del Prado, Madrid)[3] who behold Apollo, god of the arts, just as Renoir's figures respond to works by Degas and himself. Most important, the composition and theme recall Velázquez's *Spinners* (1657, Museo del Prado, Madrid).[4] Renoir claimed to know nothing more beautiful than this picture. Emulating Velázquez, Renoir places in the foreground an impressive and monumental female who spins, while honorable men—if not quite gods—evaluate fine art in the background.

At about the same time he painted *Christine Lerolle Embroidering*, Renoir also completed *Breakfast at Berneval* (1898, private collection), which is most certainly a pendant to the Sirak painting.[5] It is the same size and format and is similarly composed, only in reverse. In this painting, Renoir's son Pierre is seated and reading intently, with pen in hand, in the right foreground. In the background, seen through a doorway, another Renoir son, Jean, distracts a maid who is setting the dining-room table. These two pictures emphasize an important theme in Renoir's oeuvre: the male province includes serious reading, high art and its appreciation, whereas that of females is limited to crafts and domestic activities.

Renoir's yearning for the past went beyond his affirmation of increasingly outdated sex roles at a time when they were being fervently debated.[6] Renoir longed for a pre-industrial age when all people were artisans, before the machine age could dislodge tailors like his father or porcelain painters like himself from useful enterprise.[7] Thus the young woman embroidering may represent, in Renoir's mind, an ideal which he contrasted to the province of high art, of painting and criticism. Paradoxically, Renoir celebrates this ideal in a painting in which he aligns himself with one of the greatest artists of the past, Velázquez. *Christine Lerolle Embroidering* reflects Renoir's deep ambivalence toward women, the industrial age, and, finally, toward himself. It is an ambitious vehicle, challenging Velázquez and betraying his longings for a society and politic far removed from his own age. —TP

1. Illustrated in Nicola Spinosa, *Velázquez, Every Painting* (New York, 1979), p. 88.
2. Illustrated in John Walker, *National Gallery of Art, Washington* (New York, 1984), p. 243; and in Antonio Dominquez Ortiz et al., *Velázquez* (exh. cat., Metropolitan Museum of Art, New York, 1989), p. 217.
3. Illustrated in Ortiz et al., p. 111.
4. Illustrated in Ortiz et al., pp. 50–51.
5. Illustrated in Susan Ferleger Brades, *Renoir* (exh. cat., Hayward Gallery, London; Grand Palais, Paris; and Museum of Fine Arts, Boston, 1985), no. 98, pp. 266–267.
6. See Kathleen Adler, "Reappraising Renoir," *Art History* 8 (September 1985): 374–379.
7. Regarding Renoir's class anxiety and discomfort with modernity, see John House, "Renoir's Worlds," in Brades, pp. 11–18.

# AUGUSTE RODIN

French, 1840–1917

## 58. THE AGE OF BRONZE

*L'Age d'airain*
1875–1876

Bronze, H. 41½ in. (105.4 cm)
Signed on top of base (right): *Rodin*. Foundry mark on side
of pedestal: *Alexis Rudier, Fondeur, Paris*

An early work and the first life-size figure exhibited by
Rodin, *The Age of Bronze* embodies many fundamental aspects of the artist's subsequent nontraditional
approach to sculpture, in particular to theme, allegory, and style. Begun in Brussels in 1875, *The Age of
Bronze* represents a year and a half of intense work,
during which time the model—a Belgian soldier
named Auguste Neyt—posed for long stretches daily,
aiming for relaxed muscles to achieve Rodin's desired
quality of naturalness. Inspired by the profound and
subtle naturalism of the Greeks, Rodin aspired to surpass the prosaic naturalism of his contemporaries and
the idealized naturalism in the art of Michelangelo,
whose works he studied in Italy while working on this
figure.[1] Rodin's naturalism, in contrast to that of
Michelangelo, is based on rigorous observation from
nature and is reflected in the lifelike fluidity of the figure's contour and the impression of movement in both
the figure's hesitant step and raised arms.

*The Age of Bronze* was originally conceived to
commemorate the tragic heroism connected with
France's defeat in 1870 in the Franco-Prussian War. It
was exhibited for the first time in 1877 at the Cercle
Artistique in Brussels, under the title *The Vanquished
One (Le Vaincu)*.[2] The poignant facial expression of
Rodin's figure, the evocative gestures—one hand
raised in despair, the other simply grasping in mid-air
(an early drawing reveals that Rodin had considered
having the figure hold a spear)[3]—convey a psychological resonance as palpable as it is ambiguous. That
Rodin favored dispensing with identifying attributes
in a public monument, which traditionally depended
on viewer recognition, destined the work for controversy. It received a mixed response: positive recognition of its naturalism but also suspicion that Rodin had
used casts of the living model; and criticism of the figure's lack of a clear subject.

For its exhibition later the same year at the Paris
Salon, Rodin changed the title to *The Age of Bronze*,
broadening the meaning from a specific, patriotic
theme to a more general and familiar context. The
meanings associated with the age of bronze, opened
the work to a range of interpretations. For several
biographers, the new title pointed to the figure's slow
ascending movement as a pose and gesture of awakening. That the revised title encompasses Rodin's own
creative awakening as a sculptor has been suggested
by several of his early biographers and is certainly
consistent with his tendency throughout his work to
produce symbolic self-portraits.[4]

In Paris as in Brussels, the work was criticized.[5]
Moreover, the new title did not prevent criticism over
lack of a specific subject. Rodin's subsequent Salon
figure, *Saint John the Baptist Preaching*, begun in 1878,
is rendered larger than life, and again depicts a figure
in motion. His interest in expressive figures devoid of
attributes culminated in the portal *The Gates of Hell*.
For this commission, received in 1880, Rodin depicted
smaller-than-life nude figures, still wishing to prove he
could model from life.[6] In their powerful and enigmatic
poses and gestures, the figures that comprise the monument are direct descendants of *The Age of Bronze*.

*The Age of Bronze* is one of Rodin's most popular
works, as evidenced by the number and range of casts
in other sizes.[7] The cast in the Sirak Collection is a half-size version.

—RFJ

1. Regarding the relation to Michelangelo's art, see Albert Elsen,
   *Rodin* (New York, 1963), pp. 23–25; and Jacques de Caso and
   Patricia Sanders, *Rodin's Sculpture: A Critical Study of the
   Spreckels Collection, California Palace of the Legion of Honor*
   (Rutland, Vt., and Tokyo, 1977), p. 44, n. 5.
2. The most authoritative sources for this work are Elsen (1963),
   pp. 21–26; De Caso and Sanders, pp. 39–47; and John Tancock,
   *The Sculpture of Auguste Rodin* (Boston, 1976), pp. 342–356.
3. The drawing is reproduced in Léon Maillard, *Auguste Rodin,
   statuaire: Études sur quelques artistes originaux* (Paris, 1899),
   opposite p. 6.
4. For a discussion of the work's multiple levels of meaning, see
   De Caso and Sanders, pp. 41–42, 47, nn. 23, 24.
5. For pertinent correspondence on the controversy, see Alain
   Beausire and Hélène Pinet, *Correspondance de Rodin*, 3 vols.
   (Paris, 1985–1987), 1: pp. 35, 37–39, 41–43, 45.
      The photographs of the model juxtaposed with Rodin's
   plaster *The Age of Bronze* are reproduced in Albert Elsen,
   *In Rodin's Studio* (Ithaca, New York, 1980), pp. 36–37, pls. 2–5.
6. Cited in Elsen (1963), p. 35.
7. See Tancock, pp. 349, 354–356.

# MEDARDO ROSSO

Italian, 1858–1928

*59.* SICK BOY

*Bimbo malato*
ca. 1893

Wax, H. 9³/₈ in. (23.8 cm)

*Sick Boy*, alternately titled *Dying Boy*,[1] is part of Rosso's lifelong series of sculptures of children. These range from tender depictions of mother and child to more socially motivated, pointedly humanitarian subjects, such as *Baby Chewing Bread*, of 1893 (Museo d'arte moderna, Ca'Pesaro), Rosso's depiction of a poor child at a soup kitchen. The subject derives from the small-scale genre motifs of the *verismo* movement in nineteenth-century Italian sculpture, for example the works of Vincenzo Gemito, and especially from the realism and open, pictorial style of the Milanese Scapligiatura sculptor Giuseppe Grandi.[2]

*Sick Boy* has been variously dated between 1886 and 1895. Luciano Caramel, among others, dates the work as early as 1889, when Rosso underwent a period of hospitalization in Paris.[3] Margaret Scolari Barr, proposing a date of 1893, suggests that the work closes an early cycle of images of children in Rosso's oeuvre and was produced following *Child in the Sun* and *Jewish Boy*, both of 1892 (both in the Galleria nazionale d'arte moderna, Rome), and in the same year as *Baby Chewing Bread*.[4]

Rosso's poignant portrait of a withdrawn, sick child conveys a delicate, momentary impression of mood and interior psychology which is significantly enhanced through the fugitive effects of light, color, and atmosphere. Regarded as the first Impressionist sculptor, Rosso produced sculptures modeled in wax that are close in intent to French Impressionist painting, although he formed his style in Milan, independent of direct contact with the French movement.[5] Rosso's bold simplifications of form, his effort to evoke the unity of a figure and its surrounding atmosphere and especially to capture the visual distortions that a fleeting impression presents to the eye, are concerns he shared with the Impressionists. In 1883 Rosso invented the method of modeling wax over a core of plaster to exploit wax's reflectivity and potential for fluid handling,[6] techniques that find analogies in the freer brushstrokes and divided color of Impressionist painters. Somewhat distinct from Impressionism, however, his analytic interest in representing perceptual reality merged with a desire to show that the truth of the first impression was subjective, "charged with poetry and suggestiveness."[7]

*Sick Boy* exemplifies the play between abstraction and nature in Rosso's work. The head conveys a transitory moment through a sharply downturned, three-quarter view and asymmetrical handling of the facial features, Rosso's method of encouraging a single point of view. The subtly inflected surfaces and ambiguous shadows, the summary texture and broken outline of the hair, the crude definition of the ear and especially the eyes, all work to impart a sense of form diffused by light and atmosphere. In *Sick Boy* large abstract passages (in the hair, temple, and cheek) are juxtaposed with areas that are more smoothly delineated and modeled (the forehead, slender nose, mouth, and chin). The small, perfect features, the clarity of the profile of nose and mouth, and the smooth oval shape of the face, together with the tender, mysterious expression evoke an idealized naturalism like that of Renaissance portraits.[8] The abstract tendencies seen in *Sick Boy* are developed further by Rosso in other works of the early 1890s, culminating in the highly abstract portrait, *Madame X*, of 1896 (Museo d'arte moderna, Venice).

Rosso's contribution goes beyond introducing Impressionism into sculpture. His work offers analogies in form and theme to the Symbolist art of Eugène Carrière,[9] whose grisaille renditions of sick children favor the effects of light and atmosphere over color, distancing the subjects and heightening a sense of symbolic meaning. *Sick Boy* is often noted as one of the important antecedents for Brancusi's *Sleeping Muse* (1906), a critical work in which Brancusi began to evolve his reductive, geometric style. Rosso was also deeply admired by the Italian Futurists. Boccioni, in his manifesto of sculpture, published in 1912, hailed Rosso as the key precursor of the Futurists in their aim to render dynamic sensation and suggest the interpenetration of forms and space.      — RFJ

1. The common titles for the work are *Bimbo malato, Bimbo morente,* and *Enfant malade.* The work has also been associated with the titles *San Giovannini* and *San Luis.* See Luciano Caramel, *Medardo Rosso: Impressions in Wax and Bronze, 1882–1906* (New York, 1988), p. 116; and Jole de Sanna, *Medardo Rosso, la creazione dello spazio moderno* (Milan, 1985), p. 134.

2. The early work of Gemito includes a series of heads depicting sad, withdrawn children, among them a life-size terracotta of 1870 called The *Sick Boy* (illustrated in H. W. Janson, *19th-Century Sculpture* [New York, 1985], p. 222, fig. 260).

3. See Luciano Caramel in *Mostra di Medardo Rosso* (Milan, 1979), pp. 133–134; and De Sanna, pp. 134–135.

4. Margaret Scolari Barr, *Medardo Rosso* (New York, 1963), p. 38.

5. Through art dealer Vittore Grubicy, Rosso probably knew reproductions, prints, or actual Impressionist works (Barr, p. 12).

6. In conversation with the author, Albert Elsen suggested that the smooth, seamless passages, among other aspects of the head, suggest that Rosso may have adapted to wax the method of dip casting of plaster into plaster, a studio technique used by Rodin, Carrier-Belleuse, and others to provide a clean surface on dirty plasters. See Elsen's discussion of this method in "When Sculptures Were White: Rodin's Work in Plaster," in Elsen, ed., *Rodin Rediscovered* (exh. cat., National Gallery of Art, Washington, D.C., 1981), p. 137.

7. Rosso's statement is quoted in Luciano Caramel, *Medardo Rosso 1858–1928* (Frankfurt am Main, 1984), p. 56.

8. See Dore Ashton, "A Sculptor of Mystical Feeling," *New York Times* (December 27, 1959), and Barr, p. 9.

9. Barr, p. 54, also observed the relationship of Rosso's art to that of Carrière and to Symbolism.

## 60. HEAD OF A YOUNG WOMAN

*Busto di donna*
ca. 1901

Wax over plaster (unique copy), H. 15¾ in. (40 cm)
Signed lower right: *M. Rosso*

Compared to Rosso's years in Paris from 1889 to 1897, which represent the climax of his career, his late period, beginning in 1900, was characterized by the creation of few new works. Following a phase of dejection and inactivity because of a controversy with Rodin,[1] he devoted himself to promoting his art and traveling extensively to participate in exhibitions. Only two commissioned works from this period are documented: the portrait of Dr. Fles,[2] a commission in 1900 from Fles's daughter Etha, the Dutch artist who became Rosso's major patron; and the well-known portrait of Alfred William Mond, called *Ecce Puer (Behold the Child)* of 1906–1907 (Hirshhorn Museum and Sculpture Garden, Washington, D.C.), a masterpiece that called forth the sensitivity to children seen in numerous earlier works.

Though no further work after 1900 is recorded, Margaret Scolari Barr has suggested that *Head of a Young Woman* may stem from this period.[3] The work has carried this title and has been dated 1897 since it was exhibited in 1959 at the Peridot Gallery in New York, in the first American exhibition devoted to Rosso. Barr proposed revising the date to circa 1901, based on the remarks of critic Edmond Claris, who described a work he saw Rosso modeling in his studio some time after the portrait of Dr. Fles, which was executed circa 1900–1901. Barr observed that Claris's description brought to mind the *Head of a Young Woman*:

> The first time I saw him, he placed himself in the exact spot where he had posed a woman whose portrait he was doing. Then, removing the wet cloth that covered the clay, which was still damp, he asked me to tell him frankly how this woman struck me. I shall always remember his joy when, after having described to him the character that emanated from the face I had under my eyes and the feelings that seemed to animate it, I declared to him that this simply modeled clay gave me the impression of a blonde, with golden hair and a white, milky complexion. I understand fully the joy of Rosso, who, in putting me in the place where he had conceived this impression, was able to observe one more time his having translated it so well that he communicated it to a spectator accustomed to seeing form and color expressed quite differently.[4]

*Head of a Young Woman*, in its depiction of a woman sleeping or in reverie, with her head shown in three-quarter view and inclined to one side, reveals Rosso's characteristic interest in encouraging a specific angle of view. By creating the head in the form of a mask, he enforced a frontal view, a method he had experimented with as early as 1883 in *Mother and Child Sleeping* (Collection Cesare Fasola, Bagno a Ripoli, Florence). The Sirak portrait also reveals Rosso's pictorial style and his continuing interest in suggesting forms dissolved in light and atmosphere. Details of face and clothing are rendered in selective focus. The eyes, typical of his style, are indicated by an almost imperceptible inflection of the wax surface. The full, wavy hair is described with a flowing, irregular outline, with a large segment boldly cut away at the right, serving to unite the figure with its environment. The transition from hair to clothing at the left is not delineated, but by contrast the right collar and ruffles at the shoulder are loosely defined. Exemplifying Rosso's synthesis of naturalism and abstraction, the dainty nose, the slightly pursed lips, and the face are relatively defined and smoothly modeled in contrast to the broader, abstract forms and more freely modeled surfaces of the hair and clothing. Characteristic of Rosso's intermittent explorations of abstraction, *Head of a Young Woman* is less abstract in conception than earlier works such as *Yvette Guilbert* of 1894 (Museo d'arte moderna, Venice), with its coarse and irregularly textured facial surface, or *Madame Noblet* of 1897 (Galleria d'arte moderna, Milan), with half of the face almost obliterated under large, vertical finger lines that boldly texture the surface.

—RFJ

1. Rosso contended that his work had influenced Rodin's conception of Balzac. For a discussion of the Rodin-Rosso controversy, see Margaret Scolari Barr, *Medardo Rosso* (New York, 1963), pp. 53–54.
2. The Fles portrait, known only through reproductions, is discussed by Barr, ibid., p. 55.
3. Ibid., pp. 58, and 77 n. 160.
4. Translated by R.F. Jamison, from Edmond Claris, *L'Impressionisme en sculpture: Auguste Rodin et Medardo Rosso* (Paris, 1902), p. 26.

# EGON SCHIELE

Austrian, 1890–1918

*61.* THE THINKER (SELF-PORTRAIT)

*Der Denker (Selbstbildnis)*
1914

Graphite on light tan paper, 19 × 12³/₄ in. (48.3 × 32.4 cm)
Signed and dated lower right: *Egon Schiele 1914.* Inscribed
on verso: *8 × 13 / Portrait* . . . [indistinct]

Egon Schiele, one of the greatest draftsmen of the twentieth century, produced more than 2,500 drawings and watercolors before his tragic death from influenza in October 1918 at the age of twenty-eight. He died just months after a successful exhibit at the Vienna Secession, when, after years of criticism and rejection, he was finally achieving recognition through sales and portrait commissions. Schiele's friend and mentor Gustav Klimt had died from the same illness early in 1918.

By 1914, the date of the Sirak self-portrait, Schiele was married and serving in the military. During a decade of intense activity, and after three rebellious years at the Vienna Academy (which he left in 1909), he had developed a unique Expressionist style in works that show an obsessive concentration on the human body. His investigations focused upon the potential of line to transmit emotional and intellectual states. Color, when used, was intense, but it served primarily to enhance configurations that were created independently.

Schiele's figure studies epitomize the observation credited to Ingres that drawing is a line around an idea. In a direct and seemingly simple way, Schiele used pencil and chalk to create a form that fills a page with its presence, that dominates space and precludes the inclusion of superficial detail. In his heavily erotic drawings, whether dealing with the female figure or his own as a central subject, he negates the idealized beauty of the classical nude for the distorted and twisted emaciation of modern humanity. Inspiration for Schiele's gestural imagery can be found in the art of a number of Symbolists and Expressionists: Ferdinand Hödler, Auguste Rodin, Georges Minne, Félicien Rops, and Edvard Munch. And while the artistic debt to Klimt remains secure, it has been correctly observed that "the great difference [between Klimt and Schiele] is between the joy of the nineteenth-century artist and the doubt, suffering, and emotional tension of the twentieth-century painter."[1]

Schiele's images can be of such intensity that they are visually repellent. His own emaciated nude body, twisted in exaggerated contortions, appears repeatedly, and is reminiscent of victims seen in photographs of concentration camps. The question of intent is raised with regard to his series of nude self-portraits:

> Leaving behind obvious disguises and symbolic surrogates—strategies he shared not only with Kokoschka but with many other modern artists—Schiele here did something far more personal and original. He invented a surrogate self housed in his own body, a self as *poseur* in both literal and figurative senses, to play out an identity acknowledged to be acted as much as experienced. What seems most tellingly modern about these works is not the directness of their communication, but [their] obliqueness; not the sense of revelation, but the sense of performance.[2]

In this and other drawings of the period there is indeed a sense of performance, a sense of the theatrical. Because of the inherent spareness of the works, gesture takes on special significance. In *The Thinker* the emphasis is cerebral; three fingers of the right hand touch the temple, calling attention to the clearly delineated furrowed brow. The gesture is solidified by the position of the left hand, which holds the upraised right arm in place. Overly large eye sockets with only the scant suggestion of a right pupil intensify the stress on introspection. The clothing consists of loose, blousy coverings; the body itself is secondary, even sexless; nothing in fact seems to detract from the emphasis on introspection. There is also a distinct difference between the heavy pressure of the pencil used to describe the clothing and the light touch that forms the head and hands, as though to subtly convey the sense that outer extremities of Schiele's body have

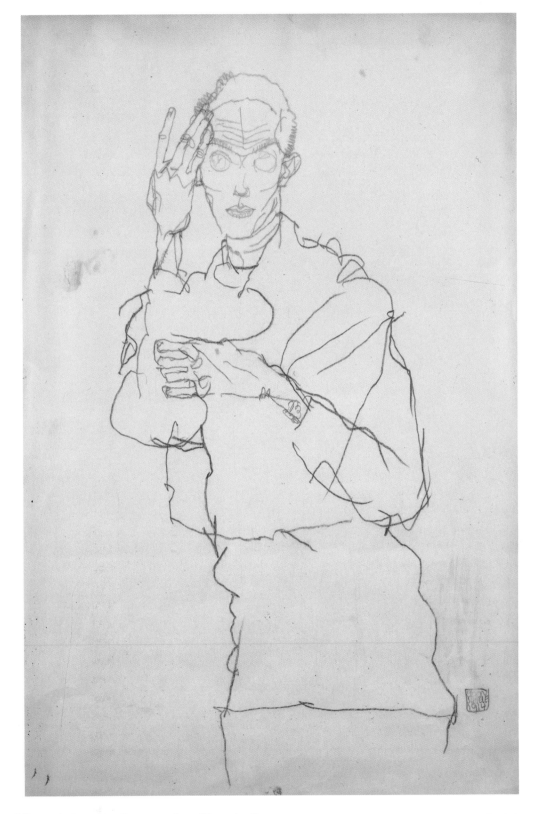

emerged from their protective coverings like a turtle from its shell, with hesitation, with great deliberation, and with consciousness of vulnerability.　　—DL

1. Peter Selz, *German Expressionist Painting* (Berkeley and Los Angeles, 1957), p. 157.
2. Kirk Varnedoe, *Vienna 1900: Art, Architecture and Design* (exh. cat., Museum of Modern Art, New York, 1986), p. 174.

# ANDRÉ DUNOYER DE SEGONZAC

French, 1884–1974

*62.* NOTRE-DAME DE PARIS
1913

Oil on canvas, 28 ⅝ × 39 ⅜ in. (73.3 × 100 cm)
Signed lower right: *A. de Segonzac*

Notre-Dame de Paris, that famous landmark of the City of Light, has become, in Segonzac's hands, a somber mass against a dark sky. This enigmatic silhouette, from which saints and sinners, demons and gargoyles have been banished, typifies Segonzac's summary treatment of architecture in poetic city scenes and landscapes. The cathedral appeared several more times in the artist's work, seen from different points of view but each time immediately recognizable and greatly simplified.

Simplification of form and heavy layering of paint smoothed with a palette knife stem from Segonzac's interest in Cézanne. While in other canvases Segonzac showed a greater interest in color, he never relied on flamboyant technique or chromatic effects to create a visual sensation; instead, he strove to develop finesse in representing the subtle relationships of values and tones.

In its high vantage point and oblique view of the west facade of the cathedral from the Left Bank of the Seine, *Notre-Dame de Paris* bears a strong compositional affinity with depictions of the cathedral by Matisse,[1] completed in 1900–1902, before the full development of Fauvism. Other aspects of the work— the monochromatic palette, the reduction of forms to geometric shapes, and the gridlike construction— suggest Segonzac's interest in the Cubists. However, *Notre-Dame de Paris*, in its thick layers of paint "in the colors of brown lava,"[2] conveys a somber mood not found in Cubist painting. Though he exhibited with the Cubists on several occasions, Segonzac never considered himself to be affiliated with Cubism or any other movement, preferring instead to pursue his own means of expressing a personal view of the world. This steadfast pursuit of his singular vision at a time when Cubism was fashionable among modernist artists won Segonzac the praise of many contemporary critics in France.

Segonzac's work was introduced to American audiences at the Armory Show of 1913. One of the initiators of the show, an American attorney named John Quinn, purchased several drawings by Segonzac from the exhibition. This pioneer American collector later purchased a number of other works by the artist, including *Notre-Dame de Paris*.　　—SK

1. For example, *A Glimpse of Notre Dame in Late Afternoon* (1902, Albright-Knox Art Gallery), illustrated in Diane Kelder, *The Great Book of Impressionism* (New York, 1986), p. 223; and *View of Notre Dame* (ca. 1902, private collection), illus. in Jack D. Flam, *Matisse, The Man and His Art* (Ithaca, New York, 1986), p. 103.
2. Anne Distel, *A. Dunoyer de Segonzac*, trans. Alice Sachs (New York, 1980), p. 58.

## 63. PROVENÇAL FARM
*Ferme provençale*
1952

Pen and brush with ink and chalk on paper, laid down,
15⁹/₁₆ × 22¹⁵/₁₆ in. (39.5 × 58.3 cm)
Signed lower right: *A. Dunoyer de Segonzac*

Beginning in 1908, when Segonzac executed his first landscape paintings, landscape drawing became an increasingly important part of his production. He worked mainly in Île-de-France and in the environs of Saint-Tropez, in Provence, an area that he first visited in 1908 and which inspired him throughout his lifetime.

The drawing in the Sirak Collection of a Provençal farm reflects the artist's love of the region surrounding Saint-Tropez, with its vines, oak and olive trees, small farms by the sea, and the authentic medieval and Renaissance character of unspoiled sites in the region. Atop one of the hills in *Provençal Farm* is a sketchily delineated motif that suggests an old fortress, possibly the castle at Grimaud, which Segonzac depicted in several other drawings.[1] That the stepped profile of the fortress was not detailed or dramatized in a picturesque way by Segonzac reveals the artist's wish to document the precise character of the site and depict its motifs as simple and truthful visual facts.

In general, Segonzac's landscape drawings of Provence are of two types: wide horizontal and relatively deep views, depicting grapevines or farms against a vista of water and mountains in the distance, or more compact and intimate views, often with chains of small hills closing off the distance. The drawing *Provençal Farm* is the latter type. The viewpoint is eye-level, and there is a limited but clear recession of space. The eye moves from a pair of trees at the left in the foreground, along the rapid curve of the road to the farm in the middle ground, then immediately to the hills closing off the distance. Segonzac avoided dramatic contrasts to convey the even, gray luminosity of a winter day.

This winter view of a Provençal farm typifies Segonzac's preference for scenes in winter and early spring, when bare branches offer abundant linear patterns and color and space are simplified. The drawing reveals a basic adherence to descriptive, fairly continuous contour line, though its texture is varied and often tremulous. Segonzac's pen work ranges from thin, energetic parallel strokes denoting branches to short, commalike flecks indicating grass, to crossed strokes for young vines. This sensitively accented calligraphy provides a rhythmic and linear counterpoint to the broad placement and varying opacities of wash and embodies an expressive vitality independent of the subject being described.

The undramatized and simple poetry of Segonzac's landscape aligns his work with the classic and naturalist tradition of Claude Lorraine (1600–1682) and Camille Corot (1796–1875) and the romanticism of the Barbizon painters. Segonzac's work exhibits a remarkably consistent and unified approach to content, style, and technique. While he admired and discussed the drawing styles of predecessors, the most interesting aspect of the artist is his individuality—his fundamental conservatism and independence from the artistic trends of his time, and the perseverance with which he followed his own inner vision.    —RFJ

1. See André Dunoyer de Segonzac, *Dessins 1900–1970* (Geneva, 1970), pp. 264, 277, 288, and *Dunoyer de Segonzac* (Paris, 1985), p. 93.

## 64. THE FOOT OF THE VALLEY

*Le Fond du golfe*
1952

Pen and brush with ink on off-white paper, laid down,
15½ × 23⅛ in. (39.4 × 58.7 cm)
Signed lower right: *A. Dunoyer de Segonzac*

The Sirak Collection includes a second Segonzac landscape drawing in pen and wash, identical in size (many of his drawings are approximately this size) and made in the same year, 1952. This drawing, too, is an unpretentious view of the countryside in Provence, in this case in early spring when grapevines are beginning to grow. The choice of viewpoint, again directly at eye level, conveys an intimate naturalism and immediacy that evoke the presence of the artist sketching directly before the scene. The compact composition and relatively narrow width of the view reinforce the sense of immediacy; the hills close off the distance, only a small proportion of sky is visible, and the diagonal lines of furrows lead in the middle ground to a screen of trees which further tempers the impression of depth. As in the drawing *Provençal Farm* (cat. no. 63), there is an overall pale gray luminosity.

Typical of Segonzac's wash drawings, the preliminary sketch in charcoal is largely removed but at the upper left remains lightly visible. Segonzac's pen line provides an energetic counterpoint to the broad areas of wash, ranging from continuous contours defining the hills to the staccato flecks and crossed lines of the turf and new vines, to the open sequences of scalloped lines evoking rounded volumes of foliage. Here again wash plays a major role, moving the eye through selectively placed accents across the foreground and imparting density, volume, and texture to the hills and foliage. At the middle ground, dark, opaque wash defines the tree trunks, reinforces the structure and contrasting textures of foliage seen in light and atmosphere. The drawing utilizes a full range of intermediate tones with dark accents. The prominence of trees in this drawing and Segonzac's summary expressive manner of transcribing their foliage in loose sequences of scalloped line combined with subtly gradated washes bring to mind the open-air studies made by Claude Lorraine in a similar medium. Claude's numerous landscapes and tree studies made in pen, bistre, and bistre wash combine breadth and rapidity of line with very subtle gradations of intermediate-range tones to express light and atmosphere. Segonzac admired the open-air studies made by Claude, observing that they were more intense and moving than many of the master's paintings, which were composed and executed in the studio.[1] Claude's own affinity with the expressiveness of Rembrandt's line would have appealed to Segonzac, who also admired the tonal drawings of Rembrandt.

Segonzac's neorealist style appears conservative because of his innate resistance to the century's abundance of abstract trends. His landscapes merge the poetic and lyrical qualities of nineteenth-century romantic realism with the objectivity of mid-century realism while also showing an indebtedness to Impressionism. Segonzac's drawing style does not display dramatic changes but is characterized rather by a remarkably consistent evolution, by an exploration and refinement of technique, and by a relentless pursuit of an inner vision.[2]　　—RFJ

1. For Segonzac's comments on Claude's drawings, see André Dunoyer de Segonzac, *Dessins 1900–1970* (Geneva, 1970), p. 16. For relevant examples of Claude's studies, see Arthur Hind, *The Drawings of Claude Lorraine* (London, New York, 1925), pls. 9–13, 20, 22.
2. Jean Adhémar observes that Segonzac was influential on a neorealist school of French landscape printmakers in the twentieth century, including Louis-Joseph Soulas, André Jacquemin, Pierre Dubreuil; see Jean Adhémar, *Twentieth Century Graphics* (New York, Washington, D.C., 1971), pp. 164ff.

*65.* THE CYPRESS BY THE SEA
(SAINT-TROPEZ)
*Le Cyprès devant la mer (Saint-Tropez)*
1956

Watercolor on paper, 22 ½ × 31 in. (57.2 × 78.8 cm)
Signed lower right: *A. Dunoyer de Segonzac.* Inscribed
on verso: *Le Cyprès devant la mer*

Segonzac's first watercolors were made in 1920. From 1930 on, the artist conceived his watercolors in large dimensions, adopting a fairly uniform size, of which the work in the Sirak Collection is representative. He distinguished these complex renderings from the rapid drawings made during World War II, which he simply heightened with touches of watercolor. He wanted his watercolor drawings to possess the density and significance of finished oil paintings, and, in fact, after 1930 they influenced his work in oil, although he gradually began to de-emphasize his use of oil about this time.[1] In conception and technique Cézanne's late watercolors and paintings epitomized for Segonzac the perfect equivalence between the two mediums.[2]

Segonzac's technical conception of watercolor, in contrast to the brevity and transparency typically associated with the medium, constituted a lengthy process based on multiple steps. For Segonzac watercolor painting was analogous to the concept of states in the graphic arts. It was his method to first sketch a brief preliminary drawing in charcoal, which ultimately would be erased, and then to clarify and accentuate this underdrawing with pen and India ink in order to create an indelible armature of line. Next, he would establish the first stage of color in the form of large color planes, which, in the subsequent, final stage were elaborated and modified by successive touches of color, superimposed quickly after the preceding ones dried. The medium thus enabled Segonzac to work in the open air before a perpetually changing landscape.

Segonzac contrasted his technique of superimposition of colors (used in the preceding century by Constable, Gericault, and Daumier, and in the twentieth century by Rouault, Chagall, Utrillo, Michel Ciry) to that of juxtaposition (reflected in the works of Delacroix, Jongkind, Turner, Cézanne, Manguin, Signac, Cross, Dufy, Brayer). He favored the method of superposition, stating that it was less analytic and more synthetic; he was more interested in plastic character and density than in transparence and brilliance of tone, and thus did not exploit or even significantly reserve the white of the paper.[3]

Like his pen and wash drawings Segonzac's many watercolor paintings executed around Saint-Tropez reflect a range of subjects, homogeneity of style, and spiritual reverence for the region's landscape. This particular work exemplifies the rich, somber beauty of the artist's mature palette, with its warm tones at the center and in the distant rooftops and the earth tones of the vineyard contrasting with the deep greens of the foliage, the gray blues of the mountains, and the richer blues of the sky. The watercolor has considerable density, and the white of the paper is visible only as a silvery outline around the trees and the contour of the hills.　　　　　—RFJ

1. Anne Distel discusses the influence of Segonzac's watercolor style on his oil paintings in *A. Dunoyer de Segonzac* (New York, 1980), p. 82.
2. Roger Passeron, *Dunoyer de Segonzac: Aquarelles* (Neuchâtel, 1976), p. 14.
3. For a discussion of Segonzac's watercolor technique and his views of the medium, see the artist's preface to François Daulte, *L'Aquarelle française au XXe siècle* (Paris, 1968), pp. 5–6; see also Segonzac's essay and Passeron's discussion of Segonzac's watercolors in Passeron, pp. 9–40, and 47–54.

*66.* THE DOG
*Le Chien*

Pen and brush with black ink on white paper, 6 ⅝ × 7 in.
(16.8 × 17.8 cm)
Signed at bottom: *A.D. de Segonzac*

Segonzac's drawing of a dog is purely linear, based on brevity and vitality of line, capturing the dog's alert posture and expression and above all its motion and energy. There is no indication of environment except for a few short strokes near the dog's front paws. Rapidly drawn staccato strokes articulate a shifting outline to convey the nervous movement of every part of the animal's body. The various strokes comprising this discontinuous contour—a loose line of dashes on the legs, squiggles under the neck, parallel curved lines on top of the back—express the afterimage of the form that has moved, a technique Segonzac also used in sports drawings. The long tail, masterfully rendered as an arc of smudged ink, is discontinuous with the body and suggests the apparent dissolution of form through rapid motion. The arc of the tail imparts energy to the entire upper portion of the sheet.

This drawing touches upon Segonzac's origins as a draftsman. His first drawings were made as a young child when he visited the Jardin des Plantes and sketched the exotic animals. The theme of animals had a lasting attraction for him, and he returned to it as late as 1937, when he made additional sketches at the Jardin des Plantes. The earliest examples in the catalogue of his drawings are dated 1911 and 1912; these include pen and ink renderings that emphasize fairly smooth contour and focus on capturing characteristic pose, and a work (of 1912) in which both pen and wash impart volume and surface texture.[1] Corresponding most closely to the sketch in the Sirak Collection are Segonzac's animal drawings of the 1930s and 1940s, which reveal a similarly free and lively sense of line, with a selective use of dark ink smudges and a variety of suggestive strokes to convey texture or motion.[2]

Segonzac's drawing relates to a long tradition of animal studies including those by the Quattrocento artist Pisanello, whose draftsmanship Segonzac admired.[3] The expressiveness and brevity of Segonzac's style also suggest comparison with the drawings created around 1906 by Pierre Bonnard to illustrate Jules Renard's *Histoires Naturelles*, although Segonzac's drawing has a much greater immediacy and eschews stylization.

—RFJ

1. The interrelation of etching and drawing is an integral part of Segonzac's conception of drawing; see André Dunoyer de Segonzac, *Dessins 1900–1970* (Geneva, 1970), pp. 38–39, 42.
2. Ibid., pp. 44–45, and especially p. 45a (*Lapin de choux*, pen and wash, ca. 1943).
3. Ibid., p. 15.

# GINO SEVERINI

Italian, 1883–1966

## 67. RHYTHM OF THE DANCE (DANCER)
*Rythme de danse (Danseuse)*
1913

Oil, plaster, and sequins on board, (sight) D. 10³/₄in.
(27.3 cm)
Inscribed and signed lower left: *À Madame Rachilde
souvenir de son admirateur Gino Severini*. Dated lower
right: *Paris Août 1913*. On verso: *Gino Severini, Paris
1913 / Rythme de Danse*

The Futurist movement in art took its identity from a
common faith in progress and technology and a style
indicative of the material and psychological conditions
of the modern, urban-industrial world. When Filippo
Tommaso Marinetti published the first manifesto of
Futurism in 1909, he called for a new attitude toward
art and life.[1] This new view identified dynamism as the
single most important quality of modern existence.
As the Futurist painters wrote in a 1910 manifesto:
"The gesture which we would reproduce on canvas
shall no longer be a fixed *moment* in universal dyna-
mism. It shall simply be the dynamic sensation itself."[2]
They turned to subjects drawn from modern life—
automobiles, trains, cities—and borrowed the most
advanced stylistic elements of the day to give form to
their vision of endless dynamism.

Gino Severini, who had lived and worked in Paris
since 1906, was the Futurist best positioned to observe
dramatic developments in art in the prewar years. He
formulated a style heavily indebted to Seurat's Neo-
Impressionism as interpreted by artists like Paul Sig-
nac. But he was also aware of the work of Braque and
Picasso and was the first of the Futurists to under-
stand the implications of the Cubist style. The Cubist
fragmentation of forms served Severini as an ex-
pressive means rather than an analytical tool. Living
in Paris, he naturally turned to the cafés and night-
life of the city as a subject, creating works animated
with the frenzied movement of figures and the lively
play of light. The divisionist application of color
and the breakdown of forms in his paintings con-
vey the impression of movement and energy typical
of such entertainment spots.

*Rhythm of the Dance* is one of a group of works
dating from mid-1912 through 1914 which deal with
the dance in a café or music-hall setting.[3] It is
inscribed with a dedication to Madame Rachilde, the
pseudonym of Marguerite Vallette, whose husband
was *Mercure de France* editor Alfred Vallette, a novel-
ist, friend, and biographer of Alfred Jarry, and one of
the luminaries of the Montparnasse bohemian cafés.
The distinctive formula that the artist used to express
the whirling forms of the dancer is based on the ear-
lier and well-known *Dynamic Hieroglyphic of the Bal
Tabarin* (1912, Museum of Modern Art, New York).[4]
In *Rhythm of the Dance*, patterns of small, dotlike
brushstrokes develop into arcs and planes that de-
scribe the movement of the dancer and echo the cir-
cular format of the work. These arcs weave through
the space of the painting, at times describing the
dancer's body, but for the most part moving indepen-
dently. A single circular breast forms an odd but stable
focal point within the active curves of the composition.
The dancer herself is placed rather stiffly and hier-
archically in the center of the composition. A central
vertical line divides her face in half and delineates the
axis around which the movement takes place. The tex-
ture of the small brushstrokes, lifted so that the pig-
ment forms tiny peaks, enhances the sense of
movement by creating an engaging surface activity.
Even their circular form picks up the leitmotif of the
circular composition.

The surface of the painting is built up in relief in
several areas with plaster. A similar relief technique is
found in the 1912 *Danzatrice a Pigal* (Baltimore
Museum of Art),[5] for example, in which peaks rise
from the picture plane and actual light plays across the
surface creating a real third dimension. Severini also
glued sequins to the surface, a technique he often used
in this period to give his works a feeling of light, as in
the *Blue Dancer* of 1912 (private collection, Milan).[6] But
these shiny points of light are an extension of the dots
of pigment, a kind of metallic equivalent to the oil
paint. This collage element suggests the textures and
materials of the fashionable cafés of Paris and inter-
jects an element of the real world upon the painted
surface.

The color of *Rhythm of the Dance* is surprisingly cool, mostly blues and greens, and, with the exception of the fleshy pink of the dancer's arms and face, the palette is rather restrained. This is perhaps Severini's means of representing the pace of the dance, a graphic indication of the element of time that was so dear to the Futurists.

*Rhythm of the Dance* is one of Gino Severini's most original conceptions. His interpretation of the Futurist aim to represent universal dynamism is both poetic and lively, without being bound to a stylistic formula. One of the artist's contributions to the Futurist movement, *Rhythm of the Dance* is both personal and engaging.            —GW

1. "The Foundation and Manifesto of Futurism," *Le Figaro* (February 20, 1909). Cited in Umbro Apollonio, ed., *Futurist Manifestos*, Documents of 20th-Century Art, trans. R. W. Flint (New York, 1973), pp. 19–24.
2. Apollonio, p. 27. "Futurist Painting: Technical Manifesto" was originally published as a pamphlet in Milan, April 11, 1910. It was signed by the five major Futurist painters, including Gino Severini.
3. Marianne W. Martin, *Futurist Art and Theory 1909–1915* (Oxford, 1968), pp. 138–147.
4. See George Heard Hamilton, *Painting and Sculpture in Europe, 1880–1940* (Harmondsworth, New York, 1972), p. 287, fig. 172.
5. See *Baltimore Museum of Art News* (summer/autumn 1963), p. 22.
6. See Apollonio, fig. 50.

# ALFRED SISLEY

French, 1839–1899

## 68. BOATYARD AT SAINT-MAMMÈS
*Chantier à Saint-Mammès*
1885

Oil on canvas, 21⅝ × 28⅞ in. (54.9 × 73.3 cm)
Signed and dated lower left: *Sisley 85*

Sisley, it is well known, was among all the Impressionists the one that suffered the most and the longest from lack of public recognition and from the resulting deprivation of material and moral resources. As Sisley's friend Gustave Geffroy wrote: "His whole existence was undermined by struggle and worry."[1] In 1885 Sisley's financial situation was extremely precarious. Apart from a few scarce sales of paintings to Dr. de Bellio, to Eugène Murer, and to Durand-Ruel, Sisley could not sell his art. Nevertheless, 1885 was a conspicuously prolific year in Sisley's career, when he executed seventy-two paintings—more than one painting per week—plus numerous works on paper and prints. Sisley executed fifty-four paintings in the previous year, and only nineteen paintings in the following year.

A pronounced sense of isolation and abandonment seems to have gradually increased throughout Sisley's life. He tended to be seen as a follower of aesthetic principles created by his peers, rather than as a contributor to those principles.[2] Diametrically contrary to this assessment were the words of Camille Pissarro, written to his son Lucien on January 22, 1899, a week before Sisley's death: "I have heard that Sisley is desperately ill. He is a great painter and in my opinion ranks among the masters. I have seen paintings done by him of the most unusual vision and beauty."[3]

It is in this context that one can best appreciate the significance of *Boatyard at Saint-Mammès* in the Sirak Collection. The subject of a construction site on the banks of a river is first seen in Sisley's work of 1875.[4] Scenes of labor on the Seine gained in importance in Sisley's work, and from 1878 on, he created eleven paintings of such related subjects.[5] Working sites occur in several of the first paintings done at Saint-Mammès, a village on the river Loing, near where

Sisley moved in 1880.[6] In 1885 Sisley executed a series of paintings of boats under construction, including the Sirak painting. All carry the unmistakable mark of strong individuality and originality.

In appearance very simple and elementary, the Sirak painting almost surreptitiously gives way to a gamut of poetic notions. A boat under construction, surrounded by tree trunks recently cut, although placed to the right in the composition, is clearly the most imposing object by its mass and volume—almost too wide for the calm, blue Loing River. Only a large vessel-shaped cloud in the center of the picture nearly matches the boat in size. Some parallel relationships are suggested between the clouds that move through the sky and the boat that will move through the water once the ship is completed. The boat's structure, resembling that of a trawler, indicates that it is most likely conceived for the sea. This painting is in essence constructed around a system of passages: the passage of clouds in the sky, the impending shift of the ship from earth to water, the transformation of raw tree trunks into a ship, and the continuous flow of the Loing. Though much human activity is suggested, very little is actually taking place. Only the clouds and the river show energetic movement. Human activity can pause, but nature's is ceaseless.

There is something slightly ominous about this desolate river site and this bulky empty ship. At first glance an apparently simple, charming, and innocent landscape, the painting interweaves imagery that echoes Sisley's own existential concerns: the boat suggests a voyage toward an unknown, or at least undefined, destiny. The aura of mystery or of anxiety aptly echoes Sisley's position in life at the time. Certainly, *Boatyard at Saint-Mammès* provides powerful evidence that Sisley's art cannot be understood within Monet's or Pissarro's idioms. It should, rather, be articulated within Sisley's unique artistic sensibility.

—JP

1. Gustave Geffroy, *Sisley* (Paris, 1927), p. 30.
2. For instance, in Lionello Venturi, *Les archives de l'impressionnisme* (Paris, New York, 1939): ''It rather seems that [Sisley] gave in to impressionism because his friends were impressionists.''
3. *Camille Pissarro, Lettres à son fils Lucien*, ed. John Rewald (Paris, 1950), pp. 465–466.
4. François Daulte, *Alfred Sisley: Catalogue raisonné de l'oeuvre peint* (Lausanne, 1959), cat. nos. 176–177.
5. Ibid., nos. 289–299.
6. Ibid., nos. 368–370, 372.

# CHAIM SOUTINE

Lithuanian, 1893–1943

*69.* LANDSCAPE AT CÉRET

*Paysage de Céret*
1920–1921

Oil on canvas, 24 11/16 × 32 3/4 in. (63.4 × 83.2 cm)
Signed lower left: *Soutine*

Soutine is often characterized, and indeed romanticized, as the archetypal desperate and out-of-control Expressionist, painting frenzied, tormented images. But a view of his work that stresses only its unbridled and raw energy does it a disservice, for underneath the turbulent surface is a deliberate formal structure.

Soutine painted from life and relied on that tangible contact with the visible world to inform his paintings. Painting landscape outside, in the midst of nature, was an experience particularly well suited to the kind of immersion and identification with his motif that he required. The landscapes painted in and around the town of Céret, in the French Pyrenees, in the years 1919–1922 communicate this sense of immersion and entrapment in the landscape. As viewers, we too feel pulled into the picture by the straining and surging forms and held there by the thick crust of paint, the compression of space—echoes of the sensations one would feel standing in the actual dense mountain landscape of Céret.

In the three-year development of the Céret landscapes, the initial thrust is toward a dense, allover, convoluted image in which forms strain and push over the surface. Once this impulse reached a climax, more overt structural elements started to assert themselves. The splendid Céret landscape in the Sirak Collection is representative of those of 1921 in which the chaotic upheaval and confusion of form are seemingly at a maximum, yet the structural devices underpinning the whole are becoming more apparent.

Our awareness is first of the paint on the surface, pulling and stretching over the canvas. Before we see houses, trees, rocks, or sky, we see grays, whites, oranges, greens. The gray could be rocks, the white streaks and cadmium slabs, houses and roofs. Forms move in and out and through one another, lose their identities, and regain them. There is a back-and-forth interchange of sensation and definition. In areas such as the hill-like shape on the left and the green mass of foliage in the center, the forms merge to create putty-like shapes on the surface, with elastic edges that Soutine is able to manipulate and pull and twist into place. The thick paint literally binds the forms together and onto the surface to create a physical presence. We feel the picture plane as a crust of paint, a canvas skin.

The emphasis on the surface is further reinforced by the foreground trees, which strain across the lower left corner to the upper right, covering the canvas with their limbs and foliage, creating a screenlike effect, and pulling the eye upward. These gesturing masses drag the other elements in the landscape—rocks, houses, pieces of sky—along with them. Elements existing on different spatial levels are joined at the surface, as forms in the foreground touch those in the distance and lock together.

The space created in this painting is typical of the Céret landscapes. It is not flat or shallow but compressed—a space into which near and far, and all the intervening houses, trees, mountains, and air have been squeezed. The feeling is one of impacted density, of fullness, of richness, of tension.

At the edges of the canvas the same forms—tree limbs, the curve of a hilltop—turn back and reenter the field, causing the viewer's eye to follow. This curling back from the absolute edges of the canvas reinforces the elliptical configuration of the total image, a scheme that increasingly characterizes the Céret landscapes as an organizing compositional tool. While the device works to reinforce sensations of claustrophobia, entrapment, and immersion, it also functions to contain the image, to anchor it, to stabilize it. The development of the Céret landscape is toward stability and clarity, expressed in later Céret paintings through such deliberate compositional organization as centrality, symmetry, elliptical schemes, bracketing of forms, as well as object definition and the opening up of space.

—ED

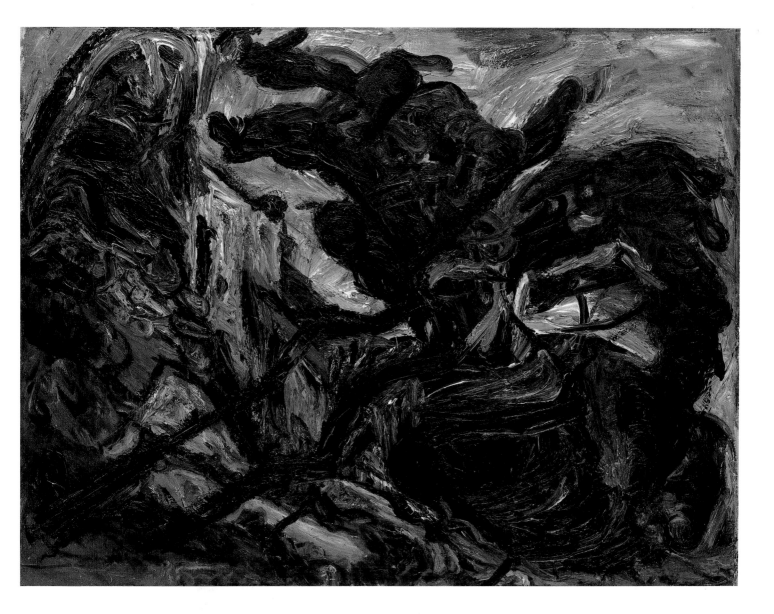

## 70. MELANIE, THE SCHOOLTEACHER
*Melanie l'institutrice*
ca. 1922

Oil on canvas, 32⅛ × 18⅛ in. (81.5 × 46 cm)
Signed lower left: *C. Soutine*

This portrait was painted during the "Cagnes years," 1922–1925, when Soutine divided his time between the south of France and Paris. These were years in which his work in landscape, still life, and portraiture were equally demanding and productive, and in which certain stylistic affinities occur among the three genres. Most striking of the shared features are the elliptical compositions and curvilinear surface rhythms, the increasingly centralized and frontal positioning of the image, the massing of single colors into broader areas, and the shallow space in which the objects are placed.

The painting of portraits was difficult for Soutine. The natural exchange of sensation between two people becomes intense when one is a painter, the other a model, and the two confront each other face to face. Soutine, perhaps to deflect this emotional charge, preferred to paint portraits of people he knew slightly, if at all. Only occasionally did he paint people with whom he was close.

Many of Soutine's anonymous figures of the 1920s were produced in series and can be referred to by type, and identified by their uniforms: pastry cooks, hotel boys, page boys, waiters, choirboys. Others are nondescript people. We do not know who Melanie the schoolteacher was, but we can safely assume she was a peripheral figure to Soutine—a model, not a friend or character from his daily life. Yet she faces us as a real person, an individual, a particular physical being, despite the distortions and exaggerations of facial features, the shiftings and dislocations of body parts.

Soutine's figures pose, open to his and our scrutiny, but somewhat indifferent to the presence of a viewer. The sense of posing is made more emphatic by the insistence on a narrow range of compositional schemes that are repeatedly, if not obsessively, used. The paintings are generally of single figures, usually seated in a half-length or three-quarter length pose, set centrally within the field, facing frontally, with his or her hands resting on the lap or placed on the hips. The figure is self-contained. The background is bare, with only an occasional minimal prop, like a chair or curtain, to offset or support the figure. The figure is presented to us, open and ready for our visual inspection, in much the same way as the artist's beef carcasses, dead fowl, and fish of the Cagnes years—up close, centered, frontal.

The confinement to certain basic repeated formulas enabled Soutine to focus on and lavish still more attention on those elements that remained open to manipulation. In almost every picture, as in this one, he concentrates on the flesh—its breakdown into richly inflected paint, stroke, and color—to accent the raw nerves and rumblings beneath the skin. In this painting, a tension is created between the apparent regularity and anonymity of the sitter and the searching quality of the strokes and contours of her face and gnarled hands.

The dominating and containing elliptical movement of the image establishes the regularity here and finds its echo within the curvilinear forms of the figure—shoulders, arms, hands, knees, hair, face—which are continued and restated in the arching back and arms of the chair. The chair frames the figure, enclosing her and forming an elastic sinuous shape that sits, if not on the surface, close and parallel to it. The swirl that encompasses the whole only accents the vertical foil of face, neck, and hands. These areas are further reinforced by the contrast between light and dark, between seemingly whole areas of single color set against the many touches and colors of the skin, between the animate and articulated nature of the flesh and the more generalized, inert areas of cloth and background. Against the relative flatness and lack of definition in the rest of the figure and background, the richness and complexity of the hands and face stand in relief.

To further offset the seeming regularities observed in the ellipse of figure and chair, the vertical presentation of face, neck, buttons, and hands, the horizontal configuration of armrest and arms, the artist interweaves certain irregularities or shifts, such as the asymmetry of ears and eyes (which are slightly askew), the twists and turns of the shoulders, and the countering ups and downs of the chair back. All these back-and-forth movements set up a spatial tension, a turning and shifting within the flat confines of the ellipse, adding an emotional dimension to the whole. The uneasiness under the surface, the nervous energy held in check—these are the attributes we have come to associate with a Soutine portrait.      —ED

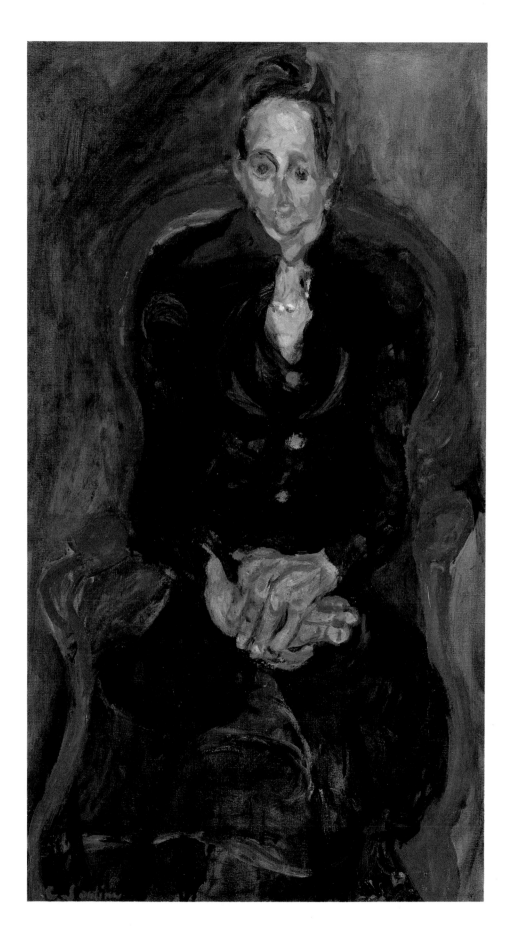

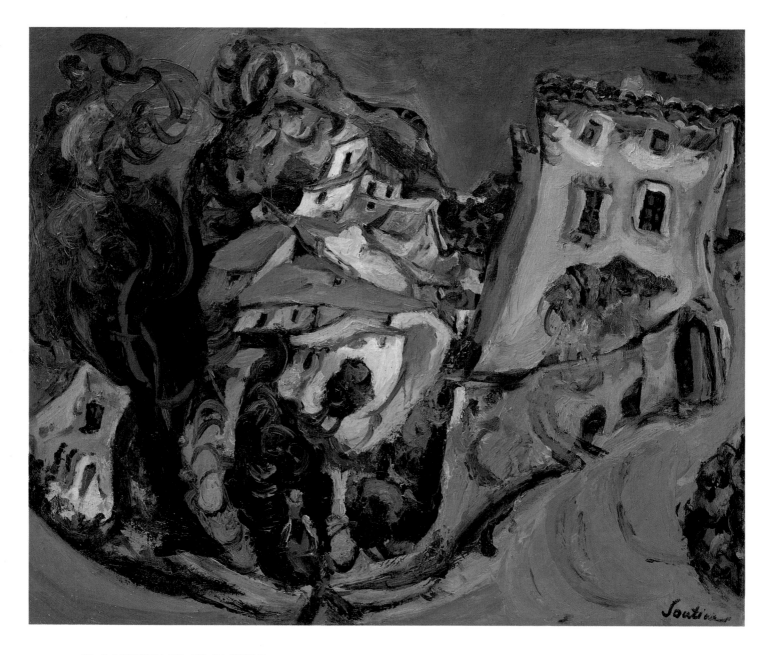

*71*. LANDSCAPE AT CAGNES
*Paysage de Cagnes*
1923

Oil on canvas, 25³/₄ × 32¹/₈ in. (65.5 × 80.5 cm)
Signed lower right: *Soutine*

After the Céret years, Soutine's next great period of landscape painting occurred from 1922 to 1925 at Cagnes in southern France. The movement toward clarity and legibility in the Céret pictures (see cat. no. 69) was continued in the more clearly defined Cagnes images. Throughout this later period, there was an increasing emphasis on the identity of objects. At Céret one form melted into another; not only can we not identify objects, we can barely talk in terms of

objects. It is more appropriate to talk of paint, movement, sensations. At Cagnes, objects—houses, trees, roads, sky—emerge as separate and distinct from one another. Brushstroke and color become tied to the objects they depict. Colors are grouped in larger areas to define objects. The greens come together to create the trees; the whites and yellows coalesce to define the houses; the sky is an expansive blue. The emphasis on the object as an autonomous entity—itself eliciting and directing sensation—links these landscapes to portraiture and still life, genres defined by a similar focus and ones to which Soutine devoted considerable attention during the Cagnes years.

Both landscapes in the Sirak Collection are articulate representatives of particular periods in Soutine's

stylistic evolution. The Céret painting is an especially outspoken Céret, and the Cagnes painting is a beautiful, well-stated example of its kind. Despite the fact that each speaks so distinctly for its own group, there is a continuity and consistency between the two that underlines the essential unity and developing focus of Soutine's work.

As we turn from the Céret to the Cagnes landscape, we see how the elliptical organization of the earlier painting came to dominate the later one. In both, the objects come forward toward the viewer, toward the surface, to create an elastic configuration. The hill on the left of the Céret painting parallels the house and tree on the left of the Cagnes scene, the central foliage bursts of the Céret picture correspond to the flattened, or compressed, mass of houses at Cagnes, and the foliage and trees of the right side of the Céret work are mirrored in the house on the right in the Cagnes work. The elliptical pattern is more overt in the Cagnes picture, anchored in a central point—the figure, an accent of cadmium red in the lower center of the composition—from which the whole radiates.

This emphasis on surface rhythm and design literally pulls the image together, but simultaneously Soutine created a deeper space for his forms. They are no longer buckled and straining in place, but are set upon a shallow stage within which they seem free to move about. The eye of the viewer, too, can move in and around these autonomous objects. Note, for example, the central mass of houses. Although they are piled one on top of the other, interconnecting to form a single surface shape, they still remain differentiated and distinct forms through which the eye can wander.

The opening up of the space in many of these Cagnes pictures is reiterated by the inclusion of a form, usually steps or a road, that visually and literally invites us to enter. This accessibility is a reversal of the claustrophobic sensation of the Céret paintings. Greater atmospheric breadth and luminosity, the inclusion of more sky, a brighter palette of increasingly pastellike colors, and a reduced sense of scale (note the little figures on the roads) all contribute to this sense of expansion. These elements also introduce a note of playfulness, in contrast to the seriousness of Céret. Of course, the shift in geographic location, from the dense, angular, mountainous entanglement of the Pyrenees to the sunny openness of a hill town in the French Riviera, was partially responsible for these changes, but even more important was Soutine's sensitivity to the particularity of a place or an experience. Equally at work is the urge toward heightened pictorial clarity and differentiation that began to assert itself earlier in the Céret paintings.

The more carefully Soutine looked, the more he restricted his focus. The early Céret panoramas gave way to a few trees, a house, a town square, a hill. The impulse to paint repeated views of a limited number of motifs became even more pronounced at Cagnes, and we can begin to think in terms of series. This Cagnes landscape can be readily grouped with other paintings of the same scene such as those in the Colin Collection, New York,[1] and the Musée de l'Orangerie, Paris.[2] In the still lifes and portraits of these years, we are also able to refer to series of motifs—beef carcasses, rayfish, hanging birds, hotel boys, pastry cooks, choirboys.

The repeated attachment to certain motifs, the increasing clarity and specificity with which they were painted, is consistent with Soutine's development toward order and definition and his move from an allover composition to a more focused, centralized one. The more specific and defined the subject, whether a single object or a repeated view, the more restricted is the formal range. Compositions became more and more regularized and predictable and dealt with fewer complexities each time. The repetition of motifs works hand in hand with the impulse toward clarity. It also emphasizes the focused concentration and emotional premium placed on developing and refining a personal imagery—whether it is slaughtered beef, a plucked fowl, a uniformed hotel boy, or a cluster of houses on a street in Cagnes.　　　—ED

1. Museum of Modern Art. See Monroe Wheeler, *Soutine* (New York, 1950), illus. p. 17.
2. *Collection Jean Walter et Paul Guillaume* (Paris, 1984), no. 118.

# NICOLAS DE STAËL

French, born in Russia, 1914–1955

## 72. THE VOLUME OF THINGS
*Volume des choses*
1949

Oil on panel, 72¼ × 39⅛ in. (183.6 × 99.4 cm)
Signed lower left: *Staël*

Nicolas de Staël was born in St. Petersburg to an aristocratic family on the eve of the Russian Revolution. He lived in Poland, then in Brussels. Following several years of study and travel, in 1943 he settled in Paris, where in time he became one of the leading artists of the postwar School of Paris. De Staël came to artistic maturity in the mid-1940s, painting in an abstract idiom. Before his death by suicide in 1955, he spent his last three years occupied with still-life, landscape, and figure compositions. During this time his technique evolved from thickly built-up canvases layered with paint, some of which required two years to finish, to much more rapidly executed works with a nearly transparent application of thinned oil. Yet for all the stylistic range of his short career, there is also continuity; clearly the later work is indebted to that of preceding years.

*The Volume of Things* marks the advent of a turning point in De Staël's work. The year 1949 saw the culmination of his style of the later 1940s, when his approach to abstraction was often characterized by a dynamic interplay of diagonal and opposing forms. Articulation of space was one of De Staël's paramount concerns from 1945 to 1949 in works that constitute the first phase of his mature production. By 1949 De Staël composed paintings with fewer and larger forms, in many cases resulting in more monumental works. Increasingly he would build up layers of impasto, allowing passages of earlier paint application (often more brilliant in the underlayers) to show through. In 1950, rectilinear forms became increasingly preponderant, and his emphasis on the surface as a flat plane became an overture to the wall-like compositions of 1950–1951 which in turn helped to forge his transition to landscape.

In *The Volume of Things* the vertical format is accentuated by the upward diagonal thrust of the composition. Yet the painting, which seems less agitated than those of preceding years, reflects the resolution and calm typical of works from 1949. The painting bears comparison, not only in style and palette but also in scale, to *La rue Gauguet* (Museum of Fine Arts, Boston),[1] a major work of the same year, which also was thickly painted on a large piece of plywood.[2] The rich, subtle tonalities, from putty to gray, cream to pale green, are more restricted in range in *The Volume of Things*, reflecting the artist's frequent visits at this time to the studio of his neighbor and mentor, Georges Braque, whom De Staël had met in 1944. Although De Staël tended to paint easel-size works, he frequently attempted a larger format, and his mature oeuvre is punctuated by such ambitious works as *La rue Gauguet* and *The Volume of Things*. His thick application of paint occasionally necessitated working on the floor, and in 1949 he began to use the palette knife as well as the brush in his work.

De Staël felt that even his abstractions had subjects which came directly from his life and visual experience.[3] He had an omnivorous eye and was acutely sensitive to qualities of color and light. A sense of locale therefore permeates his work of every period, which helps to explain the dramatic shift in his palette from the early years in Paris, when he consistently employed subtle tonality, to the late years in the South of France, when he adopted brilliant hues in response to the Mediterranean light. De Staël's admiration for Dutch and English landscape painting as well as the art of Corot and Courbet reinforced his exploration of a tonal range such as that found in *The Volume of Things*.
—ER

1. Guy Dumur, *Staël* (New York, 1976), illus. p. 20 (color).
2. The artist used plywood as a support because he was given several large pieces, a gift he welcomed at the time due to his financial circumstances (conversation with Françoise de Staël, 1988).
3. On December 3, 1949, De Staël wrote to his friend, the French poet Pierre Lecuire, "*toute toile a un sujet si on le veuille ou non*" (all painting has a subject whether one wishes it or not); see *Lettres de Nicolas de Staël à Pierre Lecuire* (Paris, 1966). Nevertheless, "he disliked people reading into his title any literary content" (Theodore Schempp, the American dealer who introduced De Staël's work in the United States, in a letter to Perry T. Rathbone, May 31, 1957, on file, Museum of Fine Arts, Boston).

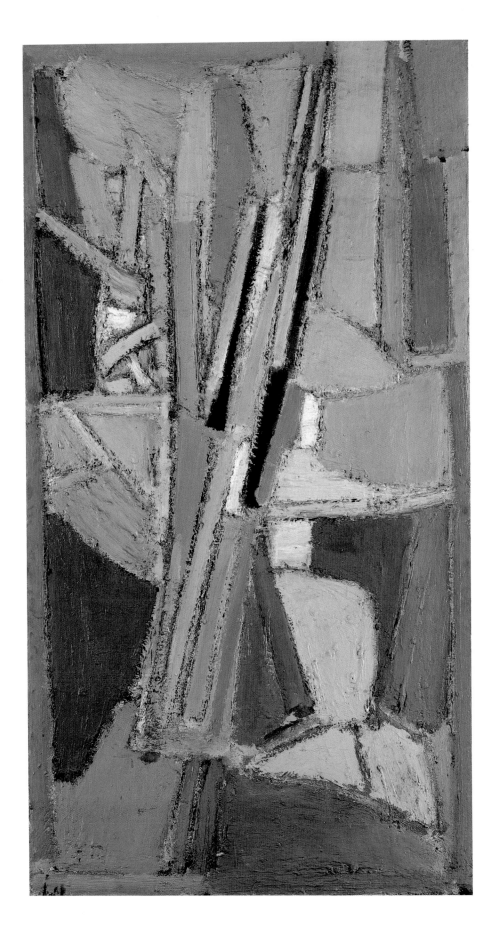

# MAURICE UTRILLO

French, 1883–1955

## 73. CHURCH SQUARE, MONTMAGNY

*Place de l'Église à Montmagny*
ca. 1908

Oil on canvas, 21⁵/₁₆ × 28¹³/₁₆ in. (54.1 × 73.1 cm)
Signed lower left: *Maurice Utrillo v.*

Utrillo spent much of his adolescence in Montmagny, a suburb fewer than ten miles north of Paris. Here he lived with his mother, the famed artist Suzanne Valadon, and the lawyer Paul Mousis, who married Valadon in 1896. Here also, in 1902, the nineteen-year-old Utrillo received his first paints, a gift from his mother as a therapeutic measure against his early alcoholism. Taking up the brush, Utrillo found solace in portraying unheralded city views whose empty streets and bleak skies mirrored his own feelings of sadness and estrangement.

Montmagny was the subject of many of Utrillo's paintings from about 1906 to 1910: rural hillside views —often seen through dense black webs of leafless trees—clusters of houses with their gardens, the country church, and of course the streets. *Church Square, Montmagny* is probably one of two nearly identical views of the street and a corner of the square that lie adjacent to the church of Saint Thomas.[1] Utrillo favored this site, painting the eighteenth-century church five times and a full view of the tree-lined square once.[2] The picture is from Utrillo's so-called Montmagny period—the first stage of his development—characterized by a somber palette, Impressionist brushwork, and naive realism. Painted about 1908, the picture stands on the threshold of the *manière blanche* or "white period," which is considered by many to be his most significant. Particularly impressive here is Utrillo's bold application of pigments in response to the physical properties of the various elements of the composition: the trailing and daubing of thick paint to give literal dimension to the row of trees; the spreading of paint in heavy, rich strokes to simulate the smooth texture of plaster walls; and the scumbling to suggest the coarse, wet road surface as it reflects low clouds stirring in an overcast sky.

*Church Square, Montmagny* reflects a mood of deep melancholy. As in many of Utrillo's greatest works, the subject of the picture is a nearly deserted street which—lined with drab buildings and accented with dark brooding colors—dramatically recedes into space. Utrillo confronts the street head-on at ground level with utter familiarity. The scene is sparse, isolated, and silent, inhabited only by an anonymous couple standing motionless beneath the trees. The trees, nearly devoid of foliage, are crowned with a dense mass of chilling, clawlike branches. The sharp, raking angle of the building facades precludes visual access to doorways or windows, which are rendered as gaping black holes or tightly shuttered openings. Because any hint of interior life is hidden or obscured, the buildings become faceless and monotonous as they recede into the distance.

The sweeping perspective of the scene constantly brings the eye back to the physical center of the picture—a point just above the apex of the street. There we are not greeted by a bright vista beyond the bleak sky. Instead, as the street rises and bears right, our view is blocked by a carriage. Only the mind's eye travels onward to other endless streets whose houses harbor secrets of their own.

—EJC

1. The Sirak picture is number 2482 in Paul Pétridès, *L'Oeuvre complet de Maurice Utrillo*, 5 vols., supplement (Paris, 1974), 5: p. 120, dated ca. 1908. Utrillo painted another slightly larger version from the identical vantage point except that the view is slightly cropped on the left side and some minor differences in detail, such as the absence of a carriage in the street, can be observed. See Pétridès, vol. 1 (1959), no. 50, p. 98, dated ca. 1907.
2. Utrillo's five views of the church at Montmagny are nearly identical; four were painted in ca. 1908 and one in ca. 1913. See Pétridès, vol. 1, nos. 77–79, p. 126; no. 42, p. 192; and no. 403, p. 466. A frontal view of the church square in Montmagny is no. 137 in Pétridès, vol. 1, p. 188, dated ca. 1909.

# KEES VAN DONGEN

Dutch, 1877–1968

*74.* LILACS WITH CUP OF MILK
*Lilas et tasse de lait*
1909

Oil on canvas, 44³/₁₆ × 36⁷/₈ in. (120.3 × 93.7 cm)
Signed lower right: *van Dongen*

Kees van Dongen was deeply immersed in the unrestrained manner of the Fauves, a colorist of rich, intense hues and stridently sharp contrasts of complementary colors, yet he brought to Expressionist painting an element of very subtle commentary. Whatever the genre or subject of Van Dongen's paintings, his images are suffused with an ambience of privileged joie-de-vivre. The directness of his paintings, their resonance of light and color, their inner secrecy and provocative nature hold the viewer captive.

The large *Lilacs with Cup of Milk* in the Sirak Collection exemplifies these qualities. The blossoms, which are rendered in broad, bold, elongated brushstrokes, aggressively draw the viewer into the intense warmth of the picture space. Yet because of the ambiguous perspective and lack of background depth, the vase of lilacs hovers insecurely within this space, unsettling in its tenuous placement. A soothing cup of milk is offered by the hand of an anonymous server who exists somewhere beyond the picture frame. There is something mysteriously inviting about this gesture of hospitality, and the small cat asleep on the rug is a further charming inducement.

At the core of Van Dongen's art is a controlled sensuality, never coarse or exaggerated. In temperament the Sirak painting is typical of most of Van Dongen's oeuvre. It offers a glimpse into the aura of the last years of the Belle Epoque, as it describes a world unto itself, at once elegant and raw, suggestive of its own set of social, moral, and aesthetic standards to which only a select few are privy. In this, Van Dongen may be a product of the Dutch and Flemish artistic heritage in which objects were chosen for their symbolic meaning. Suspended in time, immersed in the metaphysical nature of Dutch Baroque still lifes, meticulously handled but oddly inconsistent with logic, Van Dongen's painting has provocative overtones.

Where Van Dongen departs from the traditions of the seventeenth century is in his obsession with the lithe body of the female, here only tauntingly suggested.

First displayed at the Galerie Druet in Paris in 1910, the Sirak painting dates to a time when Van Dongen's art underwent a change determined by his newly found tall and slender models, the Countess Cassati and Jasmy Jacob. The hand in the Sirak painting might, in fact, belong to one of these femmes fatales. With a mannered, attenuated quality, the hand proffers the cup and saucer, a configuration that is echoed on the opposite side of the composition by the round carpet on which sleeps a curled feline, the embodiment of physical grace. Between these two points, the unruly leafiness of the floral arrangement and the lilacs bespeckled with dabs of chartreuse amidst patches of purple create a contrast with the sharp edges and smooth surfaces of other objects. The bushy lilacs overflow the vase, augmenting the sensual overtones of the painting, while the embryonic composition throughout the rest of the work provides an atmosphere of comfortable closure.[1]

Van Dongen's painting *La Vasque fleurie* of circa 1916–1917 (Musée d'Art moderne de la Ville de Paris)[2] is a later version of a similar subject, with Countess Cassati posed elegantly along the left side of the painting. In the middle of the composition is a large, compositionally dominant, fountain vase with flowers, and on the right, a dog rests watchfully on the floor. *Lilacs with Cup of Milk* is a far more highly nuanced painting. More than a display of the glamour that surrounded Van Dongen throughout his life, it is a glimpse into the private world of the artist. It is both urban and intimate, private and public, and these alternating elements are exquisitely held in balance.

—MMM

1. A painting similar to the Sirak painting and equally provocative is *Le Sphinx* of ca. 1925, also known as *La Femme aux chrysanthèmes* (Musée d'Art moderne de la Ville de Paris), illustrated in *Van Dongen, le peintre, 1877–1968* (Paris, Musée d'Art moderne de la Ville de Paris, 1990), p. 58.
2. See ibid., p. 175.

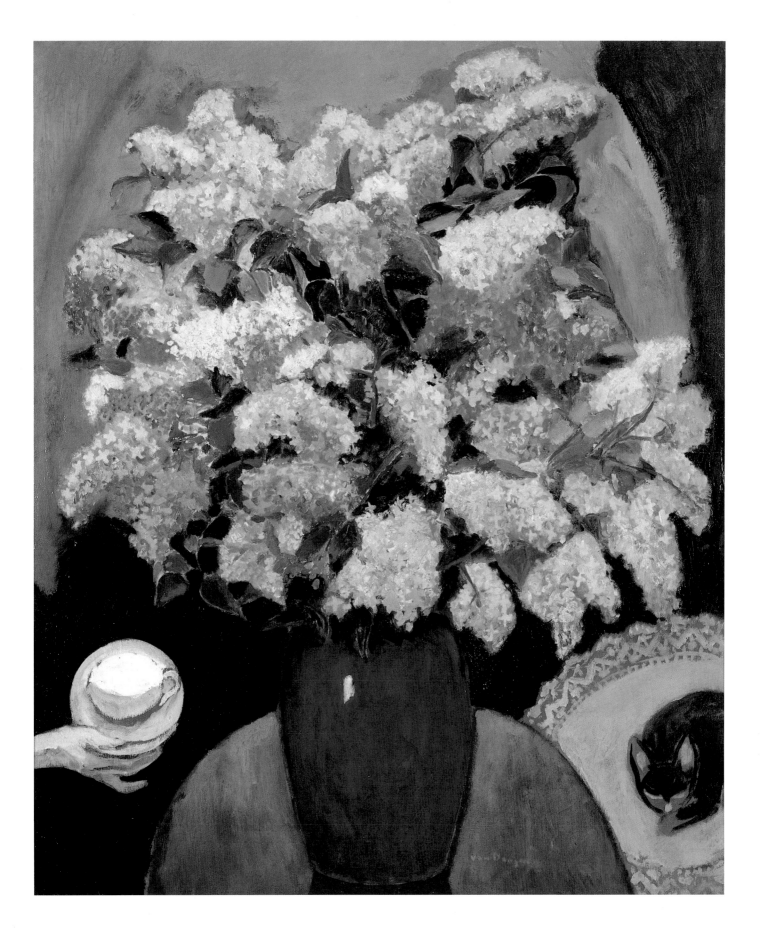

# MARIA ELENA VIEIRA DA SILVA

French, born in Portugal, 1908

## 75. THE ATLANTIC
*Atlantique*
1961

Oil on canvas, 31 3/4 × 39 3/8 in. (80.6 × 100 cm)
Signed and dated lower right: *Vieira da Silva 61*

The paintings of Maria Elena Vieira da Silva reflect the aesthetic values of an entire generation of painters who at the outset accepted the viability of expressive abstraction. Vieira da Silva's early career was spent in the shadow of the School of Paris painters, who were concerned with essentially formal artistic problems, but she moved in the late 1930s toward a more personal and less rigorous abstraction chiefly concerned with the construction of space. As a result, she has since sought the lyrical and mysterious possibilities within both recognizable and ambiguous forms. As John Rewald wrote, "Vieira da Silva closely observes the world around her; her canvases spring from things that she has seen, transformed into those strange, serene or moody vistas perceived whenever her eyes turn inward."[1]

Poetic and personal, *The Atlantic* is typical of the canvases Vieira da Silva painted after returning to Paris from Brazil in 1947. She had begun to develop gridlike structures in her paintings in the mid- to late 1930s. The resulting images suggest either large-scale architecture in urban landscapes or intimate interiors not unlike the patterns of tiled floors in Dutch Baroque interiors. The grids expanded and filled her paintings by the 1940s, as seen in works like *The Studio, Lisbon,* 1940 (private collection, New York).[2] They eventually became an overall mesh of lines and shapes throughout the space of the painting. By the late 1940s, in works like *Egypt*, 1948 (private collection, Paris),[3] the grids were softened and broken into an explosion of fragments that emerge from and recede into misty clouds of color. While the architectonic structure is still present, the increasingly ambiguous forms of her paintings after the late 1950s give them a more sensuous feeling and an almost organic vitality.

While it may seem a contradiction to speak of colorism when discussing a work that is basically monochromatic, color is important to *The Atlantic*. The overall impression is that the painting is richly colored, when in fact the palette is limited. The muted harmonies of gray run the gamut from warm to cool, light to dark. This remarkable sensitivity to subtle color and value can be found throughout Vieira da Silva's oeuvre. Color is personalized in the same way that forms are personalized, and it is disciplined in a manner that reminds us that Vieira da Silva's roots go back to Analytic Cubism. Late in her career she developed an interest in stained glass, and later paintings such as *The Atlantic* reflect a preoccupation with the same rich glow of inner light.

Vieira da Silva preserves the peculiarly French sense of the beautiful touch in her paintings. Despite the aggressive stamp of Expressionist and Abstract Expressionist art in the works of many artists in the 1950s and 1960s, Vieira da Silva looks back to a tradition that is indebted to Matisse or even Braque. The surface of *The Atlantic* is sensuous and carefully crafted, and although the immediate impression is of spontaneous execution, it preserves its painterly character even while it reflects a rational technique. This contradiction, or contrast, is indicative of Vieira da Silva's art as a whole. While it is sensual and personal, it is also intellectually engaging. —GW

1. John Rewald, *Vieira da Silva: Paintings 1967–1971* (New York, 1971), p. 6.
2. See Jacques Lassaigne and Guy Weelen, *Vieira da Silva*, trans. John Shepley (New York, 1979), p. 124, fig. 152.
3. Ibid., p. 141, fig. 166.

# MAURICE DE VLAMINCK

French, 1876–1958

*76.* FIELD OF WHEAT
*Champ de blé*
n.d.

Oil on canvas, 10 5/8 × 13 3/4 in. (27 × 35 cm)
Signed lower left: *Vlaminck*

After exhausting the possibilities of Fauvism, with its shocking color contrasts, Vlaminck developed a still vibrant, but less harsh palette, and began to explore the expressive qualities of nature in a somewhat more restrained fashion. In one small picture, *Field of Wheat*, the artist expressed much about himself and his art. From the beginning of his career, through the Fauve years, to the final paintings of the 1950s, Vlaminck found his primary inspiration in nature. At the turn of the century nature drew him to the banks of the Seine, where he painted not with the intention of becoming an artist but "to bring back some order into my thoughts, to calm my desires, and especially to get a little purity into myself."[1] Although he went on to depict human figures, still lifes, and city scenes in a variety of media, rural landscape would always remain central to his oeuvre.

A native of the Île-de-France with family ties to Flanders, Vlaminck found northern France, with its gray skies and dark rain clouds, more appealing as subject matter than the southern landscapes favored by so many of his contemporaries. Disaffected by the senselessness and inhumanity of World War I, Vlaminck left Paris in 1920 for the small town of Valmondois, some twenty miles away. When urban growth threatened to make Valmondois a suburb of Paris, the artist moved sixty miles from the city, to the Beauce region, where he purchased a farm house called La Tourillière in 1925.

There, having found the solitude he sought, Vlaminck painted the wheat fields for which the Beauce is known, and the sight of which he said always moved him deeply.[2] He knew the wheat fields intimately and depicted them at various stages in their life cycle and under various climatic conditions. In the wheat fields he found the sort of subject matter he said he liked to use as a "prop…to re-create in the beholder emotions that were believed to be buried and gone forever."[3]

Most likely the site of *Field of Wheat* was in the vicinity of La Tourillière, for the picture is similar in its subject matter, vigorous style, and dramatic tension to other works painted there in the 1940s and 1950s. The work particularly resembles a painting of 1945, entitled *Cut Fields*, or *Blés coupés* ( private collection),[4] which shares the same close-up view of shafts of wheat indicated in diagonal slashing strokes of thick orange and yellow paint laid over dark green. In the background of both works are white buildings with low roofs of red and brown, surmounted by turbulent skies in which clouds move in the opposite direction of the wheat. In each case, the man-made structures are thinly painted, small, and quiet in comparison to the passionately expressed trees, clouds, and fields.  —SK

1. Klaus G. Perls, *Vlaminck* (New York, 1941), p. 51.
2. Robert Rey, *Maurice de Vlaminck* (New York, 1956), n.p.
3. Ibid.
4. Illustrated in Pierre MacOrlan, *Vlaminck, Peintures, 1900–1945* (Paris, 1947), n.p.

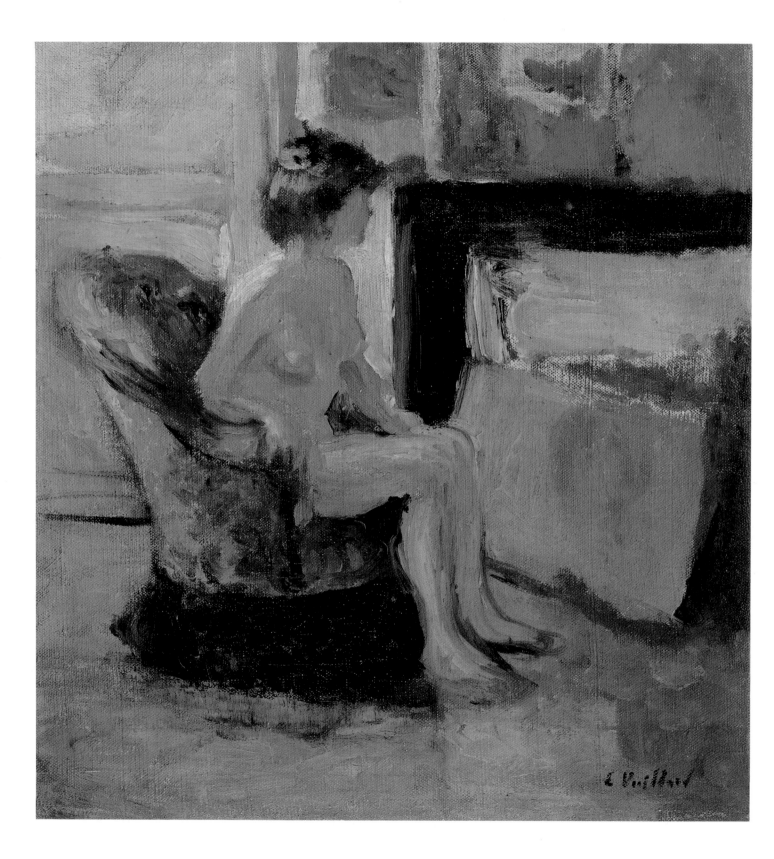

# ÉDOUARD VUILLARD

French, 1868–1940

## 77. NUDE SEATED BEFORE A FIREPLACE

*Nu assis devant la cheminée*
ca. 1899

Oil on canvas, 13½ × 12 ¾ in. (34.5 × 32.2 cm)
Signed lower right: *E. Vuillard*

Édouard Vuillard was, more than any other French artist of the twentieth century, the heir to Edgar Degas. The two artists met several times, and Vuillard's journal tells how intimidating it was for him to meet the irascible genius who lived so long that he was, at the end of his life, out of step with his own time. Degas died lonely—and alone—in 1917, the penultimate year of World War I. Vuillard died in 1940 just before Germany invaded his beloved France and World War II began in earnest. Each was a quintessential Parisian, living and working in and around the city that was the aesthetic capital of the world. Yet, in a very real sense, each artist sought to escape the rushing public life of Paris in the private homes and apartments of family and friends. Each lived in a world at once cushioned from material want and subject to daily intellectual—and moral—rigors; life was easy only in a physical sense.

Vuillard's earliest major works have proved to be his most famous. His highly complex paintings of populated domestic interiors that dissolve into patterns have become icons of modern painting, and most writers about his career dwell on the 1890s before slipping into apologies for Vuillard's oeuvre of the twentieth century. Unlike his friend and colleague Bonnard, whose career was made in the twentieth-century, Vuillard is seen as an artist who backed into the twentieth century and never turned around to face it.

This tiny painting made about 1899 would never be chosen for an exhibition of Vuillard's famous pattern paintings of the 1890s, in spite of its date. In painting it, Vuillard re-created in oil a corner of his studio, giving substance to the nude and her chair and space to the room in which she sits. There is very little ambiguity in the painting. The nude was most certainly a hired model, and Vuillard painted her as she was about to rise from his armchair, perhaps to examine some drawings in the portfolio that sits propped in front of the fireplace. We know from this detail that the day was warm since there was no need for a fire. The window behind the model provides light for her shoulder and hair, and she appears so apparently comfortable in the room that she seems to have no awareness whatsoever of the painter or the viewer.

The sheer reality of the world in this painting makes it difficult for us to place it in art history. The nude has none of the historical connotations of Manet's great realist nudes. Nor is she as frankly erotic as the nudes of Renoir. And she is certainly not a mythic female playing her part in a world constructed utterly by the artist as in Cézanne's tiny painting of the 1870s in the Sirak Collection. And even when we come to Degas—the obvious parallel—the differences outweigh the similarities. Degas was so completely fascinated by the contortions and physical maneuvers of the female figure that we as viewers feel some discomfort when looking at his painted, printed, and pastel nudes. By comparison, the very ease and naturalness of Vuillard's compositions are the hallmarks of his painting.

Vuillard has represented the realm of the modern, urban studio with an unfettered directness almost unknown in previous art. We know from the dated, overstuffed chair and from the hairstyle of the nude that we are at the turn of the nineteenth and twentieth centuries. We also know that Vuillard felt completely comfortable in painting this small, controllable canvas. His hand, wrist, and arm moved deftly with a small brush and paint, jabbing quickly to define the space under the model's knees and blending her legs into a single mass with parallel strokes before they are separated at her feet. Vuillard gloried principally in the shininess of the polished floor as revealed by the light from the unseen window. We are privileged viewers in the painter's own studio, particularly fortunate because Vuillard is as at home with us as he is with himself.

—RB

*78.* THE BIG TREE (THE TREE TRUNK)
*Le Grand Arbre (Le Tronc)*
ca. 1930

Charcoal and pastel on brown paper, laid down on canvas,
43¹³/₁₆ × 32½ in. (111.3 × 82.5 cm)
Stamped lower left: *E. Vuillard*

Perhaps because landscape painting was without question the predominant genre in nineteenth-century art, its holdover in the twentieth-century imagination has been slight by comparison. A history of twentieth-century art illustrated by one hundred crucial masterpieces would include few, if any, landscapes. Yet when certain great artists like Braque, Picasso, Matisse, or Léger painted landscapes, they made works that engage traditional, nineteenth-century landscape paintings in a sort of dialogue.

About 1930, Édouard Vuillard decided to make this very large pastel of a decidedly unremarkable subject—the trunk of a large tree. The form of the tree trunk itself dominates the picture surface, decorated, where it meets the ground, with a ring of dancing flowers. The sheer mass and volume of the tree trunk are its most remarkable characteristics, and Vuillard avoided all but the very base of the tree in order to emphasize these particular elements.

The tree as a proper subject for the painter has a long, distinguished history. Theorists of landscape painting throughout the nineteenth century recommended that the proper study of the single tree should be paramount in the preparation of the landscape painter. And there are countless paintings, oil sketches, and drawings made throughout the nineteenth and early twentieth centuries in which the tree is the dominating subject. Yet there seems to be little clear precedent for Vuillard's study not of the entire tree but of its immense trunk. The rhythm of branches and foliage was more often the real subject of study for the artist representing a single tree, and these are precisely the forms that Vuillard left out of his pastel.

Why did he choose such a subject? His journal is mute. The work remained in his atelier until his death in 1940, when it entered the collection of his nephew, Jacques Roussel. Our only clues are to be found in the pastel itself. Clearly, Vuillard wished to convey the immense physical power of the tree trunk in contrast with the delicate flowers at its base, and this is the true subject of the work. The viewer is encouraged to think less of the physiognomy of the tree than of its size and, hence, age. In Vuillard's landscape, the tree is an ancient, enduring form, while the flowers are temporary inhabitants of the scene.　　　—RB

# DOCUMENTATION

Leslie Stewart Curtis

The number following the title of the work is the museum's accession number.

Entries in brackets are considered to be reliable but are not confirmed.

Research on these works continues. The listings here should be regarded as the foundation for ongoing studies and not as complete historical records.

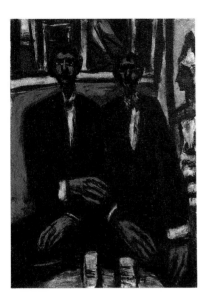

1.
Max Beckmann
*Two Negroes in a Cabaret* 91.1.1
*Zwei Neger im Varieté*
1946

PROVENANCE
Ulfert Wilke, New York, 1949; Howard D. and Babette L. Sirak, June 1965.

EXHIBITION HISTORY
J. B. Speed Art Museum (Louisville), October 22–December 1, 1968, *The Sirak Collection*, cat. no. 11, illus. (as *Two Negroes in a Café*).

REFERENCES
Benno Reifenberg and Wilhelm Hausenstein, *Max Beckmann* (Munich, 1949), cat. no. 601, p. 80.
Lothar-Günter Buchheim, *Max Beckmann* (Feldafing, 1959), pp. 166, 196, fig. 102 (appears in photograph of the artist in his studio).
University of Iowa Museum of Art, *An Artist Collects: Ulfert Wilke, Selections from Five Continents* (exh. cat., Iowa City, 1975), pp. 11, 24 (as *Two Negroes in a Cafe*).
Erhard Göpel and Barbara Göpel, *Max Beckmann: Katalog der Gemälde*, 2 vols. (Bern, 1976), 1: cat. no. 725, pp. 433, 434; 2: pl. 264.
Erhard Göpel, ed., and Mathilde Q. Beckmann, comp., *Max Beckmann: Tagebücher 1940–1950* (Munich and Vienna, 1979), p. 154 (February 24, 1946, as *"2 Neger"*), p. 167 (June 23, 1946, as *"zwei Neger"*), p. 171 (July 28, 1946, as *"Neger"*), p. 350 (September 15, 1949, as *"die beiden Nigger in der Bar,"* and September 18, 1949, as *"Nigger"*).

RELATED WORKS
*Soldatenkneipe*, 1946 (-1948?), oil on canvas, Staatsgalerie, Stuttgart; see Göpel and Göpel, cat. no. 723, p. 433, illus.

2.
Julius Bissier
*usque ad finem* 91.1.3
1961

PROVENANCE
R. N. Ketterer, Campione bei Lugano, Switzerland; Howard D. and Babette L. Sirak, September 1965.

EXHIBITION HISTORY
R. N. Ketterer (Campione bei Lugano, Switzerland), March 1–31, 1965, *Jules Bissier: Ei-Öl-Tempera—Aquarelle*, cat. no. 11, illus.
J. B. Speed Art Museum (Louisville), October 22–December 1, 1968, *The Sirak Collection*, cat. no. 12, illus.

3.
Julius Bissier
*A.31.Oct.62* 91.1.2
1962

PROVENANCE
R. N. Ketterer, Campione bei Lugano, Switzerland; Howard D. and Babette L. Sirak, September 1965.

EXHIBITION HISTORY
R. N. Ketterer (Campione bei Lugano, Switzerland), March 1–31, 1965, *Jules Bissier: Ei-Öl-Tempera—Aquarelle*, cat. no. 21, illus.
J. B. Speed Art Museum (Louisville), October 22–December 1, 1968, *The Sirak Collection*, cat. no. 13, illus. (as *A.31.Oktober 1962*).

RELATED WORKS
*A 31.10.62*, 1962, watercolor, Kunstsammlung Nordrhein-Westfalen, Düsseldorf; see Arts Council of Great Britain, *Julius Bissier 1893–1965: An exhibition from the Kunstsammlung Nordrhein-Westfalen, Düsseldorf* (exh. cat., London, 1977), no. 81, p. 53.

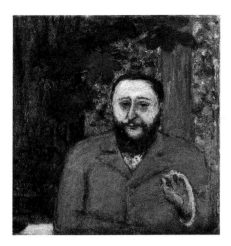

4.
Pierre Bonnard
*Portrait of Thadée Natanson*    91.1.4
1897

PROVENANCE
Thadée Natanson; Édouard Vuillard, purchased at the Hôtel Drouot
sale of the Natanson collection in Paris, June 13, 1908; [Private collec-
tion, Paris]; Jacques Roussel, Paris (1951?); Sam Salz, New York;
Howard D. and Babette L. Sirak, January 1972.

EXHIBITION HISTORY
Galerie Bernheim-Jeune (Paris), December 16, 1907–January 4, 1908,
    *Portraits d'hommes*, cat. no. 10, p. 4 (as *M. Thadée Natanson*).
Kunsthaus Zürich, June 6–July 24, 1949, *Pierre Bonnard*, cat. no. 7, p. 17
    (as *Portrait de Thaddée Nathanson* [*sic*]).
Kunsthalle Bern, March 21–April 22, 1951, *Die Maler der Revue
    Blanche: Toulouse-Lautrec und die Nabis Bonnard, Vuillard, Vallot-
    ton, Denis, Roussel, Ranson, Sérusier, Maillol*, cat. no. 9.
Marlborough Fine Art (London), May 5–June 12, 1954, *Roussel, Bon-
    nard, Vuillard*, cat. no. 34, pp. 20, 44, illus.
Musée Jenisch (Vevey), July 17–September 26, 1954, *Paris 1900*, cat.
    no. 10.
Maison de la Pensée Française (Paris), June 1955, *Bonnard*, cat. no. 3.
Huguette Berès (Paris), May 8–June 6, 1957, *Bonnard, Roussel,
    Vuillard*, cat. no. 9 (as *Thadée Natanson en buste, de face*).
[Musée d'Albi]
Lefevre Gallery (London), March 5–March 26, 1964, *Vuillard et son
    Kodak*, cat. no. 26, pp. 12, 16, illus. (as *Thadée Natanson*).
Christie's (New York), November 14–30, 1968, *Van Gogh, Gauguin and
    Their Circle* (exhibition for the benefit of the Episcopal Mission
    Society in the Diocese of New York), cat. no. 5, illus.

REFERENCES
Hôtel Drouot (Paris), *Vente Thadée Natanson*, sale cat., June 13, 1908,
    no. 15.
Gustave Coquiot, *Bonnard* (Paris, 1922), p. 23.
Georges Besson, *Bonnard* (Paris, 1934), fig. 15.
*Bonnard*, special issue of *Le Point: revue artistique et littéraire* 24
    (1943), texts by Maurice Denis, René-Marie, Charles Terrasse, and
    with a letter from Bonnard to Pierre Betz, p. 15, fig. 2 (as *Thadée
    Natanson*).
John Rewald, *Pierre Bonnard* (New York, 1943), p. 136.
Thadée Natanson, *Le Bonnard que je propos, 1867–1947* (Geneva,
    1951), pp. 55, 115, 234, 236, 360 (dated as 1893), pl. 5.
Musée national d'Art moderne, *Bonnard, Vuillard et Les Nabis, 1888–
    1903* (exh. cat., Paris, 1955), p. 35.
Alberto Martini, "Gli Inizi difficili di Pierre Bonnard," in *Arte Antica e
    Moderna* 3 (July/September, 1958): 275.
Jean and Henry Dauberville, *Bonnard: Catalogue raisonné de l'oeuvre
    peint, 1888–1905*, vol. 1 (Paris, 1965), cat. no. 144, p. 180, illus.
Hilton Kramer, "Art: Christie's, New York," *New York Times* (Novem-
    ber 15, 1968).
University of Iowa Museum of Art, *An Artist Collects: Ulfert Wilke,
    Selections from Five Continents* (exh. cat., Iowa City, 1975), p. 50.

RELATED WORKS
Édouard Vuillard, *Portrait of Thadée Natanson*, ca. 1898, oil on board,
    Musée national d'Art moderne, Paris.
Félix Vallotton, *Portrait of Thadée Natanson*, 1897, oil on canvas,
    collection of M. Pierre Cailler, Geneva, 1955.
Joseph Rippl-Ronäi, *Portrait of Thadée Natanson*, private collection,
    Hungary.

REMARKS
The date 1893 is given by Thadée Natanson in his book (1951), but
elsewhere in the text he writes that the portrait was painted at
Villeneuve-sur-Yonne, at his home, "Relais," in 1897.

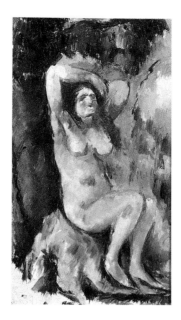

5.
Paul Cézanne
*Seated Bather*    91.1.5
*Baigneuse assise*
ca. 1873–1877

PROVENANCE
Ambroise Vollard, Paris; Sam Salz, New York; Howard D. and Babette
L. Sirak, February 1966.

EXHIBITION HISTORY
J. B. Speed Art Museum (Louisville), October 22–December 1, 1968,
    *The Sirak Collection*, cat. no. 1, illus.

REFERENCES
Georges Rivière, *Le Maître Paul Cézanne* (Paris, 1923), p. 201 (as
    *Baigneuse*).
Lionello Venturi, *Cézanne: son art—son oeuvre*, 2 vols. (Paris, 1936), 1:
    cat. no. 258, p. 122; 2: pl. 69.
Pierre-Marie Auzas, *Peintures de Cézanne* (Paris, 1945), pl. 6 (color).
Adrien Chappuis, *The Drawings of Paul Cézanne, A Catalogue Rai-
    sonné*, trans. Paul Constable and M. and Mme. Jacques Féjoz, 2 vols.
    (Greenwich, Conn., 1973), 1: 126–127.
Lionello Venturi, *Cézanne*, preface by Giulio Carlo Argan (New York
    and Geneva, 1978), pp. 41, 170, illus. (as *Seated Woman Bather*).
Mary Louise Krumrine, *Paul Cézanne: The Bathers* (Basel, 1989), pp. 75,
    261 n. 61.

RELATED WORKS
*Pastorale*, ca. 1870, oil on canvas, Musée d'Orsay, Paris; see Venturi
    (1936), cat. no. 104, illus., and Krumrine, p. 69, illus. (color).
*Seated Woman Bather*, 1873–1877, pencil (present whereabouts
    unknown); see Venturi (1978), p. 41, illus.; Chappuis, no. 372, p. 126,
    illus.
*Woman Bather*, 1873–1877, pencil, collection of Kenneth Clark,
    London; see Chappuis, no. 374, p. 127, illus.
*Baigneuse au bord de la mer*, 1875–1876, oil on canvas, Barnes Founda-
    tion, Merion, Penn.; see Venturi (1936), no. 256, illus.
*Baigneuses feuille d'études*, 1879–1882, pencil and pen, Öffentliche
    Kunstsammlung Basel, Kupferstichkabinett; see Chappuis, no. 373,
    pp. 126–127, illus.
*Les Grandes Baigneuses*, 1900–1906, oil on canvas, National Gallery of
    Art, London; see Venturi (1936), no. 721, illus.

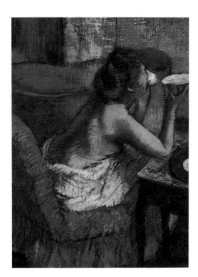

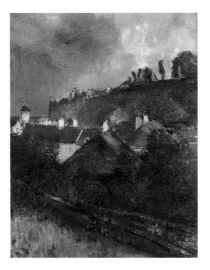

*6.*
Edgar Degas
*The Breakfast* 91.1.8
*Le Petit Déjeuner*
ca. 1885

PROVENANCE
Yeatman Collection, Paris; Charles Durand-Ruel, Paris; Sam Salz, New York; Howard D. and Babette L. Sirak, May 1970.

EXHIBITION HISTORY
Galeries Georges Petit (Paris), April 12–May 2, 1924, *Exposition Degas*, cat. no. 172, illus.
Galeries Durand-Ruel (Paris), 1936.
Gazette des Beaux-Arts (Paris), 1955, *Degas dans les collections françaises*, cat. no. 145 (dated as 1893).

REFERENCES
P.-A. Lemoisne, "Artistes contemporains: Edgar Degas, à propos d'une exposition récente," *La Revue de L'Art ancien et moderne* 46 (July-August 1924): 106, 108, illus. (dated as ca. 1894).
J. B. Manson, *The Life and Work of Edgar Degas* (London, 1927), p. 46.
P.-A. Lemoisne, *Degas et son oeuvre*, 4 vols. (Paris, 1946–1949), 3: cat. no. 1153, pp. 670, 671, illus. (dated as ca. 1894).
Jean Bouret, *Degas*, trans. Daphne Woodward (New York, 1965), p. 231.
Fogg Art Museum, Harvard University, *Degas Monotypes* (exh. cat., Cambridge, Mass., 1968), cat. by Eugenia Parry Janis, no. 145.
Franco Russoli and Fiorella Minervino, *L'Opera completa di Degas* (Milan, 1970), no. 1019, p. 132, illus. (as *Donna con tazza*, 1894).
Jean Adhémar and Françoise Cachin, *Degas: The Complete Etchings, Lithographs and Monotypes*, trans. Jane Brenton (London, 1974), p. 282.
Philippe Brame and Theodore Reff, with assistance of Arlene Reff, *Degas et son oeuvre: A Supplement*, vol. 5 (New York and London, 1984), p. 128.

RELATED WORKS
*La Tasse de chocolat*, ca. 1885, pastel over monotype, 44.4 × 34.3 cm, private collection, South Africa; see Brame and Reff, no. 118, p. 128, illus.

REMARKS
Brame and Reff (1984) state that the work has been incorrectly dated to ca. 1894 and should be ca. 1885, and that *La Tasse de chocolat*, pastel over monotype on white paper, of ca. 1885, in a private collection in South Africa, "is the first of two impressions of a monotype, both of which were reworked in pastel. The other version is *Le Petit Déjeuner* [Columbus Museum of Art, Sirak Collection], incorrectly dated ca. 1894 by Lemoisne."

*7.*
Edgar Degas
*Houses at the Foot of a Cliff* 91.1.7
*Maisons au pied d'une falaise (Saint-Valéry-sur-Somme)*
ca. 1895–1898

PROVENANCE
Galerie Georges Petit, Paris, 1919; Charles Vignier, until March 1935; Durand-Ruel, Paris, no. 15667; Durand-Ruel, New York, no. 5253; private collection (Durand-Ruel), Switzerland; Howard D. and Babette L. Sirak, January 1973.

EXHIBITION HISTORY
Dallas Museum of Fine Arts, January 14–February 28, 1942.
Grandell Public Library, September 14–October 8, 1942.
Cleveland Museum of Art, February 5–March 9, 1947, *Works by Edgar Degas*, cat. no. 48 (as *Landscape, St. Valéry-en-Caux [Maisons au pied d'une falaise]*), p. 18, pl. 45.
Durand-Ruel Galleries (New York), November 10–29, 1947, *Degas*, cat. no. 28 (dated as ca. 1890).
Phillips Memorial Gallery, December 2, 1947–January 7, 1948.
Galeries Durand-Ruel (Paris), June 9–October 1, 1960, *Edgar Degas, 1834–1917* (exhibition organized to benefit the Société des amis du Louvre), cat. no. 52, illus.

REFERENCES
Galerie Georges Petit (Paris), *Catalogue des tableaux, pastels et dessins par Edgar Degas et provenant de son atelier (3e vente)*, sale cat., April 7–9, 1919, no. 1, p. 9, illus.
Camille Mauclair, *Degas* (Paris, 1937), pp. 86, 166, illus.
P.-A. Lemoisne, *Degas et son oeuvre*, 4 vols. (Paris, 1946–1949), 3: cat. no. 1219, pp. 706, 707, pl. 1219.
Franco Russoli and Fiorella Minervino, *L'Opera completa di Degas* (Milan, 1970), no. 1179, pp. 138, 139, illus. (as *Villaggio e colle*).
Philippe Brame and Theodore Reff, with assistance of Arlene Reff, *Degas et son oeuvre: A Supplement*, vol. 5 (New York and London, 1984), pp. 162, 164, 166.

RELATED WORKS
*Le Village, Saint-Valéry-sur-Somme*, 1895–1898, oil on canvas, 51 × 61 cm, Metropolitan Museum of Art, New York, Robert Lehman Collection; see Brame and Reff, no. 150, p. 162, illus.

REMARKS
This picture was painted during a summer vacation at Saint-Valéry-sur-Somme. The artist stayed with his brother René and painted with his friend Louis Braquaval.

8.
Edgar Degas
*Seated Dancer*    91.1.6
*Danseuse assise*
ca. 1898

PROVENANCE
Ambroise Vollard, Paris; C.S. Wadsworth Trust (sale: Parke-Bernet Galleries, December 11, 1948, no. 78); Edward Bragaline, New York; Parke-Bernet Galleries, New York, 1965; Howard D. and Babette L. Sirak, October 1965.

EXHIBITION HISTORY
M. Knoedler & Co. (New York), 1963, *Twentieth Century Masters, from the Bragaline Collection*, cat. no. 15, illus.
J. B. Speed Art Museum (Louisville), October 22–December 1, 1968, *The Sirak Collection*, cat. no. 2, illus.

REFERENCES
Galerie Georges Petit (Paris), *Catalogue des tableaux, pastels et dessins par Edgar Degas et provenant de son atelier (2e vente)*, sale cat., December 12–13, 1918, no. 73, p. 42, illus.
P.-A. Lemoisne, *Degas et son oeuvre*, 4 vols. (Paris, 1946–1949), 3: cat. no. 1332, pp. 774, 776, 777, illus.
Parke-Bernet Galleries (New York), *Important Paintings and Drawings…property of the C. Wadsworth Trust*, sale cat., December 11, 1948, no. 78.
Parke-Bernet Galleries (New York), *Highly Important Impressionist & Modern Paintings & Drawings*, sale cat., October 14, 1965, no. 119, pp. 78, 79, illus.
University of Iowa Museum of Art, *An Artist Collects: Ulfert Wilke, Selections from Five Continents* (exh. cat., Iowa City, 1975), p. 52.

RELATED WORKS
*Seated Dancer* was a study for *Les Grandes Danseuses vertes*, ca. 1898, pastel, 75 × 70 cm, collection of Marcel Guérin, Paris; see Lemoisne, vol. 3, cat. no. 1330, pp. 774, 775, illus.
*Deux Danseuses*, ca. 1898, pastel on paper, Gallery of Modern Art, Dresden; see Lemoisne, vol. 3, cat. no. 1331, pp. 776, 777, illus.
*Deux Danseuses au repos*, ca. 1898, pastel over monotype; see Lemoisne, vol. 3, cat. no. 1331bis, pp. 776, 777, illus.
*Danseuses assise*, ca. 1898, reverse impression in pastel, 66 × 51 cm, Lepoutre collection, Paris; see Lemoisne, vol. 3, cat. no. 1332bis, pp. 776, 777, illus.

9.
Robert Delaunay
*Portuguese Woman*    91.1.10
*Portugaise*
1916

PROVENANCE
Galerie Louis Carré, Paris; M. Knoedler & Co., New York (consigned in April 1965, from Royal Ambassadors, Inc., New York); Howard D. and Babette L. Sirak, May 12, 1965.

EXHIBITION HISTORY
Kunsthalle Bern, July 27–September 2, 1951, *Ausstellung Robert Delaunay*, cat. no. 36, illus.
Galerie Bing (Paris), July 1952, *Hommage à Robert Delaunay*.
Grand Palais des Champs-Elysées (Paris), *Salon d'Automne*, November 4–29, 1953, cat. no. 92.
Museum Boymans-van Beuningen (Rotterdam), July 10–September 20, 1954, *Vier Eeuwen Stilleven in Frankrijk*, cat. no. 169, pp. 117–118, pl. 86 (as *Portugese vrouw met stilleven — Nature morte portugaise*).
Musée d'Art et d'Industrie, Saint-Étienne, 1955, *Natures mortes de Géricault à nos jours*, cat. no. 81, pl. 38.
Musée de Lyons, June–October 1959, *Robert et Sonia Delaunay*, cat. no. 30, fig. 9.
J. B. Speed Art Museum (Louisville), October 22–December 1, 1968, *The Sirak Collection*, cat. no. 15, illus. (color).

REFERENCES
[F. Gilles de la Tourette, *Robert Delaunay* (Paris, 1950), pp. 60–61 (as *Les Portugaises parmi les fleurs*).]
Robert Délaunay, *Du Cubisme à l'art abstrait*, ed. Pierre Francastel, with a catalogue of the artist's work by Guy Habasque (Paris, 1957), no. 176, pp. 373–375, 377.
University of Iowa Museum of Art, *An Artist Collects: Ulfert Wilke, Selections from Five Continents* (exh. cat., Iowa City, 1975), p. 32.

RELATED WORKS
*La Grande Portugaise*, 1916, wax on canvas, collection of A. Gmurzynska, Cologne; see Musée d'Art moderne de la Ville de Paris, *Le Centenaire Robert et Sonia Delaunay* (exh. cat., Paris, 1985), cat. no. 42, pp. 88, 126, illus. (color).
*Nature morte portugaise*, 1916, oil on canvas, Centre national d'art et de culture Georges Pompidou, Paris; see F. Gilles de la Tourette, *Robert Delaunay* (Paris, 1950), pl. 18.
*Nature morte portugaise*, 1916, glue on canvas, 51.5 × 54 cm; see Galerie d'Art moderne, *Quelques oeuvres de Robert Delaunay et de Sonia Delaunay* (exh. cat., Basel, 1961), no. 7, illus.
See also related works in Robert Delaunay, pp. 277–280.
Sonia Delaunay, *Marché au Minho*, 1916, oil and wax on canvas; see Michel Hoog, *Robert et Sonia Delaunay* (Paris, 1967), no. 99, p. 157, illus.
Sonia Delaunay, *Nature morte portugaise*, 1916, oil and wax on canvas; see Hoog, no. 104, p. 157, illus.

REMARKS
According to Habasque, there is a study on the verso: *Trois Graces*, Portugal, 1915, "ni signé ni daté, cire sur toile, même dimensions."

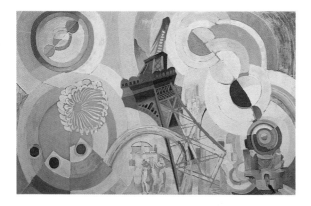

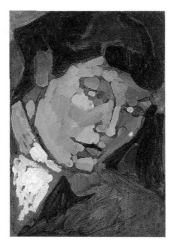

**10.**
Robert Delaunay
*Air, Iron, and Water*   91.1.9
*Air, fer et eau*
1936–1937

PROVENANCE
[M. Lefebvre-Foinet, Paris]; Ira Haupt, New York, 1954; Parke-Bernet Galleries, New York, 1965; M. Knoedler & Co., New York, January 13, 1965; Howard D. and Babette L. Sirak, April 1965.

EXHIBITION HISTORY
Kunsthalle Bern, July 27–September 2, 1951, *Exposition Robert Delaunay,* cat. no. 64.
Solomon R. Guggenheim Museum (New York), March 23–May 22, 1955, *Robert Delaunay.*
Institute of Contemporary Art (Boston), 1955.
Fine Arts Associates (New York), January 13–31, 1959, *Robert Delaunay, Paintings,* cat. by Pierre Courthion, no. 8, illus.
J. B. Speed Art Museum (Louisville), October 22–December 1, 1968, *The Sirak Collection,* cat. no. 16, illus.

REFERENCES
Robert Delaunay, *Du Cubisme à l'art abstrait,* ed. Pierre Francastel, with a catalogue of the artist's work by Guy Habasque (Paris, 1957), no. 329, pp. 303, 371, 375.
Carlton Lake and Robert Maillard, eds., *A Dictionary of Modern Painting,* trans. Alan Bird et al. (New York, n.d.), pp. 76, 212, illus.
Parke-Bernet Galleries (New York), *20th Century Paintings from the Ira Haupt Collection,* sale cat. no. 2321, January 13, 1965, no. 21, pp. 30, 31, illus. (color).
Musée d'Art moderne de la Ville de Paris, *Le Centenaire de Robert et Sonia Delaunay* (exh. cat., Paris, 1985), reproduced in a photograph of Robert Delaunay working on the 1937 exposition panels, p. 31.

RELATED WORKS
*Air, fer et eau,* 1937, 16 m × 9 m 70 cm, in Musée Grenoble; see Delaunay, p. 127.
*Air, fer et eau* (study), 1936–1937, gouache on paper, attached to plywood, 47 × 74.5 cm; see Galerie Gmurzynska, *Robert Delaunay* (exh. cat., Cologne, 1983), p. 127, illus. (color); also, see Delaunay, cat. no. 700.
See also other related works in Delaunay, nos. 329–331, 469, 470.
[The Parke-Bernet sale catalogue (1965) refers to a cognate work in the Ayala and Sam Zacks Collection in Toronto. This is probably Habasque, cat. no. 331.]

**11.**
André Derain
*Portrait of Maud Walter*   91.1.12
ca. 1904–1906

PROVENANCE
Kellermann, 55 rue de Varenne, Paris; M. Knoedler & Co., New York (purchased on joint account with Fine Arts Associates), February 1956; Mrs. Bagley Wright, Seattle, June 1957; M. Knoedler & Co., New York, August 1965; Howard D. and Babette L. Sirak, August 1965.

EXHIBITION HISTORY
J. B. Speed Art Museum (Louisville), October 22–December 1, 1968, *The Sirak Collection,* cat. no. 18, illus.

REMARKS
Inscribed on the back of a photograph of the portrait suspended to the back of the support: *"Je sous signée Alice Derain declare que la peinture sur carton parquetée que reproduit cette photo est bien l'oeuvre de mon mari. Le tableau même, 37 cm. sur 26, est le portrait peint vers 1906 est celui de Madame Maud Walter, une amie habitant Chatou. Paris le 8 février 1956, Alice Derain."* (The undersigned, Alice Derain, declares that the painting, on board, which is reproduced by this photograph, is the work of my husband. The painting measures 37 × 26 cms. The portrait, painted about 1906, is that of Madame Maud Walter, a friend living at Chatou. Paris, the 8th of February, 1956, Alice Derain.)

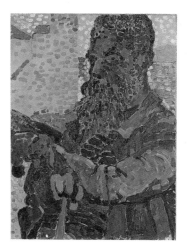

**12.**
André Derain
*Portrait of the Painter Étienne Terrus*   91.1.11
1905

PROVENANCE
Mme. Comte (daughter of Terrus); Sam Salz, New York; Howard D. and Babette L. Sirak, March 1967.

EXHIBITION HISTORY

Paris, Salon des Indépendants, 1906.

J. B. Speed Art Museum (Louisville), October 22–December 1, 1968, *The Sirak Collection*, cat. no. 17, illus. (color).

Wellesley College Museum (Wellesley, Mass.), April 15–May 30, 1978, *One Century: Wellesley Families Collect; An Exhibition Celebrating the Centennial of Wellesley College*, cat. no. 45, illus.

REFERENCES

Eugenia S. Robbins, ed., "News: Family Collections," *Art Journal* 37 (spring 1978): 257, illus.

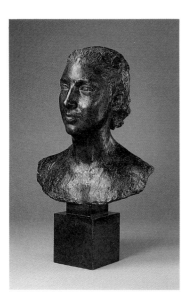

**13.**

Charles Despiau

*Mademoiselle Gisèle Gérard*    91.1.13

1942–1943

PROVENANCE

Private collection, Switzerland; La Boétie, New York; Howard D. and Babette L. Sirak, October 1966.

EXHIBITION HISTORY

J. B. Speed Art Museum (Louisville), October 22–December 1, 1968, *The Sirak Collection*, cat. no. 19, illus.

RELATED WORKS

*Buste de Mlle. Gisèle Gérard*, ca. 1944, terracotta (de Mayodon), collection of Mme. Gisèle Gérard Zijlstra, Paris; see *Charles Despiau, sculptures et dessins* (Musée Rodin, Paris, 1974), cat. no. 96.

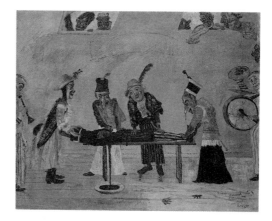

**14.**

James Ensor

*The Assassination*    91.1.14

*L'Assassinat*

1890

PROVENANCE

R. Gevers, Brussels; Marcelle Mabile, Brussels; Sam Salz, New York; Howard D. and Babette L. Sirak, February 1965.

EXHIBITION HISTORY

Palais des Beaux-Arts (Brussels), January 19–February 17, 1929, *James Ensor*, no. 195, p. 8.

Musée national du Jeu de Paume (Paris), June 10–July 10, 1932, *L'Oeuvre de James Ensor*, cat. no. 63, p. 18.

Galerie Georges Giroux (Brussels), 1942.

Galerie Georges Giroux (Brussels), October 13–November 4, 1945, *Hommage à James Ensor*, cat. no. 55, p. 20.

Arts Council of Great Britain (London), 1946, *The Works of James Ensor*, cat. no. 21, p. 8.

XXIIIᵉ Salon, Cercle Artistique et Littéraire (Charleroi), *Rétrospective Ensor*, 1949.

Musée Royal des Beaux-Arts Anvers (Antwerp), June 16–August 15, 1951, *Rétrospective James Ensor*, cat. no. 82, p. 31, illus., p. 61.

Museum of Modern Art (New York), 1951, *James Ensor*, cat. by Libby Tannenbaum, no. 20, pp. 85, 126, illus. (as *Murder*). Also shown at Institute of Contemporary Art (Boston), Cleveland Museum of Art, City Art Museum of St. Louis.

Tate Gallery (London), *Ensor*, 1952.

Nuremberg, *Ensor*, 1952.

Venice, *Ensor*, 1952.

Musée national d'Art moderne (Paris), 1954, *James Ensor*, cat. by Marcel Abraham, Jean Cassou, and Walther Vanbeselaere, no. 48, illus.

Kunsthalle Basel, June 15–August 1963, *James Ensor*, cat. no. 50, pl. 2 (color).

J. B. Speed Art Museum (Louisville), October 22–December 1, 1968, *The Sirak Collection*, cat. no. 3, illus.

REFERENCES

Émile Verhaeren, *James Ensor*, Collection des artistes belges contemporains (Brussels, 1908), listed in "Catalogue de l'oeuvre de James Ensor: Toiles et dessins," p. 116.

André de Ridder, *James Ensor*, Les Maîtres de l'art moderne, vol. 31 (Paris, 1930), pl. 32.

Paul Fierens, *James Ensor* (Paris, 1943), pp. 65, 163, illus. (color).

Albert Croquez, *L'Oeuvre gravé de James Ensor* (Geneva and Brussels, 1947), p. 17.

Frederick S. Wight, "Masks and Symbols in Ensor," *Magazine of Art* (November 1951): 256–259, illus. (as *Murder*).

Paul Haesaerts, *James Ensor*, trans. Norbert Guterman (New York and London, 1959), pp. 291, 379, illus. (as *Murder*).

Francine-Claire Legrand, *Ensor, cet inconnu* (1971), no. 122, pp. 73, 113, 121.

Roger van Gindertael, *Ensor*, trans. Vivienne Menkes (Boston, 1975), p. 147.

Xavier Tricot, *Ensoriana* (Ostend, 1985), no. 8b, p. 53.

RELATED WORKS

*L'Assassinat*, 1888, etching; see Auguste Taevernier, *James Ensor: Illustrated Catalogue of His Engravings* (Ghent, 1973), no. 38, p. 103, illus.

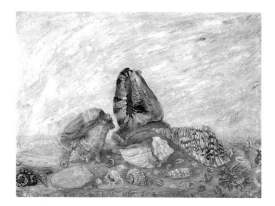

15.
James Ensor
*The Sea Shells*   91.1.15
*Les Coquillages*
1895

PROVENANCE
Georges Giroux, Brussels; Baron A. de Broqueville, Brussels; Sam
Salz, New York; Howard D. and Babette L. Sirak, December 1966.

EXHIBITION HISTORY
Galerie Georges Giroux (Brussels), January 7–18, 1920, *James Ensor*
  (*Bulletin et catalogue des expositions*), cat. no. 59, illus.
Exposition Internationale de Bale, 1925.
Exposition Internationale de Dresden, 1926.
Palais des Beaux-Arts (Brussels), January 19–February 17, 1929, *James
  Ensor*, no. 214, p. 9.
Kursaal d'Ostende, 1931 (Salon des humoristes).
Musée national du Jeu de Paume (Paris), June 10–July 10, 1932,
  *L'Oeuvre de James Ensor*, cat. no. 73, p. 19.
Galerie Georges Giroux (Brussels), 1942.
Galerie Georges Giroux (Brussels), October 13–November 4, 1945,
  *Hommage à James Ensor*, cat. no. 78, p. 25.
Arts Council of Great Britain (London), 1946, *The Works of James
  Ensor*, cat. no. 36, p. 10.
[Palais des Beaux-Arts (Brussels), 1950, *Peinture de la Mer*.]
Musée Royal des Beaux-Arts Anvers (Antwerp), June 16–August 15,
  1951, *Rétrospective James Ensor*, cat. no. 112, pp. 34, 83, illus.
Museum of Modern Art (New York), 1951, *James Ensor*, cat. by Libby
  Tannenbaum, no. 91, p. 126, illus. Also shown at Institute of Contem-
  porary Art (Boston), Cleveland Museum of Art, City Art Museum of
  St. Louis.
Musée national d'Art moderne (Paris), 1954, *James Ensor*, cat. by
  Marcel Abraham, Jean Cassou, and Walther Vanbeselaere, cat. no.
  67, illus.
Kunsthalle Basel, June 15–August 4, 1963, *James Ensor*, cat. no. 73,
  illus.
Museum of Art, Carnegie Institute (Pittsburgh), October 22–December
  5, 1965, *The Seashore: Paintings of the 19th and 20th Centuries*, cat.
  no. 27, illus.
J. B. Speed Art Museum (Louisville), October 22–December 1, 1968,
  *The Sirak Collection*, cat. no. 4, illus. (color).

REFERENCES
Émile Verhaeren, *James Ensor*, Collection des artistes belges contem-
  porains (Brussels, 1908), pp. 52, 119.
Paul Colin, *James Ensor* (Potsdam, 1921), pp. 63, 68, illus. (as *Muscheln*).
Paul Colin, *La Peinture belge depuis 1830* (Brussels, 1930), pp. 21, 22, pl.
  309.
André de Ridder, *James Ensor*, Les Maîtres de l'art moderne, vol. 31
  (Paris, 1930), cat. no. 37, pp. 42, 64.
Paul Fierens, *James Ensor* (Paris, 1943), pp. 105, 165, illus. (color).
*Cahiers de Belgique* 3 (March 1929): 1–38, pl. 105; special issue devoted
  to James Ensor with articles by Paul Fierens, A. H. Cornette, and J. E.
  Sonderregger.
Jozef Muls, *James Ensor, Peintre de la Mer*, in *Musées Royaux des
  Beaux-Arts de Belgique, Conférences, 1940–1941* (1940–1941), pp. 6,
  13.
Paul Haesaerts, *James Ensor*, trans. Norbert Guterman (New York and
  London, 1959), pp. 71, 365, 380, illus. (color).
Hugh and Marguerite Stix, and R. Tucker Abbott, *The Shell: Five
  Hundred Million Years of Inspired Design* (New York, 1968), fig. 14.
Évelyne Schlumberger, "Les angoisses de James Ensor, esquisse d'un
  scenario par Paul Haesaerts," *Connaissance des Arts* 216 (February
  1970): 76, 77, illus. (color) (as *Nature morte aux coquillages, crustacés
  et coquillages*).

Évelyne Schlumberger, "Project for a Film on James Ensor, Notes for a
  Scenario by Paul Haesaerts," *Réalités* 241 (December 1970): 86, 87,
  illus. (color) (as *Still Life with Shellfish and Shells* and as *Nature morte
  aux crustacés et coquillages*).
[Francine-Claire Legrand, *Ensor, cet inconnu* (1971), pp. 115, 121, 168 (as
  *Coquillages et poissons*).]
Roger van Gindertael, *Ensor*, trans. Vivienne Menkes (Boston, 1975),
  pp. 16–17, illus.
Xavier Tricot, *Ensoriana* (Ostend, 1985), no. 31b, p. 35.

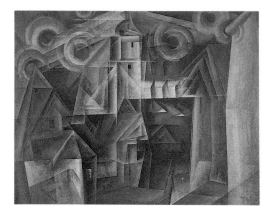

16.
Lyonel Feininger
*Cathedral*   91.1.16
*Der Dom*
1920

PROVENANCE
Kurt Feldhaeusser, Berlin; Mrs. Käte Bernhard-Robinson, Berlin;
Feigl Gallery, New York; Mr. and Mrs. Barton H. Lippincot, Fort
Washington, Pennsylvania; Howard D. and Babette L. Sirak, Novem-
ber 1965.

EXHIBITION HISTORY
National-Galerie (Berlin), September 1931, *Lyonel Feininger*, cat. no.
  74, p. 29.
San Francisco Museum of Art, November 5–December 13, 1959,
  *Lyonel Feininger Memorial Exhibition, 1959–1961*, cat. no. 19, p. 14;
  shown January 5–June 26, 1960, Minneapolis Museum of Art, Cleve-
  land Museum of Art, Albright-Knox Art Gallery (Buffalo), Boston
  Museum of Fine Arts. Shown October 6–December 17, 1960, at City
  Art Gallery (York), Arts Council of Great Britain (London), and
  Edinburgh, cat. no. 10. Also shown January 21–June 1961 as *Lyonel
  Feininger 1871–1956: Gedächtnis-Ausstellung*, Kunstverein (Ham-
  burg), Museum Folkwang (Essen), Staatliche Kunsthalle (Baden-
  Baden), cat. no. 20, illus. (color).
Philadelphia Museum of Art, October 3–November 17, 1963, *Phila-
  delphia Collects 20th Century*, p. 15, illus.
Columbus Gallery of Fine Arts, April 7–30, 1967, *Gordian Knot: Design
  and Content*.
J. B. Speed Art Museum (Louisville), October 22–December 1, 1968,
  *The Sirak Collection*, cat. no. 20, illus.

REFERENCES
Hans Hess, *Lyonel Feininger* (New York, 1961), pp. 96, 195, 267, pl. 23.

RELATED WORKS
*Church (of Mellingen)*, 1920, oil on canvas, 23¾ × 29¾ in., Kunst- und
  Museumsverein, Wuppertal, Germany; see Hess, no. 214, p. 268,
  illus.

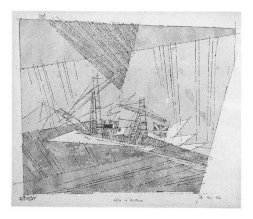

**17.**
Lyonel Feininger
*Ship in Distress*    91.1.17
1946

PROVENANCE
R. N. Ketterer, Campione bei Lugano, Switzerland; Howard D. and
Babette L. Sirak, October 1965.

EXHIBITION HISTORY
R. N. Ketterer (Campione bei Lugano, Switzerland), 1965, *L. Feininger:
Gemälde, Aquarelle, Zeichnungen, Graphik*, cat. no. 11, pp. 22–23,
illus.
J. B. Speed Art Museum (Louisville), October 22–December 1, 1968,
*The Sirak Collection*, cat. no. 21, illus.

**18.**
Albert Gleizes
*To Jacques Nayral*    91.1.18
*À Jacques Nayral*
1917

PROVENANCE
Mme. Albert Gleizes, Paris; Maillard, Paris; Leonard Hutton Galleries,
New York; Howard D. and Babette L. Sirak, April 1965.

EXHIBITION HISTORY
Staatliche Museen (Berlin), November 1920, *Albert Gleizes*, 91st exhi-
bition of *Der Sturm*, p. 266; also shown in Stuttgart, Rome, and New
York; see *Der Sturm* (Baden-Baden, 1954).
Kuhn and Kuhn (Dresden), 1924, *Albert Gleizes*.
Galerie Vavin-Raspail (Paris), 1925, *Rétrospective Albert Gleizes*.
Galerie Lucien Blanc (Aix-en-Provence), November–December 1954,
*Rétrospective Albert Gleizes*, cat. no. 9, illus.
Marlborough Fine Art (London), September–October 1956, *Albert*

*Gleizes: Paintings, Gouaches, Drawings*, cat. no. 12, pp. 11, 12, illus. (as
*Jacques Nayral*).
Galerie Suillerot (Paris), June 1963, *Les Peintres Cubistes*.
Solomon R. Guggenheim Museum (New York) in collaboration with
the Musée national d'Art moderne (Paris) and the Museum am
Ostwall (Dortmund), 1964–1965, *Albert Gleizes, 1881–1953: A Retro-
spective Exhibition*, cat. by Daniel Robbins, no. 98, pp. 74, 81, illus.
(color); also shown at San Francisco Museum of Art, City Art
Museum of St. Louis, Krannert Art Museum (College of Fine and
Applied Arts, University of Illinois, Champaign), National Gallery of
Canada (Ottawa), Albright-Knox Art Gallery (Buffalo), Arts Club of
Chicago.
J. B. Speed Art Museum (Louisville), October 22–December 1, 1968,
*The Sirak Collection*, cat. no. 23, illus.

REFERENCES
Geneviève Coste, "Albert Gleizes," *Connaissance des Arts* 154
(December 1964): 123, illus. (color).
Daniel Robbins, "The Formation and Maturity of Albert Gleizes; A
Biographical and Critical Study, 1881 through 1920," New York
University, Ph.D. dissertation, 1974, pp. 6, 204, fig. 98.

RELATED WORKS
*Portrait of Jacques Nayral*, 1911, oil on canvas; see Solomon R. Gug-
genheim Museum, *Albert Gleizes, 1881–1953: A Retrospective Exhi-
bition* (exh. cat., New York, 1964), cat. no. 27, pp. 28, 29, 43, illus.
*To Jacques Nayral (À Jacques Nayral)*, 1914, gouache; see Solomon R.
Guggenheim Museum, exh. cat., no. 97, p. 74.

**19.**
Juan Gris
*Sheet of Music, Pipe, and Pen*    91.1.19
*Musique, plume et pipe*
1913

PROVENANCE
Galerie Kahnweiler, Paris; Hôtel Drouot, Paris (4th Kahnweiler sale),
May 7–8, 1923; Mme. Pierre Charreau, New York; Harold Diamond,
New York; Howard D. and Babette L. Sirak, February 1966.

EXHIBITION HISTORY
Buchholz Gallery (New York), March 28–April 27, 1944, *Juan Gris,
1887–1927*, cat. no. 3 (as *Music Sheet, Pipe and Pen*).
Cincinnati Art Museum, April 30–May 31, 1948, *A Retrospective Exhi-
bition of the Work of Juan Gris, 1887–1927*, assembled by the Cincin-
nati Modern Art Society, cat. no. 6 (as *Pipe and Pen*).
Galerie Beyeler (Basel), summer 1965.
J. B. Speed Art Museum (Louisville), October 22–December 1, 1968,
*The Sirak Collection*, cat. no. 27, illus.

REFERENCES
Hôtel Drouot (Paris), *4e vente Kahnweiler*, sale cat., May 7–8, 1923, no.
276.
Carl Einstein, "Juan Gris: Texte inédit," *Documents; Archéologie,
Beaux-Arts, Ethnographie, Variétés*, no. 5 (1930): 271, illus. (as *Nature
morte*).
Juan Antonio Gaya-Nuño, *Juan Gris*, trans. Kenneth Lyons (Boston,
1975), cat. no. 253, pp. 214, 247, illus.
University of Iowa Museum of Art, *An Artist Collects: Ulfert Wilke,
Selections from Five Continents* (exh. cat., Iowa City, 1975), pp. 26, 32.
Douglas Cooper, *Juan Gris*, 2 vols. (Paris, 1977), 1: cat. no. 41, pp. 72, 73,
illus.; 2: p. 502.

*20.*
Alexej Jawlensky
*Schokko with Red Hat*   91.1.20
*Schokko mit Rotem Hut*
1909[?] or 1910

PROVENANCE
Jawlensky Foundation, Locarno, Switzerland; Leonard Hutton Galleries, New York; Howard D. and Babette L. Sirak, July 1965.

EXHIBITION HISTORY
Leonard Hutton Galleries (New York), February 17–March 31, 1965, *A Centennial Exhibition of Paintings by Alexej Jawlensky, 1864–1941,* cat. no. 17, illus.
M. Knoedler & Co. (New York) (Public Education Association), April 26–May 21, 1966, *Seven Decades: Crosscurrents in Modern Art, 1895–1965,* cat. no. 73, pp. 51, 190, illus.
Columbus Gallery of Fine Arts, October 6–27, 1966, *Columbus Collects.*
J. B. Speed Art Museum (Louisville), October 22–December 1, 1968, *The Sirak Collection,* cat. no. 28, illus. (color).
Jewett Art Center (Wellesley College, Mass.), April 15–May 30, 1978, *One Century: Wellesley Families Collect,* cat. no. 51, illus.

REFERENCES
Clemens Weiler, *Alexej Jawlensky* (Cologne, 1959), p. 230, no. 56, illus.
Alfred Werner, "Jawlensky: Painter of the Human Soul," *Arts Magazine* 39 (February 1965): 40–45, illus.
*New York Herald Tribune,* "The Galleries—A Critical Guide," February 20, 1965, illus.
Truax, "A Russian's Contribution to Painting," *Jersey City Journal,* February 20, 1965.
Lichtbau, "At New York Galleries: Brilliant Jawlensky Exhibit," *Philadelphia Inquirer,* March 7, 1965, illus.

RELATED WORKS
*Schokko,* 1910, oil on canvas, 75 × 65 cm, Leonard Hutton Galleries, New York; see Weiler, p. 230, fig. 57.

REMARKS
*Schokko* (Leonard Hutton Galleries, New York) was originally painted on the verso of *Schokko with Red Hat.*

*21.*
Ernst Ludwig Kirchner
*Girl Asleep*   91.1.22
*Schlafendes Mädchen*
1905–1906

PROVENANCE
Kirchner Estate; R. N. Ketterer, Campione bei Lugano, Switzerland; Howard D. and Babette L. Sirak, September 1965.

EXHIBITION HISTORY
Museum Folkwang (Essen), October–December, 1958, *Brücke 1905–1913, eine Künstlergemeinschaft,* cat. no. 53.
Kunsthalle Bremen, March 20–May 1, 1960, *Meisterwerke des deutschen Expressionismus: E. L. Kirchner, E. Heckel, Schmidt-Rottluff, M. Pechstein, Otto Mueller,* cat. no. 1; also shown May 15–November 20, 1960, at Kunstverein Hannover, Gemeentemuseum (The Hague), Wallraf-Richartz-Museum (Cologne).
Kunsthaus Zürich, May 18–June 18, 1961, *Meisterwerke des deutschen Expressionismus: E. L. Kirchner, E. Heckel, Schmidt-Rottluff, M. Pechstein, Otto Mueller,* cat. no. 1. (Except for two additional works, this exhibition was identical to that at the Kunsthalle Bremen.)
R. N. Ketterer (Campione bei Lugano, Switzerland), autumn 1964, *E. L. Kirchner—Brücke,* cat. no. 2, pp. 10, 11, illus. (color).
J. B. Speed Art Museum (Louisville), October 22–December 1, 1968, *The Sirak Collection,* cat. no. 29, illus.

REFERENCES
Donald E. Gordon, *Ernst Ludwig Kirchner* (Cambridge, Mass., 1968), cat. no. 8, pp. 47, 48, 266, pl. 1 (color).
Anton Henze, *Ernst Ludwig Kirchner—Leben und Werk* (Stuttgart and Zurich, 1980), pp. 10, 16, illus. (color).
Christian Lenz, "Modern Art: Erst [sic] Ludwig Kirchner and Max Beckmann," *Universitas: A German Review of the Arts and Sciences, Quarterly English Language Edition* 24 (1982): 125 (as *Sleeping Girl*).

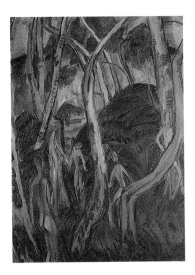

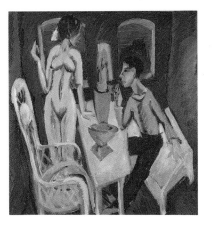

**22.**
Ernst Ludwig Kirchner
*Landscape at Fehmarn with Nudes (Five Bathers at Fehmarn)*   91.1.21
*Fehmarnlandschaft mit Akte (Fünf Badende auf Fehmarn)*
1913

PROVENANCE
Angermuseum, Erfurt, Germany; Dr. Viktor Wallerstein, Berlin; Kurt Feldhäusser, Berlin (1934); Mrs. M. Feldhäusser, Berlin; Lothar Wallerstein, Berlin; Galerie Ferdinand Moeller, Berlin; Mrs. Greta Feigl, New York; Howard D. and Babette L. Sirak, June 1965.

EXHIBITION HISTORY
J. B. Speed Art Museum (Louisville), October 22–December 1, 1968, *The Sirak Collection,* cat. no. 31, illus.

REFERENCES
Donald E. Gordon, *Ernst Ludwig Kirchner* (Cambridge, Mass., 1968), cat. no. 353, pp. 90, 317, illus.
University of Iowa Museum of Art, *An Artist Collects: Ulfert Wilke, Selections from Five Continents* (exh. cat., Iowa City, 1975), p. 24.

RELATED WORKS
*Two Bathers among Trees, Fehmarn,* 1913, oil on canvas, 120.5 × 93.5 cm; see Gordon, p. 316, fig. 352.
*Three Nudes under Trees,* 1913, oil on canvas, 124 × 90 cm; see Gordon, p. 317, fig. 354.
*Four Nudes under Trees,* 1913, oil on canvas, 120.5 × 90.5 cm; see Gordon, p. 317, fig. 355.
*Bathers under Trees,* 1913, oil on canvas, 150 × 120 cm; see Gordon, p. 317, fig. 357.

**23.**
Ernst Ludwig Kirchner
*Tower Room, Fehmarn (Self-Portrait with Erna)*   91.1.23
*Turmzimmer, Fehmarn (Selbstbildnis mit Erna)*
1913

PROVENANCE
Kirchner Estate; R. N. Ketterer, Campione bei Lugano, Switzerland; Howard D. and Babette L. Sirak, September 1965.

EXHIBITION HISTORY
R. N. Ketterer (Campione bei Lugano, Switzerland), 1963, *E. L. Kirchner,* pp. 22, 23, illus. (color).
Galatea—Galleria d'Arte Contemporanea (Turin), March 5–25, 1964, *Kirchner,* cat. no. 5, illus. (as *La Camera nella torre [autoritratto con Erna]).*
Palazzo Strozzi (Florence), May–June 1964, *L'Espressionismo, Pittura, Scultura, Architettura, XXVII Maggio Musicale Fiorentino,* cat. no. 196, illus.
R. N. Ketterer (Campione bei Lugano, Switzerland), autumn 1964, *E. L. Kirchner—Brücke,* cat. no. 53, p. 69, illus. (color).
J. B. Speed Art Museum (Louisville), October 22–December 1, 1968, *The Sirak Collection,* cat. no. 30.

REFERENCES
Kirchner Archive documentation, vol. 1 of four photograph albums, p. 397.
Donald E. Gordon, *Ernst Ludwig Kirchner* (Cambridge, Mass., 1968), pp. 87, 89, 311, cat. no. 312, pl. 12 (color), also illus. p. 311.
Carol Duncan, "Virility and Domination in Early 20th-Century Vanguard Painting," *Artforum* 12 (December 1973): 33, 34, illus. (as *Tower Room, Self-Portrait with Erma* [sic]).
Philip Larson, letter to the editors, in "Letters," *Artforum* 12 (March 1974): 9.

RELATED WORKS
*Leuchtturmzimmer,* 1913, etching with drypoint; see Annemarie and Wolf-Dieter Dube, *E. L. Kirchner: Das Graphische Werk,* 2 vols. (Munich, 1967), 1: 91, cat. no. 162; 2: 164, fig. 162.I.
*Tea at Fehmarn (Fehmarntee),* 1913 and 1920, oil on canvas, 120 × 90 cm; see Gordon, p. 311, fig. 313.

REMARKS
The painting is also signed and inscribed on the verso: *13, KN-Be/Bg 5.* (KN is the Kirchner Estate seal bearing the words "Nachlass E. L. Kirchner." The code "Be" is for Berlin, and the letters "Bg" refer to the subject matter.)

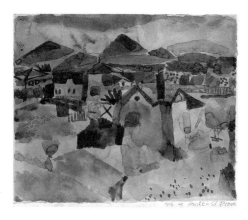

*24.*
Paul Klee
*View of Saint Germain*  91.1.33
*Ansicht von Saint Germain*
1914

PROVENANCE
Wilhelm Hausenstein, Tutzing, Oberbayern; Renée-Marie Hausenstein, Tutzing, Oberbayern; Delius Giese, New York; [Curt Valentin Gallery, New York]; Fred Schang, New York; Howard D. and Babette L. Sirak, March 1968.

EXHIBITION HISTORY
Society of the 4 Arts (Palm Beach, Fla.), March 9–April 1, 1951, *Paintings by Paul Klee, 1879–1940*, cat. no. 2.
Curt Valentin Gallery (New York), December 7, 1954–January 8, 1955, *Der Blaue Reiter.*
Harvard University (Cambridge, Mass.), Busch-Reisinger Museum, January 21–February 24, 1955, *Artists of the Blaue Reiter: Exhibition of Painting and Graphic Works*, cat. no. 33, p. 9.
Saidenberg Gallery (New York), November 11–December 14, 1957, *Third Bi-Annual Exhibition of Paintings and Drawings by Paul Klee*, cat. no. 1.
Leonard Hutton Galleries (New York), February 19–March 30, 1963, *Der Blaue Reiter*, cat. no. 68, illus.
Solomon R. Guggenheim Museum (New York), February–April 1967, *Paul Klee: 1879–1940, A Retrospective Exhibition*, p. 30, cat. no. 15, illus.
Kunsthalle Basel, June 3–August 13, 1967, *Paul Klee 1879–1940: Gesamtausstellung*, cat. no. 18, illus. no. 7, introductory text by Will Grohmann.
J. B. Speed Art Museum (Louisville), October 22–December 1, 1968, *The Sirak Collection*, cat. no. 32, illus. (color).
National Gallery of Art (Washington, D.C.), September–October 1969, *German Expressionist Watercolors*, cat. no. 16 (in supplement).

REFERENCES
Paul Klee, Oeuvrekatalog, Paul Klee Foundation, Kunstmuseum Bern, no. 1914 (41).
Paul Klee, *The Diaries of Paul Klee, 1898–1918*, ed. Felix Klee (Berkeley, Los Angeles, and London, 1964), p. 290, entry 926i., Saturday, 4.11.
Wilhelm Hausenstein, *Ganymed: Jahrbuch für die Kunst* 3 (1921): 8, illus. (color) (as *Tunesiche Landschaft*).
Pierre Courthion, *Klee* (Paris, 1953), pl. 1 (as *Vue de Saint-Germain*).
Gualtieri di San Lazzaro, *Klee: A Study of His Life and Work*, trans. Stuart Hood (New York and Washington, 1957 and 1964), pp. 83, 260, 288, fig. 11.
Mahonri Sharp Young, "Letter from the U.S.A.: From Hogarth to Peale, to Reinhardt," *Apollo* 85 n.s. (March 1967), p. 229, fig. 8.
Milton S. Fox, ed., *August Macke: Tunisian Watercolors and Drawings*, trans. Norbert Guterman (New York, 1969), p. 20.
Alone dei Contrafforti in Pilotta, *Klee: Fino al Bauhaus* (exh. cat., Parma, 1973), p. 114 (as *Veduta di St. Germain, 1914/41*).
Peter Selz, *German Expressionist Painting* (Berkeley, Los Angeles, London, 1974), pp. xvii, 294–296, pl. 133, illus.
Jürgen Glaesemer, *Paul Klee: The Colored Works in the Kunstmuseum Bern*, trans. Renate Franciscono (Bern, 1979), pp. 28, 29, fig. 84d.
Städtische Galerie im Lenbachhaus, *Paul Klee: Das Frühwerk, 1883–1922* (exh. cat., Munich, 1980), pp. 132–133, 139, 140.
Ernst-Gerhard Güse, *Die Tunisreise: Klee, Macke, Moilliet* (Stuttgart, 1982), pp. 61, 64, 74, 328, illus. (color).
Margareta Benz-Zauner, *Werkanalytische Untersuchungen zu den Tunesien-Aquarellen Paul Klees*, in Europäische Hochschulschrifte (European University Studies), vol. 34 (Frankfurt am Main, 1984), pp. 25, 26, 196 n. 34.

Jim Jordan, *Paul Klee and Cubism* (Princeton, 1984), pp. xi, 120, 125–126, 133–135, 213 n. 25, fig. 45.

RELATED WORKS
August Macke, *St. Germain bei Tunis*, 1914, watercolor, 26 × 21 cm, Städtische Galerie im Lenbachhaus, Munich; see Fox (1969), p. 38, illus. (color).

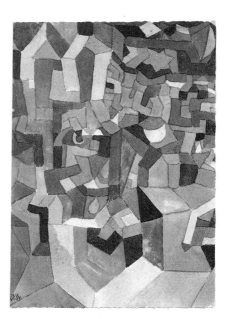

*25.*
Paul Klee
*With the Yellow Half-moon and Blue Star*  91.1.34
*Mit dem gelben Halbmond und blauen Stern*
1917

PROVENANCE
Private collection, Alabama; Henry Kleeman, New York; Fred Schang, New York; Howard D. and Babette L. Sirak, January 1969.

EXHIBITION HISTORY
Galerie Hans Goltz (Munich), May–June 1920, *Der ersten Paul Klee Ausstellung in München*, cat. no. 130 (as *1917/51*).

REFERENCES
Paul Klee, Oeuvrekatalog, Paul Klee Foundation, Kunstmuseum Bern, no. 1917 (51).
Gualtieri di San Lazzaro, *Klee: A Study of His Life and Work*, trans. Stuart Hood (New York and Washington, 1957 and 1964), p. 288, fig. 20.
University of Iowa Museum of Art, *An Artist Collects: Ulfert Wilke, Selections from Five Continents* (exh. cat., Iowa City, 1975), p. 36.

RELATED WORKS
*Yellow, Blue, and Violet*, 1917, watercolor (present whereabouts unknown); see Leopold Zahn, *Paul Klee: Leben, Werk, Geist* (Potsdam, 1920), p. 56, illus.

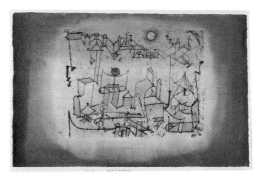

26.
Paul Klee
*City between Realms* 91.1.30
*Stadt im Zwischenreich*
1921

PROVENANCE
Lily Klee, Bern, 1940; Klee Foundation, Bern, 1946; Nierendorf Gallery, New York, 1947; Clifford Odets, New York, 1947; Galerie Berggruen, Paris, 1964; Ernst Beyeler, Basel, 1964; Howard D. and Babette L. Sirak, November 1965.

EXHIBITION HISTORY
J. B. Speed Art Museum (Louisville), October 22–December 1, 1968, *The Sirak Collection*, cat. no. 33, illus.

REFERENCES
Paul Klee, Oeuvrekatalog, Paul Klee Foundation, Kunstmuseum Bern, no. 1921 (25).

27.
Paul Klee
*Dream of a Fight* 91.1.32
*Traum von einem Kampf*
1924

PROVENANCE
Ernst Beyeler, Basel; Howard D. and Babette L. Sirak, November 1965.

EXHIBITION HISTORY
Galerie Beyeler (Basel), March–April 1963, *Klee*, cat. by Walter Ueber-wasser, no. 19.
Galerie Renée Ziegler (Zurich), September–October, 1963, *Paul Klee*, cat. no. 13, p. 8, illus.
Hamilton Galleries (London), July 7–August 8, 1964, *The Blue Four: Klee, Kandinsky, Feininger, Jawlensky*, cat. no. 4, illus. (as *Traum von Einem Kampf [Dream of a Battle]*).

J. B. Speed Art Museum (Louisville), October 22–December 1, 1968, *The Sirak Collection*, cat. no. 34, illus.

REFERENCES
Paul Klee, Oeuvrekatalog, Paul Klee Foundation, Kunstmuseum Bern, no. 1924 (84).
Will Grohmann, *Klee: Handzeichnungen*, vol. 2: *1921–1930* (Berlin and Potsdam, 1934), p. 22, no. 43.
*Dimensions: Ideas in Literature*, book 3 (Columbus), illus. (cover).
Museen der Stadt Köln, *Paul Klee: Das Werk der Jahre 1919–1933, Gemälde, Handzeichnungen, Druckgraphik* (exh. cat., Cologne, 1979), cat. no. 130, pp. 120, 231, illus.

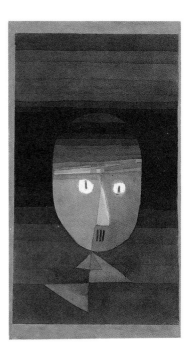

28.
PAUL KLEE
*Thoughtful* 91.1.29
*Nachdenksam über Lagen*
1928

PROVENANCE
[Nierendorf Gallery, New York]; Emil Hirsch, New York; Fred Schang, New York; Howard D. and Babette L. Sirak, January 1969.

EXHIBITION HISTORY
Minneapolis Institute of Arts, June 5–August 31, 1955, *40 Works by Paul Klee from the Collection of F. C. Schang*.
Solomon R. Guggenheim Museum (New York), February–April 1967, *Paul Klee, 1879–1940: A Retrospective Exhibition*, cat. no. 97, p. 73, illus.

REFERENCES
Paul Klee, Oeuvrekatalog, Paul Klee Foundation, Kunstmuseum Bern, no. 1928 (79) qu.9.
Marcel Brion, *Klee* (Paris, 1955), fig. 37 (as *En réfléchissant sur la situation*).
University of Iowa Museum of Art, *An Artist Collects: Ulfert Wilke, Selections from Five Continents* (exh. cat., Iowa City, 1975), p. 24.

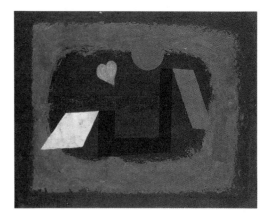

**29.**
Paul Klee
*Composition*  91.1.24
1931

PROVENANCE
Rolf and Kathi Burgi, Belp; private collection, Bern; Ernst Beyeler, Basel; Howard D. and Babette L. Sirak, November 1965.

EXHIBITION HISTORY
Ohio State University (Columbus), School of Art Gallery, November 11–30, 1966, *Klee, Kandinsky, and Jawlensky: Works from the Bauhaus Period*, cat. no. 1 (medium given as oil and encaustic).
J. B. Speed Art Museum (Louisville), October 22–December 1, 1968, *The Sirak Collection*, cat. no. 36, illus.
Cleveland Museum of Art, October 3–November 25, 1979, *The Spirit of Surrealism*, cat. by Edward B. Henning, no. 62, pp. 108, 109, illus.

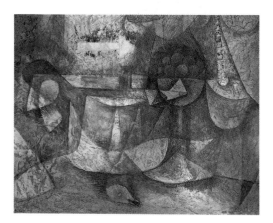

**30.**
Paul Klee
*Still Life with Dove*  91.1.31
*Stilleben mit der Taube*
1931

PROVENANCE
Rolf and Kathi Burgi, Belp; private collection, Bern; Ernst Beyeler, Basel; Howard D. and Babette L. Sirak, November 1965.

EXHIBITION HISTORY
Kunstmuseum Bern, August 11–November 4, 1956, *Paul Klee: Ausstellung in Verbindung mit der Paul Klee-Stiftung*, cat. no. 609, p. 97.
Galerie Beyeler (Basel), June–September, 1965, *Paul Klee: The Later Work*, cat. by Walter Ueberwasser, no. 3, illus. (color).
J. B. Speed Art Museum (Louisville), October 22–December 1, 1968, *The Sirak Collection*, cat. no. 35, illus. (reproduced upside down).

REFERENCES
Paul Klee, Oeuvrekatalog, Paul Klee Foundation, Kunstmuseum Bern, no. 1931 (151) R 11.
Will Grohmann, *Paul Klee* (New York, 1955), pp. 310–311, 427.

Walter Ueberwasser, "La dernière période de Klee," *L'Oeil, Revue d'art mensuelle* 125 (May 1965): 34–39, 71, fig. 10.
*Vision* (August 20, 1965): 65.
Will Grohmann, *Klee*, The Library of Great Painters, trans. Norbert Guterman (New York, 1967), pp. 6, 122, 123, illus. (color) (medium given as oil and crayon on cardboard).
University of Iowa Museum of Art, *An Artist Collects: Ulfert Wilke, Selections from Five Continents* (exh. cat., Iowa City, 1975), p. 24.
Richard Verdi, *Klee and Nature* (New York, 1984), pp. xii, 53, 54, fig. 41.

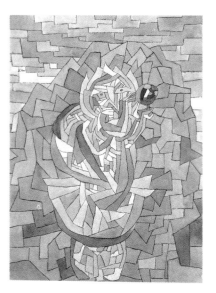

**31.**
Paul Klee
*Rock Flower*  91.1.26
*Felsenblume*
1932

PROVENANCE
Galerie Rosengart, Lucerne, Switzerland; Fred Schang, New York; Howard D. and Babette L. Sirak, October 1967.

EXHIBITION HISTORY
Solomon R. Guggenheim Museum (New York), February–April, 1967, *Paul Klee, 1879–1940: A Retrospective Exhibition*, cat. no. 124, p. 98, illus. (color).
Kunsthalle Basel, June 3–August 13, 1967, *Paul Klee, 1879–1940, Gesamtausstellung*, cat. no. 132, pl. 16 (color).
J. B. Speed Art Museum (Louisville), October 22–December 1, 1968, *The Sirak Collection*, cat. no. 37, illus.

REFERENCES
Paul Klee, Oeuvrekatalog, Paul Klee Foundation, Kunstmuseum Bern, no. 1932 (64) m 4.
Edward B. Henning, *Fifty Years of Modern Art: 1916–1966* (Cleveland Museum of Art, 1966), cat. no. 55, pp. 68, 202, illus.
*Dimensions: Ideas in Literature*, book 3 (Columbus), illus. (cover).

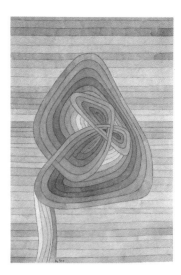

**32.**
Paul Klee
*Lonely Flower*    91.1.25
*Einsame Blüte*
1934

PROVENANCE
Hamilton Galleries, London, 1963; Galerie Beyeler, Basel; Stephen Hahn, New York; Howard D. and Babette L. Sirak, November 1965.

EXHIBITION HISTORY
Hamilton Galleries (London), July 7–August 8, 1964, *The Blue Four: Klee, Kandinsky, Feininger, Jawlensky,* cat. no. 9, illus.
Galerie Beyeler (Basel), June–September 1965, *Klee: The Later Work,* cat. by Walter Ueberwasser, no. 13, illus. (color).
Stephan Hahn Gallery (New York), October 12–30, 1965, *Flowers: From Boudin to Braque,* illus. (cover).
J. B. Speed Art Museum (Louisville), October 22–December 1, 1968, *The Sirak Collection,* cat. no. 38, illus.

REFERENCES
Paul Klee, Oeuvrekatalog, Paul Klee Foundation, Kunstmuseum Bern, no. 1934 (5) 5.
Gene Baro, "Things to Come in London," *Arts Magazine* 38 (May–June 1964): 53, illus.
Richard Verdi, *Klee and Nature* (New York, 1984), pp. xiv, 1, 147, 148, fig. 135.
Ernst-Gerhard Güse, *Paul Klee: Wachstum regt sich Klees Zwiesprache mit der Natur* (exh. cat., Faarland Museum, Saarbrücken, 1990), p. 36, illus.

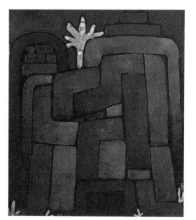

PROVENANCE
[Thompson]; [Curt Valentin, New York]; Private collection, Connecticut; M. Chanin, New York; Staempfli Gallery, New York; Howard D. and Babette L. Sirak, July 1965.

EXHIBITION HISTORY
Buchholz Gallery (New York), November 1–26, 1938, *Paul Klee,* cat. no. 29.
Buchholz Gallery (New York), February 23–March 20, 1943, *Paul Klee, André Masson and Some Aspects of Ancient and Primitive Sculpture,* cat. no. 20.
Staempfli Gallery (New York), September–October 1962, *Recent Acquisitions,* illus.
J. B. Speed Art Museum (Louisville), October 22–December 1, 1968, *The Sirak Collection,* cat. no. 39, illus.

REFERENCES
Paul Klee, Oeuvrekatalog, Paul Klee Foundation, Kunstmuseum Bern, no. 1935 (109), p. 9.

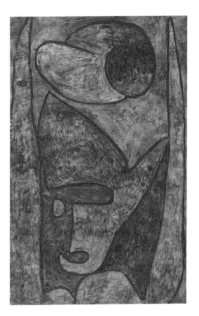

**34.**
Paul Klee
*Fire Spirit*    91.1.27
*Feuer-geist*
1939

PROVENANCE
Richard Doetsch-Benziger, Basel; Ernst Beyeler, Basel; Howard D. and Babette L. Sirak, November 1965.

EXHIBITION HISTORY
Kunstmuseum Basel, June 9–July 8, 1956, *Katalog der Sammlung Richard Doetsch-Benziger,* cat. no. 206, p. 58, illus.
Galerie Beyeler (Basel), June–September 1965, *Klee: The Later Work,* cat. by Walter Ueberwasser, no. 28, illus. (color).
J. B. Speed Art Museum (Louisville), October 22–December 1, 1968, *The Sirak Collection,* cat. no. 40, illus.

REFERENCES
Paul Klee, Oeuvrekatalog, Paul Klee Foundation, Kunstmuseum Bern, no. 1939 (xx) 12.
Walter Ueberwasser, "La dernière période de Klee," *L'Oeil, Revue d'art mensuelle* 125 (May 1965): 34–39, 71, fig. 7 (as *L'Esprit du Feu*).
*Arts Magazine* 39 (May–June 1965): 13, illus. (medium given as tempera and watercolor).

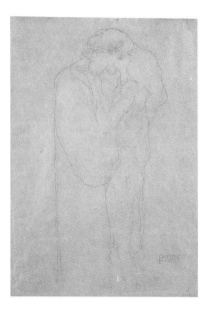

*35.*
Gustav Klimt
*The Embrace*   91.1.35
*Das Liebespaar*
ca. 1910

PROVENANCE
La Boetie Gallery, New York; Howard D. and Babette L. Sirak, March 1964.

EXHIBITION HISTORY
J. B. Speed Art Museum (Louisville), October 22–December 1, 1968, *The Sirak Collection,* cat. no. 41, illus.

RELATED WORKS
Several groups of works are related to the Sirak drawing. These include preparatory sketches for the *Beethoven Frieze* (1902, casein paint on stucco, inlaid with various materials, Österreichische Galerie, Vienna), *The Kiss* (1907–1908, oil on canvas with various materials, Österreichische Galerie, Vienna), and the dining room decorations for the Palais Stoclet (1905–1912, Palais Stoclet, Brussels). See Alice Strobl, *Gustav Klimt: Die Zeichnungen, 1904–1912,* 4 vols. (Salzburg, 1982).

*36.*
Gustav Klimt
*Portrait of Adele Bloch-Bauer*   91.1.36
*Bildnis Adele Bloch-Bauer*
1910–1911

PROVENANCE
Sold at auction by Kornfeld und Klipstein, May 1964; La Boetie Gallery, New York; Howard D. and Babette L. Sirak, March 1964.

EXHIBITION HISTORY
J. B. Speed Art Museum (Louisville), October 22–December 1, 1968, *The Sirak Collection,* cat. no. 42, illus.

REFERENCES
Kornfeld und Klipstein (Bern), *Moderne Kunst: Des Neunzehnten und Zwanzigsten Jahrhunderts,* sale no. 112, Thursday, May 28, 1964 (afternoon session), cat. no. 637d, p. 98, pl. 60 (as *Studien zum Portrait Frau Adele Bloch-Bauer, heute in der Österreichischen Galerie in Wien: Stehend, im Zweidrittelprofil nach links*).
Alice Strobl, *Gustav Klimt: Die Zeichnungen, 1904–1912,* vol. 2 (Salzburg, 1982), cat. no. 2092, pp. 268, 269, illus. (as *Bildnis Adele Bloch-Bauer: Etwas nach links gedreht,* dated 1910–1911).

RELATED WORKS
For other studies for the same portrait, see Strobl, vol. 2, nos. 2074–2112, illus.
*Portrait of Adele Bloch-Bauer II,* 1912, oil on canvas, Österreichische Galerie, Vienna; see Fritz Novotny and Johannes Dobai, *Gustav Klimt, with a Catalogue Raisonné of His Paintings* (New York and Washington, 1975), no. 177, pp. 354–355, illus., also pl. 79 (color).

REMARKS
Kornfeld gives the support as Japan paper.

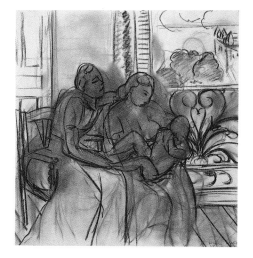

*37.*
Henri Matisse
*Still Life with Self-Portrait* 91.1.38
*Nature morte à l'autoportrait*
1896

PROVENANCE
Paul Cézanne; Ambroise Vollard, Paris; Sam Salz, New York; Howard
D. and Babette L. Sirak, April 1968.

EXHIBITION HISTORY
Galerie Bernheim-Jeune (Paris), 1908.
Galerie Georges Petit (Paris), 1926.
UCLA Art Council (Los Angeles), January 5–February 27, 1966, *Retro-
spective 1966–Henri Matisse*, pp. 32, 182, cat. no. 3, illus. (color) (as
*Still Life*). Shown March 11–June 26, Art Institute of Chicago and
Museum of Fine Arts (Boston).
J. B. Speed Art Museum (Louisville), October 22–December 1, 1968,
*The Sirak Collection*, cat. no. 43, illus. (color).

REFERENCES
Pierre Schneider, *Matisse*, trans. Michael Taylor and Bridget Strevens
Romer (New York, 1984), pp. 27, 426–428.
Jack D. Flam, *Matisse: The Man and His Art, 1869–1918* (Ithaca and
London, 1986), pp. 38, 42, 48, fig. 21.

RELATED WORKS
*Woman Reading*, 1895, oil on canvas, Musée national d'Art moderne,
Paris; see Flam, p. 41, fig. 20.
*Interior with Top Hat*, 1896, oil on canvas, private collection; see Flam,
p. 43, fig. 22 (color).

*38.*
Henri Matisse
*Maternity* 91.1.37
*Maternité*
1939

PROVENANCE
Albert Loeb & Krugier Gallery, New York; Howard D. and Babette L.
Sirak, March 1968.

EXHIBITION HISTORY
Albert Loeb & Krugier Gallery (New York), November 1967, *Henri
Matisse, Drawings*, no. 5 in Taurus-series, cat. no. 21, illus.
J. B. Speed Art Museum (Louisville), October 22–December 1, 1968,
*The Sirak Collection*, cat. no. 44, illus.

REFERENCES
Christian Zervos, "Dessins récents de Henri Matisse," *Cahiers d'Art*,
nos. 1–4 (1939): 22, illus.
Hilton Kramer, "Art: A Reminder of Matisse's Quality and Diversity;
40 Drawings on View at Loeb & Krugier," *New York Times*, Saturday,
November 25, 1967, illus.
University of Iowa Museum of Art, *An Artist Collects: Ulfert Wilke,
Selections from Five Continents* (exh. cat., Iowa City, 1975), p. 32.
John Elderfield, *The Drawings of Henri Matisse* (exh. cat., Arts Council
of Great Britain, London, and Museum of Modern Art, New York,
1984), pp. 118, 289.

RELATED WORKS
For a series of related drawings, see *Zervos*, pp. 5–24. Especially close
are the others depicting the mother and child theme, pp. 20, 21,
and 23.

39.
Claude Monet
*Seascape at Pourville*   91.1.39
*Marine à Pourville*
1882

PROVENANCE
Gaston Bernheim de Villers (Galerie Bernheim-Jeune), Paris, 1923
(purchased from the artist); Durand-Ruel, Paris, 1926; Sam Salz, New
York; Howard D. and Babette L. Sirak, June 1972.

EXHIBITION HISTORY
Galerie Bernheim-Jeune (Paris), 1892.
Galeries Durand-Ruel (Paris), 1931.

REFERENCES
Marc Elder, *À Giverny, chez Claude Monet* (Paris, 1924), p. 86, pl. 27 (as
   *Pleine Mer, Pourville*, dated 1883).
University of Iowa Museum of Art, *An Artist Collects: Ulfert Wilke,
   Selections from Five Continents* (exh. cat., Iowa City, 1975), p. 50.
Daniel Wildenstein, *Claude Monet, Biographie et catalogue raisonné*,
   vol. 2: *1882–1886, Peintures* (Lausanne, Paris, 1979), pp. 6, 84, 298, cat.
   no. 775, illus.

RELATED WORKS
*Marée basse à Pourville*, 1882, oil on canvas, 65 × 100 cm (present
   whereabouts unknown); see Wildenstein, vol. 2, no. 776, p. 84, illus.
*Pointe de l'ailly, marée basse*, 1882, oil on canvas, 60 × 100 cm, private
   collection, United States; see Wildenstein, vol. 2, no. 778, p. 84, illus.

40.
Claude Monet
*The Seine at Port-Villez (A Gust of Wind)*   91.1.43
*La Seine à Port-Villez (Le Coup de vent)*
1883 or 1890

PROVENANCE
Sacha Guitry, Paris, ca. 1924; Madame Sacha Guitry, Paris; Sam Salz,
New York; Howard D. and Babette L. Sirak, December 1968.

EXHIBITION HISTORY
Hôtel de la Curiosité et des Beaux-Arts (Paris), 1924, *Exposition de
   collectionneurs*, no. 89.
Art Institute of Chicago, March 15–May 11, 1975, *Paintings by Monet*,
   cat. no. 59, pp. 30, 31, 113, illus.

REFERENCES
Daniel Wildenstein, *Claude Monet, Biographie et catalogue raisonné*,
   vol. 3: *1887–1898, Peintures* (Lausanne, Paris, 1979), cat. no. 1264, pp.
   37, 136, 137, 303, 305, illus. (as *Le Coup de vent*, dated 1890).

RELATED WORKS
*La Seine à Port-Villez*, 1883, oil on canvas, 60 × 100 cm, Aquavella
   Galleries, New York; see Wildenstein, vol. 2: *1882–1886, Peintures*
   (1979), cat. no. 834, pp. 106, 107, illus.
*Les Îles à Port-Villez*, 1890, oil on canvas, 60 × 100 cm, private collec-
   tion, United States; see Wildenstein, vol. 3, cat. no. 1262, pp. 136, 137,
   illus.
*La Seine à Port-Villez*, 1890, oil on canvas, 65 × 92 cm, Musée d'Orsay,
   Paris; see Wildenstein, vol. 3, cat. no. 1263, pp. 136, 137, illus.
*L'Île au sable de Port-Villez*, 1890, oil on canvas, 65 × 81 cm; see Wild-
   enstein, vol. 3, cat. no. 1265, pp. 136–137, illus.

REMARKS
Wildenstein, in his catalogue raisonné (1979), asserts that the paint-
ing was signed long after it was painted and was given the wrong date
at that time. In the catalogue of the Chicago exhibition (1975), an
anecdote is recounted that suggests the signing actually took place on
the occasion of Sacha Guitry's marriage to Yvonne Printemps. As the
story goes, Monet began to date the painting "81" when Guitry
inquired whether it should really be "83"; Monet then changed the "1"
to a "4" because it was the best he could do without smearing the
paint. This account has not been confirmed. There is strong visual
evidence to indicate the work was done in 1890, based on a com-
parison with related works. As Wildenstein notes, p. 136, the Sirak
painting (no. 1264) is very close to *Les Îles à Port-Villez* (no. 1262),
except the wind comes from the opposite direction.

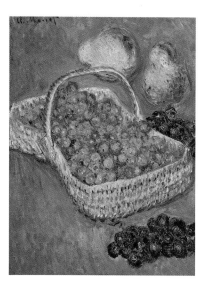

41.
Claude Monet
*Basket of Grapes*   91.1.40
*Panier de raisins*
1883

PROVENANCE
Durand-Ruel, 1883 (purchased from the artist); Mathias, Paris;
Durand-Ruel, 1898; Sam Salz, New York; Howard D. and Babette L.
Sirak, November 1971.

EXHIBITION HISTORY
Galeries Durand-Ruel (Paris), May–September 1959, *Claude Monet*,
   cat. no. 34, illus. (dated 1884).
Galeries Durand-Ruel (Paris), January 24–April 10, 1970, *Claude
   Monet*, cat. no. 33, illus.
Carnegie Institute, Museum of Art (Pittsburgh), October 26, 1974–
   January 5, 1975, *Celebration* (inaugural exhibition of the Sarah Scaife
   Gallery of the Museum of Art), cat. no. 5, illus. (dated 1884).
Art Institute of Chicago, March 15–May, 1975, *Paintings by Monet*, p.
   123, cat. no. 66, illus. (as *Basket of Grapes and Quinces [Decorative
   Panel]; Panier de raisins et coings [panneau decoratif]*, dated 1884).
Jewett Art Center, Wellesley College (Mass.), April 15–May 30, 1978,
   *One Century: Wellesley Families Collect*, cat. no. 6, illus. (as *Basket of
   Grapes [Pannier* (sic) *des fruits]*, dated 1884).

REFERENCES

Daniel Wildenstein, *Claude Monet, Biographie et catalogue raisonné*, vol 2: *1882–1886, Peintures* (Lausanne, Paris, 1979), cat. no. 954, pp. 148, 149, illus. (as *Panier de raisins, coings et poires*, dated 1883).

Claire Joyes, *Monet's Table: The Cooking Journals of Claude Monet*, trans. Josephine Bacon (New York, 1989), p. 42, illus. (color). French ed., *Les Carnets de Cuisine de Monet* (Paris, 1989).

REMARKS

At least two different reconstructions of this work and its related panels have been proposed:

In the Durand-Ruel catalogue (1970), the Sirak painting is identified as the lower left-hand side of the "*reconstitution d'une porte double du salon de Paul Durand-Ruel, 35, rue de Rome.*" The ensemble is titled: *Pivot Blanc, Panier de raisins, Pêches, Lys du Japon, Panier de pommes, Azalées, Blanches et roses.* See cat. no. 33.

An alternate reading is given in the Wildenstein catalogue raisonné, vol. 2 (1979), where the painting is identified as one of the fragments of "*Six Panneaux. Décoration pour* La Porte F: *on ne possède pas de photographie de cette porte qui semble n'avoir jamais été réalisée.*" (Six panels, Decorations for *Door F*: there is no known photograph of this door which seems to have never been realized.) The Sirak painting is shown as the lower right panel; the others are: *Lys Rouges, Lys du Japon, Pêches, Pêches,* and *Roses de Noël.* These six panels are Wildenstein nos. 949–954, p. 148, illus.

Although the literature is not clear concerning the identification of the fruit, it is clear that the composition consists of a basket of green grapes, with purple grapes outside the basket, and either pears or quinces at the top. Since pears and quinces are similar in appearance, it is difficult to say which are represented here.

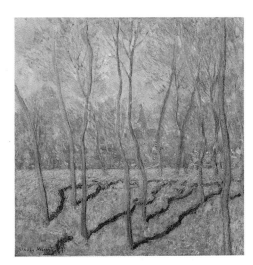

42.
Claude Monet
*View of Bennecourt*    91.1.42
*Vue sur Bennecourt*
1887

PROVENANCE

Boussod, Valadon et Cie, April 1888 (purchased from the artist by Theo van Gogh); Richardson, 1888; Mrs. James F. Sutton; American Art Association, auction, October 26, 1933; [Durand-Ruel]; Hector Binney, ca. 1954; Durand-Ruel, Paris; Sam Salz, New York; Howard D. and Babette L. Sirak, February 1965.

EXHIBITION HISTORY

London, The Royal Society of British Artists (London), 1887–1888, no. 384 (as *Village of Bennecourt*).
Galeries Durand-Ruel (Paris), 1892.
Durand-Ruel Galleries (New York), 1922.
Arthur Tooth & Sons Ltd. (London), April 13–May 6, 1939, *Claude Monet, 1840–1926*, cat. no. 23 (as *Arbres en hiver*).
Galerie Wildenstein (Paris), 1952, *Claude Monet*.
[Kunsthalle Zürich, May 10–June 15, 1952, *Claude Monet, 1840–1926*, cat. no. 49(?), p. 21 (as *Paysage d'hiver à Bennecourt*, dated 1879 1880, and dimensions given as 100 × 64 cm).]
Gemeentemuseum van 's Gravenhage, July 24–September 22, 1952, *Claude Monet*, cat. no. 43 (as *Winterlandschap te Bennecourt*, dated 1879).

J. B. Speed Art Museum (Louisville), October 22–December 1, 1968, *The Sirak Collection*, cat. no. 5, illus. (color) (as *Le Printemps, paysage de Vétheuil*).

REFERENCES

American Art Association, *Twelve Important Paintings by Monet from the Sutton Collection, together with fine examples of the Barbizon School and works by other artists from estates and private collections*, sale cat., October 26, 1933, no. 88.

M. Malinque, *Claude Monet*, Les Documents d'Art (Paris, 1943), pp. 120, 148, illus. (as *Arbres en hiver*).

John Rewald, "Theo van Gogh, Goupil and the Impressionists, Part I," *Gazette des Beaux-Arts* 81 (January 1973), p. 21 (as *Village de Bennecourt*); and in "Theo van Gogh, Goupil and the Impressionists, Part II," (February 1973), appendix I [p. 99, as *Village de Bennecourt*]; reprinted as "Theo van Gogh as Art Dealer," in John Rewald, *Studies in Post-Impressionism*, ed. Irene Gordon and Frances Weitzenhoffer (New York, 1986), pp. 7–115, mentioned, pp. 27, 92.

*Works Exhibited at the Royal Society of British Artists, 1824–1893 and The New English Art Club, 1888–1917w*, comp. Jane Johnson (Suffolk, 1975), p. 327 (as *Village of Bennecourt*).

Daniel Wildenstein, *Claude Monet, Biographie et catalogue raisonné*, vol. 3: *1887–1898, Peintures* (Lausanne, Paris, 1979), cat. no. 1125, pp. 6, 31, 88, 89, 229–231, 305, illus. (as *Arbres en hiver, Vue sur Bennecourt*).

RELATED WORKS

*Bennecourt*, 1887, oil on canvas, 81 × 81 cm; see Wildenstein, vol. 3, no. 1126, pp. 88–89.

REMARKS

In his catalogue raisonné, vol. 3, Wildenstein lists this painting as *Arbres en hiver (Vue sur Bennecourt)*. While it is not impossible that the season here is late winter, the leaves on the trees suggest that it is perhaps early spring. It should be noted, however, that the preliminary research suggests that Monet's own title may have been *Village de Bennecourt*, for that is how the work was exhibited in London in 1888 and the way it was recorded in the sales ledger of Boussod, Valadon et Cie.

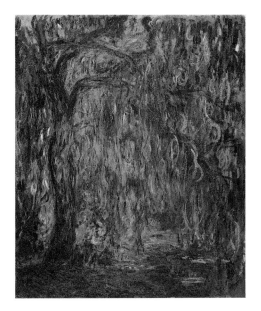

43.
Claude Monet
*Weeping Willow*    91.1.41
*Saule pleureur*
1918

PROVENANCE

Galerie Bernheim-Jeune, Paris, January 23, 1919 (purchased from the artist, along with Durand-Ruel, each taking half-interest); [Mr. (Marc?) François, Paris]; Henri Canonne, Paris, January 1926 (purchased from Galerie Bernheim-Jeune); private collection, Geneva, Switzerland; Sam Salz, New York; Howard D. and Babette L. Sirak, February 1977.

EXHIBITION HISTORY
Galerie Bernheim-Jeune (Paris), 1919, *Monet-Rodin.*
Galerie Bernheim-Jeune (Paris), January 21–February 2, 1921, *Claude Monet.*
Galerie Bernheim-Jeune (Paris), 1923, *Monet.*
Palais de Beaulieu (Lausanne), Exposition Nationale Suisse, 1964, *Chets-a oeuvres des collections suisses de Manet à Picasso,* cat. no. 47, illus.
Musée de l'Orangerie (Paris), 1967, *Chefs-d'oeuvres des collections suisses de Manet à Picasso,* cat. no. 41, illus. (as *Le grand saule à Giverny*).

REFERENCES
Arsène Alexandre, *La Collection Canonne* (Paris, 1930), p. 36.
S. Melikian, "Les cinq Monet décisifs, choisis et commentés par René Huyghe, de l'Académie française," *Réalités* (May 1967): 78, illus.
J. Chazade (interview of René Huyghe), "Monet: The Life and Death of Impressionism," *Réalités* (English ed.), no. 202 (September 1967): 72, illus. (color) (as *The Willow at Giverny*).
Daniel Wildenstein, *Claude Monet,* Italian trans. Aurora Colloridi (Milan, 1971), p. 71, illus. (color) (as *Il salice piangente, Giverny*); reprinted (Milan, 1974), p. 71.
Dennis Rouart and Jean-Dominique Rey, *Monet: Nymphéas ou Les Miroirs du Temps,* with a catalogue raisonné by Robert Maillard (Paris, 1972), p. 168, illus.
Alberto Martini, *Monet* (New York, 1978), pl. 62 (color) (as *Weeping Willow at Giverny*).
[Robert Gordon and Andrew Forge, *Monet* (New York, 1983), pp. 280, 294, illus. (color) (as *Paysage, saule pleureur [Landscape, Weeping Willow]*, dimensions given as 130 × 110 cm).]
Daniel Wildenstein, *Claude Monet, Biographie et catalogue raisonné,* vol. 4: *1899–1926, Peintures* (Lausanne, Paris, 1985), cat. no. 1869, pp. 89 n. 823, 280, 281, 401, 402, 437, illus.

RELATED WORKS
See Wildenstein, vol. 4, nos. 1868–1877.

REMARKS
The tree that served as the model for this painting and the related series of paintings (Wildenstein, vol. 4, nos. 1868–1877) has been identified by Wildenstein as the youngest of the two willows decorating the north bank of the basin. This younger tree is to the west of the one appearing in a series of works (Wildenstein, vol. 4, nos. 1848–1855) executed at about the same time as or slightly earlier than the Sirak painting. There was a third tree to the southwest of the Japanese foot bridge which served as the model for another group of paintings (Wildenstein, vol. 4, nos. 1911–1933). This is discussed by Wildenstein, vol. 4, p. 274.

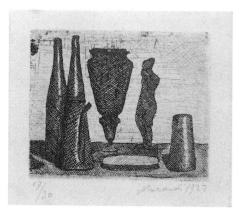

*44.*
Giorgio Morandi
*Still Life with Statuette* 91.1.45
*Natura morta con la statuina*
1922

PROVENANCE
Albert Loeb & Krugier Gallery, New York; Museum of Modern Art, New York; Harriet Griffin Gallery, New York; Howard D. and Babette L. Sirak, June 1976.

EXHIBITION HISTORY
Albert Loeb & Krugier Gallery (New York), May 1967, *Morandi,* no. 4 in Taurus series, cat. no. 51.

REFERENCES
Lamberto Vitali, *L'Opera grafica di Giorgio Morandi* (Turin, 1964), p. 27, cat. no. 17, illus.
Franco Basile, *Morandi Incisore* (Bologna, 1985), pp. 23, 40, cat. no. 18.

REMARKS
The plate is preserved in the Calcografia Nazionale, Rome.

*45.*
Giorgio Morandi
*Still Life with Seven Objects in a Tondo* 91.1.44
*Natura morta con sette oggetti in un tondo*
1945

PROVENANCE
Museum of Modern Art, New York; Harriet Griffin Gallery, New York; Howard D. and Babette L. Sirak, April 1976.

REFERENCES
Lamberto Vitali, *L'Opera grafica di Giorgio Morandi* (Turin, 1964), cat. no. 111, pp. 25, 30, illus.
Franco Basile, *Morandi Incisore* (Bologna, 1985), cat. no. 128, pp. 25, 149.

REMARKS
The plate is preserved in the Calcografia Nazionale, Rome.

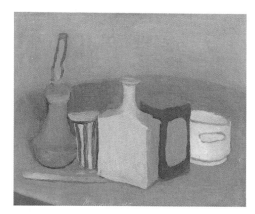

*46.*
Giorgio Morandi
*Still Life* 91.1.46
*Natura morta*
1945

PROVENANCE
P. Rollino, Rome; F. Rollino, Rome; Galleria dell'Annunciata, Milan; G. Lizzola, Milan; Galerie Krugier et Cie; Albert Loeb & Krugier Gallery, New York; Howard D. and Babette L. Sirak, December 1967.

EXHIBITION HISTORY
Galerie Krugier et Cie (Geneva), November 1963, *Giorgio Morandi*, no. 5 in Suites series, cat. no. 17, p. 13, illus.
Badischer Kunstverein (Karlsruhe), June 22–July 26, 1964, *Giorgio Morandi*, cat. no. 6.
Albert Loeb & Krugier Gallery (New York), October-November 1966, *Homage to Silence . . . or metaphysica*, no. 1 in Taurus series, cat. no. 14.
Albert Loeb & Krugier Gallery (New York), May 1967, *Morandi*, no. 4 in Taurus series, cat. no. 16, illus.
J. B. Speed Art Museum (Louisville), October 22–December 1, 1968, *The Sirak Collection*, cat. no. 46, illus. (color).
Des Moines Art Center, September 19–October 29, 1978, *Art in Western Europe—The Postwar Years, 1945–1955*, cat. no. 49, illus.

REFERENCES
Jiri Siblik, *Giorgio Morandi* (Prague, 1965), pl. 44.
Lamberto Vitali (introduction), *Giorgio Morandi pittore*, Monografie di artisti italiani contemporanei, no. 7 (Milan, 1965), pl. 161.
Lamberto Vitali, *Morandi, catalogo generale*, vol. 1: *1913–1947* (Milan, 1977), cat. no. 485.

*47.*
Jan Müller
*Apparition from Hamlet*   91.1.47
1957
Painted on verso: *Abstract (Mosaic)*

PROVENANCE
Staempfli Gallery, New York; Howard D. and Babette L. Sirak, March 1965.

EXHIBITION HISTORY
Staempfli Gallery (New York), 1963.
J. B. Speed Art Museum (Louisville), October 22–December 1, 1968, *The Sirak Collection*, cat. no. 47, illus.

REMARKS
The title *Abstract (Mosaic)* for the painting on verso was given by the museum, based on the painting's similarity to other works that the artist referred to as his "mosaics." For similar works see Rosa Esman Gallery, *Jan Müller: Mosaic Paintings from the 1950s* (exh. cat., New York, 1980).
As with many of his works from this time period, the support for this painting is roof shingle.

*48.*
Emil Nolde
*Steamboat and Sailboat*   91.1.48
*Dampfer und Segler*
1913

PROVENANCE
Private collection, Germany; Kunsthaus Lempertz, Cologne, auction, December 9, 1966; M. Knoedler & Co., New York, January 1967; Howard D. and Babette L. Sirak, April 1967.

EXHIBITION HISTORY
J. B. Speed Art Museum (Louisville), October 22–December 1, 1968, *The Sirak Collection*, cat. no. 48, illus. (as *Dampfer und Segeler* [sic]).

REFERENCES
Kunsthaus Lempertz (Cologne), *Kunst des 20. Jahrhunderts*, sale cat. no. 491, December 9, 1966, no. 530, p. 95, pl. 11.

RELATED WORKS
*Sailing-Boats on Yellow Sea*, 1913, oil on canvas; see Martin Urban, *Emil Nolde, Catalogue Raisonné of the Oil Paintings*, vol. 1: *1895–1914* (London, 1987), no. 606.
*Sailing-Boats on Yellow Sea II*, 1913, oil on canvas; see Urban, no. 607.
*Stormy Sea (2 Sailing-Boats and 1 Small Steamer)*, 1913, oil on canvas, see Urban, no. 608.
*Junks on the Han River*, 1913, watercolor; see Martin Urban, *Emil Nolde Landscapes: Watercolors and Drawings* (New York, Washington, D.C., London, 1970), pl. 2 (color).

**49.**
Emil Nolde
*Young Girl*  91.1.50
*Junges Mädchen*
1920

PROVENANCE
Heinz Schultz, New York; Grace Borgenicht Gallery, New York, March–April 1954(?); Herman Cooper, New York; M. Knoedler & Co., New York (consigned from Herman Cooper, New York, October 1965); Howard D. and Babette L. Sirak, December 1965.

EXHIBITION HISTORY
Museum of Modern Art (New York), March 4–April 30, 1963, *Emil Nolde*, cat. by Peter Selz, no. 91, p. 84. Shown May 28–September 1, 1963, at the San Francisco Museum of Art and the Pasadena Art Museum.
J. B. Speed Art Museum (Louisville), October 22–December 1, 1968, *The Sirak Collection*, cat. no. 49, illus.

**50.**
Emil Nolde
*Sunflowers in the Windstorm*  91.1.49
*Sonnenblumen im Sturmwind*
1943

PROVENANCE
Stiftung Seebüll Ada und Emil Nolde, Seebüll, Germany; M. Knoedler & Co., New York (consigned from Stiftung Seebüll Ada und Emil Nolde, March 1963); Howard D. and Babette L. Sirak, June 1964.

EXHIBITION HISTORY
Städtisches Museum (Flensburg), January 18–February 12, 1950, *Emil Nolde.*

Kölnischer Kunstverein, May 13–July 2, 1950, *Emil Nolde, Gemälde und Aquarelle,* cat. no. 12.
Städtisches Kunsthalle (Kiel), August 1950, *Emil Nolde.*
Graphisches Kabinett, Ursula Voigt (Bremen), January 14–February 28, 1951, *Emil Nolde.*
Venice, June 16–October 21, 1956, *XXVIII Biennale di Venezia,* p. 391, cat. no. 12.
Städtisches Kunsthalle (Kiel), December 9, 1956–January 13, 1957, *Emil Nolde.*
Hamburg Kunstverein, April 27–June 16, 1957, *Gedächtnisausstellung Emil Nolde,* cat. no. 173, illus.
Schloss Charlottenborg, Copenhagen, April 18–May 4, 1958, *Emil Nolde,* cat. no. 84, illus.
Stedelijk Museum (Amsterdam), May 30–July 7, 1958, *Emil Nolde,* cat. no. 59 (as *Zonnebloemen in de storm*).
Frankfurter Kunstverein (Frankfurt-am-Main), August 1–September 15, 1958, *Emil Nolde, Gemälde und Aquarelle,* cat. no. 40.
Kunsthaus Zürich, October 11–November 9, 1958, *Emil Nolde: 1867–1956,* cat. no. 66.
Kunsthalle Recklinghausen, May 23–July 5, 1959, *Die Handschrift des Künstlers,* cat. no. 229.
Palais des Beaux-Arts (Brussels), May 12–June 18, 1961, *Emil Nolde,* cat. no. 49, illus. (as *Tournesols dans la tempête*).
Hannover Kunstverein, July 16–September 3, 1961, *Emil Nolde: Oelgemälde-Aquarelle- Zeichnungen,* cat. no. 52, illus.
Museum of Modern Art (New York), March 4–April 30, 1963, *Emil Nolde,* cat. no. 59 (as *Sunflowers in the Storm [Sonnenblumen im Sturmwind]*). Shown May 28–September 1, 1963, San Francisco Museum of Art and Pasadena Art Museum.
J. B. Speed Art Museum (Louisville), October 22–December 1, 1968, *The Sirak Collection,* cat. no. 50, illus. (color).

REFERENCES
Franz Roh, *Geschichte der deutschen Kunst von 1900 bis zur Gegenwart* (Munich, 1958), p. 51, illus.
Martin Urban, *Emil Nolde, Catalogue Raisonné of the Oil Paintings,* vol. 2: *1915–1951* (London, 1990), cat. no. 1246, p. 509, illus. (support listed as plywood).

RELATED WORKS
*Sunflowers in the Wind,* 1926, oil on canvas, 74 × 89 cm, private collection, Switzerland; see Martin Urban (1990), cat. no. 1030, p. 350, illus.
*Sunflowers in Evening Light,* 1943, oil on canvas; see *Emil Nolde* (exh. cat., London, 1966), p. 16, no. 4.

REMARKS
This work appears in Nolde's "handlists" as: *1943 Sonnenblumen im Sturmwind.*

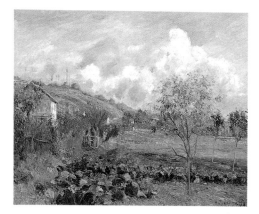

**51.**
Camille Pissarro
*Landscape near Pontoise*  91.1.52
*Paysage près Pontoise*
1878

PROVENANCE
Paul Durand-Ruel, Paris; Count Jean d'Alayer (?), Paris; Sam Salz, New York; Howard D. and Babette L. Sirak, March 1971.

EXHIBITION HISTORY
Galeries Durand-Ruel (Paris), June 1–18, 1898, *Exposition d'oeuvres récentes de Camille Pissarro.*
Galeries Durand-Ruel (Paris), January 10–26, 1910, *Tableaux et gouaches par Camille Pissarro,* cat. no. 24, p. 3.
Arthur Tooth & Sons (London), January 1937.

REFERENCES
Ludovic Rodo Pissarro and Lionello Venturi, *Camille Pissarro: son art—son oeuvre,* 2 vols. (Paris, 1939), 1: 150, cat. no. 491; 2: pl. 100.

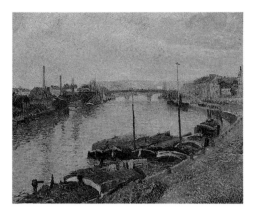

52.
Camille Pissarro
*The Stone Bridge and Barges at Rouen*   91.1.53
*Le Pont de pierre et les péniches à Rouen*
1883

PROVENANCE
Galeries Durand-Ruel, Paris; D. Moffat Dunlap, Toronto; Galeries Durand-Ruel, Paris; Sam Salz, New York; Howard D. and Babette L. Sirak, April 1968.

EXHIBITION HISTORY
Galeries Durand-Ruel (Paris), April 7–30, 1904, *Catalogue de l'exposition de l'oeuvre de Camille Pissarro,* cat. no. 75.
Grafton Galleries (London), January–February 1905, *Pictures by Boudin, Cézanne, Degas, Manet, Monet, Morisot, Pissarro, Renoir, Sisley,* cat. no. 200 (as *The Stone Bridge, Rouen*).
Galeries Durand-Ruel (Paris), January 10–26, 1910, *Tableaux et gouaches par Camille Pissarro,* cat. no. 12.
Galerie Manzi et Joyant (Paris), January–February 1914, *Rétrospective C. Pissarro,* cat. no. 92.
Durand-Ruel Galleries (New York), January 3–24, 1933, *Exhibitions of Paintings by Camille Pissarro in Retrospect,* cat. 15 (as *Le pont de pierre Rouen*).
J. B. Speed Art Museum (Louisville), October 22–December 1, 1968, *The Sirak Collection,* cat. no. 6, illus. (color).

REFERENCES
Ludovic Rodo Pissarro and Lionello Venturi, *Camille Pissarro: son art—son oeuvre,* 2 vols. (Paris, 1939), 1: 167, cat. no. 605; 2: pl. 126.
Janine Bailly-Herzberg, *Correspondance de Camille Pissarro,* 2 vols. (Paris, 1980), 1: 238.

RELATED WORKS
*Le Port de Rouen,* 1883, oil on canvas, 50 × 60 cm (present whereabouts unknown); see Pissarro and Venturi, cat. no. 604, illus.
*Quai Napoléon à Rouen,* 1883, oil on canvas, 54 × 66 cm, Philadelphia Museum of Art; see Pissarro and Venturi, cat. no. 606, illus.
*L'Île Lacroix à Rouen,* 1883, oil on canvas, 54 × 66 cm, Aquavella Galleries, New York; see Pissarro and Venturi, cat. no. 607, illus.

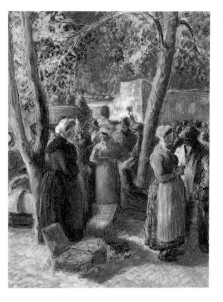

53.
Camille Pissarro
*The Marketplace at Pontoise*   91.1.51
*Le Marché de Pontoise*
1887

PROVENANCE
Charles Durand-Ruel, Paris; Sam Salz, New York; Howard D. and Babette L. Sirak, June 1965.

EXHIBITION HISTORY
Galeries Durand-Ruel (Paris), April 7–30, 1904, *Catalogue de l'exposition de l'oeuvre de Camille Pissarro,* cat. no. 159.
Grafton Galleries (London), January–February 1905, *Pictures by Boudin, Cézanne, Degas, Manet, Monet, Morisot, Pissarro, Renoir, Sisley,* cat. no. 186.
Galeries Durand-Ruel (Paris), January 10–26, 1910, *Tableaux et gouaches par Camille Pissarro,* cat. no. 84 (as *Market Day at Pontoise*).
Galeries Durand-Ruel (Paris), February 27–March 10, 1928, *Tableaux de Camille Pissarro,* cat. no. 121.
Musée de l'Orangerie (Paris), February–March 1930, *Centenaire de la naissance de Camille Pissarro,* cat. no. 23.

REFERENCES
Théodore Duret, "Camille Pissarro," *La Gazette des Beaux-Arts 31,* 3rd series (May 1, 1904), p. 401, illus.
Ludovic Rodo Pissarro and Lionello Venturi, *Camille Pissarro: son art—son oeuvre,* 2 vols. (Paris, 1939), 1: 277, cat. no. 1413; 2: pl. 275.
Richard Brettell and Christopher Lloyd, *A Catalogue of the Drawings by Camille Pissarro in the Ashmolean Museum, Oxford* (Oxford, 1980), p. 161.
Janine Bailly-Herzberg, *Correspondance de Camille Pissarro,* 2 vols. (Paris, 1980), 2: 179, 180.
Camille Pissarro, *Camille Pissarro, Letters to His Son Lucien,* ed. John Rewald, with assistance of Lucien Pissarro, trans. Lionel Abel (Santa Barbara and Salt Lake City, 1981), pp. 127 (letter of June 1, 1887), 129 (letter of June 5, 1887). French ed., *Camille Pissarro, lettres à son fils Lucien* (Paris, 1972).

RELATED WORKS
*Le Marché à Gisors,* gouache, 1884, 27 × 21 cm; see Pissarro and Venturi, cat. no. 1388, illus.
*Le Marché à la volaille, Gisors,* 1885, tempera on canvas, 81 × 81 cm, Museum of Fine Arts, Boston; see Pissarro and Venturi, cat. no. 1400, illus.
*Compositional Study for Le Marché de Pontoise,* 1885 or 1887, brush drawing in gray wash, 26.3 × 20.5 cm, The Ashmolean Museum, Oxford; see Brettell and Lloyd, cat. no. 178, p. 161, illus.

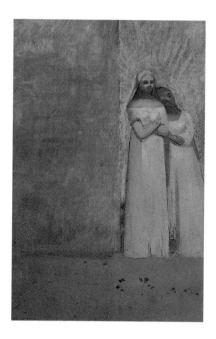

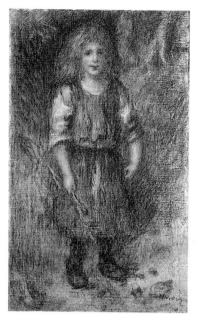

*54.*
Odilon Redon
*The Two Graces*   91.1.54
*Les Deux Grâces*
ca. 1900

PROVENANCE
Arï Redon (son of the artist), Paris; Jacques Bellier, Paris; Sam Salz, New York; Howard D. and Babette L. Sirak, April 1970.

EXHIBITION HISTORY
Galerie Georges Petit (Paris), 1910, illus.
Leicester Gallery (London).
Art Gallery of Ontario (Toronto), October 24–November 30, 1975, *Puvis de Chavannes and the Modern Tradition*, cat. no. 70, pp. 157, 161, illus. (color).

RELATED WORKS
*The Priestesses Were Waiting (Les Prêtresses furent en attente)*, lithograph, pl. 5 of *La Nuit*, 1886, album of 6 plates; see André Mellerio *Odilon Redon* (Paris, 1913), no. 66; reprinted (New York, 1968).
*Apparition*, 1910, oil on canvas, Art Museum, Princeton University; see John Rewald, *Odilon Redon, Gustave Moreau, Rodolphe Bresdin* (exh. cat., New York, 1961), p. 83 (color).

*55.*
Pierre-Auguste Renoir
*The Gypsy Girl*   91.1.56
*La Bohémienne*
1879

PROVENANCE
Ambroise Vollard, Paris; Madame de Galea, Paris; Christian de Galea, Paris; Sam Salz, New York; Howard D. and Babette L. Sirak, November 1967.

EXHIBITION HISTORY
J. B. Speed Art Museum (Louisville), October 22–December 1, 1968, *The Sirak Collection*, cat. no. 7, illus.

REFERENCES
Museum of Fine Arts, Boston, *Renoir* (exh. cat., Boston, 1985), p. 215.

RELATED WORKS
*La Bohémienne*, 1879, oil on canvas, collection of Herbert Black, Canada; see François Daulte, *Auguste Renoir: Catalogue raisonné de l'oeuvre peint*, vol. 1: *Figures, 1860–1890* (Lausanne, 1971), cat. no. 291, illus. Also, see *Renoir* (1985), p. 215, cat. no. 46, illus. (as *Gypsy Girl [La petite bohémienne]*).
*Mussel-fishers at Berneval*, 1879 (Salon of 1880), oil on canvas, Barnes Foundation, Merion, Penn.; see *Renoir*, p. 254, fig. a.

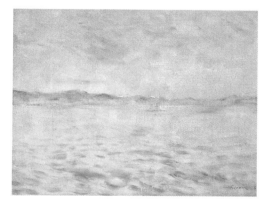

*56.*
Pierre-Auguste Renoir
*The Bay of Naples*   91.1.55
*La Baie de Naples*
1882

PROVENANCE

E. Bignou, Paris; LeFevre Gallery, London; Sam Salz, New York; M. Knoedler & Co., New York (from Sam Salz on joint account, December 1959); Sam Salz, New York (Knoedler's share sold back to Salz, February 1972); Howard D. and Babette L. Sirak, February 1972.

EXHIBITION HISTORY

Alex, Reid, & LeFevre (London), March–April 1942, *Catalogue of British and French Paintings*, cat. no. 15 (as *Marine*).
LeFevre Gallery (London), June 1948, *Renoir*, cat. no. 10.

RELATED WORKS

*Breakfast at Berneval*, 1898, oil on canvas, 82 × 66 cm, private collection; see *Renoir* (exh. cat., Museum of Fine Arts, Boston, 1985), cat. no. 98, p. 266, illus.
*Christine and Yvonne Lerolle at the Piano*, 1897, oil on canvas, 73 × 92 cm, Musée de l'Orangerie, Paris; see *Renoir* (1985), cat. no. 97, p. 266, illus.

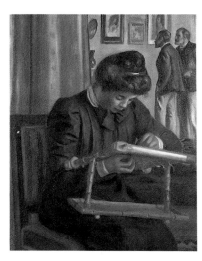

57.
Pierre-Auguste Renoir
*Christine Lerolle Embroidering*   91.1.57
*Christine Lerolle brodant*
ca. 1895–1898

PROVENANCE

Galeries Durand-Ruel (received on consignment from the artist in 1914); Studio of the artist (returned from Galeries Durand-Ruel, July 27, 1917); Durand-Ruel, Paris; Charles Sessler, London (bought from Durand-Ruel, September 1, 1929); private collection, Switzerland; Sam Salz, New York; Howard D. and Babette L. Sirak, March 1973.

EXHIBITION HISTORY

Galeries Durand-Ruel (Paris), June 1902, *Tableaux par A. Renoir*, cat. no. 20 (as *La Brodeuse*).
Durand-Ruel Galleries (New York), March 29–April 15, 1939, *Loan Exhibition of Portraits by Renoir*, cat. no. 12, illus.
Galeries Durand-Ruel (Paris), May 30–October 15, 1958, *Hommage à Renoir*, cat. no. 43.
Städtische Galerie (Munich), November 5–December 14, 1958, *Renoir*, cat. no. 33, p. 43, illus.
Galeries Durand-Ruel (Paris), January 7–February 8, 1969, *Renoir intime* (exhibition organized to benefit La Fondation Renoir and La Société des Amis de Nogent), cat. no. 36, illus. (as *Christine Lerolle brodant [le sculpteur Devillaz et Henri Rouart]* [sic], dated 1896).
Seibu Gallery (Tokyo), October 12, 1971–November 24, 1971, *Rétrospective Pierre-Auguste Renoir*, cat. no. 35, illus. Shown December 8, 1971–February 6, 1972, at the Cultural Center of Fukuoka and at the Museum of Modern Art of the Prefecture of Hyogo (Kobe).
Art Institute of Chicago, February 3–April 1, 1973, *Paintings by Renoir*, cat. no. 65, p. 26, illus. (as *Mademoiselle Lerolle Sewing*).

REFERENCES

Gustave Coquiot, *Renoir* (Paris, 1925), p. 230, illus.
Julius Meier-Graefe, *Renoir* (Leipzig, 1929), p. 167, no. 146 (as *Die Stickerin [Mlle. Chr. Lerolle, im Hintergrund der Bildhauer Devillaz und Louis Rouart]* [sic]).
Albert André, *L'Atelier de Renoir*, vol. I (Paris, 1931), pl. 36, no. 101 (as *Jeune fille brodant*).
Michel Drucker, *Renoir* (Paris, 1944), pp. 88, 112, 240, illus. (as *Jeune fille au métier: Mlle Christine Lerolle*, dated ca. 1897); rev. ed. (Paris, 1955).
Douglas Davis, "Flesh and Form," *Newsweek*, February 5, 1973.

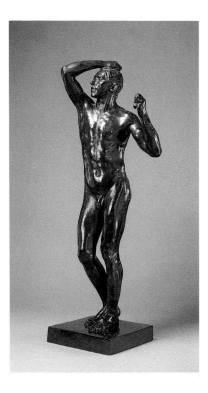

58.
Auguste Rodin
*The Age of Bronze*   91.1.58
*L'Age d'airain*
1875–1876

PROVENANCE

Baron de Baroqueville, Brussels; Sam Salz, New York; Howard D. and Babette L. Sirak, November 1967.

EXHIBITION HISTORY

J. B. Speed Art Museum (Louisville), October 22–December 1, 1968, *The Sirak Collection*, cat. no. 8, illus.

RELATED WORKS

John Tancock, who has published the most complete lists of Rodin casts, records thirty-eight life-size casts in bronze and five in plaster. Rodin had reductions made in two sizes, a half life-size version (41 inches), of which Tancock lists nine casts (the Sirak cast is not included), and a smaller version (26 inches), of which he lists eleven casts. See John Tancock, *The Sculpture of Auguste Rodin* (Boston, 1976).

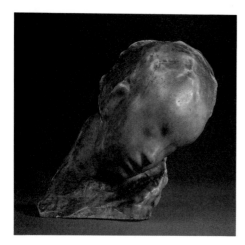

59.
Medardo Rosso
*Sick Boy*  91.1.59
*Bimbo malato*
ca. 1893

PROVENANCE
Enrico Mascioni; Dr. Filippo DiCarlo; Peridot Gallery, New York; Howard D. and Babette L. Sirak, January 1966.

EXHIBITION HISTORY
Peridot Gallery (New York), December 15, 1958–January 16, 1959, *The First Exhibition in America of Sculpture by Medardo Rosso*, cat. by Giorgio Nicodemi, no. 10, illus. (dated as 1895).
[Peridot Gallery (New York), December 18, 1962–January 12, 1963, *Medardo Rosso.*]
J. B. Speed Art Museum (Louisville), October 22–December 1, 1968, *The Sirak Collection*, cat. no. 9, illus.

REFERENCES
Genauer, "Art: Some Rediscoveries," *New York Herald Tribune*, Sunday, December 20, 1959.
*Life International*, May 9, 1960, p. 69, illus. (color).
University of Iowa Museum of Art, March 23–May 3, 1975, *An Artist Collects: Ulfert Wilke, Selections from Five Continents* (exh. cat., Iowa City, 1975), p. 36.

REMARKS
A certificate of authenticity and a photograph of the work are signed by Giorgio Nicodemi (Rosso expert and friend of the artist).

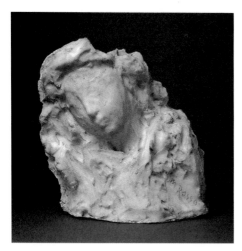

60.
Medardo Rosso
*Head of a Young Woman*  91.1.60
*Busto di donna*
ca. 1901

PROVENANCE
Alberto Corozzi, Paris; Peridot Gallery, New York; Howard D. and Babette L. Sirak, January 1967.

EXHIBITION HISTORY
Peridot Gallery (New York), December 15, 1958–January 16, 1959, *The First Exhibition in America of Sculpture by Medardo Rosso*, cat. by Giorgio Nicodemi, no. 11, illus. (dated as 1897).
Museum of Modern Art (New York), September 30–November 23, 1963, *Medardo Rosso*, no. 160, pp. 77, 79, illus.
Paul Rosenberg Gallery (New York), April 26–May 21, 1966, *Seven Decades: Cross-Currents in Modern Art, 1895–1965*, cat. by Peter Selz, no. 17, pp. 25, 192, illus.
J. B. Speed Art Museum (Louisville), October 22–December 1, 1968, *The Sirak Collection*, cat. no. 10, illus.

REFERENCES
Hilton Kramer, "Medardo Rosso," *Arts* 34 (December 1959): 34, illus.
Dore Ashton, "A Sculpture of Mystical Feeling," *New York Times*, December 27, 1959.
Katharine Kuh, *Break-Up: The Core of Modern Art* (Greenwich, Conn., 1965), pp. 22–23, 142, fig. 7.
University of Iowa Museum of Art, March 23–May 3, 1975, *An Artist Collects: Ulfert Wilke, Selections from Five Continents* (exh. cat., Iowa City, 1975), p. 36.

REMARKS
A certificate of authenticity and a photograph of the work are signed by Giorgio Nicodemi (Rosso expert and friend of the artist). The authenticity is also attested by Lucian Fassuto, member of the Lombard Association of Experts.
Numerous casts of this work are known. Nine in wax and two in bronze are recorded by Jole de Sanna (*Medardo Rosso o la creazione dello spazio moderno* [Milan, 1985], p. 135), and, additionally, one in wax and one in bronze are illustrated in the Museum of Modern Art exhibition catalogue (1963), p. 40. The work also exists in a variant, seen in both bronze and wax, in which a halolike ridge protrudes at the top of the head. The problem of posthumous casts, of which apparently a number exist, is discussed by Luciano Caramel (*Medardo Rosso: Impressions in Wax and Bronze, 1882–1906* [New York, 1988], p. 3).

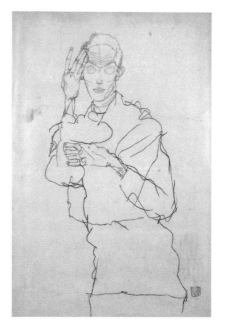

61.
Egon Schiele
*The Thinker (Self-Portrait)*  91.1.61
*Der Denker (Selbstbildnis)*
1914

PROVENANCE
Heinrich Stinnes; Gutekunst & Klipstein, June 20–22, 1938, lot 1054; Zdenko Bruck; Galerie St. Etienne, New York; Howard D. and Babette L. Sirak, April 1965.

EXHIBITION HISTORY
Galerie St. Etienne (New York), March 1–April 17, 1965, *Egon Schiele (1890–1918)*, cat. no. 48 (as *Self-Portrait*).
Des Moines Art Center, September 20–October 31, 1971, *Egon Schiele and the Human Form: Drawings and Watercolors*, cat. no. 37, illus. (as *Self-Portrait*, 1914); also shown November 15, 1971–February 13, 1972, Columbus Gallery of Fine Arts and Art Institute of Chicago.
J. B. Speed Art Museum (Louisville), October 22–December 1, 1968, *The Sirak Collection*, cat. no. 52, illus. (as *Self portrait* [*sic*]).

REFERENCES
Franz Pfemfert, ed., *Die Aktion*, July 8, 1916, p. 390, illus. (as *Studie*). The page number here corresponds to the reprinted collection of this publication (Munich, 1967).
Gutekunst & Klipstein, *Sammlung Dr. Heinrich Stinnes: Moderne Graphik des XX, Jahrhunderts*, sale cat., June 20–22, 1938, no. 1054, p. 80 (as *Der Denker: Stehender junger Mann*).
Jane Kallir, *Egon Schiele: The Complete Works* (New York, 1990), cat. no. 1652, p. 541, illus.

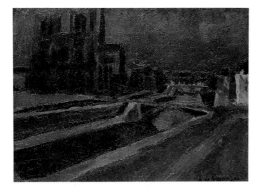

*62.*
André Dunoyer de Segonzac
*Notre-Dame de Paris*   91.1.65
1913

PROVENANCE
John Quinn (purchased from the artist), March 1918; John Quinn estate, 1924–1926 (?); Joseph Brummer Gallery, New York; Edgar A. Levy, New York; Sam Salz, New York (purchased at auction, Sotheby Parke Bernet, New York, May 3, 1974); Howard D. and Babette L. Sirak, June 1974.

EXHIBITION HISTORY
The Sculptor's Gallery (New York), March 24–April 10, 1922, *Exhibition of Contemporary French Art*, no. 115 (as *Notre Dame*).
Galerie Bernheim-Jeune (Paris), 1922.
Musée de l'Orangerie (Paris), February 20–May 3, 1976, *Dunoyer de Segonzac*, cat. no. 11, illus.
Hirshhorn Museum and Sculpture Garden, Smithsonian Institution, Washington, D.C., June 15–September 4, 1978, *The Noble Buyer: John Quinn, Patron of the Avant-Garde*, cat. no. 69, pp. 140, 184, illus.

REFERENCES
Ledger (two-volume record of John Quinn's art purchases from 1913 to 1924, in the collection of Thomas F. Conroy as of 1978), vol. 1, p. 249.
René-Jean, *A. Dunoyer de Segonzac*, Les Peintres français nouveaux, no. 11 (Paris, 1922), p. 37, illus.
Loans (bound file of outgoing loans from John Quinn collection from 1914 to 1924, in the collection of Thomas F. Conroy as of 1978), p. 26.
Inventory (Estate of John Quinn, Deceased, *Catalogue of the Art Collection Belonging to Mr. Quinn*, July 28, 1924; now in the John Quinn Memorial Collection of the New York Public Library), n.p.
*John Quinn, 1870–1925* [*sic*]. *Collection of Paintings, Watercolors, Drawings & Sculpture*, foreword by Forbes Watson (Huntington, New York, 1926), pp. 8, 51, illus.
Paul Jamot, *Dunoyer de Segonzac* (Paris, 1929), pp. 48, 49, 231, illus.; rev. ed. (Paris, 1941), pp. 55, 179.
Claude Roger-Marx, "André Dunoyer de Segonzac," *Conferncia* (June 20, 1929): 154.
Claude Roger-Marx, *Dunoyer de Segonzac* (Geneva, 1951), pp. 67, 70.
Sotheby Parke Bernet, New York, *Modern Paintings, Drawings, Sculpture*, sale cat. no. 3633, May 3, 1974, no. 367, illus.
Anne Distel, *A. Dunoyer de Segonzac*, trans. Alice Sachs (New York, 1980), pp. 29, 58, illus. (color).

*63.*
André Dunoyer de Segonzac
*Provençal Farm*   91.1.63
*Ferme provençale*
1952

PROVENANCE
Sam Salz, New York (purchased from the artist); Howard D. and Babette L. Sirak, November 1967.

EXHIBITION HISTORY
J. B. Speed Art Museum (Louisville), October 22–December 1, 1968, *The Sirak Collection*, cat. no. 54, illus. (as *St. Tropez*).

*64.*
André Dunoyer de Segonzac
*The Foot of the Valley*   91.1.64
*Le Fond du golfe*
1952

PROVENANCE
Sam Salz, New York (purchased from the artist); Howard D. and Babette L. Sirak, November 1967.

EXHIBITION HISTORY
J. B. Speed Art Museum (Louisville), October 22–December 1, 1968, *The Sirak Collection*, cat. no. 53, illus.

*65.*
André Dunoyer de Segonzac
*The Cypress by the Sea (Saint-Tropez)*   91.1.66
*Le Cyprès devant la mer (Saint-Tropez)*
1956

PROVENANCE
Sam Salz, New York (purchased from the artist); Howard D. and Babette L. Sirak, November 1967.

EXHIBITION HISTORY
J. B. Speed Art Museum (Louisville), October 22–December 1, 1968, *The Sirak Collection*, cat. no. 55, illus.

*66.*
André Dunoyer de Segonzac
*The Dog*   91.1.62
*Le Chien*

PROVENANCE
Sam Salz, New York (purchased from the artist); Howard D. and Babette L. Sirak, March 1968.

EXHIBITION HISTORY
J. B. Speed Art Museum (Louisville), October 22–December 1, 1968, *The Sirak Collection*, cat. no. 56, illus.

REMARKS
This work was a gift to Babette Sirak on her birthday, March 19, 1968.

*67.*
Gino Severini
*Rhythm of the Dance (Dancer)*   91.1.67
*Rythme de danse (Danseuse)*
1913

PROVENANCE
Madame Rachilde, Paris; Stuttgarter Kunstkabinett, sale, December 1, 1955; Walter Bareiss, New York; Leonard Hutton Gallery, New York; Howard D. and Babette L. Sirak, July 1965.

EXHIBITION HISTORY
Galerie 23 (Paris), December 27, 1929–January 9, 1930, *Peintres Futuristes Italiens*, cat. no. 3 (as *Danseuse*, dated 1912).
Museum of Modern Art (New York), The Museum's Guest House, April 23–May 11, 1958, *50 Selections from the Collection of Mr. and Mrs. Walter Bareiss* (exhibition sponsored by the Junior Council of the Museum of Modern Art), cat. no. 47, illus.
J. B. Speed Art Museum (Louisville), October 22–December 1, 1968, *The Sirak Collection*, cat. no. 57, illus.

REFERENCES
Stuttgarter Kunstkabinett, December 1, 1955, *22. Kunst-Auktion*, cat. no. 1975, p. 175, pl. 56.
Herta Wescher, *Collage*, trans. Robert E. Wolf (New York, 1968), pp. 54–55, 331, fig. 47 (as *Dancer*).
University of Iowa Museum of Art, *An Artist Collects: Ulfert Wilke, Selections from Five Continents* (exh. cat., Iowa City, 1975), p. 32.
Daniela Fonta, *Gino Severini, Catalogo ragionato* (Milan, 1988), cat. no. 162, p. 156, illus.

RELATED WORKS
*Dynamic Hieroglyph of the Bal Tabarin*, 1912, oil on canvas with sequins, Museum of Modern Art, New York; see Pontus Hulten, *Futurism & Futurisms* (New York, 1986), p. 571, illus.
*The Blue Dancer*, 1912, oil on canvas with sequins, Mattioli Collection, Milan; see Hulten, p. 228, illus. (color).
*Dynamism of a Dancer*, 1912, oil on canvas, Riccardo and Magda Jucker Collection on Loan to Pinacoteca of Brera; see Hulten, p. 229, illus. (color).
*Danseuse dans la lumière*, 1913, oil on board with sequins, 35 × 30 cm; see Museum Boymans-van Beuningen, *Gino Severini* (exh. cat, Rotterdam, 1963), cat. no. 28, illus.

REMARKS
This is a scene from the Bal Tabarin in Paris, where Madame Rachilde was a star dancer.

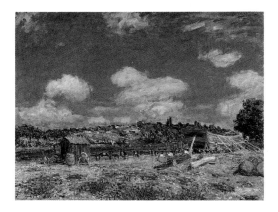

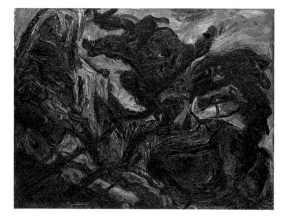

*68.*
Alfred Sisley
*Boatyard at Saint-Mammès*   91.1.68
*Chantier à Saint-Mammès*
1885

PROVENANCE
[Durand-Ruel, Paris]; H. Vever, Paris; Galerie Georges Petit, Paris (purchased at H. Vever sale, February 1–2, 1897); Georges Petit, Paris; Dr. Maurice Gilbert, Geneva; Charles Durand-Ruel, Paris; Sam Salz, New York; Howard D. and Babette L. Sirak, January 1973.

EXHIBITION HISTORY
[Galerie Georges Petit (Paris), 1897, *Exposition Alfred Sisley*, cat. no. 65 (dated as 1883).]
Galeries Durand-Ruel (Paris), February 15–March 1, 1902, *Exposition de Tableaux de A. Sisley*, cat. no. 8.
Galeries Durand-Ruel (Paris), 1903.
Leicester Galleries (London), 1922.
Musée Rath (Geneva), June 26–October 3, 1954, *Trésors des collections romandes*, cat. no. 125, illus.

REFERENCES
Galerie Georges Petit (Paris), *Vente H. Vever*, sale cat., February 1–2, 1897, no. 114.
François Daulte, *Alfred Sisley: Catalogue raisonné de l'oeuvre peint* (Lausanne, 1959), cat. no. 579, illus.

RELATED WORKS
*Bords de rivière à Saint-Mammès*, 1885, oil on canvas, 38 × 55 cm; see Daulte, cat. no. 577, illus.
*Bateaux en construction à Saint-Mammès*, 1885, oil on canvas, 65 × 92 cm; see Daulte, cat. no. 578, illus.
*Construction d'un bateau à Saint-Mammès*, 1885, oil on canvas, 38 × 55 cm; see Daulte, cat. no. 580, illus.

*69.*
Chaim Soutine
*Landscape at Céret*   91.1.70
*Paysage de Céret*
ca. 1920–1921

PROVENANCE
E. and A. Silberman Galleries, New York, 1961; Howard D. and Babette L. Sirak, September 1965.

EXHIBITION HISTORY
E. and A. Silberman Galleries (New York), March 1–April 1, 1961, *Exhibition 1961, Paintings from the Galleries' Collection*, cat. no. 29, illus. (as *Cannes Landscape*).
The Royal Scottish Academy (Edinburgh), August 17–September 15, 1963, *Chaim Soutine, 1893–1943* (Edinburgh International Festival, arranged by Arts Council of Great Britain, 1963), pp. 7, 19. Also shown October 31, 1963, Tate Gallery (London).
Los Angeles County Museum of Art, February 20–April 14, 1968, *Chaim Soutine, 1893–1943*, cat. no. 14, pp. 5, 25, 52, 70, illus. (color).
J. B. Speed Art Museum (Louisville), October 22–December 1, 1968, *The Sirak Collection*, cat. no. 58, illus.

REFERENCES
Andrew Forge, *Soutine* (London, 1965), p. 38, pl. 10 (color).
J. Lovoos, "The Home Forum," *Christian Science Monitor*, Wednesday, April 3, 1968, p. 8, illus.
"On Exhibition," *Studio International* (April 1968), p. 211, illus.
Hilton Kramer, "Soutine and the Problem of Expressionism," *Artforum* 6 (summer 1968), p. 25, illus.
Pierre Courthion, *Soutine, peintre du déchirant* (Lausanne, 1972), pp. 52, 53, illus. (color, backwards; as *Paysage de Céret [La Maison dans les arbres]*), p. 69 (as *La Maison dans les arbres*), p. 206, fig. C.
University of Iowa Museum of Art, *An Artist Collects: Ulfert Wilke, Selections from Five Continents* (exh. cat., Iowa City, 1975), p. 24.
Landschaftsverband Westfalen-Lippe and Westfälisches Landesmuseum für Kunst und Kulturgeschichte Münster, *Chaim Soutine, 1893–1943*, ed. Ernst-Gerhard Güse (exh. cat., English ed., London, 1981), pp. 37, 38, 250, fig. 18.
Maurice Tuchman, Klaus Perls, Esti Dunow, *The Chaim Soutine Catalogue Raisonné*, vol. 1 (Paris, 1991–1992, forthcoming), illus. (color).

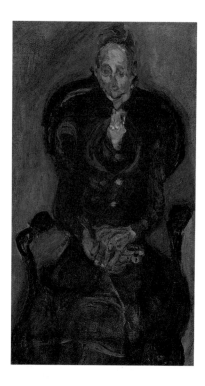

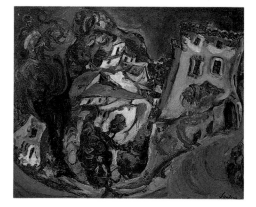

*70.*
Chaim Soutine
*Melanie, The Schoolteacher*   91.1.71
*Melanie, l'institutrice*
ca. 1922

PROVENANCE
Hôtel Drouot sale, March 17, 1928; Kleinmann, Paris (purchased at Hôtel Drouot sale, March 17, 1928); Dr. Jacques Soubiès, Paris (until December 13, 1940); Hôtel Drouot, Paris, auction sale, December 13, 1940; private collection, Paris; Galerie Charpentier sale, June 10, 1955; Edward A. Bragaline, New York; M. Knoedler & Co., New York; Howard D. and Babette L. Sirak, April 1965.

EXHIBITION HISTORY
M. Knoedler & Co. (New York), November 6–23, 1963, *Twentieth Century Masters from the Bragaline Collection,* cat. no. 8, illus. (color).
J. B. Speed Art Museum (Louisville), October 22–December 1, 1968, *The Sirak Collection,* cat. no. 59, illus. (color).

REFERENCES
Hôtel Drouot (Paris), *Catalogue des tableaux, pastels, aquarelles, gouaches, dessins,* sale cat., March 17, 1928, p. 37, illus. (as *Vieille femme assise dans un fauteuil*).
Hôtel Drouot (Paris), *Collection de feu le Docteur Jacques Soubiès,* sale cat., December 13, 1940, no. 79.
"Calendrier des ventes," *Arts* 519 (June 8–14, 1955): 13, illus.
Galerie Charpentier (Paris), sale cat., June 10, 1955, no. 107, pl. 16 (as *Femme au fauteuil rouge*).
Pierre Courthion, *Soutine, peintre du déchirant* (Lausanne, 1972), p. 234, fig. B (as *Mélanie l'institutrice, II [Femme au fauteuil rouge],* dated 1923–1924).
E. Bénézit, ed., *Dictionnaire critique et documentaire des peintres, sculpteurs, dessinateurs et graveurs,* vol. 9 (Paris, 1976), p. 725 (as *Vieille femme assise dans un fauteuil* and as *Femme au fauteuil rouge*), and p. 726 (as *Femme au fauteuil rouge*).
Maurice Tuchman, Klaus Perls, Esti Dunow, *The Chaim Soutine Catalogue Raisonné,* vol. 1 (Paris, 1991–1992, forthcoming), illus. (color).

RELATED WORKS
*Vieille femme assise (Mélanie l'institutrice),* 1923–1924, oil on canvas, 65 × 54 cm, Cleveland Museum of Art; see Courthion, p. 234, fig. A.

*71.*
Chaim Soutine
*Landscape at Cagnes*   91.1.69
*Paysage de Cagnes*
1923

PROVENANCE
Dr. Jacques Soubiès, Paris (until December 13, 1940); Hôtel Drouot, Paris, sale, December 13, 1940; private collection, Paris; M. Knoedler & Co., New York, December 1964–March 1965; Howard D. and Babette L. Sirak, March 1965.

EXHIBITION HISTORY
Columbus Gallery of Fine Arts, October 6–27, 1966, *Columbus Collects.*
Los Angeles County Museum of Art, February 20–April 14, 1968, *Chaim Soutine, 1893–1943,* cat. no. 31, pp. 29, 53, 85, illus. (dated as ca. 1923–1924).
J. B. Speed Art Museum (Louisville), October 22–December 1, 1968, *The Sirak Collection,* cat. no. 60, illus.

REFERENCES
Hôtel Drouot (Paris), *Collection de feu le Docteur Jacques Soubiès,* sale cat., December 13, 1940, no. 94 (as *Paysage Montagneux*).
Hilton Kramer, "The Sadness of Soutine," *New York Times,* Sunday, March 3, 1968, Section 2, p. 21, illus.
Pierre Courthion, *Soutine, peintre du déchirant* (Lausanne, 1972), pp. 69, illus. (color), p. 231, fig. B (as *Paysage de Cagnes [La Gaude],* dated 1923–1924).
E. Bénézit, ed., *Dictionnaire critique et documentaire des peintres, sculpteurs, dessinateurs et graveurs,* vol. 9 (Paris, 1976), p. 725 (as *Paysage montagneux*).
Musée de l'Orangerie, *Collection Jean Walter et Paul Guillaume* (Paris, 1984), p. 262.
Maurice Tuchman, Klaus Perls, Esti Dunow, *The Chaim Soutine Catalogue Raisonné,* vol. 1 (Paris, 1991–1992, forthcoming), illus. (color).

RELATED WORKS
*Paysage de Cagnes,* 1923, oil on canvas, 73 × 92 cm; see Courthion, p. 230, fig. A.
*Paysage de Cagnes,* 1923, oil on canvas, 81 × 100 cm; see Courthion, p. 230, fig. B. *Paysage de Cagnes,* 1923, oil on canvas, 60 × 73 cm; see Courthion, p. 231, fig. D.

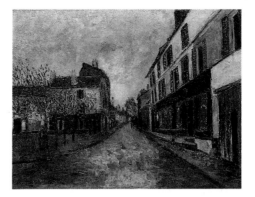

**73.**
Maurice Utrillo
*Church Square, Montmagny* 91.1.73
*Place de l'Église à Montmagny*
ca. 1908

PROVENANCE
Galérie Van Leer, Paris; [Mme. Baron]; Paul Pétridès, Paris; Sam Salz, New York; Howard D. and Babette L. Sirak, January 1965.

EXHIBITION HISTORY
Galérie Barbazanges (Paris), 1921.
Kunsthaus (Cologne), 1923, *Utrillo White Period.*
Carnegie Institute, Museum of Art (Pittsburgh), October 18–December 1, 1963, *Maurice Utrillo,* cat. no. 13, illus. (as *Rue de Montmagny*), also mentioned in essay by Gustave von Groschwitz, n.p.
Columbus Gallery of Fine Arts, October 7–21, 1965.
J. B. Speed Art Museum (Louisville), October 22–December 1, 1968, *The Sirak Collection,* cat. no. 64, illus.

REFERENCES
Tanneguy de Quénétain, "Les trésors de Sam Salz," *Réalités* 230 (March 1965): 74, 75, illus. (color) (as *Rue de Montagny* [*sic*], dated 1909).
Tanneguy de Quénétain, "The Treasures of Sam Salz," *Réalités* (English ed.) 175 (June 1965): 44–45, illus. (color) (as *Rue de Montagny* [*sic*], dated 1909).
Paul Pétridès, *L'Oeuvre complet de Maurice Utrillo,* supplement, vol. 5 (Paris, 1974), cat. no. 2482, p. 120, illus. p. 121 (as *Place de l'Église à Montmagny [Val-d'Oise]*).

RELATED WORKS
*Place de l'Église à Montmagny,* ca. 1907, oil on canvas, 54 × 73 cm; see Paul Pétridès, *L'Oeuvre complet de Maurice Utrillo,* vol. 1 (Paris, 1959), no. 50, p. 98, illus.
*Église de Montmagny,* ca. 1908, oil on canvas, 50 × 73 cm; see Pétridès, vol. 1, no. 77, p. 126, illus.
*Église de Montmagny,* ca. 1908, oil on canvas, 54 × 72 cm; see Pétridès, vol. 1, no. 78, p. 126, illus.
*Église de Montmagny,* ca. 1908, oil on canvas, 21 × 28 ½ in., Denver Art Museum; see Pétridès, vol. 1, no. 79, p. 126, illus.
*Rue de Paris à Asnières,* ca. 1910, oil on canvas, 54 × 73 cm; see Pétridès, vol. 1, no. 185, p. 234, illus.

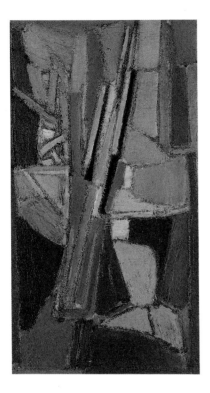

**72.**
Nicolas de Staël
*The Volume of Things* 91.1.72
*Volume des choses*
1949

PROVENANCE
Theodore Schempp, Paris (purchased from the artist); Mr. and Mrs. H. Weintraub, New York; Parke-Bernet Galleries, auction, April 14, 1965; Howard D. and Babette L. Sirak, August 1965.

EXHIBITION HISTORY
Stephen Hahn Gallery (New York), 1961, cat. no. 8.

REFERENCES
Parke-Bernet Galleries, sale cat., April 14, 1965, no. 73.
André Chastel, *Nicolas de Staël,* letters of Nicolas de Staël, annotated by Germain Viatte, and catalogue raisonné of the paintings by Jacques Dubourg and Françoise de Staël (Paris, 1968), cat. no. 169, p. 112, illus.
Des Moines Art Center, *Art in Western Europe: The Post-War Years, 1945–1955* (exh. cat., Des Moines, 1978), cat. no. 60, illus. (as *Volume of Objects*).

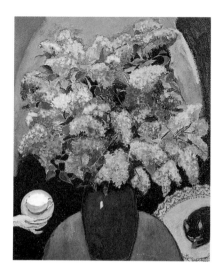

*74.*
Kees van Dongen
*Lilacs with Cup of Milk*   91.1.74
*Lilas et tasse de lait*
1909

PROVENANCE
Marcel Kapferer, Paris; Sam Salz, New York; Howard D. and Babette L. Sirak, November 1971.

EXHIBITION HISTORY
Galerie Druet (Paris), 1910.
Petit Palais (Paris), 1937.

*76.*
Maurice de Vlaminck
*Field of Wheat*   91.1.76
*Champ de blé*
n.d.

PROVENANCE
Private collection, Paris; Howard D. and Babette L. Sirak, January 1965.

EXHIBITION HISTORY
J. B. Speed Art Museum (Louisville), October 22–December 1, 1968, *The Sirak Collection*, cat. no. 66, illus. (as *Champ de blés* [*sic*]).

*75.*
Maria Elena Vieira da Silva
*The Atlantic*   91.1.75
*Atlantique*
1961

PROVENANCE
M. Knoedler & Co., New York (purchased from the artist), August 1961; Beatrice Glass Fine Arts, Inc., October 1961; M. Knoedler & Co., New York, consigned in May 1963; Howard D. and Babette L. Sirak, January 1964.

EXHIBITION HISTORY
M. Knoedler & Co. (New York), October 3–28, 1961, *Recent Paintings by Vieira da Silva*, cat. no. 24 (on supplemental list of paintings).
J. B. Speed Art Museum (Louisville), October 22–December 1, 1968, *The Sirak Collection*, cat. no. 65, illus.

REFERENCES
*Pictures on Exhibit* 25 (October 1961): 19, illus.
*International Directory of Contemporary Art* (Milan, 1964), p. 393, illus.

*77.*
Édouard Vuillard
*Nude Seated before a Fireplace*   91.1.78
*Nu assis devant la cheminée*
ca. 1899

PROVENANCE
Jos. Hessel, Paris; [Marcel Kapferer, Paris]; Ralph Bellier; Sam Salz, New York; Howard D. and Babette L. Sirak, November 1971.

EXHIBITION HISTORY
Galerie Bernheim-Jeune (Paris), November 11–24, 1908, *Vuillard*, no. 62.
Musée des Arts décoratifs, Pavillon de Marsan, Palais du Louvre (Paris), May–July 1938, *Exposition E. Vuillard*, cat. no. 72, p. 13 (as *Femme nue, assise devant une cheminée noire*).

213

*78.*
Édouard Vuillard
*The Big Tree (The Tree Trunk)*   91.1.77
*Le Grand Arbre (Le Tronc)*
ca. 1930

PROVENANCE
Jacques Roussel, Paris (the artist's nephew); Sam Salz, New York;
Howard D. and Babette L. Sirak, November 1967.

EXHIBITION HISTORY
J. B. Speed Art Museum (Louisville), October 22–December 1, 1968,
   *The Sirak Collection,* cat. no. 67, illus.

REFERENCES
André Chastel, *Vuillard, 1868–1940* (Paris, 1946), pp. 101, 124, illus. (as
   *Le Tronc*).

# ACKNOWLEDGMENTS

Many individuals and institutions gave generously of their time, expertise, and talents to help in the research for this catalogue and in its production. Each one deserves our heartfelt gratitude, admiration, and respect.

Howard and Babette Sirak made their fine arts library available for research and study, shared letters and other documents, answered endless questions thoroughly and patiently, and offered much helpful advice. We have felt their encouragement and support at every stage.

In spite of their intense schedules, Richard Brettell and Peter Selz not only contributed enlightening essays but read all the other texts for accuracy and completeness. In addition, Albert Elsen read the sculpture entries and Lorenz Eitner read the Segonzac entries. They and the many catalogue contributors have been especially patient and cooperative through all the phases of editing, and it has been wonderfully rewarding and enlightening to work with such respected scholars.

Sheldan Collins, the book's principal photographer, made a grueling schedule a pleasure for those of us who stood by to marvel or to assist.

We could not have accomplished so much in so little time had it not been for the many librarians who provided information and cheerful service—in particular: Jo Ann Vanetti, assistant librarian, and Ann B. Abid, head librarian, Ingalls Library, Cleveland Museum of Art; Diana Druback, circulation supervisor, and Susan Wyngaard, head of Fine Arts Library, Ohio State University; Shirley Coffin, Public Library of Cincinnati and Hamilton County; Clive Phillpot, director, Janis Ekdahl, assistant director, Hikmet Doğu, Eumie Imm, Daniel Starr, and Tom Micchelli, Museum of Modern Art Library, New York; William B. Walker, chief librarian, and Patrick F. Coleman, supervising technician, Thomas J. Watson Research Library, Metropolitan Museum of Art; Chuck Thompson, librarian, and Constance Wall, chief of arts library reference division, Detroit Institute of Arts Library; and Annette Oren, resource center coordinator, Columbus Museum of Art. Others who were especially helpful were Jane Kallir and Hildegard Bachert of the Galerie St. Etienne; Melissa de Medeiros, M. Knoedler & Co.; Antoine Salomon, Paris, expert on Vuillard; Nick Wilke, son of collector Ulfert Wilke; Stephen Hauser, research supervisor for the Feininger catalogue raisonné, at Achim Moeller Fine Art, New York; Suzanne Vanderwoude, of Vanderwoude/Tananbaum Galleries, New York; Gilbert Pétridès of Galerie Gilbert and Paul Pétridès, Paris, expert on Vlaminck and Utrillo; and the staffs of Columbus Metropolitan Library, Columbus College of Art and Design, State Library of Ohio, Frick Collection Library, Ryerson and Burnham Libraries of the Art Institute of Chicago, and Ursus Books in New York.

We are indebted to those friends of the museum who offered expert advice in a variety of areas: Christine Verzar, chair, Department of the History of Art, and Mathew Herban III, professor of art history, Ohio State University; Ryan Howard, Morehead State University; Matthew Senior, assistant professor of French, University of New Orleans; Jacqueline Hall, art critic, *Columbus Dispatch*; Rex Wallace, associate professor, University of Massachusetts; and Ulla Thomas, a resource on German language and culture. Eliza Skaggs, Hattie Heller, Josephine Berry, Susan Saxby, Heather Kneeland, Susan Sheaffer Curtis, Ralph Roberts, and Joshua Roberts all went beyond hopes and expectations in their willingness to assist in numerous ways, to deliver materials, and to endure inconveniences. The museum's docents were eager learners about the collection and provided many insights and ideas for exploration. Fran Luckoff deserves special thanks for donating books relevant to the Sirak Collection to the museum's resource center in memory of her husband Seymour Luckoff.

The staff of the Columbus Museum of Art have all been deeply involved in the success of every area of

this milestone event in the institution's history. The curatorial department—Roger Clisby, Rod Bouc, E. Jane Connell, Jeff Douglas, Greg Jones, Nannette V. Maciejunes, Brian Maloney, John Owens, and Martha Torres—in addition to creating a superb inaugural exhibition installation provided measurements and information about media and accompanied researchers on frequent missions to check inscriptions, color, or other aspects of the works. Sharon Kokot and Carole Genshaft of the education department and Roger Clisby read the entries and essays. Beth Roach deftly and kindly managed the telephone traffic to our benefit in many situations. The staff of the Publications Department—Karen Kneisley, Jenifer Roulette, and Cheryl Wipert—were wonderfully heroic at times as they labored intensely to meet deadlines.

In the early days of the project, former director Budd Harris Bishop and former chief curator Steven W. Rosen laid the groundwork for the acquisition of the collection and pointed out various directions that cataloguing might take.

Ed Marquand created the elegant design, and Suzanne Kotz and Patricia Draher, with good humor and almost daily gifts of encouragement, helped guide the book through the production process.

And most important, Director Merribell Parsons, through her trust and support, praise and encouragement, made the seemingly endless, often frustrating, process a pleasure and a challenge.

Leslie Stewart Curtis
Norma Roberts

Design by Marquand Books, Inc., Seattle.
Typesetting by The Type Gallery, Seattle, in Versailles
with display lines in French Roman.
Printed on 128 gsm New Age stock.
Color separation, printing, and binding by Toppan
Printing Co., Ltd., Tokyo.